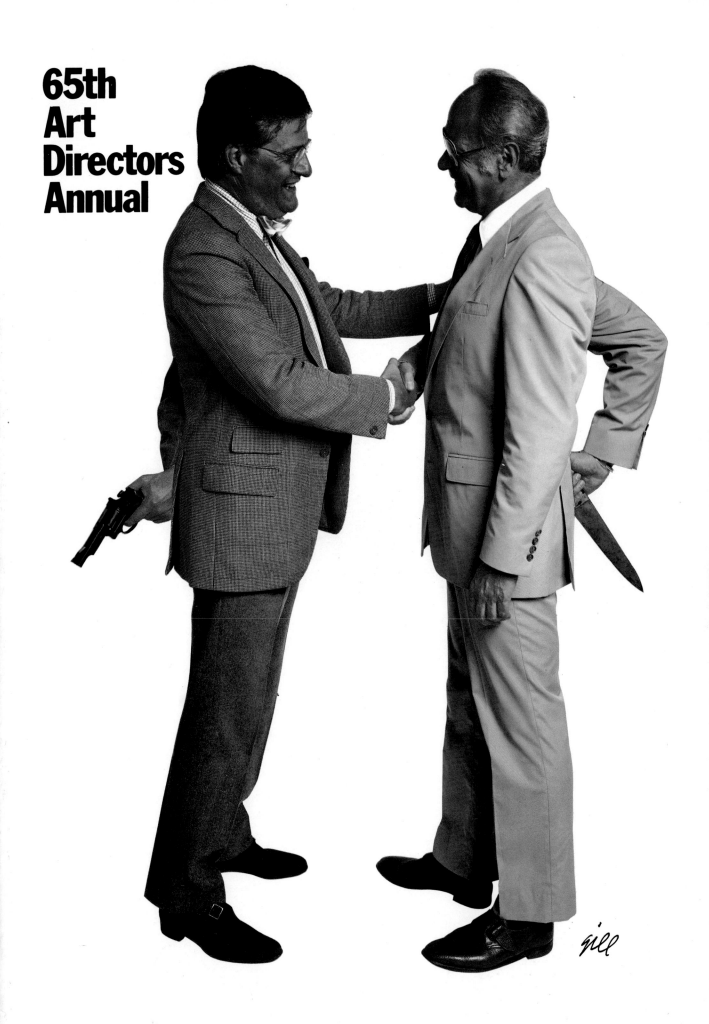

65th
Art
Directors
Annual

gill

CREDITS

Book Division President
 Ernest Scarfone
Book Division Committee
 Bob Ciano
 Blanche Fiorenza
 Steve Heller
 Andrew Kner
 Jack G. Tauss
Call for Entries &
 Annual Book Design
 Bob Gill
ADC Executive Director
 Diane Moore
Editor
 Paula Radding
Art Director
 Ryuichi Minakawa
Jacket & Chapter Opener
 Photography
 Marty Jacobs
Exhibition
 Paula Radding, Supervisor
 Michael Chin,
 Assistant Supervisor
 Daniel Forte
 Glenn Kubota

BOOK PACKAGING
 Frank DeLuca
 Supermart Graphics, Inc.
 PO Box 900
 Murray Hill Station
 New York, NY 10156

TYPOGRAPHY
 Fisher Composition
 118 East 25th Street
 New York, NY 10010

PRINTING
 Toppan Printing Company
 Tokyo, Japan

DISTRIBUTION
UNITED STATES
 Robert Silver Associates
 307 East 37th Street
 New York, NY 10016

CANADA
 General Publishing Co. Ltd.
 30 Lesmill Road
 Don Mills, Ontario M3B 2T6

INTERNATIONAL
 Roto Vision
 10 rue de l'Arquebuse
 Case postale 434
 CH-1211 Geneva
 Switzerland

Published by ADC Publications

Copyright © 1986 by the
Art Directors Club, Inc.

ISBN 0-937414-06-9

TABLE OF CONTENTS

TABLE OF CONTENTS

This year, 1986,
The Art Directors Club of New York
Honors the divine hand
of the creator of a universe
of lovable mice...

We honor the twinkle-eyed designer
of a different breed of rabbit...

We honor an innovator who proved
a book *can* be judged by its cover...

And lastly, we honor a talent
still making waves
in ever widening circles.

Walt Disney
Arthur Paul
Alvin Lustig
Roy Grace

These craftsmen,
If not forming, certainly helped to shape
The semiotics of our time.

Gene Federico
Hall of Fame Chairman, 1986

HALL OF FAME SELECTION COMMITTEE

Gene Federico, Chairman
Ed Brodsky
Aaron Burns
David Deutsch
Lou Dorfsman
Steve Heller
Andrew Kner
George Lois
B. Martin Pedersen
Jack G. Tauss
Bradbury Thompson
Henry Wolf

Len Sirowitz, Patron Chairman

Andrew Kner, Presentation Chairman

MANAGING AND PLANNING
William H. Buckley, Chairman
Jack G. Tauss

mators, storymen and technicians. Disney personally supervised the origin, development and completion of all pictures made in the studio. So meticulous was he that when dissatisfied with *Pinocchio,* he completely scrapped five months of finished product.

In the 1940s and 1950s, Disney tackled a new area of endeavor, live-action films such as *Treasure Island* and *20,000 Leagues Under the Sea,* and the award-winning nature series, *True-Life Adventure.* During World War II, the studio produced instructional films to aid in the war effort and propaganda films to boost morale overseas and at home.

The culmination of Disney's work in animation and live-action filmmaking was, without question, *Mary Poppins,* released in 1964. Seamlessly marrying live actors into an animated setting and animated characters into live-action footage, Mary Poppins became one of the greatest hits in the history of the motion picture industry.

Walt Disney was truly the film Aesop of the twentieth century. He and members of his creative staff received more than 950 honors and citations from every nation in the world, including 48 Academy Awards and seven Emmy's.

Disney's television show, *Disneyland,* later *Walt Disney Presents,* which he hosted for twelve years, premiered in 1954. When the show switched from ABC to NBC, the name change, *Walt Disney's Wonderful World of Color,* reflected the prestigious color offerings of the network and the program. The series retained solid ratings for twenty years and has recently been revived.

In 1955, Disney began production of one of the most popular children's shows in television, *The Mickey Mouse Club,* featuring the Mouseketeers. Disney's entry into television was motivated, in large part, by his quest for a way to finance a dream called Disneyland. Neither the financial community nor the nation's amusement park industry had faith in Disney's idea for a "family park where parents and children could have fun together."

To build his park, Disney enlisted a group of his top animators and motion picture designers and put together an organization of "Imagineers." Disneyland was not planned as a traditional amusement park, but as a series of extraordinary storytelling environments in which the architecture, landscaping, costuming, sound effects, entertainment, and even food and merchandise, combine to make the visitor a participant in a highly theatrical experience—an experience which has been enjoyed by more than 250 million visitors since the park's opening.

Disney's penchant for technical innovation was soon reflected in Disneyland, first with the advent of Audio-Animatronics, a computerized system which brings voice and movement to a cast of life-like robotic figures, from singing grizzly bears to pillaging pirates. Innovative public transit systems were also introduced at Disneyland, including America's first daily-operating monorail system and a silent, electric-powered PeopleMover.

In 1963, city planner James Rouse declared, ". . . the greatest piece of urban design in the United States today is Disneyland. . . . It took an area of activity—the amusement park—and lifted it to a standard so high in its performance, in its respect for people, in its functioning for people, that it really becomes a brand new thing."

Disney had the opportunity to export the Disneyland experience outside the park's boundaries in 1964, when he developed four shows for the New York World's Fair. "The Carousel of Progress" for General Electric, "Ford Wonder Rotunda," "Great Moments with Mr. Lincoln" for the State of Illinois and "It's A Small World" for Pepsi Cola and UNICEF, were four of the five most popular shows at the Fair.

Walt Disney gave his Imagineering staff a chance to prove their skills in community planning when, in the mid-1960's, his organization acquired 28,000 acres of land in central Florida for Walt Disney World. Opened in 1971, five years after Disney's death, Walt Disney World grew to encompass the Magic Kingdom park, themed resort hotels, campgrounds, recreation facilities, a shopping village, vacation home community, and a complete transportation network including monorails, watercraft, steam trains and PeopleMovers. In 1982 the Disney organization realized Disney's dream for a community of ideas, research and cultural opportunities with the opening of EPCOT Center at Walt Disney World.

Disney's theme park concept has now proved its international appeal with the opening of Tokyo Disneyland in 1983 and plans for a Euro-Disneyland to be built just outside Paris, France.

One of Walt Disney's final accomplishments was the formation of a new school for the arts where a multi-disciplinary workshop approach would allow a "kind of cross-pollinization that would develop the best in students." The California Institute of the Arts was built, shortly after Disney's death on a sixty-six acre site north of Los Angeles.

Walt Disney summed up his method of making dreams come true in a statement that also captures the spirit of his life: "The special secret, it seems to me, can be summarized in four C's. They are Curiosity, Confidence, Courage and Constancy and the greatest of these is Confidence. When you believe a thing, believe it all the way, implicitly and unquestionably."

WALT DISNEY

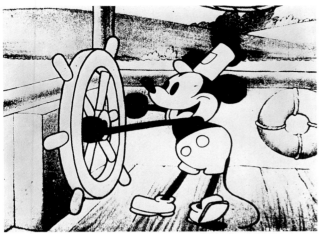

Steamboat Willie, 1928

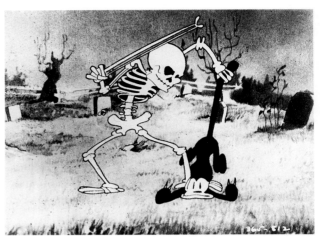

The Skeleton Dance, 1929

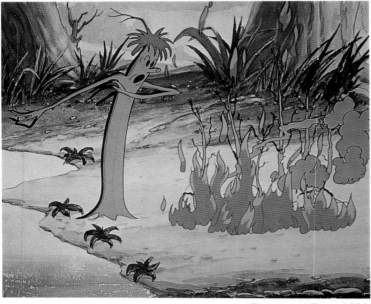

Flowers and Trees, 1932

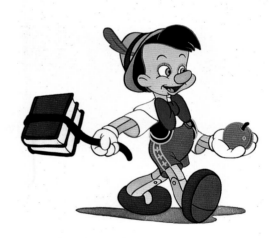

Pinocchio, 1940

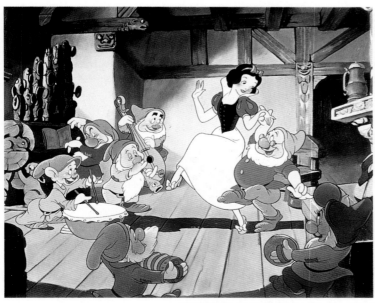

Snow White and the Seven Dwarfs, 1937

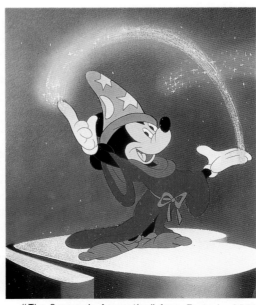

"The Sorcerer's Apprentice" from *Fantasia*, 1941

HALL OF FAME

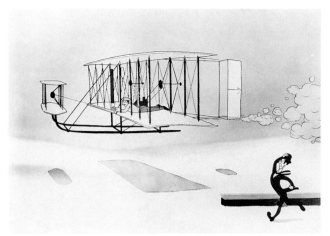

Victory Through Air Power, 1940s

True-Life Adventure Series, 1950s

"Our Friend the Atom" from *Disneyland* TV series

"Donald in Mathmagic Land"
from *Walt Disney's Wonderful World of Color* TV series

Pluto

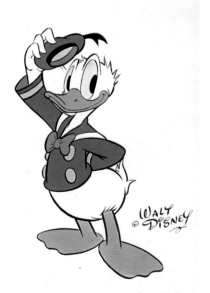

Donald Duck

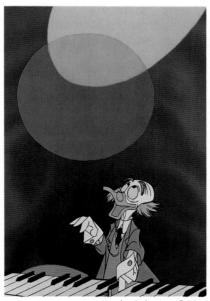

Ludwig von Drake

ROY GRACE

Twenty years ago humorous commercials were considered inappropriate by most agency and client standards yet Roy Grace brought us *Spicy Meatballs* for Alka Seltzer and *Mr. Jones and Mr. Kempler* for Volkswagen. Grace, who was just at the start of his distinguished career at Doyle Dane Bernbach, demonstrated that intelligence and originality can make humor work to enhance the quality of a product, make a TV spot memorable, and entertain without boring or insulting the audience. In fact, *Spicy Meatballs* won the International Broadcasting Award for the Best Commercial done between 1960 and 1980.

The willingness to take risks and ignore the rules characterizes Grace's highly acclaimed work in television. The IBA award is just one of the many honors bestowed upon him, more honors than anyone else in advertising; 25 Clios, 9 Gold and 8 Silver Awards from the Art Directors Club, 8 Andy's, 7 One Show Gold Awards and 8 Silver Awards, and 5 Gold Lions and 3 Silver Lions from the Cannes Film Festival. Of the 17 Classic Commercials in the collection of the Museum of Modern Art, four were art directed by Roy Grace. Six of his spots have been elected to the Clios U.S. Television Classic Hall of Fame.

Grace joined DDB as an art director in 1964 and through the years worked on virtually every major account including American Tourister, Bristol-Myers, Avis, Chanel, IBM, Miles Laboratories, S.O.S., Alka Seltzer, Mobil Oil and Volkswagen. Some of his most memorable spots are *Funeral* for Volkswagen in which a thrifty and practical Beetle-driving nephew inherits his uncle's millions, and *Gorilla* for American Tourister, in which a gorilla batters a suitcase while the voiceover lists the many

ways that luggage can be abused. Also of note are *Puddle* for American Tourister, *Cold Weather* for Mobil Oil and the S.O.S. campaign featuring taciturn Moe and his wife. His cinematic style involves very little camera work: the distinctive characters, both human and non-human, provide the commercials with their action and energy.

For Grace, good advertising is achieved by cooperative effort between agency talent and clients with courage and intelligence. Since advertising has to deliver a selling message to a disinterested audience, the industry has come to acknowledge the value of entertainment in communicating that message. In much of advertising, the entertainment merely surrounds the message; in Grace's work, the two are inseparable. The gorilla battering an American Tourister suitcase, for example, isn't bait to lure the viewer to the point of the commercial, it *is* the point of the commercial. The comedy

and the drama is never extraneous to the sales proposition, it is inextricable from it.

Grace's style does not allow him the luxury of drawing from an unlimited universe of references and illusions. That he has managed to produce so varied and inventive a body of work within a limited context is evidence of the extraordinary imagination he brings to each product.

Grace's secret to success is the determination to excel, not an easy task considering that we are bombarded with four- to six-thousand messages and product images daily. Advertising uses up more ideas more rapidly than any other profession. To stand out among the pick-and-choose clutter of impressions, the successful creative director must be willing to take risks. Breakthroughs are achieved by commitment and by accident, and by ignoring the rules. In fact, Grace likes to point out that there should be only one rule in advertising and that is

not to pay attention to the rules.

Grace has his own interpretation of the distinction between "hard sell" and "soft sell." For him all good advertising should be hard sell; not boring and dull sell, but able to grab attention while delivering a believable propositioin in a memorable way. Hard sell is to stand out in the jungle of advertisers by reaching an audience who is at best, apathetic.

Grace grew up in the Bronx and graduated from Cooper Union in 1962. He is currently a member of the Board of Trustees. He speaks highly of his alma mater, especially for providing him with an awareness of the limitless possibilities of analyzing and solving design problems. His education gave him a philosophical framework which has guided his aesthetic sense and that is, how to improve upon a blank sheet of paper. In 1981, Cooper Union honored him with the Augustus St. Gaudens Medal, the highest alumni award for professional achievement.

In the years following his graduation, Grace held twenty-five different jobs. He explored almost every aspect of design, from books to packaging, including an assignment as an animator for Paramount Pictures. Though he was not finding the satisfaction he sought, he had reseervations about going into advertising—it was against his principles. At age 25, he did join an advertising agency, Benton & Bowles. Within a year he was promoted to an art director and had his own clientele. He then went to Grey Advertising for a year, followed by a year with DDB in Germany, and finally his long-lasting association with DDB in New York.

Grace's diverse experience and creative ingenuity came together at DDB, an agency known in the 60s for its

experimentation and adventurousness. His stint as a cartoon animator doing Little Lulu, Casper the Ghost and Popeye, provided a good understanding of the film medium. Animation lent itself, technically, to the production style which marked Grace's spots, that of favoring a dead-pan camera over a moving one, and a remarkable knack for evoking a full personality or complete environment with just one artfully directed scene.

His year-long stay with DDB in Germany sensitized him to the nuances and peculiarities of language. As a neophyte German speaker and writer, he struggled to find precise words to convey a message. On his return to New York, he retained an astute appreciation of the power of language to suggest ideas and images beyond literal translation.

Once Grace found his niche in advertising, DDB was the only agency that really interested him. The firm was leading a creative revolution which Grace wanted to be a part of. He found a significant source of support and encouragement in Bill Bernbach, a creative genius who guided the firm through decades of tremendous growth. Grace became the first creative staffer to be promoted to a vice chairman and at the time he left the agency in 1986, he was Chairman and Executive Creative Director of DDB-U.S. and DDB-NY, and Vice Chairman of the Board of The Doyle Dane Bernbach Group. He led DDB through particularly difficult years when, following Bernbach's death and the loss of some major accounts, the agency strove to attract big, established clients yet still produce fresh, creative and risky work.

Finding himself farther away from the creative end than he wished to be, Grace and partner, Diane Rothschild,

formed their own agency, Grace and Rothschild. He is glad to be back to the drawing board, involving himself in a variety of projects. He sees a different set of challenges in advertising today; stricter rules that control what can be said and done, as well as a more sophisticated audience of readers and viewers. In many ways Grace regards the climate of the 60s as easier because the work done had never been tried before. As a young man his enthusiasm lay in producing ads. Now an experienced veteran, he finds himself more interested in whether his ads work to sell a product.

As for the future, Grace sees the world-as-global-village becoming a major influence on advertising styles and messages. As nations become more closely linked through electronic communications, advertising will be more visual and less verbal. Simpler, more graphic design will be the key to universal comprehension. As for American advertising, New York may not retain its lead, not because it produces bad work, but because every place else is getting better. And as for television, particularly the proliferation of 15-second spots, Grace sees television as the place for the simplest messages while print will be the medium for real information. Whatever the course advertising will take, it is more than likely that Roy Grace will be in the forefront.

If it is true, as Grace proposes, that creative people are slightly crazy and that their drawn images mirror their minds, then it is no wonder that he finds a blank sheet of paper to be a terrifying but exciting challenge. He likes to quote psychologist, R. D. Laing who wrote that madness is the highest form of sanity in an insane world. In the advertising world, Grace may be the sanest of all.

ROY GRACE

"Spicy Meatballs," Alka Seltzer

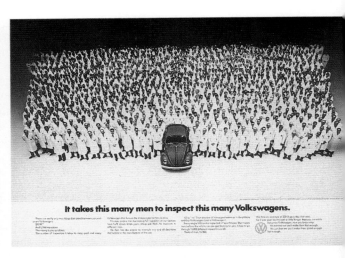

It takes this many men to inspect this many Volkswagens.

"Funeral," Volkswagen

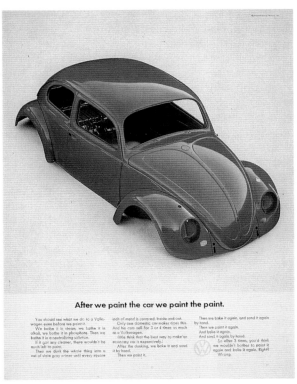

After we paint the car we paint the paint.

Print ads, Volkswagen

"Falling Parts," Volkswagen

HALL OF FAME

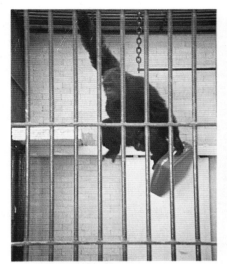

"Gorilla," American Tourister

"Mud Puddle," American Tourister

"Dear American Tourister: You make a fabulous jack."

Print ad, American Tourister

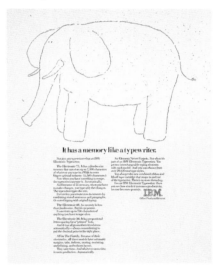

Print ad, IBM

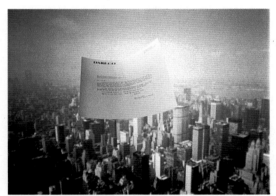

"Flying Letter," IBM

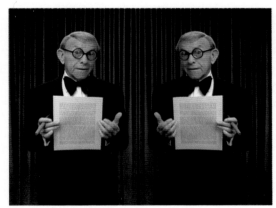

"George Burns II," IBM

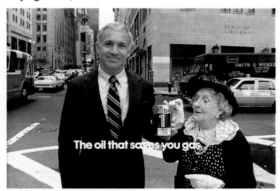

"New York to New York," Mobil 1

"Cold Weather," Mobil 1

ALVIN LUSTIG

With the current interest in American design history, it is fitting that Alvin Lustig be honored for his significant influence on American design and design education. His wide-ranging work from the 1940s and early 1950s included book and book jacket design, magazines, letterheads, catalogs, signage, furniture and lighting, textiles, interior design, logos, identity programs, sculpture and architecture. This diversity mirrored a philosophy which eschewed specialization and embraced synthesis. For Lustig, all design projects involved problem-solving and all solutions were found in form and color.

Lustig's approach to design reflected the Bauhaus tradition of integrating fine and applied arts—of wedding technology with artistic creativity. Since he regarded differences in projects as largely technical, a designer had to develop and maintain a high standard of design which could be successfully applied to any medium. The designer's task, no matter what the project, was to use words, forms and color to create a harmonious whole, more powerful than any single element. For Lustig, creating form was simultaneously to create content. While rooted in a tradition of design orderliness and complementarity, Lustig was an experimenter who played with and altered forms, cautioning against settling into a routine format. His strategy incorporated a respect for simplicity, for the need to eliminate design elements not contributing to the force of the image. Lustig set definite and universal criteria for good design, but looked to technology to offer unlimited opportunities for achieving visual excellence.

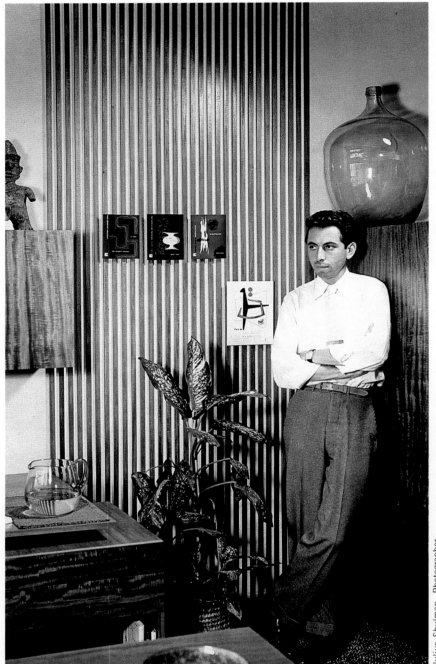

Julius Shulman, Photographer

1915–1955

Lustig had an intellectual approach to design problems which he said were solved more often in the head than anywhere else. He was known to spend days thinking about a project before putting anything down on paper. He was a voluminous reader on a variety of subjects and possessed a broad knowledge of painters and painting. All this background information was brought to an assignment as well as the need to research the particular

project. When designing a book jacket for example, Lustig would read the text first, so that his design better represented the feel of the literature.

Lustig was an active proselyter of good design who regarded the public as "form blind" and insistently re-programmed his clients. When publisher Ward Ritchie invited Lustig to share studio space, Lustig redesigned Ritchie's office. Likewise, when Arthur A. Cohen, President of Noonday Press, hired Lustig as a jacket designer, Lustig attempted to redesign the entire publishing firm. The designer felt the more information a client had, the better informed would be his or her decision. The client was responsible for self-education in order to select quality design talent.

Lustig's success in converting clients and his drive to improve the visual environment was paralleled in his effectiveness as a teacher during the same years, 1937 to 1955. For someone so passionately involved in design education, Lustig had only one year of formal training, at the Art Center School in Los Angeles. He didn't think it possible to teach creative art but he did think it possible to teach awareness. He looked to the campus as an area for experimentation and research not possible in the working world, the results of which could lead business and industry. Lustig lobbied for education programs which combined creative pursuits with technical instruction and which balanced the theoretical with the practical. In addition to studio courses on color and form, he advocated for proof presses, printing equipment and darkrooms as well as workshops conducted by leading professionals immersed in the "real" world.

One of the most influential of Lustig's educational activities was the design program he helped develop for Yale where he had begun teaching in 1951 as Visiting Critic in Design. Lustig felt the best design programs were affiliated with the best painting programs. The painter generated private, subjective symbols while the designer produced objective, public symbols. The interaction of the two would result in design with an ideal balance of originality and universality. The design program for Yale grew out of a 1945 summer course that Lustig conducted at Black Mountain College in North Carolina which was based on the teachings of artist Josef Albers. Lustig also developed a proposal for a design school at the University of Georgia and taught at the Art Center School in Los Angeles and the University of Southern California.

Originally from Denver, Lustig moved to Los Angeles as a child and there began his design career. In 1933 at the age of eighteen, he became art director of Westways Magazine published by the Automobile Club of Southern California. In 1935 he studied for three months with Frank Lloyd Wright at Taliesin and in 1936, with Jean Charlot, the Mexican fresco artist. Between 1937 and 1944, Lustig operated his own typographic and printing business where he experimented with standard geometric type ornaments for printed pieces and books, much of it for Ward Ritchie Press. In the early forties, James Laughlin of New Directions Books in New York, began to commission jacket designs which earned for Lustig an international reputation.

He left Los Angeles for New York in 1944 to create a visual research department for Look Magazine while continuing a freelance practice. In 1946 he returned to LA to open a design office and took on a variety of projects including several stores, an apartment hotel and even a molded plywood helicopter. Lustig returned to New York in 1951 where he continued to involve himself in diverse assignments, from book jackets for Noonday Press to an architectural identification program for Northland shopping center in Detroit. His work was exhibited at the American Institute of Graphic Arts, the AD Gallery in New York, the Walker Art Center in Minneapolis, the Victoria and Albert Museum in London, and the Museum of Modern Art.

Articles by and about Lustig appeared in most every major design periodical in the 1940s and 1950s; American Artist, New Furniture, Print, Architectural Forum, Arts and Architecture, Graphis, Interiors, American Fabric, Progressive Architecture and Art News. Among his awards were Fifty Books of the Year Award from the AIGA, numerous Awards of Merit from the AIGA and the Good Design Award, for chair design, from the Museum of Modern Art. His work is in the permanent collections of the UCLA Clark Printing Library, Rochester Institute of Technology and the Museum of Modern Art.

Lustig possessed what he described as "a very high standard of dissatisfaction" and strove unrelentlessly for order and harmony in his own design and in others. So keen was his vision of the power of design, he thought it a force capable of bettering society. In his short, forty-year life, Lustig produced a prodigious amount of work and pioneered a comprehensive approach to design which will last far beyond his lifetime. His work is as vibrant today as it was forty years ago. From the International style, Lustig forged a distinctive American design aesthetic of timeless beauty and technical virtuosity.

ALVIN LUSTIG

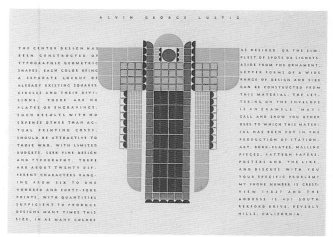

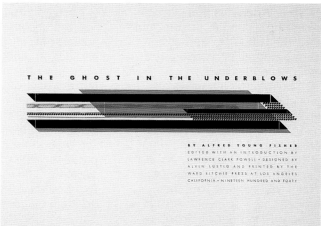

Geometric type designs, late 1930s to early 1940s

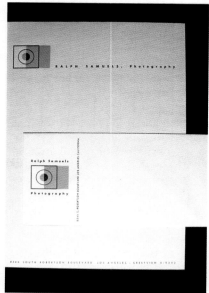

Letterhead, Ralph Samuels, Photographer, 1946

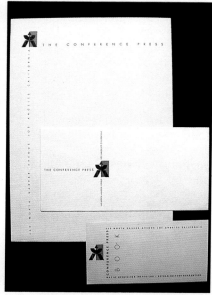

Letterhead, Conference Press, mid-1940s

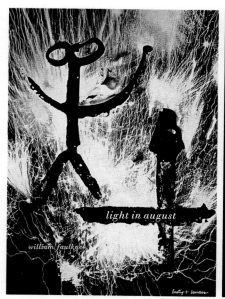

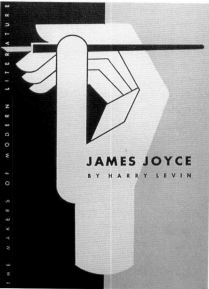

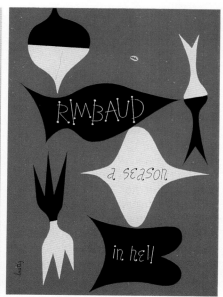

Book jackets, New Directions, mid-1940s

HALL OF FAME

Catalog cover, 1943

Book jacket, Whitney Publishing, 1946

Book jacket, New Directions, 1945

House organ, Look Magazine, 1944–1945

Book jacket, Noonday Press, 1953

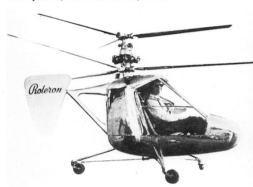

Helicopter design, 1945

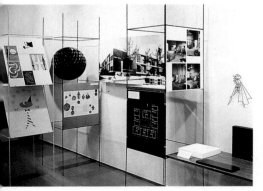

Traveling exhibition of Lustig design, 1949

Photos courtesy of Elaine Lustig Cohen

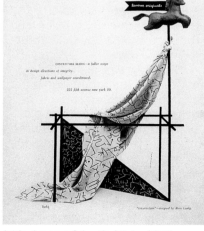

Ad for Laverne & Lustig fabric, 1947

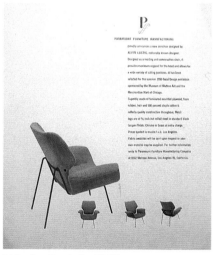

Ad for Lustig chair, 1949

ARTHUR PAUL

Even as a teenager, Art Paul had rebellious notions about what an illustrator should paint and what a painter should illustrate. He could not accept the distinction between "high art" and "low art" and admired equally, Norman Rockwell and Michelangelo. So frequently did he argue with his high school art teacher that he was amazed when she submitted his work to a scholarship competition that won him free tuition to the School of the Art Institute of Chicago. His education was interrupted when he volunteered for Air Corps Service in World War II. On his return, Paul chose instead to attend the Institute of Design.

During the war years, Chicago and the Institute of Design in particular, had become a center of graphic talent with the influx of refugees such as Moholy-Nagy and other followers of the Bauhaus. Paul was intrigued by the ID, which aimed to give students inexhaustable resources by encouraging a challenging, questioning and experimentalist attitude. This fit Paul's personality and his post-war mood exactly, for he realized, as did his Bauhaus teachers, that Modern Technology had changed people's ways of perceiving reality. Although the ID did not imbue Paul with its scorn for "easel" painting, he abandoned the idea of doing any one thing as an artist. When he left in 1950, he felt he could take on anything.

Soon he was successfully freelancing as an illustrator but was frustrated with the 50s climate of bland commercialism which made it difficult to sell his best and most innovative ideas. Thus when Hugh Hefner offered him artistic autonomy in starting a magazine from scratch, Paul accepted. He had learned that "art directors are born through frustration and idealism— frustration because too many

good images and ideas die if you're not the person in control; idealism because your own sense of quality and standards are often jeopardized if you're not in a position to fight for them." At *Playboy* he was able to put his ID training into action, and working on a shoestring only added to the excitement of the challenge.

At the beginning, Hefner and Paul were the only two employees and had what Paul describes as an ideal editor-art director relationship of mutual respect and flexibility. This was crucial to Paul for it enabled him to lead the competition in putting new ideas and experimental solutions in print. At *Playboy,* Paul was able to implement what he thinks every art director must have, a "grand plan of his own."

Paul's grand plan envisioned illustration which combatted the literalism of the day by capturing the mood of a text and not merely a situation within it. He saw illustration not as decoration but as a way to provoke and intrigue the reader. He hoped to "generate excitement through craftsmanship and innovation,

without sacrificing appropriateness and relevance" and to prove that "mass communication does not mean production-line communication." From the start, Paul avoided the sameness of illustration prevalent in the 1950s, a sameness, in Paul's view, born from a commercialism which "cheated illustrators of their true sense of themselves and cheated the client and the public of first-rate art." While illustration was stagnating, American painting was bursting on the 50s scene with unprecedented experimentation and vitality. Thus Paul's ideas about editorial art were timely.

Art Paul led what Print Magazine called the "Illustration Liberation Movement," and in so doing, made *Playboy* the most visually exciting magazine of the day. His greatest challenge in buying art for *Playboy* was to convince illustrators to free up and to persuade painters that they weren't selling out. Finding this difficult initially, he reproduced his own experimental work in the magazine to demonstrate to prospective artists the kind of

artistic freedom he was allowing and requiring. Paul blurred the distinction between fine art and commercial art. Yet he maintained that as illustration, the work of both must be honestly relevant to the material illustrated while "illuminating words with an added dimension."

Not only did he vitalize the standard two-dimensional fare, he also introduced other media to magazine illustration; construction, collage, sculpture, and multi-media work. He developed working concepts that would be emulated by other publications. One of these was the layout of the interview page which began with three photos above three quotes of the featured subject. Another was the use of visuals on the contents page where a detail of an illustration or a photograph from an interior page would be shown. Story copy was continued at the back of the magazine but headed with the same title typeface to make it easier to find. He also explored and helped develop what he termed "participatory" graphics such as die-cuts, pull-outs and pop-ups designed to enhance the editorial message as the reader turns the page.

Paul imparted a strong and comprehensive visual image to *Playboy* which reflected the editor's intent of sophistication, urbanity, and liveliness. Key to this was his concept of pacing, an excitement generated by rhythm and flow—a balance-in-motion. This orchestration, or visual architecture, made *Playboy* a magazine to be perused; it felt friendly and abundant but did not overwhelm.

Except for the first issue, the rabbit logo has appeared on every cover of *Playboy*. Paul designed the symbol to be used in miniature as a sign-off to articles. Over the past thirty years, the rabbit, in some 240 variations, has identified hundreds of products and

services of the Playboy Corporation. Paul explains that the rabbit succeeded because it was a symbol rather than a trademark. It is a testament to Paul's design acumen that the rabbit invokes universal recognition despite the absence of the Playboy name.

When *Playboy* was new and financially limited, Paul turned to lesser-known Chicago artists in whose work he had faith. His willingness to hire new talent as readily as established artists continued throughout his twenty-nine years at *Playboy.* He is credited with supporting many well-known artists early in their careers; artists such as Brad Holland, Paul Davis, Ed Paschke, Kinuko Craft and Robert Lostutter, to name a few. In encouraging young artists to do their best work, he advises them not to "set up religious orders around obviously successful illustrators and designers" or to "associate dogma with knowledge, or temperament with creativity."

The collective high caliber of *Playboy* illustrations enabled the formation of a traveling exhibition, *Beyond Illustration: The Art of Playboy,* which toured museums in the United States, Canada, Europe and Japan between 1971 and 1974. An updated version, *The Art of Playboy: From the First 25 Years,* opened at Chicago's Cultural Center in 1978 for a tour of North and South American museums and universities.

Paul has earned numerous awards for his work for *Playboy* and for his own illustration, photography and design, including a number of special awards: from the Society of Typographic Arts, a special award for outstanding achievement in trademark design for the *Playboy* rabbit head symbol; from the Art Directors Club of Boston, an award for "inspiring, encouraging, and creating an outstanding showcase for

contemporary artists;" from the Art Directors of Philadelphia, the Polycube Award for "consistent excellence in communications;" from the City of Milan, Italy, their Gold Medal for his work on the exhibition, *Beyond Illustration*; from Art Direction Magazine, the first award in its publishing history for "interest and support of illustration and illustrators and the tremendous range of illustrative styles that run in *Playboy* magazine;" from the Illinois Institute of Technology, Institute of Design, the Professional Achievement Award; and in 1980, election into the Alliance Graphique Internationale. Critics note that Paul has "elevated the art of illustration by giant steps" and that over his long stay at one magazine he "has not compromised the magazine's visual spontaneity and energy."

After thirty years at *Playboy*, Paul wanted a change. Since leaving, he has applied to his own life, many of the design values he preached in the past. He is trying to allow himself free rein in his painting and in his hobby of extemporaneous piano composition, making no distinction between work and play. Just as he made no distinction between high and low art, he makes no distinction between high and low design and thus has accepted a whimsically diverse assortment of design jobs. The enjoyment of tackling new design problems is as exciting to him as was his first involvement with art direction. Paul once stated that "good design principles should apply to bubble gum wrappers as well as museum posters." He now applies his ideas to the design of hot dog stands and anti-war posters, knitting books and newspapers. And he makes no distinction between big and little clients, seeking only the fun of a different sort of challenge, and, at this mellow stage of his life, time to think out his solutions at a pace that allows him to enjoy each project fully.

ARTHUR PAUL

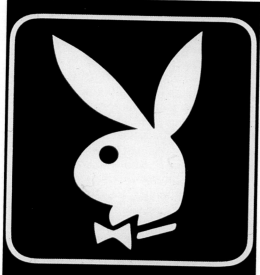

Playboy rabbit symbol, 1953

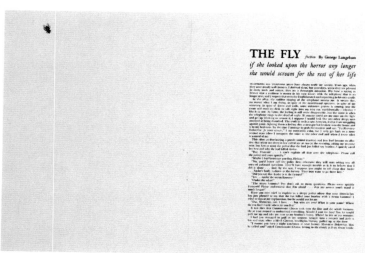

"The Fly," 1957; Arnold Ryan, artist

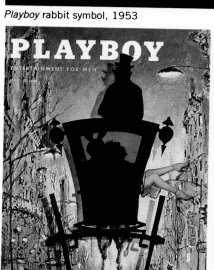

Playboy cover, 1955; LeRoy Neiman, artist and Don Bronstein, photographer

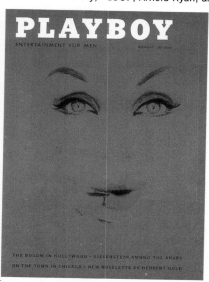

Playboy cover, 1959; Mort Shapiro, photographer

Playboy cover, 1961; Mario Casilli, photographer

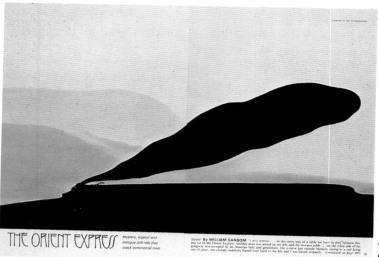

"The Orient Express," 1969; Roy Schnackenberg, artist

HALL OF FAME

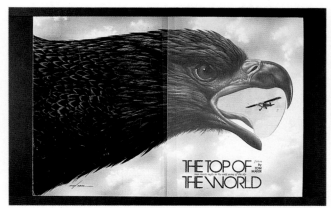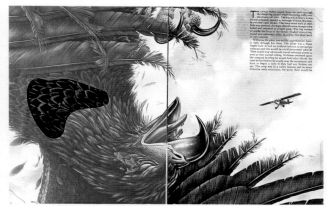

"Top of the World" participatory graphics, 1974; Alex Ebel, artist

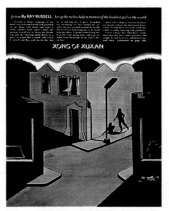

"Xong of Xuxan," 1970; Roger Brown, artist

Shoshin Society poster, 1986

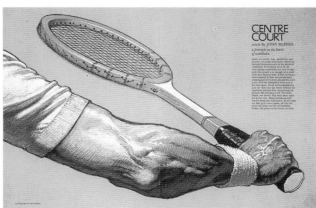

"Centre Court," 1971; Fred Berger, artist

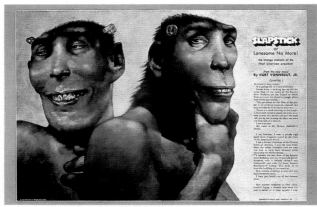

"Slapstick," 1976; Brad Holland, artist

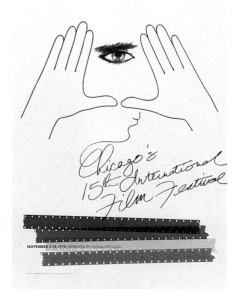

Chicago Film Festival poster, 1979

Half page or less, b&w
More than half, up to full page, b&w
More than full page, b&w
Campaign, b&w
More than full page, color
Campaign, color
Public service
Public service campaign
Political

Newspaper
dvertising

1

Art Director	Nancy Rice
Photographer	Jim Marvy
Writer	Rod Kilpatrick
Agency	Fallon McElligott, Minneapolis, MN
Client	Wall St. Journal
Publication	Wall St. Journal

2

Art Director	Nancy Rice
Illustrator	Hans Holbein the Younger
Writer	Tom McElligott
Agency	Fallon McElligott, Minneapolis, MN
Client	Episcopal Ad Project

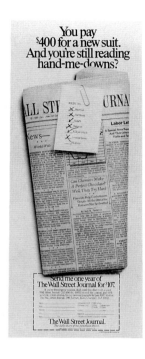

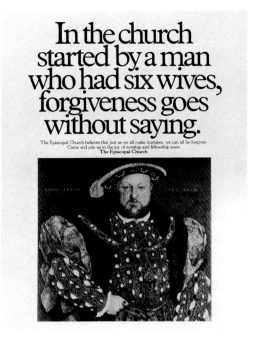

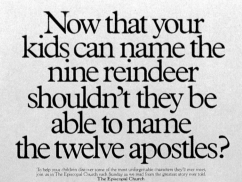

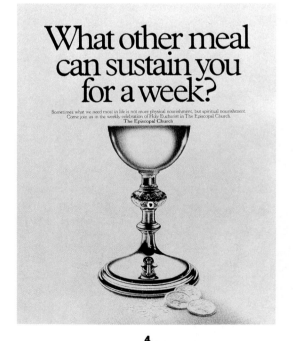

3

Art Director	Nancy Rice
Illustrator	Unknown
Writer	Tom McElligott
Agency	Fallon McElligott, Minneapolis, MN
Client	Episcopal Ad Project

4

Art Director	Nancy Rice
Photographer	Tom Bach
Writer	Tom McElligott
Agency	Fallon McElligott, Minneapolis, MN
Client	Episcopal Ad Project

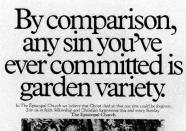

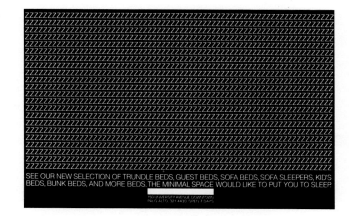

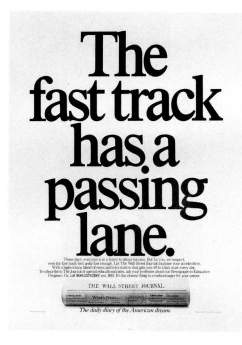

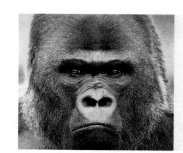

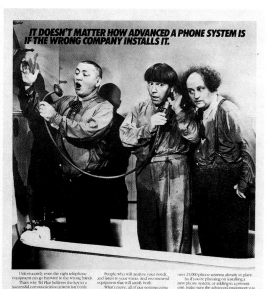

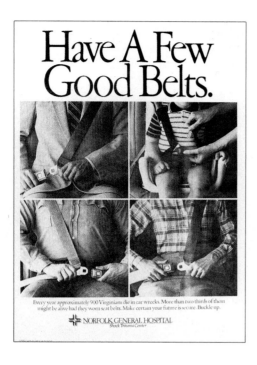

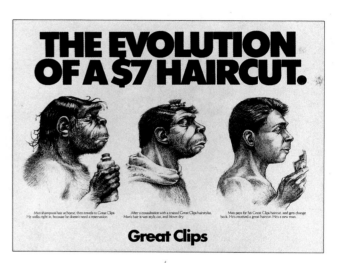

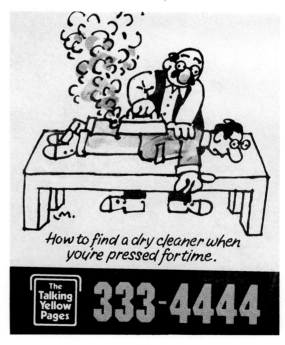

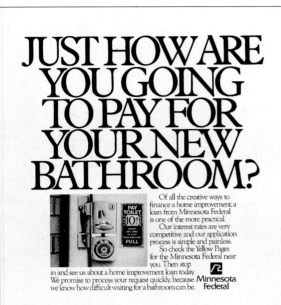

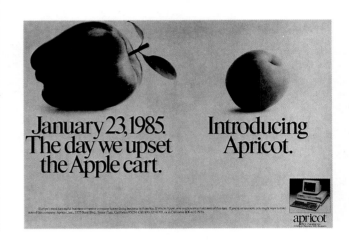

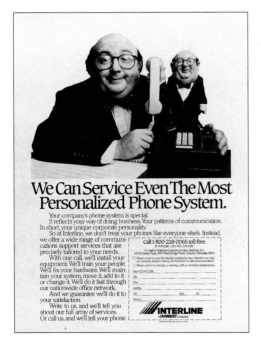

Gold Award

Art Director Tod Seisser
Photographer Francesco Scavullo
Writer Stephanie Arnold
Agency Levine, Huntley, Schmidt &
 Beaver, New York, NY
Client McCall's

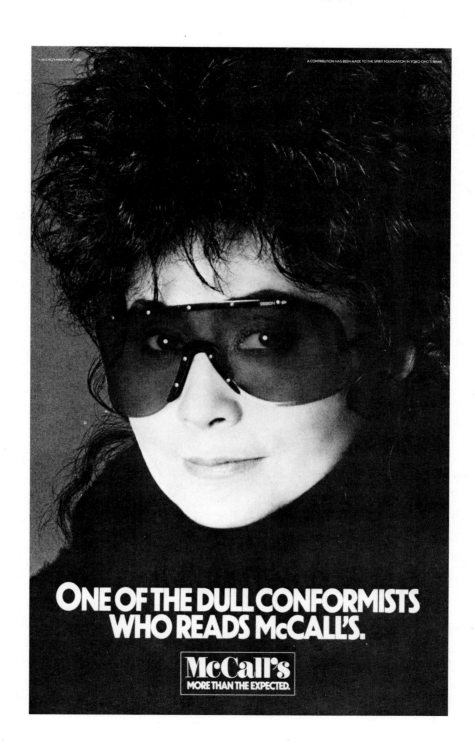

Silver Award

Art Director	Rob Dalton
Illustrator	Maureen Kenny
Writer	Jarl Olsen
Agency	Fallon McElligott, Minneapolis, MN
Client	Emmis Broadcasting/WLOL
Publication	Twin Cities Reader

Togetanymore intothirtysecondswe'd havetotalklikethis.

A very full half-minute of news, gossip and entertainment trivia.
The Thirty Second Scoop, heard every other hour at ten minutes to the hour.

Silver Award

Art Director Michelle Weibman
Illustrator Michelle Weibman
Writer Emma Hayward
Agency Ogilvy & Mather Inc., New York, NY
Client Trans World Airlines

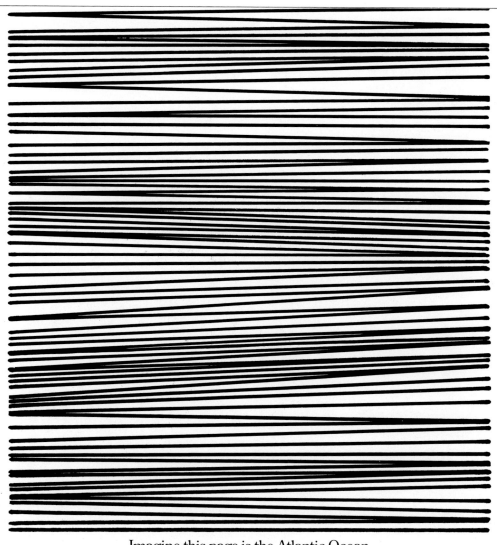

Imagine this page is the Atlantic Ocean.
See those black lines? That's us.

Those black lines going back and forth across the page are the number of times TWA flies across the Atlantic each week.

About four hundred times in fact. (Don't count them, they didn't all fit.)

That, by the way, is more than anyone else.

And on April 28th, we even discover three brand-new places. Copenhagen, Geneva and Bombay.

(The latter, you may feel, is something of an exciting departure from our traditional destinations.)

You'll be able to get to Copenhagen and Geneva from J.F.K. every day. And to Bombay three times a week.

We're also starting a new Gateway to Europe at St. Louis which will make your life a great deal easier if you happen to live in the West and want to go nonstop to London or Paris or even Frankfurt.

And we'll have a new nonstop from J.F.K. to Tel Aviv. And from June 15th, a nonstop to Munich, and a 747 on our nonstop to Amsterdam.

That, of course, is on top of all the existing ones.

Twenty-eight opportunities a week to get to London from J.F.K. Twenty-one to get to Paris. Fourteen to get to Rome, Frankfurt and Athens. Twelve to get to Madrid. Daily flights from Boston to London, Rome and Paris. Three times a week to Cairo and Tel Aviv. The list is endless.

The only important thing you really need to know is that we fly nonstop from the U.S. to more places in Europe than any other airline.

Then, next time you need to go, all those little black lines will begin to make a lot of sense.

LEADING THE WAY. TWA.

Distinctive Merit

Art Director	Yvonne Smith
Photographer	Lamb & Hall
Writer	Mark Monteiro
Agency	Chiat/Day inc. Advertising, Los Angeles, CA
Client	Porsche Cars North America
Publication	Wall Street Journal

It was easier to turn a Porsche into a luxury car than vice versa.

Ever since the first 356 rolled off the assembly line and into automotive history, enthusiasts have associated the name Porsche with one thing.

Performance.

So it's no wonder that, when words like comfortable and luxurious started showing up next to our 928S, more than one eyebrow was raised.

Was this sacrilege? Had Porsche finally given in? Had they gotten soft?

The answer was, as always, an emphatic no.

Because the 928S was, in fact, exactly what Professor Porsche meant it to be: a grand touring car which would offer superb appointments and unparalleled comfort. Yet still deliver all the exhilarating performance you'd expect of any car which bears the Porsche marque.

This year, the 928S is better than ever. Faster, quieter, smoother and more efficient.

Thanks, in large part, to a new four-valve head design which, when adapted to an already legendary V8 engine, not only increased both horsepower (234 to 288) and top speed (144 to 155), but fuel economy as well.

Facts which, while certainly impressive, tell only part of the 928S story.

If you'd like to experience the rest, stop by your Porsche dealer and drive the new 928S four-valve.

You'll soon learn that this Porsche, like those that came before, wasn't created to support accepted notions of what a car should be, but to create new ones.

You'll also understand why it's easier to convert owners of other cars into Porsche enthusiasts than vice versa.

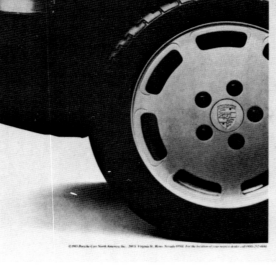

22

Art Director	Judy Austin
Illustrator	Rob Bolster
Writer	Tom Pedulla
Agency	Hill, Holliday, Connors, Cosmopulos, Boston, MA
Client	The Boston Globe

23

Art Director	Scott Frederick
Photographer	Corson Hirschfeld
Writer	Craig Jackson
Agency	Northlich, Stolley, Inc., Cincinnati, OH
Client	Northlich, Stolley, Inc. (self-promotion)
Publication	Cincinnati Enquirer

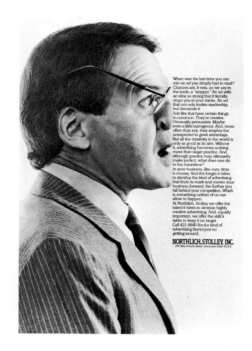

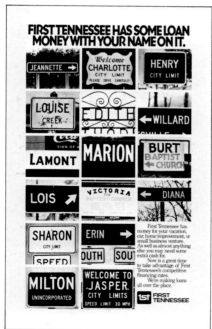

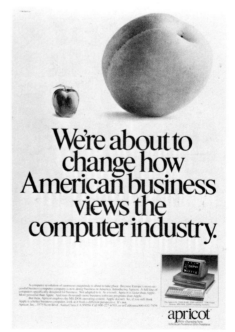

24

Art Director	Tom Lichtenheld
Photographer	Stock
Writer	Jarl Olsen
Agency	Fallon McElligott, Minneapolis, MN
Client	First Tennessee
Publication	Memphis Commercial Appeal

25

Art Director	Michael Vitiello
Designer	Michael Vitiello
Photographer	Jerry Cailor
Writer	Lee Garfinkel
Agency	Levine, Huntley, Schmidt & Beaver, New York, NY
Client	Apricot, Inc.

Art Director Robert Reed
Writer Bruce J. Bloom; Paul A. Bissonette
Agency Bruce J. Bloom, Inc., New York, NY
Client Paul A. Bissenette, WPIX

Art Director Pat Epstein
Designer Pat Epstein
Writer Larry Hampel, John Swartzwelder
Agency Scali, McCabe, Sloves, New York, NY
Client Continental

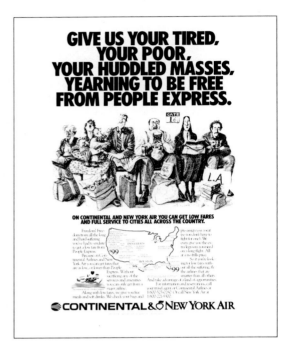

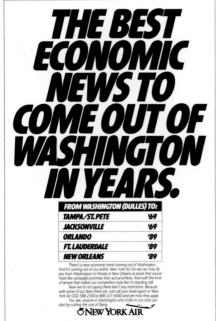

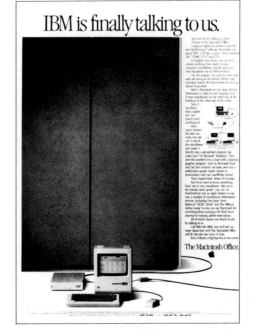

28

Art Director Tod Seisser
Writer Jay Taub
Agency Levine, Huntley, Schmidt & Beaver, New York, NY
Client New York Air

29

Art Director Marten Tonnis
Illustrator Barbara Banthien
Photographer Bo Hylen
Writer Steve Rabosky
Agency Chiat/Day inc. Advertising, Los Angeles, CA
Client Apple Computer, Inc.
Publication Wall Street Journal

30

Art Director Michael Fazende
Photographer Craig Perman
Writer Mike Lescarbeau
Agency Fallon McElligott, Minneapolis, MN
Client American Association of Advertising Agencies

31

Art Director Stan Kovics
Illustrator Kam Hong Chow
Writer Ellen Simons
Creative Director Lorraine Borden
Agency Great Scott Advertising Co., Inc, New York, NY
Publication New York Times

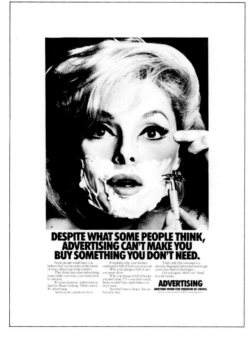

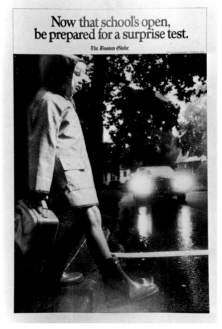

32

Art Director Michael Fazende
Photographer Carl Fischer
Writer Bill Miller
Agency Fallon McElligott, Minneapolis, MN
Client American Association of Advertising Agencies

33

Art Director Judy Austin
Photographer Fred Collins
Writer Seumas McGuire
Agency Hill, Holliday, Connors & Cosmopulos, Boston, MA
Client The Boston Globe

Art Director Mike Thomas
Designer Mike Thomas
Writer Ed McCabe
Agency Scali, McCabe, Sloves,
New York, NY
Client Perdue

Art Director John LeeWong & Brenda
Shniderson
Designer John LeeWong
Writer Ken Fitzgerald
Associate Creative Director Judy Johnson
Agency DYR, Inc., Los Angeles, CA
Client Pacific Southwest Airline
Publication Los Angeles Times

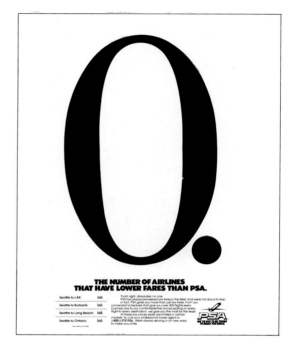

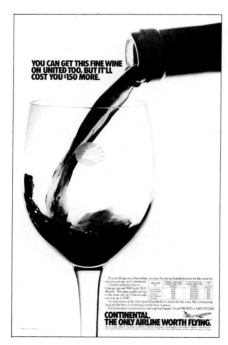

Art Director Pat Epstein
Designer Pat Epstein
Photographer Dan Wolff
Writer John Swartzwelder
Agency Scali, McCabe, Sloves, New York,
NY
Client Continental

37

Art Director Jim Peck
Writer Chuck Gessner
Agency Doyle Dane Bernbach, New York, NY
Client Audi
Publication Auto Week

38

Art Director Tod Seisser
Illustrator Best Studio
Writer Jay Taub
Agency Levine, Huntley, Schmidt & Beaver, New York, NY
Client New York Air

408 reasons why this name stands out.

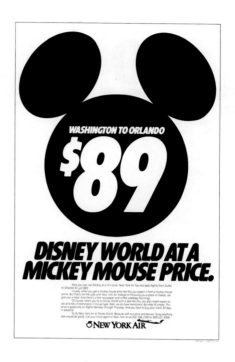

WASHINGTON TO ORLANDO

$89

DISNEY WORLD AT A MICKEY MOUSE PRICE.

NEW YORK AIR

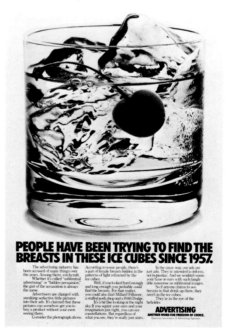

PEOPLE HAVE BEEN TRYING TO FIND THE BREASTS IN THESE ICE CUBES SINCE 1957.

ADVERTISING
ANOTHER WORD FOR FREEDOM OF CHOICE.

39

Art Director Tom Lichtenheld
Photographer Buck Holzemer
Writer Rod Kilpatrick
Agency Fallon McElligott, Minneapolis, MN
Client American Association of Advertising Agencies

40

Art Director	Ed Wolper
Designer	Ed Wolper
Writer	Michael Feinberg
Agency	Scali, McCabe, Sloves, New York, NY
Client	Coalition to Free Soviet Jews
Publication	The New York Times

41

Art Director	Garrett Jewett
Designer	Garrett Jewett
Photographer	Chuck La Monica
Writer	Peter Bregman
Agency	Doyle Dane Bernbach, New York, NY
Client	GTE Telenet
Publication	Wall Street Journal

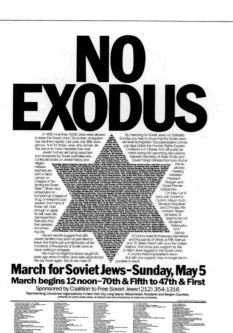

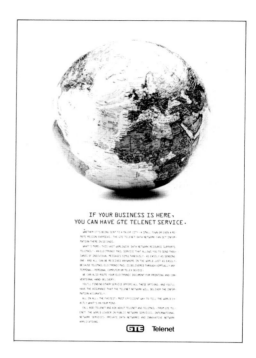

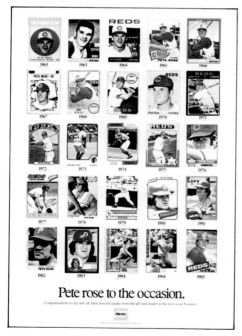

42

Art Director	Steve Montgomery
Designer	Steve Montgomery
Writer	David Metcalf
Agency	Scali, McCabe, Sloves, New York, NY
Client	Hertz

Silver Award

Art Director	Bob Barrie
Illustrator	Henry Winkles
Writer	Rod Kilpatrick
Agency	Fallon McElligott, Minneapolis, MN
Client	MedCenters Health Plan
Publication	Minneapolis Star & Tribune

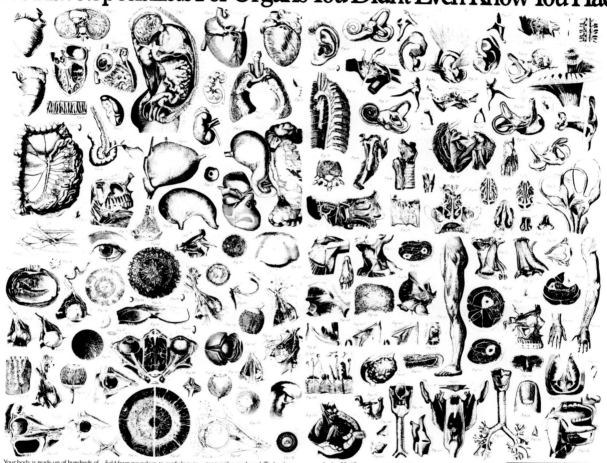

Distinctive Merit

Art Director David Nathanson
Designer David Nathanson
Writer Neal Gomberg
Agency Chiat/Day inc. Advertising, New
York, NY
Client Mitsubishi Electric

45

Art Director	Marten Tonnis
Illustrator	Barbara Banthien
Photographer	Bo Hylen
Writer	Steve Rabosky
Agency	Chiat/Day inc. Advertising, Los Angeles, CA
Client	Apple Computer, Inc.
Publication	Wall Street Journal

46

Art Director	Dean Stefanides
Designer	Dean Stefanides
Photographer	Phil Mazzurco
Writer	Larry Cadman
Agency	Scali, McCabe, Sloves, New York, NY
Client	Volvo

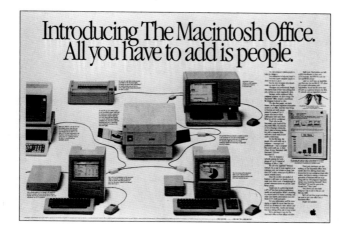

47

Art Director	Marten Tonnis
Illustrator	Cynthia Shern
Photographer	Bo Hylen
Writer	Steve Rabosky
Agency	Chiat/Day inc. Advertising, Los Angeles, CA
Client	Apple Computer, Inc.
Publication	Wall Street Journal

48

Art Director	Tod Seisser
Illustrator	Robert Grossman
Writer	Jay Taub
Agency	Levine, Huntley, Schmidt & Beaver, New York, NY
Client	New York Air

<table>
<tr><td colspan="2" align="center">__49__</td></tr>
</table>

Art Director	Dick Pantano/Rosalind Schell
Photographer	Michael O'Neill
Writer	Tony Winch
Agency	Hill, Holliday, Connors, Cosmopulos, Boston, MA
Client	Lotus Development Corporation

__50__

Art Director	Jeff Terwilliger/Mike Murray
Designer	Jeff Terwilliger/Mike Murray
Writer	Dick Thomas/John Francis
Agency	Bozell, Jacobs, Kenyon & Eckhardt, Minneapolis, MN
Client	FirsTel Information Systems

__51__

Art Director	Frances Ullenberg
Writer	Steve Laughlin
Agency	Frankenberry, Laughlin & Constable, Milwaukee, WI
Client	Forward Wisconsin
Publication	Orange County Business Journal
Production Manager	Wendy J. Westadt

__52__

Art Director	Marten Tonnis
Illustrator	Barbara Banthien
Photographer	Bo Hylen
Writer	Steve Rabosky
Agency	Chiat/Day inc. Advertising, Los Angeles, CA
Client	Apple Computer, Inc.
Publication	Wall Street Journal

Gold Award

Art Director	Nancy Rice
Photographer	Tom Bach
Writer	Tom McElligott
Agency	Fallon McElligott, Minneapolis, MN
Client	Episcopal Ad Project

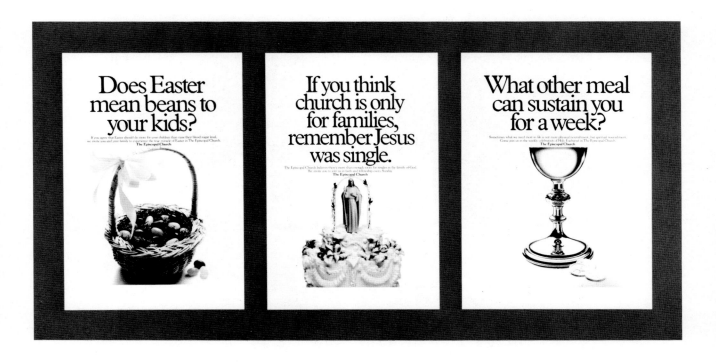

Gold Award

Art Director	Jeff Roll/Yvonne Smith
Photographer	Lamb & Hall
Writer	David Butler/Mark Monteiro
Agency	Chiat/Day inc. Advertising, Los Angeles, CA
Client	Porsche Cars North America
Publication	Wall Street Journal

Why a car that needs no introduction needs an introduction.

No other luxury car comes with this interior.

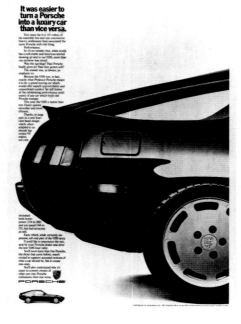

It was easier to turn a Porsche into a luxury car than vice versa.

Silver Award

Art Director	Michael Fazende, Tom Lichtenheld
Photographer	Carl Fischer, Stock, Buck Holzemer
Writer	Bill Miller, John Stingley, Jarl Olsen
Agency	Fallon McElligott, Minneapolis, MN
Client	American Association of Advertising Agencies

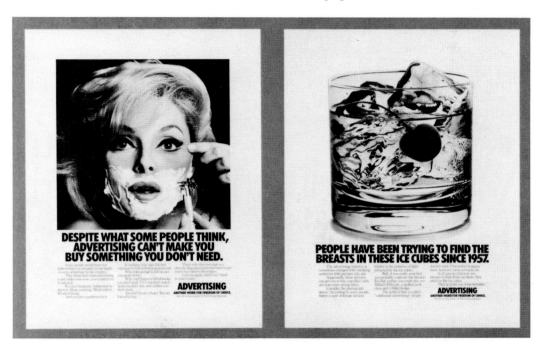

Distinctive Merit

Art Director	Rod Smith
Designer	Rod Smith
Photographer	Fred Collins
Writer	Fred Bertino, Peter Caroline
Agency	HBM/Creamer, Boston, MA
Client	Bank of Boston
Publication	Boston Globe, Boston Magazine

How to buy an Audi without being a Saudi.

$489/mo. $319/mo.

BANK OF BOSTON
First Choice Auto Loan

It's easy with our new First Choice Auto Loan. It requires no downpayment, and can lower your monthly payments 25-50%. Apply at any Bank of Boston office. Or call **1-800-848-AUTO**.

How to buy a Lincoln without a grant.

$661/mo. $437/mo.

BANK OF BOSTON
First Choice Auto Loan

It's easy with our new First Choice Auto Loan. It requires no downpayment, and can lower your monthly payments 25-50%. Apply at any Bank of Boston office. Or call **1-800-848-AUTO**.

How to buy an LTD on a ltd. budget.

$275/mo. $182/mo.

BANK OF BOSTON
First Choice Auto Loan

It's easy with our new First Choice Auto Loan. It requires no downpayment, and can lower your monthly payments 25-50%. Apply at any Bank of Boston office. Or call **1-800-848-AUTO**.

Distinctive Merit

Art Director	Nancy Rice/Tom Lichtenheld
Photographer	Jim Marvy
Writer	Rod Kilpatrick/Mike Lescarbeau
Agency	Fallon McElligott, Minneapolis, MN
Client	Wall St. Journal
Publication	Wall St. Journal

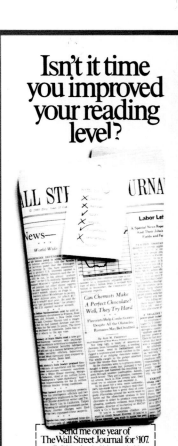

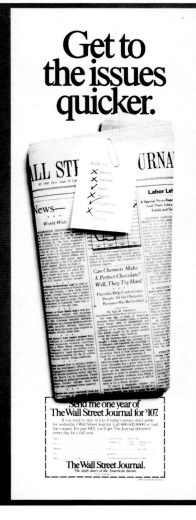

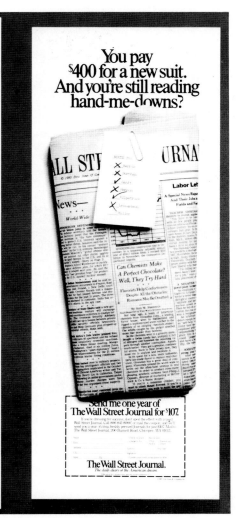

58

Art Director	Joe Carri
Designer	Joe Carri
Illustrator	Ray Domingo
Writer	Liz FitzGerald
Agency	Needham Harper Worldwide, Inc., McLean, VA
Client	The Washington Post
Publisher	The Washington Post
Publication	The Washington Post

59

Art Director	Ted Shaine/David Nathanson
Designer	Ted Shaine/David Nathanson
Illustrator	Sydnie Salmieri
Photographer	Walter Iooss
Writer	Diane Rothschild/Jane Talcott
Agency	Doyle Dane Bernbach, New York, NY
Client	Cigna
Publication	Various newspapers

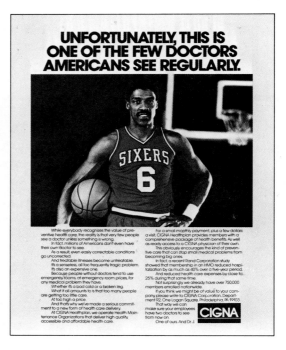

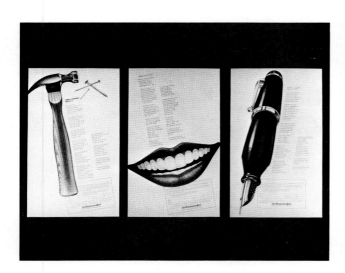

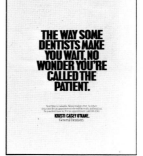

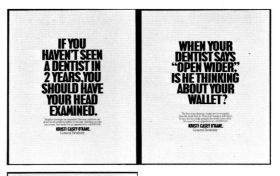

60

Art Director	Paul Niski
Photographer	Art Kane
Writer	Cynthia Rittenhouse, Chris Rockmore
Creative Director	John C. Jay
Agency	Bloomingdales, New York, NY
Client	Bloomingdale's
Publication	New York Times

61

Art Director	Mike Fazende
Writer	Kerry Casey
Agency	Bozell, Jacobs, Kenyon & Eckhardt, Minneapolis, MN
Client	Kristi Casey O'Kane

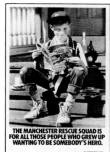

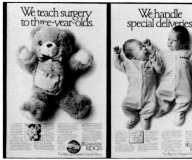

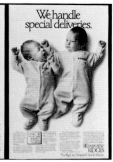

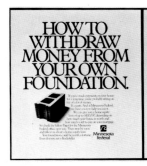

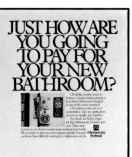

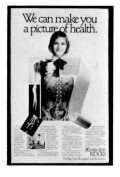

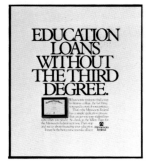

66

Art Director Gregg Byers
Photographer Alex Bachnick
Writer Peter Pohl
Agency Bozell, Jacobs, Kenyon &
Eckhardt, Minneapolis, MN
Client Northwestern Bell

67

Art Director Bob Barrie
Photographer Rick Dublin
Writer Phil Hanft
Agency Fallon McElligott, Minneapolis,
MN
Client Max Long Distance
Publication Detroit Free Press

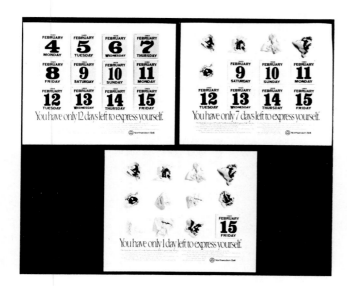

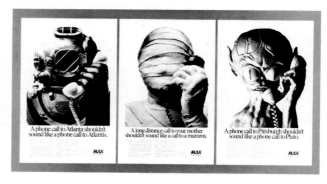

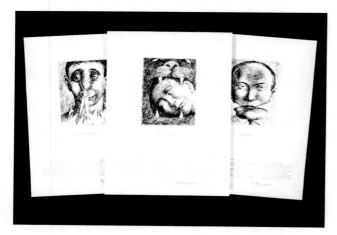

68

Art Director Charles Hively
Designer Charles Hively
Illustrator Roland Topor
Writer Charles Hively
Agency The Hively Agency, Inc., Houston,
TX
Client The Hively Agency, Inc.

69

Art Director Mark Oliver
Designer Mark Oliver/Carolyn Tyler
Illustrator Carolyn Tyler
Writer Mark Oliver/Carolyn Tyler
Agency Mark Oliver, Inc., Santa Barbara, CA
Client Victoria Court Management

70

Art Director Tom Schwartz
Designer Tom Schwartz
Writer Richard Middendorf
Agency Doyle Dane Bernbach, New York, NY
Client IBM

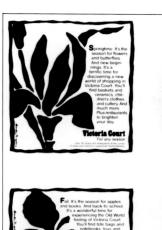

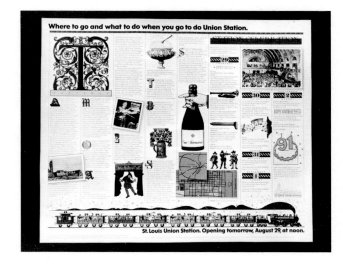

72

Art Director Ron Sullivan
Designer Ron Sullivan, Linda Helton
Illustrator Diana McKnight, Jon Flaming
Writer Mark Perkins
Agency Sullivan Perkins, Dallas, TX
Client The Rouse Company/St. Louis Union Station

Distinctive Merit

Art Director	Bob Barrie
Illustrator	Leland Klanderman
Writer	Rod Kilpatrick
Agency	Fallon McElligott, Minneapolis, MN
Client	Jackson Health Plan
Publication	Madison State Journal

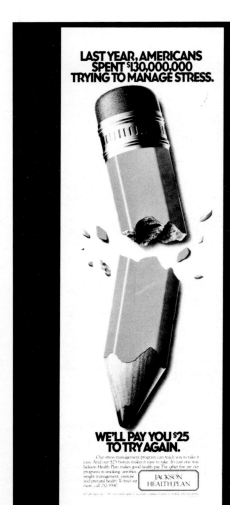

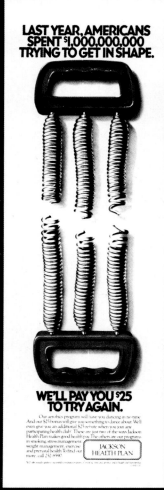

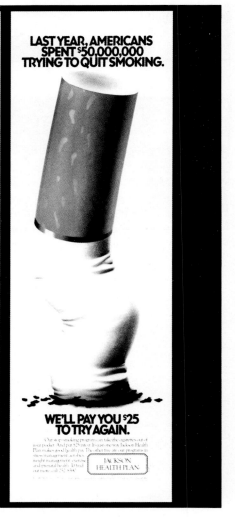

Distinctive Merit

Art Director	Greg Campbell
Illustrator	Greg Campbell
Writer	Christopher Moore
Creative Director	Jay Jasper
Agency	Ogilvy & Mather, New York, NY
Client	AT&T Information Systems

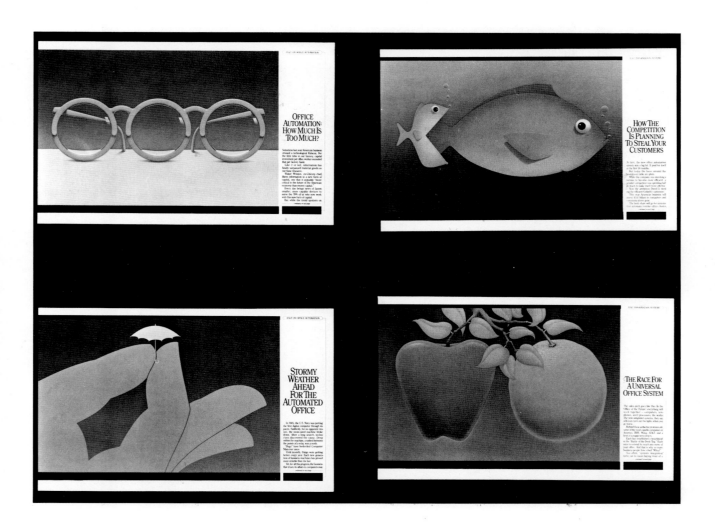

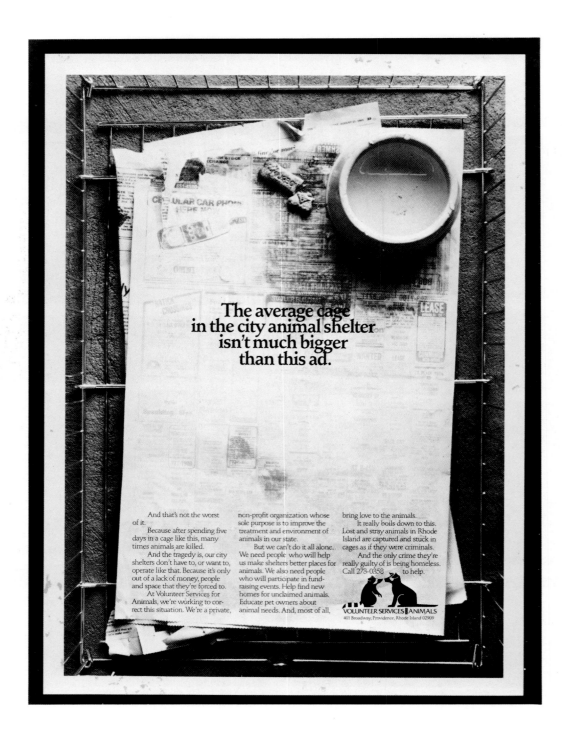

Distinctive Merit

Art Director	Sara Meyer
Illustrator	Chris Payne
Writer	Lyle Wedemeyer
Agency	Martin/Williams, Minneapolis, MN
Client	Minnesota Pollution Control

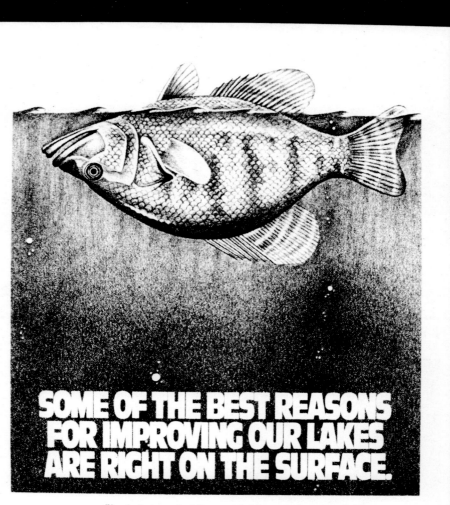

Art Director Debbie Lucke
Illustrator Cathy Toelke
Photographer John Holt
Writer David Lubars
Agency Leonard Monahan Saabye,
 Providence, R I
Client Volunteer Services for Animals

Art Director Debbie Lucke, Bryan McPeak
Illustrator Cathy Toelke
Photographer John Holt
Writer David Lubars
Agency Leonard Monahan Saabye,
 Providence, R I
Client Volunteer Services for Animals

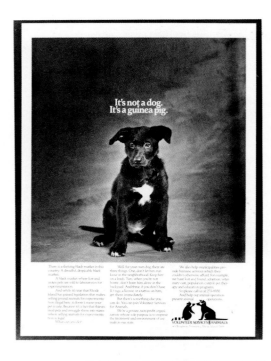

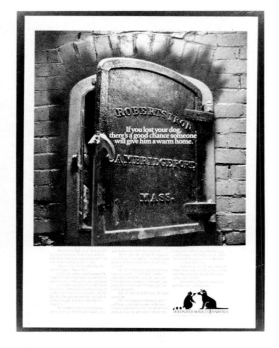

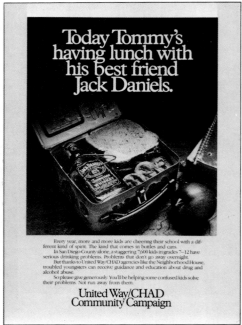

Art Director John Vitro
Designer Ron Van Buskirk
Photographer Marshall Harrington
Writer Steve Law
Client United Way/CHAD
Agency Phillips-Ramsey Advertising, San
 Diego, CA
Account Executive Richard Brooks

Art Director Charlie Carpenter
Photographer Jean-Paul Endress
Writer Doug Feinstein
Creative Director Mike Pitts
Agency Ogilvy & Mather Inc., New York, NY

Art Director Mike Schwabenland
Writer Lance Mald
Agency BBDO, New York, NY
Client Citizens Against Waste

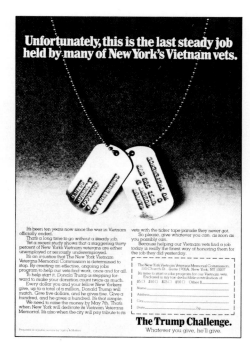

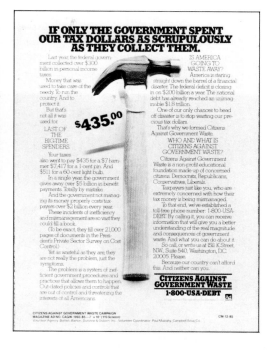

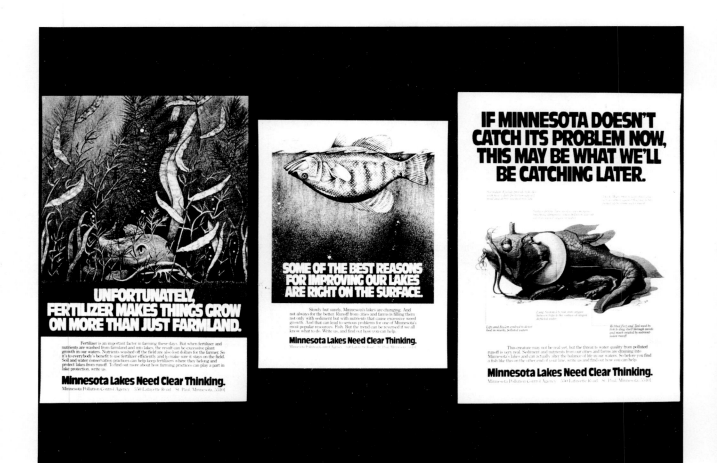

Art Director Vicki Smith
Photographer George Hausman
Writer Bill Teitelbaum
Agency Howard, Merrell & Partners, Inc.,
 Raleigh, NC
Client Find My Child, Inc./Triangle Ad
 Council

THE TYPICAL KIDNAPPER ISN'T INTERESTED IN MONEY.

There's only one way to prevent outrages like this. All of us have to accept more responsibility for the safety of our kids.

The 500-plus, assorted police agencies throughout the state have to adopt uniform procedures for reporting and recovering missing children.

We need call-back systems in our schools to make sure that absent children are not missing children.

And our community needs a specialized missing-persons unit, so reports can be acted upon without delay.

Your help could make it all happen.

Write the governor, or your state representative, or call us anytime, day or night, at 833-3780.

FIND MY CHILD, INC.
336 Fayetteville Street Mall
Room 627-628, Raleigh, NC 27601
Sponsored by Triangle Advertising Council

ACCORDING TO THE POLICE, THIS CHILD WASN'T EVEN MISSING.

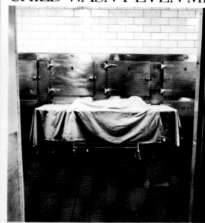

Some police will actually tell you that a child has to be missing for 24 hours before they're allowed to take official action.

That's a crime in itself. Experience proves that immediate action will improve the chances of recovery by more than 100 percent.

Our community needs a specialized missing-persons unit, so reports can be acted upon without delay.

And we need call-back systems in our schools to make sure that absent children aren't missing children.

Your help could make it all happen.

Write the governor, or your state representative, or call us anytime, day or night, at 833-3780.

FIND MY CHILD, INC.
336 Fayetteville Street Mall
Room 627-628, Raleigh, NC 27601
Sponsored by Triangle Advertising Council

HOW WOULD YOU LIKE TO SEE YOUR DAUGHTER ON BROADWAY?

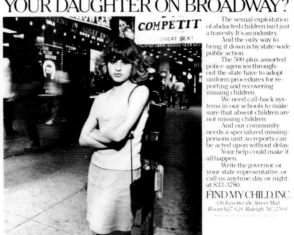

The sexual exploitation of abducted children isn't just a travesty. It's an industry.

And the only way to bring it down is by state-wide public action.

The 500-plus, assorted police agencies throughout the state have to adopt uniform procedures for reporting and recovering missing children.

We need call-back systems in our schools to make sure that absent children are not missing children.

And our community needs a specialized missing-persons unit, so reports can be acted upon without delay.

Your help could make it all happen.

Write the governor, or your state representative, or call us anytime, day or night, at 833-3780.

FIND MY CHILD, INC.
336 Fayetteville Street Mall
Room 627-628, Raleigh, NC 27601

84

Art Director	John Vitro
Designer	Ron Van Buskirk
Photographer	Marshall Harrington, David Kramer, Chris Wimpey
Writer	Steve Law
Client	United Way/CHAD
Agency	Phillips-Ramsey Advertising, San Diego, CA
Account Executive	Richard Brooks

85

Art Director	Mike Schwabenland
Writer	Lance Mald
Agency	BBDO, New York, NY
Client	Citizens Against Waste

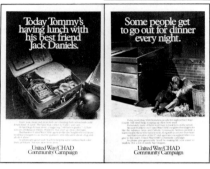

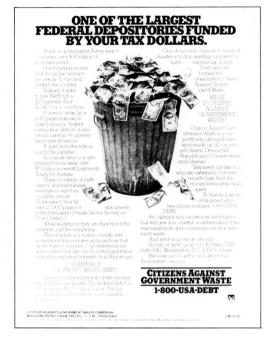

Art Director	B. A. Albert
Writer	Cleve Willcoxon
Creative Director	Joey Reiman
Agency	D'Arcy Masius Benton & Bowles, Atlanta, GA
Client	Decatur Federal Savings & Loans
Publication	Atlanta Journal & Constitution
Type	Phototype

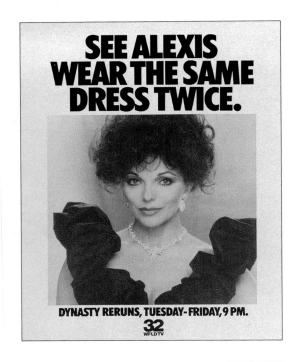

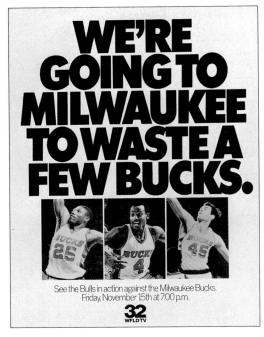

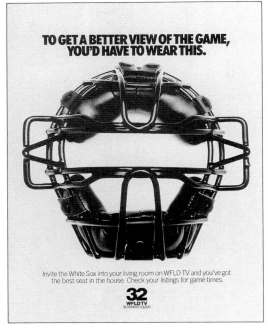

90

Art Director	Tod Seisser
Illustrator	Best Studio
Writer	Jay Taub
Agency	Levine, Huntley, Schmidt & Beaver, New York, NY
Client	New York Air

91

Art Director	John Morrison
Illustrator	Johnny Hart
Writer	Jarl Olsen
Agency	Fallon McElligott, Minneapolis, MN
Client	American Association of Advertising Agencies

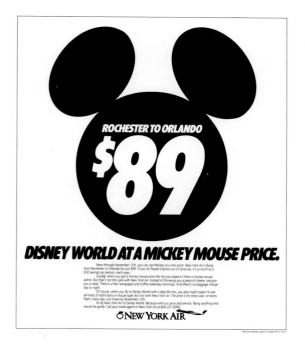

92

Art Director	Houman Pirdavari
Photographer	Stock
Writer	George Gier
Agency	Fallon McElligott, Minneapolis, MN
Client	WFLD-TV
Publication	TV Guide/Chicago

Art Director Michelle Mar
Designer Michelle Mar
Writer Peter Bregman
Agency Scali, McCabe, Sloves, New York, NY
Client Continental

Art Director Donald Sterzin
Photographer Bruce Weber
Creative Director Sandy Carlson
Agency Geers Gross Advertising, Inc., New York, NY
Client Ralph Lauren

CONTINENTAL ANNOUNCES FOUR GREAT WAYS TO AVOID ALL THE ★◎#⚡!!!! LINES AT THE AIRPORT.

No one has more great ways to get you around all the ★◎#⚡!!!! lines at airports than Continental.

THE CONTINENTAL FLYING MACHINE™
Easily one of the simplest ways to fly.

When you're at the airport, instead of going to a ticket counter, go to our machine. Just insert any major credit card and follow the instructions. In moments you'll not only have the Continental ticket to your destination in your hands, but your boarding pass as well.

CONTINENTAL'S REDI-TRIP™
With this, you make a reservation over another easy-to-use machine. Your telephone.

Call us up to four hours before departure and tell us where you want to go. And we'll take care of the rest.

At the airport, a special Redi-Trip agent will have your tickets, boarding passes and even bag tags.

All ready for you to take off with.

TICKET BY MAIL
With this little shortcut, you call us in advance. And we mail you everything you need to go straight to the plane. Tickets. Boarding passes. All with no waiting. And no ★#⚡-ing.

(You might also consider our convenient city ticket offices to get your tickets and boarding passes in even less time.)

YOUR TRAVEL AGENT
Guess what! In early 1986, your travel agent, who's always been able to give you hassle-free ticketing far from the maddening crowds at the terminal, will also be able to get you boarding passes.

All of which should mean more convenience and less ◎#⚡!!

For more information and reservations, call Continental at 1-800-525-0280.

◎ **CONTINENTAL**
The only airline worth flying.™

© 1985 Continental Air Lines, Inc.

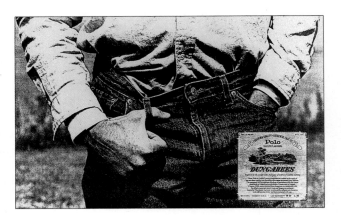

Silver Award

Art Director	Nancy O'Neal
Photographer	Matthew Rolston, Henry Wolf
Writer	Jeffrey Atlas
Creative Director	Tom Rost
Agency	Ogilvy & Mather, New York, NY
Client	American Express Company
Publication	New Yorker, Time, Business Week

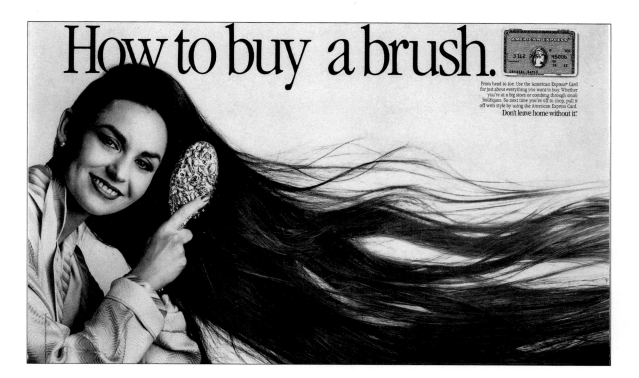

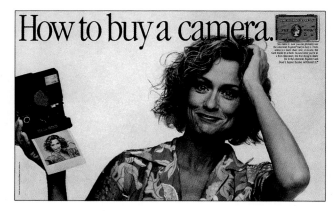

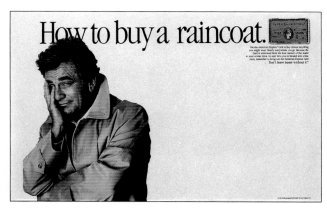

96

Art Director — Christopher Chaffin
Designer — Christopher Chaffin
Photographer — Bruce Ayres
Writer — Galen Wright, Nancy Thomson
Agency — Ketchum Advertising, San Francisco, CA
Client — Avia Athletic Shoes
Publication — Running, Glamour, Tennis
Print Production — Jean Zeidler
Traffic — Tina Berblinger

97

Art Director — Frank Young
Photographer — Lois Greenfield
Writer — Regina Ovesey
Creative Director — Regina Ovesey
Agency — Ovesey & Company, Inc., New York, NY
Client — Capezio-Ballet Makers, Inc.
Publication — Dancemagazine

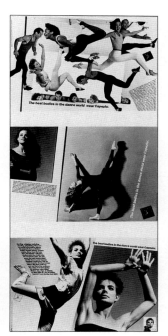

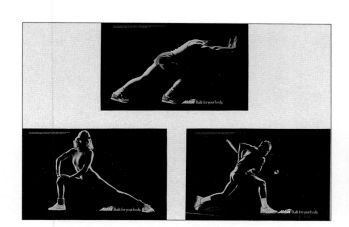

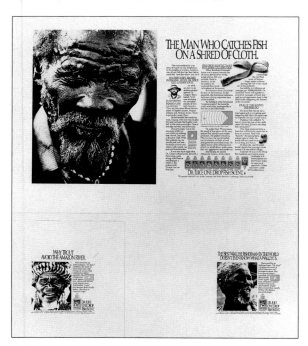

98

Art Director — Frank Haggerty
Illustrator — Larry Tople
Photographer — Gary Silberman
Writer — Jack Supple
Agency — Carmichael-Lynch, Minneapolis, MN
Client — Blue Fox Tackle Company

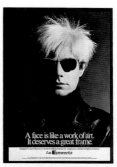

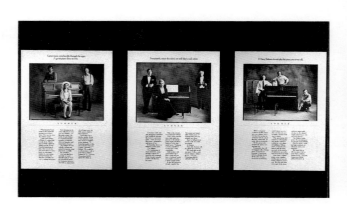

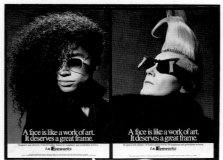

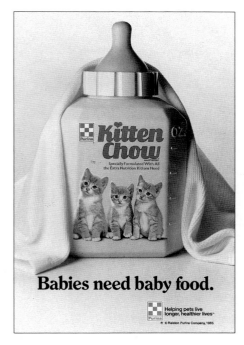

102

Gold Award

Art Director	Bob Barrie
Illustrator	Leonardo Da Vinci, Dick & Mark Hess
Writer	John Stingley
Agency	Fallon McElligott, Minneapolis, MN
Client	Prince Foods Canning Division
Publication	Blair Publications

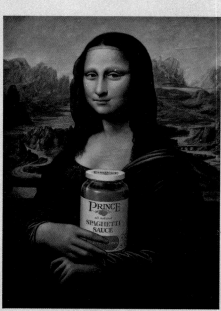
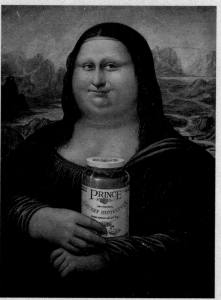

Original.　　　Chunky.

Whether you choose our original sauce with imported olive oil
and romano cheese, or our chunky homestyle with bits of tomato,
herbs and spices, you'll get classic Italian taste.

PRINCE

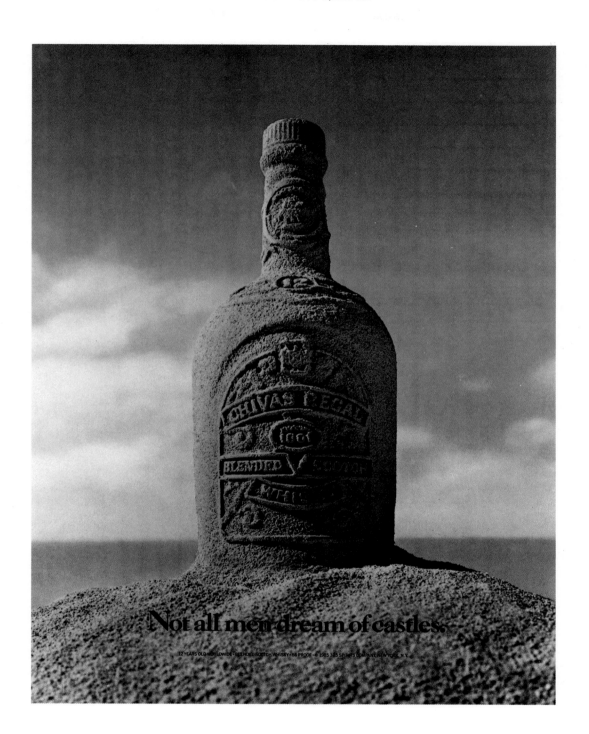

Distinctive Merit

Art Director	Hal Nankin
Photographer	Charles Gold
Writer	Alan Barcus
Agency	D'Arcy Masius Benton & Bowles, Inc., New York, NY
Client	The Procter & Gamble Co./Crest
Publication	Better Homes & Gardens

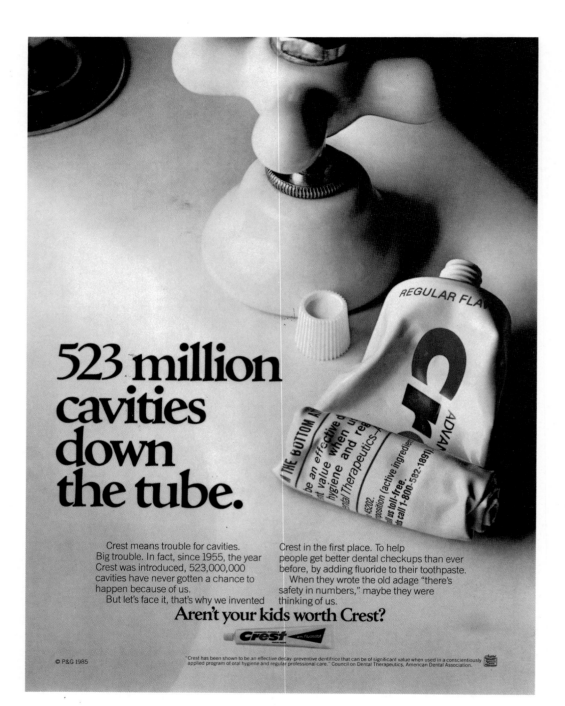

Distinctive Merit

Art Director Susan Hoffman
Photographer Steve Bonini
Writer Ken Wieden
Agency Wieden & Kennedy, Portland, OR
Client Nike, Inc.
Publication Track & Field Quarterly Review

JUST ADD ADRENALIN.

For distance running...
Zoom Air

For all-purpose running...
Rival II

For cross country...
Zoom X II

For all-purpose running...
Flame-Tech

For sprinting...
Zoom S II

For high jump...
High Jump

For long jump...
LJ III

For triple jump...
TJ 60

For javelin throw...
Javelin 88

For shot and discus...
SD Glide

NIKE
Beaverton, Oregon

112

Art Director	Rick Carpenter
Photographer	Bill Werts
Writer	Jaci Sisson
Agency	Della Femina, Travisano & Partners of California Inc., Los Angeles, CA
Client	Isuzu Motors
Publication	Sunset Magazine, Time Magazine

113

Art Director	Geoff Hayes
Artist	Andy Warhol
Writer	Evert Cilliers
Agency	TBWA Advertising, Inc., New York, NY
Client	Carillon Importers, Ltd.
Concept	Michel Roux, President, Carillon Importers, Ltd.

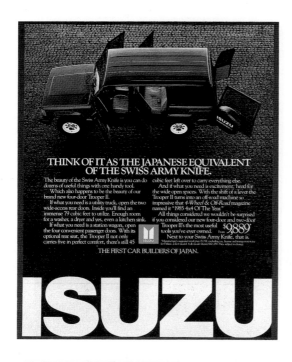

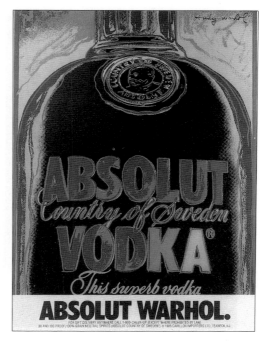

114

Art Director	Gary Goldsmith
Designer	Gary Goldsmith
Photographer	Gil Cope
Writer	Steven Landsberg
Agency	Chiat/Day inc. Advertising, New York, NY
Client	William Grant & Sons

115

Art Director	Rick McQuiston
Photographer	Annie Liebovitz
Writer	Jim Riswold
Agency	Wieden & Kennedy, Portland, OR
Client	Honda Scooters
Publication	Rolling Stone

116

Art Director	Rich Johnson
Photographer	Carl Corey
Writer	Gerry Miller
Creative Director	Gerry Miller
Agency	Leo Burnett Co., Inc., Chicago, IL
Client	John Hevine/Pillsbury

117

Art Director	Gary Goldsmith
Designer	Gary Goldsmith
Photographer	Gil Cope
Writer	Steven Landsberg
Agency	Chiat/Day inc. Advertising, New York, NY
Client	William Grant & Sons

118

Art Director James Caporimo
Illustrator Norm Bendell
Writer Bob Reilly
Agency Waring & LaRosa, Inc., New York, NY
Client The Perrier Group of America
Publication New York Magazine

119

Art Director Woody Litwhiler
Photographer Aaron Rezny
Writer Ted Charron
Agency Campbell Ewald, New York, NY
Client Eastern Airlines
Publication Time Magazine

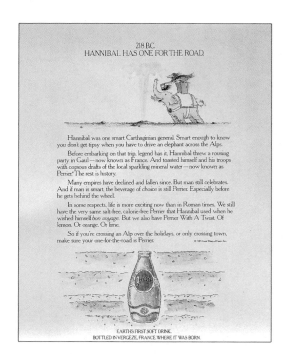

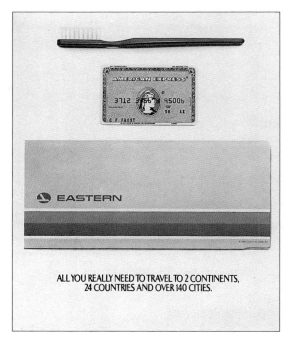

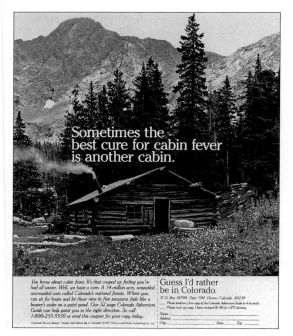

120

Art Director Jerry Murff
Photographer David Muench
Writer Jim Glynn
Creative Director Jerry Murff
Agency Tracy-Locke, Denver, CO
Client Colorado Tourism Board

121

Art Director　Gary Goldsmith
Designer　Gary Goldsmith
Photographer　Gil Cope
Writer　Steve Landsberg
Agency　Chiat/Day inc. Advertising, New York, NY
Client　William Grant & Sons

122

Art Director　John Klimo
Photographer　Wahlund Olof
Writer　Lois Korey
Agency　Korey, Kay & Partners, Inc., New York, NY
Client　Halston Fragrances
Publication　Harper's Bazaar

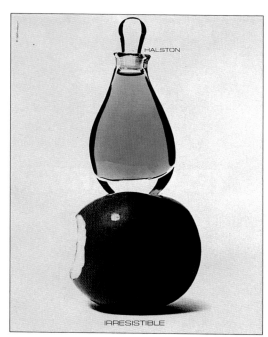

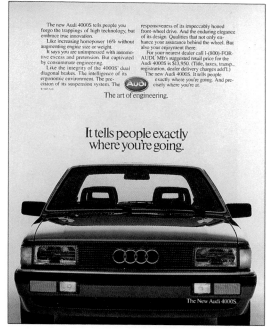

123

Art Director　Ron Louie
Designer　Ron Louie
Photographer　Harry DeZitter
Writer　Mike Rodgers
Agency　Doyle Dane Bernbach, New York, NY
Client　Audi of America
Publication　New Yorker

129

Art Director	Kurt Tausche
Photographer	Dennis Manarchy
Writer	Bert Gardner
Agency	Bozell, Jacobs, Kenyon & Eckhardt, Minneapolis, MN
Client	Swiss Miss - Beatrice

130

Art Director	Rick McQuiston
Photographer	George Hurrell/Gary McGuire
Writer	Jim Riswold
Agency	Wieden & Kennedy, Portland, OR
Client	Honda Scooters
Publication	Rolling Stone

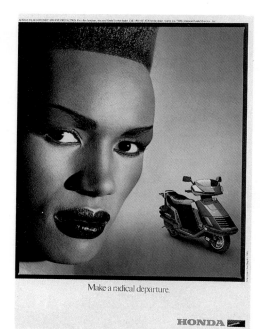

131

Art Director	Robert Reitzfeld
Designer	Robert Reitzfeld
Photographer	Robert Ammirati
Writer	David Altschiller
Agency	Altschiller Reitzfeld Inc., New York, NY
Client	Paolo Boselli, Marco Pirelli

132

Art Director	Larry Corby
Photographer	Bill Werts
Writer	Jack Foster
Creative Director	Jack Foster
Agency	Foote, Cone & Belding, Los Angeles, CA
Client	Linda Stegeman
Executive Creative Director	Michael Wagman

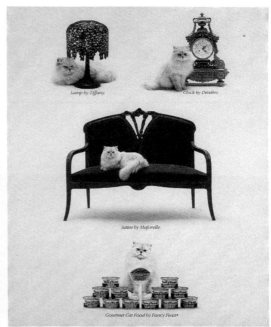

135

Art Director Gary Johns, Rick Boyko, Andy
 Dijak, Yvonne Smith
Photographer Mark Coppos
Writer Jeff Gorman, Bill Hamilton, Mark
 Monteiro
Agency Chiat/Day inc. Advertising, Los
 Angeles, CA
Client Nike, Inc.
Publication Bicycling

136

Art Director Bill Cozens
Designer Bill Cozens
Photographer Peter Thomas
Writer Alvin Wasserman
Agency McKim Advertising, Vancouver,
 B.C. Canada
Client Tourism British Columbia

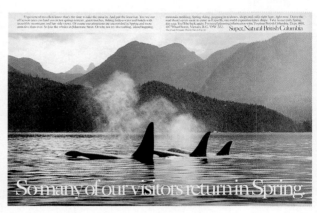

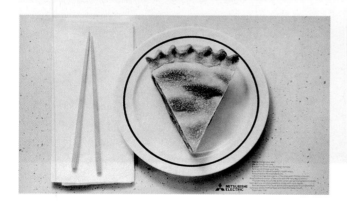

137

Art Director David Nathanson
Designer David Nathanson
Photographer Dennis Gottlieb
Writer Neal Gomberg
Agency Chiat/Day inc. Advertising, New
 York, NY
Client Mitsubishi Electric

138

Art Director Ivan Horvath
Photographer Mike Chesser
Writer Bob Ancona
Agency N W Ayer, Los Angeles, CA
Client Yamaha International Corporation

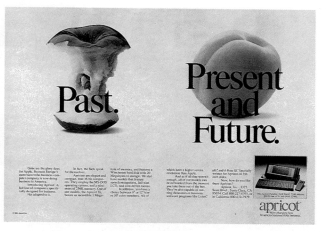

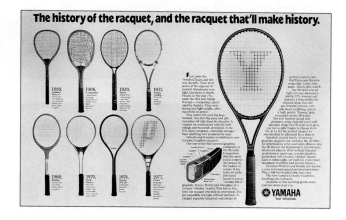

Art Director Gary Johns, Rick Boyko, Andy

145

Distinctive Merit

Art Director Simon Bowden
Designer Simon Bowden
Writer Marty Cooke
Agency Scali, McCabe, Sloves, New York, NY
Client Nikon

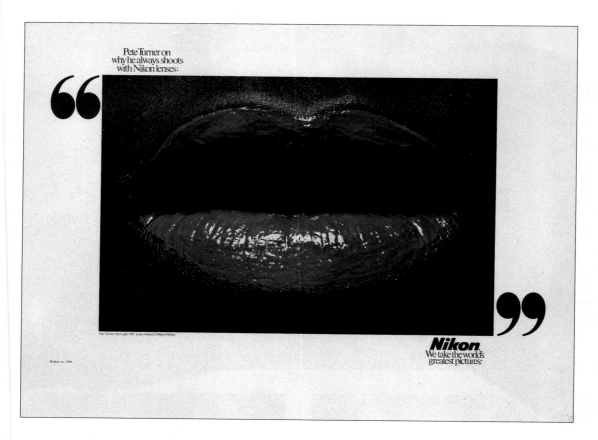

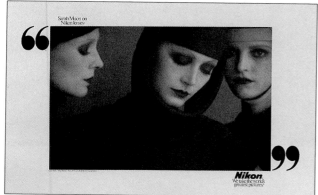

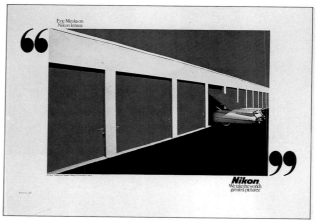

146

Art Director	Steve Pharr
Designer	Steve Pharr
Photographer	Chipp Jamison & Jerry Burns
Writer	Sarah Bowman
Agency	Pringle Dixon Pringle, Atlanta, GA
Client	Georgia Department of Industry & Trade/Tourism Dept.

147

Art Director	Mario Giua
Designer	Mario Giua
Photographer	Dan Weeks
Writer	Robin Raj
Creative Director	Jay Chiat
Agency	Chiat/Day inc. Advertising, New York, NY
Client	Miller Brewing Co.

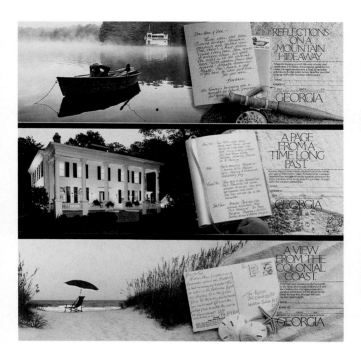

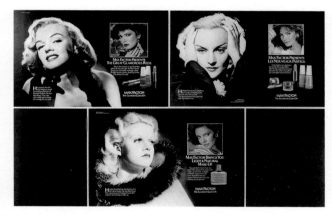

148

Art Director	Don Zimmerman
Photographer	Niwa Ogrudek
Writer	Carolyn Reider, Charles Silbert
Creative Director	Jeff Odiorne
Agency	NW Ayer Inc., New York, NY
Client	DeBeers Consolidated Mines Inc.

149

Art Director	Gary McKinley
Photographer	Bill Ring and Charles Bush
Writer	Melissa Barasch
Agency	Wells, Rich, Greene Inc., New York, NY
Client	Max Factor

150

Art Director	Tony DeGregorio, Michael Vitiello
Designer	Tony DeGregorio, Michael Vitiello
Illustrator	Don Ivan Punchatz
Photographer	Stock photo
Writer	Lee Garfinkel, Marc Shenfield
Agency	Levine, Huntley, Schmidt, & Beaver, New York, NY
Client	Tel Plus Communications

151

Art Director	David Sanchez
Photographer	Gerald Zanetti
Writer	Mickey Lonchar
Agency	Ketchum Advertising, San Francisco, CA
Client	Potato Board
Executive Creative Director	Ken Dudwick

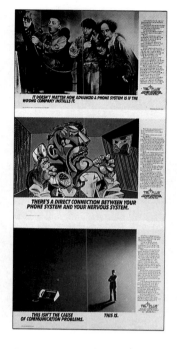

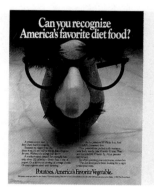
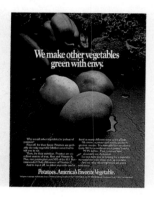

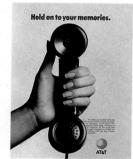
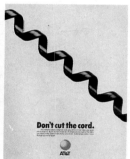
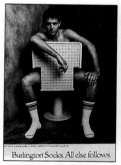
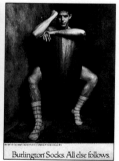

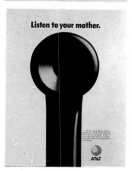

152

Art Director	Jane Evans
Photographer	Togashi
Writer	Grant Monsarrat
Agency	Young & Rubicam, New York, NY
Client	AT&T Corp.
Publication	International Herald Tribune

153

Art Director	Kurt Haiman
Designer	Kurt Haiman
Photographer	Carl Fischer
Writer	Janis Gott
Associate Creative Director	Judy Frisch, Kurt Haiman
Agency	Grey Advertising, Inc., New York, NY
Client	Burlington Socks
Publication	G.Q., Esquire, NY Times Magazine, "M" Magazine, People

154

Art Director | Paul Jervis
Photographer | Gary Perweiler
Writer | Roger Feuerman
Client | Paddington Corporation—Baileys Irish Cream
Agency | Backer & Spielvogel, New York, NY
Publication | People

155

Art Director | Christine Kilavos-Platos
Photographer | Chuck Baker
Writer | Larry Vine/Victoria Love
Creative Director | Larry Vine
Agency | Geers Gross Advertising, Inc., New York, NY
Client | Springs Industries, Inc.
Publication | New York Times Magazine

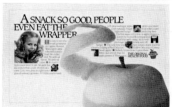

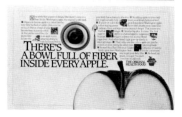

156

Art Director | Paul Cournoyer
Photographer | Mark Burnside
Writer | Michele Stonebraker
Agency | Cole & Weber Advertising, Seattle, WA
Client | Washington Apple Commission
Printer | Rainier Color
Production Manager | Lei Lani Heger

Distinctive Merit

Art Director	Sally Rouse
Illustrator	Jerry Monley
Writer	Al Acker
Agency	Ross Roy, Inc., Detroit, MI

How to fix an American symbol.

A worn-out baseball is easily replaced.
You just go out and buy a new one.
But there's another American symbol
that's going to take all of us to fix.
We can't just go out and buy a new
Statue of Liberty. We have to fix
the one we have. Please help
by sending $20...more,
if you can afford it...to:
The Statue of Liberty/
Ellis Island Foundation,
P.O. Box 1992, Dept. E
New York, NY 10008.

Ross Roy Advertising, Detroit

158

Art Director Henry Popp
Photographer Gary Blockley
Writer Colin Turney
Agency Crume & Associates, Inc., Dallas, TX
Client OPEN, Inc.

159

Art Director Bill Harris
Photographer Peter Kaplan, Joe Budne
Writer Bill Harris, Jeff Wolff
Agency Saatchi & Saatchi Compton Inc., New York, NY
Client Time Inc., "Forum for Freedom"
Publication Time

One room efficiencies. From $100,000.

Today in America, we're in the middle of a construction boom. Because the population of our prisons has never been higher. And at a time when you can still buy a single-family home for around $80,000, the cost of building a single prison cell is now over $100,000.

But if you think that's criminal, read on. It costs an extra $100,000 every five years to maintain a cell. And a further $20,000 a year in other expenses for every prisoner in America.

That's quite an investment we're making to see that crimi-

nals repay their debt to society. And to make matters worse, it's not even working. Because once released, more than 6 out of 10 prisoners commit further crimes. And return to prison.

If you feel someone should be doing something about it, be assured. Someone is. OPEN, Incorporated. The Offender Preparation and Education Network. A non-profit organization which counsels offenders and their families to prepare

them for life on the outside. And helps restore the proper values that'll keep them from ending up back inside.

We think criminals should repay their debt to society. And that the best way to make sure they do is to have them working. Paying taxes. Taking care of their families. Contributing again.

Which, when you think about it, is a lot more efficient all around.

For more information on OPEN, call 214/631-7500, or write 201 Stemmons Tower North, 2710 Stemmons Fwy., Dallas, Texas 75207.

OPEN INC.

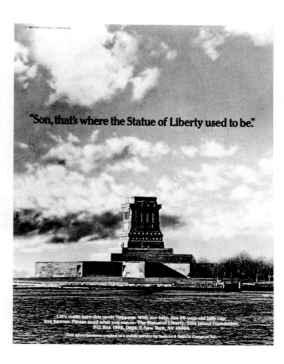

"Son, that's where the Statue of Liberty used to be."

Let's make sure this never happens. With our help, this 99-year-old lady can live forever. Please send what you can to: The Statue of Liberty/Ellis Island Foundation, P.O. Box 1986, Dept. E, New York, NY 10008.

This advertisement created as a public service by Saatchi & Saatchi Compton Inc.

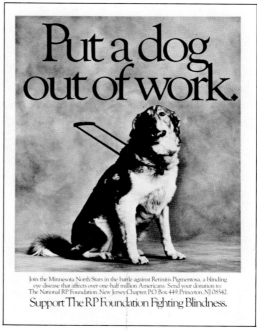

Put a dog out of work.

Join the Minnesota North Stars in the battle against Retinitis Pigmentosa, a blinding eye disease that affects over one-half million Americans. Send your donation to: The National RP Foundation, New Jersey Chapter, P.O. Box 449, Princeton, NJ 08542.

Support The RP Foundation Fighting Blindness.

160

Art Director Bob Barrie
Photographer Jim Arndt
Writer Mike Lescarbeau
Agency Fallon McElligott, Minneapolis, MN
Client Minnesota North Stars
Publication Retinitis Pigmentosa Program

Distinctive Merit

Art Director	Bob Barrie
Designer	Bob Barrie
Writer	Tom McElligott
Agency	Fallon McElligott, Minneapolis, MN
Client	Fallon McElligott Rice
Publication	Clio Magazine

162

Art Director	Renee Richmond
Photographer	Michael Newler
Writer	Bill Connors
Creative Director	Mike Pitts
Agency	Ogilvy & Mather Inc., New York, NY

163

Art Director	John Clapps, Ridgewood, NJ
Designer	John Clapps
Photographer	Scott Laperuque
Writer	Charles Mullen
Client	Custom Communications Systems

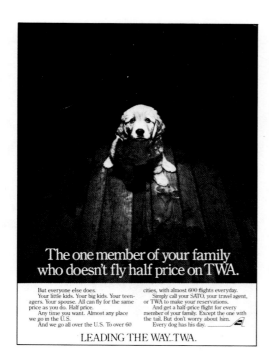

164

Art Director	George Pierson/John Martinez
Designer	Peter Comitini
Agency	HBO Creative Services, New York, NY
Client	Home Box Office

165

Art Director	Young & Laramore
Designer	Jeff Laramore
Writer	David J. E. Young
Agency	Young & Laramore, Indianapolis, IN
Client	Colin Service Systems, Inc.
Publication	Crain's New York Business

166

Art Director	Tom Lichtenheld
Designer	Tom Lichtenheld
Writer	Bruce Bildsten
Agency	Fallon McElligott, Minneapolis, MN
Client	Great Faces Typography
Publication	Format

167

Art Director	Eric Schoelles
Illustrator	Dover Publications/Eric Schoelles
Writer	Eric Schoelles
Agency	Gordon Bailey & Assoc., Stone Mtn., GA
Client	Iceland Seafood Corp.

168

Art Director	Brian Butler Blunt
Designer	Brian Butler Blunt
Photographer	David Deahl
Writer	Barry Burdiak
Creative Director	Allen Cohn
Agency	N W Ayer, Chicago, IL
Client	Mike Brainard
Executive Creative Director	Walter Hampton
Account Executive	Pamela Miller

169

Art Director	Colleen Harquail
Designer	Colleen Harquail
Photographer	Chris Collins Wooley
Writer	Paul Mahoney
Agency	Ingalls, Quinn & Johnson, Boston, MA
Client	Lowell Shoe
Publication	Footware News

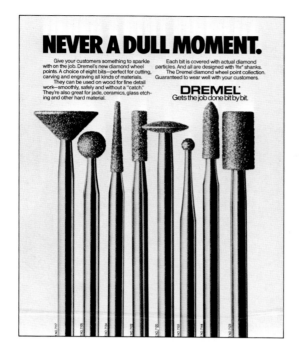

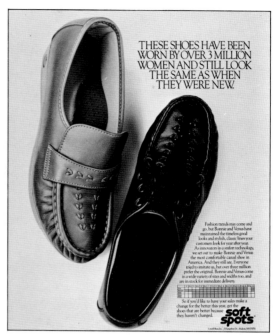

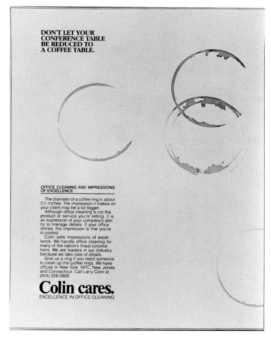

170

Art Director	Young & Laramore
Designer	Jeff Laramore
Writer	David J. E. Young
Agency	Young & Laramore, Indianapolis, IN
Client	Colin Service Systems, Inc.
Publication	Crain's New York Business

Silver Award

Art Director	John Morrison
Photographer	Tom Berthiaume
Writer	Bill Miller
Agency	Fallon McElligott, Minneapolis, MN
Client	AMF
Publication	USGF Magazine

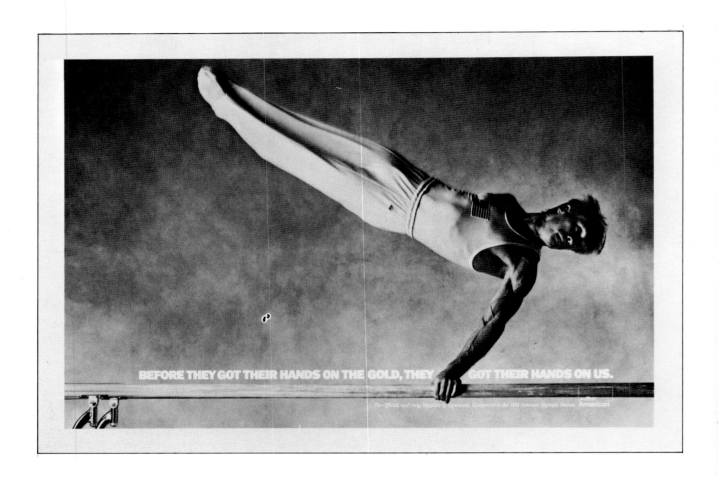

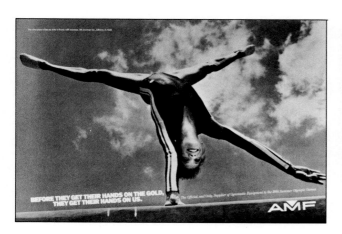

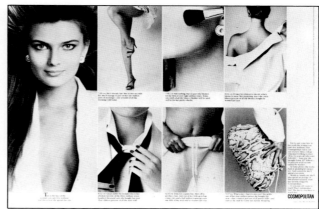

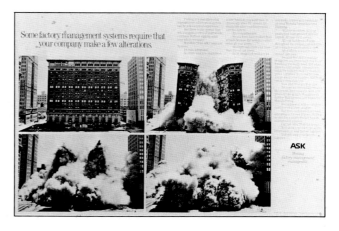

175

Art Director Rene Vidmer
Photographer Patrick Demarchelier
Writer Eve Hartman
Creative Director Ken Baron
Agency Baron & Zaretsky Advertising, New York, NY
Client Cosmopolitan Magazine

176

Art Director John Morrison
Photographer Tom Berthiaume
Writer Bill Miller
Agency Fallon McElligott, Minneapolis, MN
Client AMF
Publication Athletic Business

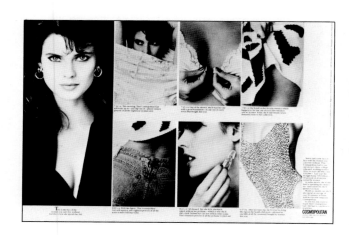

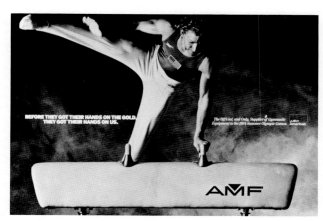

Distinctive Merit

Art Director	Paul Behnen
Illustrator	Bill Mayer
Writer	Steve Puckett
Agency	Vinyard & Lee & Partners, St. Louis, MO
Client	Huber

178

Art Director John Morrison
Photographer Tom Berthiaume
Writer Bill Miller
Agency Fallon McElligott, Minneapolis, MN
Client AMF
Publication Athletic Business

179

Art Director Craig Joslin
Designer Craig Joslin
Illustrator John Hull
Writer William Lower
Agency McCann Erickson, Los Angeles, CA
Client McCann Erickson, Los Angeles, CA

180

Art Director Glenn Dayton
Designer Phillip Squier
Photographer Bettman Archives
Writer Tony Durket
Agency Fruehling Communications, Del Mar, CA
Client Inland Specialty Chemical Corp.

181

Distinctive Merit

Art Director Amy Levitan
Designer Amy Levitan
Illustrator Chuck Pitaro
Writer Richard Middendorf
Agency Doyle Dane Bernbach, New York, NY
Client IBM

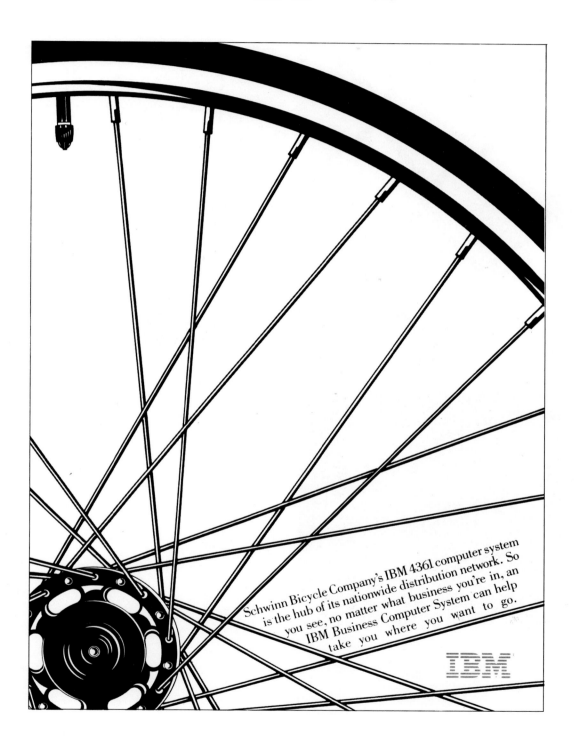

Schwinn Bicycle Company's IBM 4361 computer system is the hub of its nationwide distribution network. So you see, no matter what business you're in, an IBM Business Computer System can help take you where you want to go.

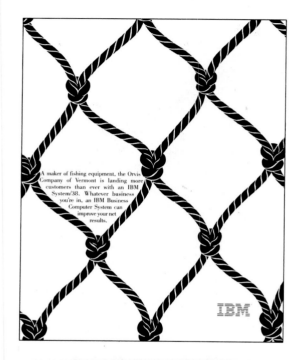

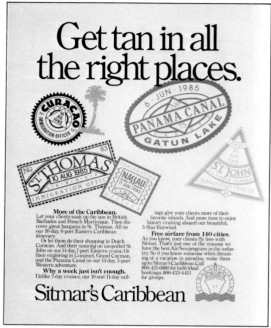

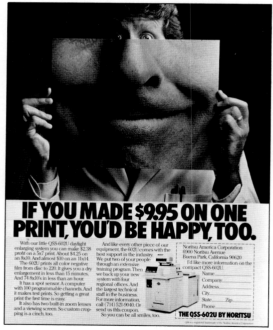

185

Art Director	Yvonne Smith/Marc Deschenes
Designer	Yvonne Smith/Marc Deschenes
Illustrator	Gina Norton
Photographer	Lamb & Hall
Writer	Marc Deschenes/Yvonne Smith
Agency	(213) 827-9695 & Associates, Los Angeles, CA
Client	Noritsu America Corporation
Publication	Photoweekly
Advertising Manager	Brad Moore

186

Art Director	Ken Chauncey
Photographer	Carl Furuta
Writer	Greg Wilson
Agency	Allen and Dorward Advertising, San Francisco, CA
Client	Dole Foods Company

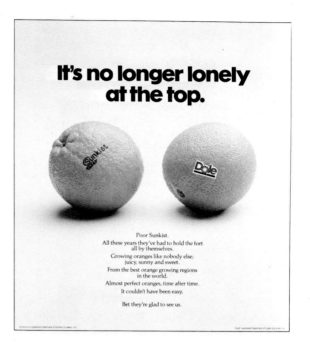

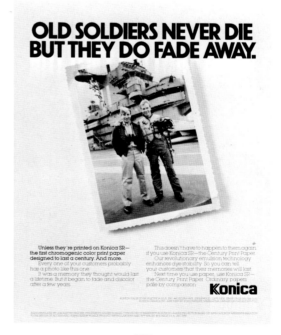

187

Art Director	Peter Hirsch
Designer	Peter Hirsch
Photographer	Carl Fischer
Writer	Ken Majka
Agency	Calet, Hirsch & Spector, Inc., New York, NY
Client	Konica
Publication	Photo Marketing, Photo Processing, Photo Lab Management

189

Art Director	Alan Goodson/Jon Reeder
Photographer	Paul Taylor/Bob Grigg
Writer	Tom Binnion/Jeff Tobin
Creative Director	Murray Kalis
Agency	HCM, Los Angeles, CA
Client	Clarion

190

Art Director	Ken Chauncey
Photographer	Carl Furuta
Writer	Greg Wilson
Agency	Allen and Dorward Advertising, San Francisco, CA
Client	Dole Foods Company

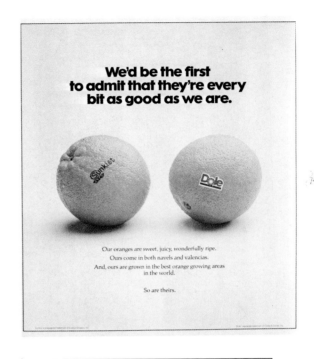

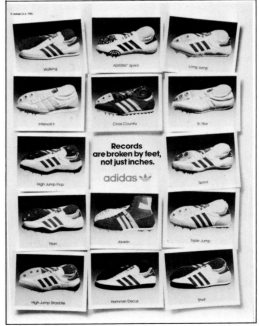

191

Art Director	Brett Shevack, Kate Corr
Designer	Brett Shevack, Kate Corr
Photographer	George Obremski, Craig Collins
Writer	Alan Levine
Agency	Calvillo, Shevack & Partners, Inc., New York, NY
Client	PhotoUnique, Inc.
Publication	Communication Arts Magazine

192

Art Director	Lou Zaffos, Brett Shevack
Designer	Lou Zaffos
Photographer	Jerry Friedman
Writer	Steve Brophy
Agency	Calvillo, Shevack & Partners, Inc., New York, NY
Client	adidas, U.S.A.
Publication	Track & Field News

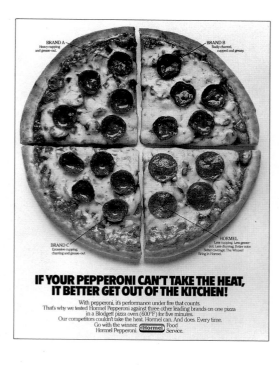

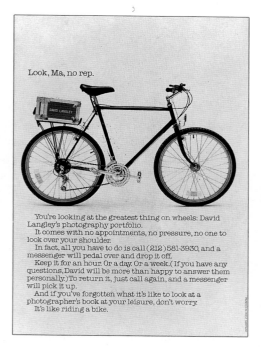

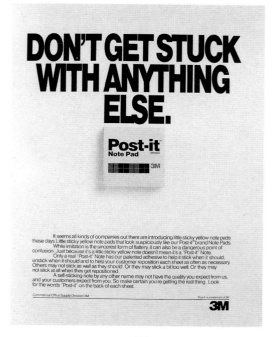

Gold Award	
Art Director	Nancy Rice
Photographer	Mark Hauser
Writer	Bill Miller
Agency	Fallon McElligott, Minneapolis, MN
Client	Rolling Stone
Publication	Marketing & Media Decision

Perception.

Reality.

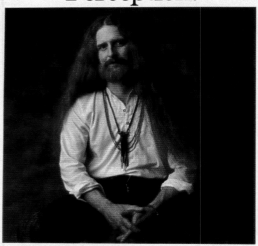

If your idea of a Rolling Stone reader looks like a holdout from the 60's, welcome to the 80's.
Rolling Stone ranks number one in reaching concentrations of 18-34 readers with household incomes exceeding
$25,000. When you buy Rolling Stone, you buy an audience that sets the trends and shapes the
buying patterns for the most affluent consumers in America. That's the kind of reality you can take to the bank.

Silver Award

Art Director Sally Wagner
Photographer Kent Severson
Writer Emily Scott
Agency Martin/Williams, Minneapolis, MN
Client 3M Company

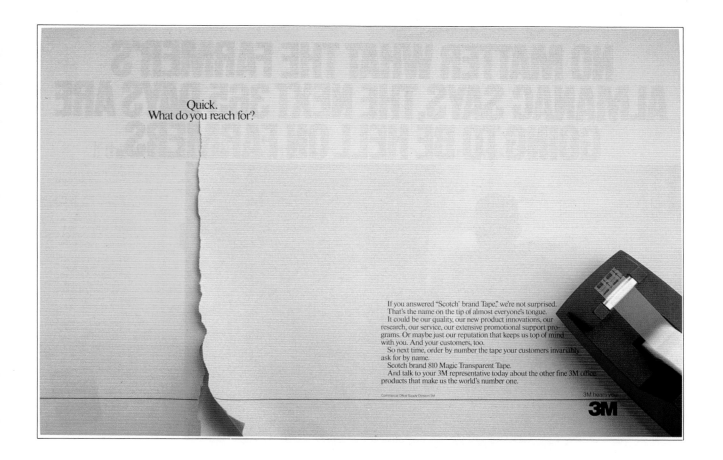

200

Art Director	Bob Saabye
Photographer	Clint Clemens, Gene Dwiggins
Writer	Jeff Abbott
Agency	Leonard Monahan Saabye, Providence, RI
Client	Siebe North, Inc.

201

Art Director	Cabell Harris
Designer	Cabell Harris
Photographer	John Whitehead
Writer	Luke Sullivan
Agency	Creswell, Munsell, Fultz & Zirbel, Des Moines, IA
Client	Meredith Corporation

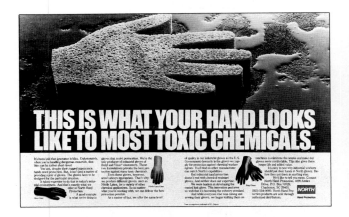

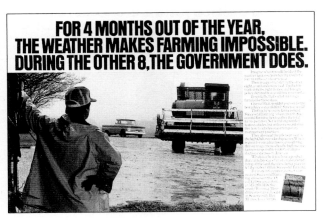

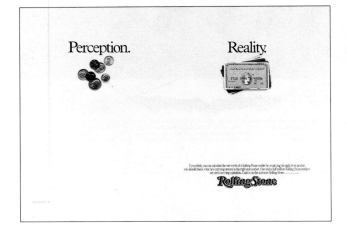

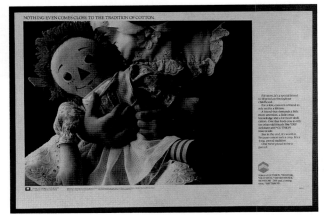

202

Art Director	Nancy Rice
Photographer	Jim Marvy
Writer	Bill Miller
Agency	Fallon McElligott, Minneapolis, MN
Client	Rolling Stone
Publication	Ad Week

203

Art Director	Gary Custer
Designer	Gary Custer
Photographer	Glen Wans
Writer	Scott McCormick
Creative Director	Bob Jensen
Agency	Valentine-Radford Advertising Agency, Kansas City, MO
Client	Mobay Chemical Corporation

204

Art Director	Pat Burnham
Photographer	Joe Pytka
Writer	Bill Miller
Agency	Fallon McElligott, Minneapolis, MN
Client	US West
Publication	The Economist

205

Art Director	Bob Jensen/Clark Lamm
Illustrator	Bob Hilborn
Photographer	Stock
Writer	David Schutten
Creative Director	Bob Jensen
Agency	Valentine-Radford Advertising Agency, Kansas City, MO

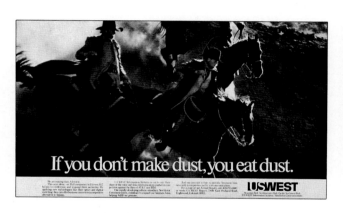

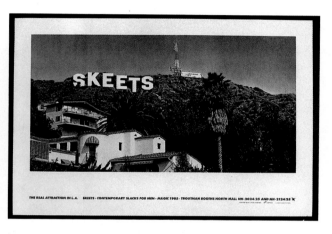

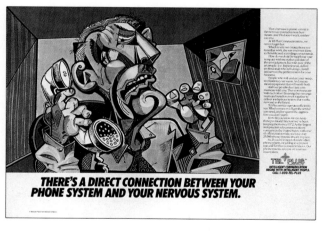

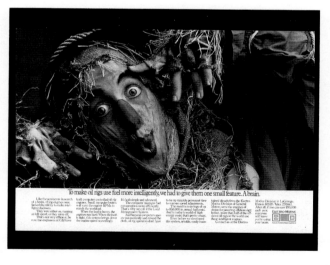

206

Art Director	Michael Vitiello
Designer	Michael Vitiello
Illustrator	Don Ivan Punchatz
Writer	Marc Shenfield
Agency	Levine, Huntley, Schmidt & Beaver, New York, NY
Client	Tel Plus Communications

207

Art Director	Hal Tench
Designer	Hal Tench
Photographer	Cailor-Resnick
Writer	Daniel Russ
Agency	The Martin Agency, Richmond, VA
Producer	Wayne Woods
Client	GM, Electro-Motive Division
Publication	Railway Age

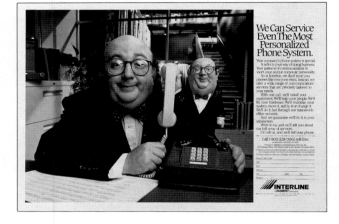

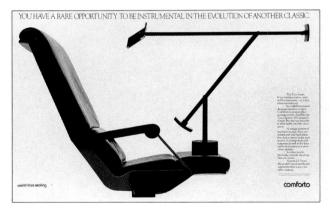

213

Art Director	Marc Marvin
Designer	Marc Marvin
Photographer	Terry Heffernan
Writer	Seth Werner
Agency	Foote, Cone & Belding, San Francisco, CA
Client	Levi Strauss & Co.
Publication	Daily News Record

214

Art Director	Bob Jensen/Clark Lamm
Illustrator	Bob Hilborn
Photographer	Stock
Writer	David Schutten
Creative Director	Bob Jensen
Agency	Valentine-Radford Advertising Agency, Kansas City, MO

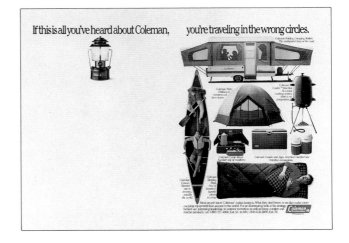

215

Art Director	Nancy Rice
Photographer	Jim Marvy
Writer	Phil Hanft
Agency	Fallon McElligott, Minneapolis, MN
Client	Coleman
Publication	Forbes

Gold Award

Art Director	Nancy Rice
Photographer	Jim Marvy
Writer	Bill Miller
Agency	Fallon McElligott, Minneapolis, MN
Client	Rolling Stone
Publication	Ad Age

Perception.

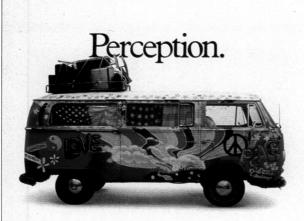

Reality.

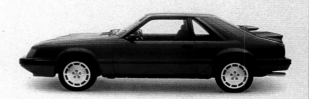

If you still think a Rolling Stone reader's idea of standard equipment is flowers on the door panels and incense in the ashtrays, consider this: Rolling Stone households own 5,199,000 automobiles. If you've got cars to sell, welcome to the fast lane. Source: Simmons 1984

Gold Award

Art Director	Cabell Harris
Designer	Cabell Harris
Photographer	John Whitehead
Writer	Luke Sullivan
Agency	Creswell, Munsell, Fultz & Zirbel, Des Moines, IA
Client	Meredith Corporation

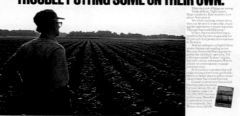

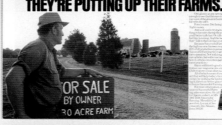

Gold Award

Art Director	Nancy Rice
Designer	Nancy Rice
Photographer	Mark Hauser, Jim Marvy
Writer	Bill Miller
Agency	Fallon McElligott, Minneapolis, MN
Client	Rolling Stone
Publication	Ad Age

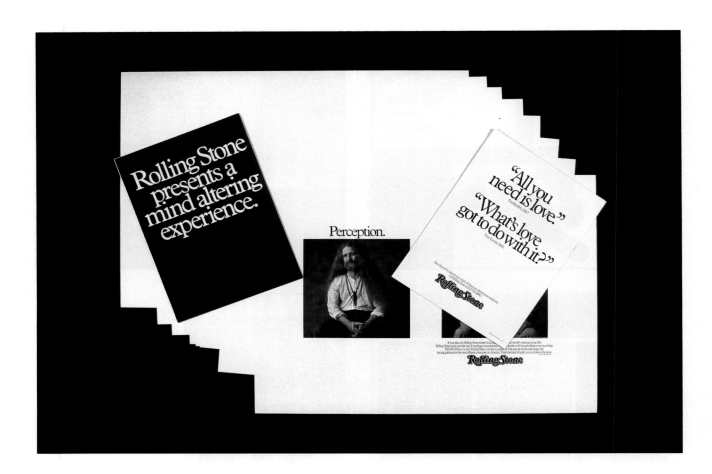

224

Gold Award

Art Director	Chris Poisson, Phoenix, AZ
Photographer	Rick Gayle
Writer	Chris Poisson, Frank Woods
Agency	Rick Gayle Studio
Client	Woods Lithographics
Printer	Woods Lithographics

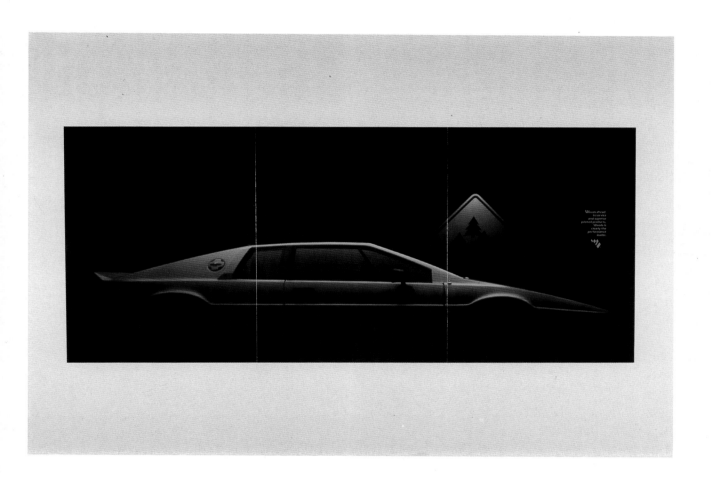

225

Art Director	Steve Beaumont
Photographer	Mark Coppos
Writer	Penny Kapousouz/Brent Bouchez
Associate Creative Director	Steve Hayden
Agency	Chiat/Day inc. Advertising, Los Angeles, CA
Client	Porsche Cars North America
Publication	Fortune

226

Art Director	Marc Marvin
Designer	Marc Marvin
Photographer	Terry Heffernan
Writer	Seth Werner
Agency	Foote, Cone & Belding, San Francisco, CA
Client	Levi Strauss & Co.
Publication	Daily News Record

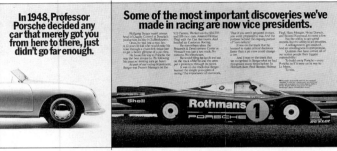

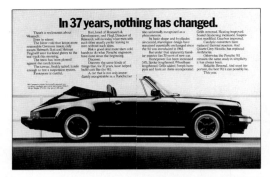

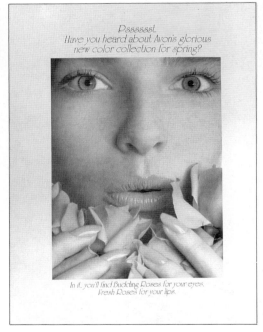

227

Art Director	Susan Slover
Designer	Susan Huyser
Photographer	Raeanne Giovanni
Writer	Jim Friedland
Client	Maharam
Publication	Sweet's Catalog
Studio	Susan Slover Design, New York, NY

228

Art Director	Ray Stollerman
Photographer	Constance Hansen
Writer	Betsy Mansfield
Agency	NW Ayer Inc., New York, NY
Client	Avon
Publication	Newsweek Woman

229

Art Director Robert L. Hohnstock
Designer Robert L. Hohnstock
Photographer Howard Sokol
Writer Robert L. Hohnstock
Agency R. L. Hohnstock & Associates, Denver, CO
Client Moser Printing
Type Straight Creek
Separations American Color
Production Sandra Perkins
Printer Moser Printing

230

Art Director Lou Fiorentino
Designer Lou Fiorentino
Illustrator Stan Fernandes
Photographer Chris Collins
Writer Hil Leibe
Agency Fiorentino Leibe, New York, NY
Client Royal Zenith
Marketing Director Ed Friedlander

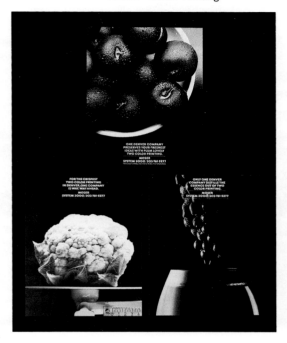

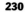

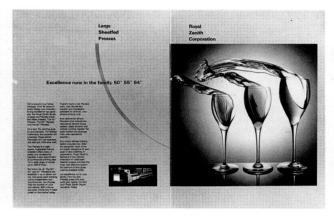

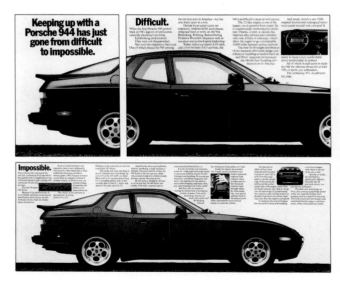

231

Art Director Jeff Roll
Photographer Lamb & Hall
Writer David Butler
Agency Chiat/Day inc. Advertising, Los Angeles, CA
Client Porsche Cars North America
Publication Road & Track

232

Gold Award

Art Director Aldona Charlton
Designer Aldona Charlton
Illustrator Patrick Blackwell
Writer Lynda Morgenroth
Editor Gail Ravgiala
Client The Boston Globe
Publisher The Boston Globe, Boston, MA
Publication The Boston Globe

233

Distinctive Merit

Art Director	Tom Bodkin
Illustrator	Charts by The New York Times Map Dept.
Client	The New York Times
Publisher	The New York Times, New York, NY
Publication	The New York Times
Graphics Editor	Nancy Lee

245

Art Director	George Benge
Designer	Kathleen Vincent
Photographer	David Leeson
Director of Photography	John Davidson
Publisher	Dallas Morning News, Dallas, TX

246

Art Director	Broc Sears
Designer	John Goecke
Photographer	Joe Patronite
Writer	Julie Vargo-Turi
Editor	Kim Marcum
Publication	Dallas Times Herald, Dallas, TX

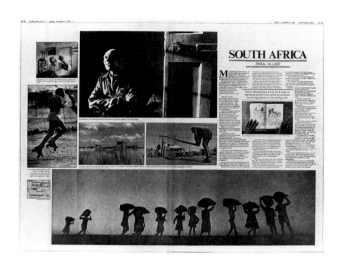

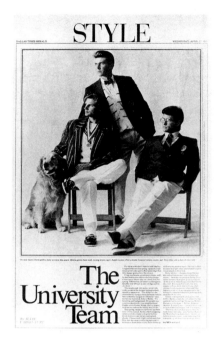

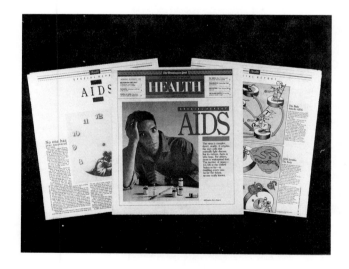

247

Art Director	Kathy Jungjohann
Designer	Kathy Jungjohann
Illustrator	Bob Dahm/Johnstone Quinan
Photographer	Lynn Johnson/Black Star
Client	The Washington Post
Publisher	The Washington Post, Washington, DC
Publication	The Washington Post

Distinctive Merit

Art Director	Ronn Campisi
Designer	Ronn Campisi
Editor	Alison Arnett
Client	The Boston Globe
Publisher	The Boston Globe, Boston, MA

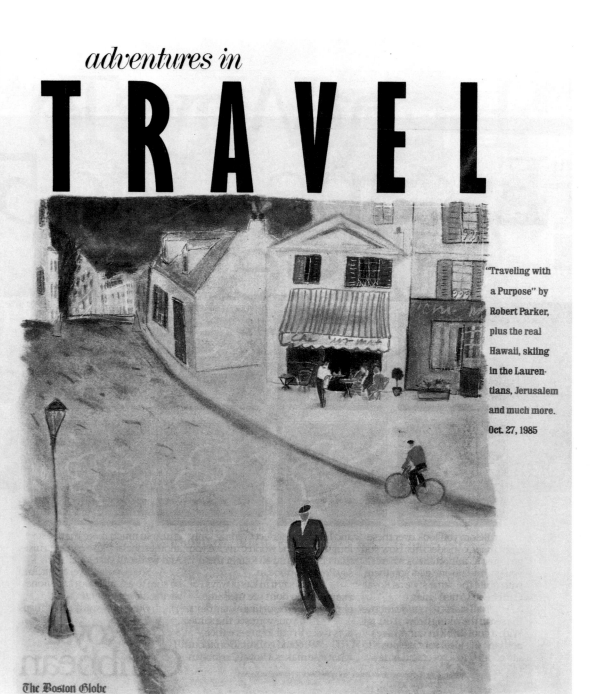

adventures in

TRAVEL

"Traveling with a Purpose" by Robert Parker, plus the real Hawaii, skiing in the Laurentians, Jerusalem and much more. Oct. 27, 1985

The Boston Globe

260

Art Director	Helene Silverman
Writer	Carol Schatz
Editor	Sharon Lee Ryder
Publisher	Horace Havemeyer III
Publication	Metropolis Magazine, New York, NY

261

Art Director	David W. Harris
Designer	David W. Harris
Photographer	David Buffington
Writer	Jennifer Tucker
Editor	Steven Reddicliffe
Publication	Dallas City Magazine, Dallas, TX

262

Art Director	Ira Yoffe and Christopher Austopchuk
Designer	Ira Yoffe and Christopher Austopchuk
Illustrator	Elwood Smith
Publication	Parade Magazine, New York, NY

263

Art Director	Douglas Steinbauer
Designer	Douglas Steinbauer
Illustrator	Nina Winters
Writer	Les Lindeman
Editor	Bard Lindeman
Publisher	Whitney Communications Company, New York, NY
Publication	50 Plus

264

Silver Award

Art Director Amy Seissler
Designer Amy Seissler
Photographer Brian R. Wolff
Publisher Bob Guccione
Publication Omni Magazine, New York, NY
Graphics Director Frank M. DeVino

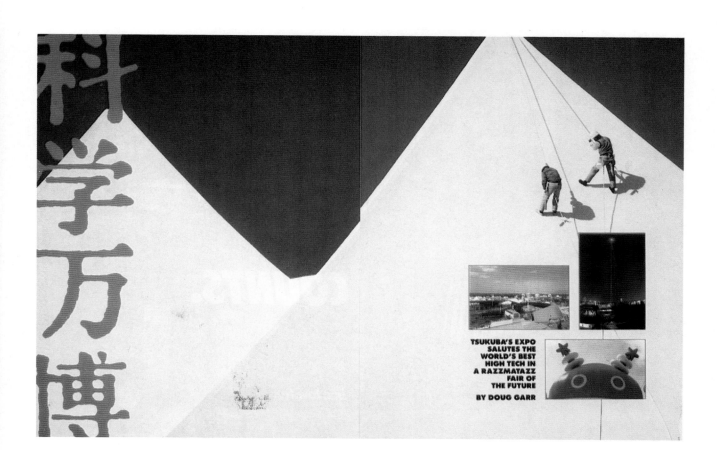

TSUKUBA'S EXPO SALUTES THE WORLD'S BEST HIGH TECH IN A RAZZMATAZZ FAIR OF THE FUTURE

BY DOUG GARR

Silver Award

Art Director Melissa Tardiff
Designer Mary Rosen
Photographer Ronnie Kaufman
Writer James Villas
Editor Frank Zachary
Publisher Hearst Corporation, New York, NY
Publication Town & Country Magazine

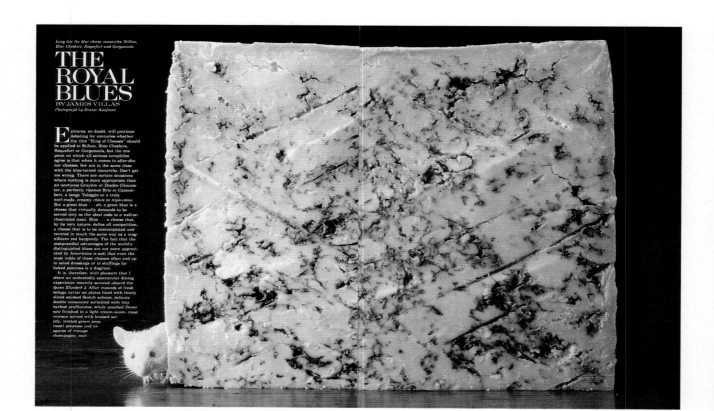

Long live the blue cheese monarchs: Stilton, Blue Cheshire, Roquefort and Gorgonzola.

THE ROYAL BLUES

BY JAMES VILLAS

Photograph by Ronnie Kaufman

Epicures, no doubt, will continue debating for centuries whether the title "King of Cheeses" should be applied to Stilton, Blue Cheshire, Roquefort or Gorgonzola, but the one point on which all serious turophiles agree is that when it comes to after-dinner cheeses, few are in the same class with the blue-veined monarchs. Don't get me wrong. There are certain occasions where nothing is more appropriate than an unctuous Gruyère or Double Gloucester, a perfectly ripened Brie or Camembert, a tangy Taleggio or a truly well-made, creamy *chèvre* or *triple-crème*. But a great blue ... ah, a great blue is a cheese that virtually demands to be served only as the ideal coda to a well-orchestrated meal. Blue ... a cheese that, by its very nature, defies all competition, a cheese that is to be contemplated and revered in much the same way as a magnificent red burgundy. The fact that the postprandial advantages of the world's distinguished blues are not more appreciated by Americans is sad; that even the most noble of these cheeses often end up in salad dressings or in stuffings for baked potatoes is a disgrace.

It is, therefore, with pleasure that I share an undeniably spectacular dining experience recently savored aboard the *Queen Elizabeth 2*. After mounds of fresh beluga caviar on plates lined with thinly sliced smoked Scotch salmon, delicate double consommé sprinkled with tiny herbed profiteroles, while poached Dover sole finished in a light cream sauce, roast venison served with braised salsify, minted green peas, rosotti potatoes and nigagaris of vintage champagne, mel-

Distinctive Merit

Art Director	Robert Best
Designer	Robert Best, Josh Gosfield
Illustrator	Burt Silverman
Publication	New York Magazine, New York, NY

A HOMELESS WOMAN'S STORY

BY SARAJANE ARCHDEACON

On January 25, 1985, six officers from the police precinct in Varanasi, India, knocked on Sarajane Archdeacon's door. Archdeacon, a writer and photographer, had been living abroad for 25 years, the last 9 in India. The police told her they had orders to deport her; they refused to let her make any phone calls or withdraw money from the bank. Having been taken to New Delhi and put on a plane headed for the United States, she landed at Kennedy Airport absolutely penniless. Her relations with her mother, in Florida, and her daughter, in California, were so strained that she did not expect aid from them. But with the help of strangers—a staffer at Travelers Aid, who got her to Manhattan, and a policewoman in Times Square, who gave her advice and a subway token—Archdeacon found her way to the women's shelter at 350 Lafayette Street.

'HAVE YOU EVER BEEN in a shelter before?" the social worker asked. I said no; he said kindly, "There's always a first time." He admitted me to this shelter, a nondescript four-story building (a former animal hospital) in a pleasant business district in NoHo, on the basis of my age—60—and because I had no money for a hotel. "This one was set up for sick old ladies," he said, "and it's the best in the city."

A matronly aide led me to the bathroom on the second floor and gave me a towel, a facecloth, a bar of strong yellow soap, and a toothbrush and toothpaste. She waited outside the shower stall and gave me a sharp look when I came out, to make sure I'd really washed my hair; they don't want anyone to bring lice into the city shelter system. She did not check to see if I'd left the shower the way I'd found it—black hairs stuck here and there over the white tiles and a ball of hair clogging the drain.

I followed the aide across the hall to a room with a bed in each corner; she showed me my locker and my bed, next to a hot radiator strung with clothes. A handsome woman, fortyish, with her leg in a cast, watched sleepily from one bed; a round-faced little West Indian, twenty or so, her hair in pink curlers, observed me silently from another. As I groped around in my plastic bag for a brush, my fingers touched the steel edge of the kitchen knife I'd grabbed in a pang of housewifely anxiety during my last min-

utes in Varanasi as the police waited at the door. I pulled it out. The woman whistled and the girl gasped.

"Put that thing out of sight before they see it and chuck you out," the girl said with unmistakable respect.

"It's only a kitchen knife."

They both smiled. I might need to wear spectacles every waking hour. I might limp a bit because of a callus on my foot. I might be gray-haired. I might talk in a tame schoolteacher idiom, but I carried a knife. I was to be reckoned with.

The West Indian crossed the room to offer me a piece of hard candy. "I'm Teena," she said. "That's Alberta." (All of the names of the shelter "clients" have been changed, but all other details, and the names of staff members, have not been altered.) Alberta had closed her eyes and was dozing off. Teena whispered, "Drugs. She's out like a light most of the time." I settled in on my bed.

An hour or so later, I heard scuffling sounds in the bathroom, and then some shouts. Footsteps pounded past the door; it was the guards. Teena went to the bathroom to check out the commotion.

"It's Big Ellie," she said. "She had the bed before you. She sneaked up the stairs though she'd be able to sleep in the shower."

Big Ellie had been put out for smoking

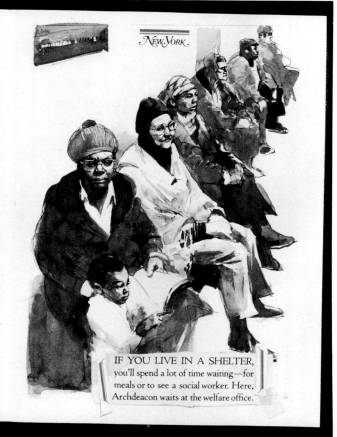

IF YOU LIVE IN A SHELTER, you'll spend a lot of time waiting—for meals or to see a social worker. Here, Archdeacon waits at the welfare office.

ILLUSTRATED BY BURT SILVERMAN

267

Art Director	Elizabeth Woodson
Designer	Elizabeth Woodson
Photographer	George Obremski
Publisher	Food & Wine Magazine, New York, NY

268

Art Director	Mark Weinberg
Designer	Bob Guccione, Jr.
Photographer	Anton Corbijn
Writer	Deidre O'Donoghue
Publication	Spin Magazine, New York, NY
Picture Editor	George DuBose

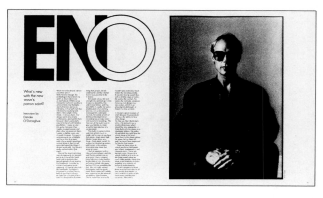

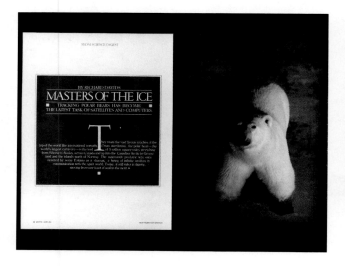

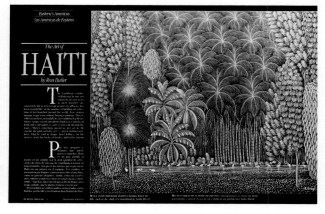

269

Art Director	Nina Ovryn, Brooklyn, NY
Designer	Connie Circosta
Photographer	Dan Guravich
Writer	Richard Davids
Editor	Donald Dewey
Client	Eastern Airlines
Publication	Review Magazine

270

Art Director	Nina Ovryn, Brooklyn, NY
Designer	Nina Ovryn
Photographer	Koji Masui
Writer	Ron Butler
Editor	Donald Dewey
Client	Eastern Airlines
Publication	Review Magazine

271

Art Director	Wm. A. Motta
Designer	Richard R. Baron
Photographer	John Lamm
Writer	John Lamm
Editor	John Dinkel
Client	Road & Track Magazine
Publisher	CBS Magazines
Publication	Road & Track Magazine, Newport Beach, CA

272

Art Director	Will Hopkins, Ira Friedlander
Photographer	Philippe-Louis Houze
Writer	Tom Hager
Editor	T. George Harris
Agency	Will Hopkins Group, New York, NY
Publisher	Owen J. Lipstein
Publication	American Health

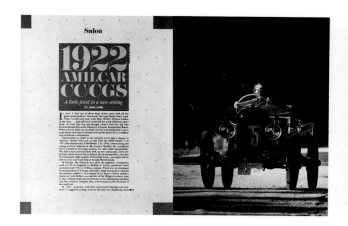

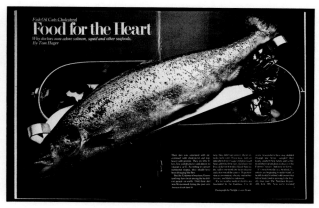

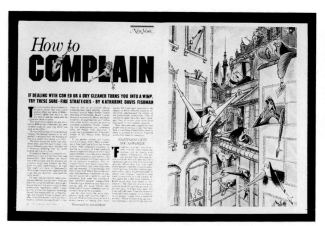

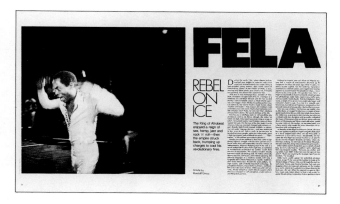

273

Art Director	Robert Best
Designer	Robert Best, Patricia von Brachel
Illustrator	Arnold Roth
Publication	New York Magazine, New York, NY

274

Art Director	Diane Luger
Designer	Bob Guccione, Jr.
Publication	Spin Magazine, New York, NY

275

Art Director	Ken Kendrick
Designer	Ken Kendrick
Photographer	Paul Fusco/Magnum (Large photo)
	& Sara Krulwich/NYT (bracelet)
Client	The New York Times Magazine
Publisher	The New York Times, New York, NY
Publication	The New York Times
Picture Editor	Peter Howe

276

Art Director	Nina Ovryn, Brooklyn, NY
Designer	Nina Ovryn
Illustrator	David Johnson
Writer	Richard Schickel
Editor	John Atwood
Client	Eastern Airlines
Publication	Review Magazine

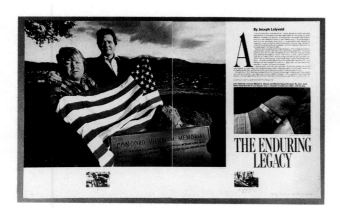

277

Art Director	Amy Seissler
Designer	Amy Seissler
Photographer	John Griebsch
Publisher	Bob Guccione
Publication	Omni Magazine, New York, NY
Graphics Director	Frank M. DeVino

278

Art Director	Elizabeth Woodson
Designer	Loretta Sala
Photographer	Thom DeSanto
Publisher	American Express Publishing Corp., New York, NY
Publication	Food & Wine Magazine

279

Art Director	Amy Seissler
Designer	Amy Seissler
Photographer	Leonard Speier
Publisher	Bob Guccione
Publication	Omni Magazine, New York, NY
Graphics Director	Frank M. DeVino

280

Art Director	Richard R. Baron
Designer	Richard R. Baron
Photographer	Jeffrey R. Zwart
Writer	Thos. L. Bryant
Editor	Thos L. Bryant
Client	Road & Track Presents Exotic Cars 3
Publisher	CBS Magazines
Publication	R & T Presents Exotic Cars 3, Newport Beach, CA

281

Art Director	Miriam Smith
Designer	Miriam Smith
Illustrator	Greg Spalenka
Writer	Budd Schulberg
Editor	John Montorio
Client	The Newsday Magazine
Publisher	Newsday, Melville, NY
Publication	The Newsday Magazine

282

Art Director	Robert Best
Designer	Robert Best, Patricia von Brachel
Photographer	Tohru Nakamura
Publication	New York Magazine, New York, NY

307

Art Director Wayne Fitzpatrick
Designer Wayne Fitzpatrick
Illustrator Brad Holland
Writer various
Editor Allen Hammond
Client SCIENCE 85/AAAS
Publisher William Carey
Publication SCIENCE 85 Magazine,
 Washington, DC

308

Art Director Ken Kendrick
Designer Ken Kendrick
Illustrator Guy Billout
Client The New York Times Magazine
Publisher The New York Times, New York,
 NY
Publication The New York Times Magazine

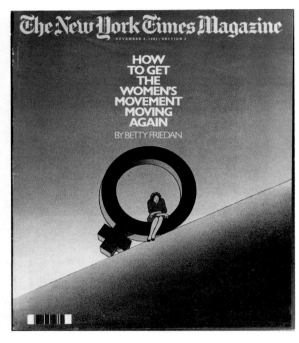

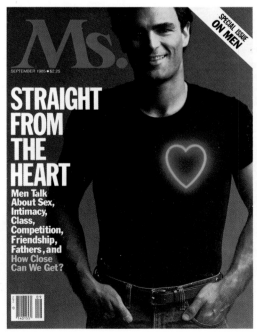

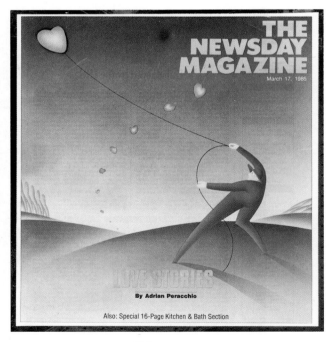

309

Art Director Phyllis Schefer
Designer Phyllis Schefer
Photographer Mark Kozlowski
Editor Suzanne Levine/Amanda Spake
Publisher Pat Carbine
Publication Ms. Magazine, New York, NY

310

Art Director Miriam Smith
Designer Miriam Smith
Illustrator Michael McGurl
Writer Adrian Peracchio
Editor John Montorio
Client The Newsday Magazine
Publisher Newsday, Melville, NY
Publication The Newsday Magazine

311

Art Director	Walter Bernard & Milton Glaser
Illustrator	Brian Bailey
Editor	Shelby Coffey III
Client	U.S. News & World Report
Publication	U.S. News & World Report
Studio	WBMG, Inc., New York, NY

312

Art Director	Gerard Sealy
Designer	Gerard Sealy
Illustrator	Mark Penberthy
Writer	Don Scobel
Editor	Diane Carman
Publisher	The Plain Dealer Publishing Co., Cleveland, OH
Publication	The Plain Dealer Magazine

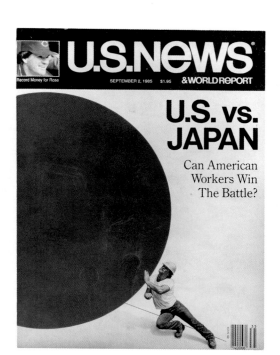

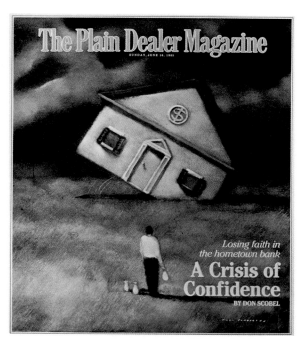

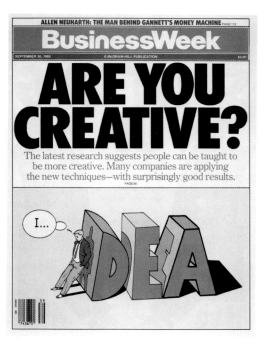

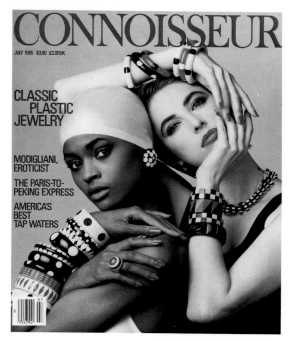

313

Art Director	Malcolm Frouman/Laura Baer
Designer	Laura Baer
Illustrator	Istvan Banyai
Client	Business Week Magazine
Publisher	McGraw Hill, New York, NY

314

Art Director	Carla Barr
Designer	Carla Barr
Photographer	Sandi Fellman
Editor	Thomas Hoving
Publisher	Hearst Corporation, New York, NY
Publication	Connoisseur Magazine

322

Art Director	Will Hopkins, Ira Friedlander
Photographer	Brownie Harris
Writer	John Diebold
Editor	Rita A. Black
Agency	Will Hopkins Group, New York, NY
Publisher	IBM System Products Division
Publication	SPD Management

323

Art Director	Shari Spier
Designer	Shari Spier
Illustrator	Jeff Jackson
Editor	Stoney McCart
Publisher	Paul Theo, Audace Communications
Publication	IO Magazine
Type	Canadian Composition
Design Firm	Reactor Art & Design, Toronto, Canada

324

Art Director	Faye H. Eng and Anthony T. Yee
Designer	Faye H. Eng and Anthony T. Yee
Writer	Milt Simpson
Editor	Didi Barrett
Client	Museum of American Folk Art
Publisher	Museum of American Folk Art, New York, NY
Publication	The Clarion

Gold Award

Art Director Kit Hinrichs
Designer Kit Hinrichs/Karen Berndt
Photographer Terry Heffernan
Writer Peterson & Dodge
Editor George Cruys
Agency Jonson Pedersen Hinrichs & Shakery, San Francisco, CA
Client Royal Viking Line
Publisher Royal Viking Line

OF FOOD AND DRINK

Some of life's spoil-sports grump, if it's fun, it must be illegal, immoral or fattening.

But there's an exception to that tiresome rule. The exception is fish, glorious, delicious, non-fattening, good-for-you fish. From the delicate pink of poached salmon to the shimmer of rainbow trout to the succulent quiver of a Bluepoint oyster—the creatures that inhabit the sea are one of life's pleasures that are good for the body as well as the spirit.

On Royal Viking Line, the acquisition, delivery, preparation and presentation of fresh fish and shellfish preoccupy the talents and energies of a small, but fiercely dedicated, cadre of food people. It all begins with Bob Koven, Purchasing Agent and self-confessed lover of halibut, shark, and almost anything else that comes equipped with gill or shell. Koven's job is to find, purchase, and arrange delivery of enough fish to feed some of the world's most demanding and discriminating diners—Royal Viking Line passengers. As a small example

Lobster

of the magnitude of Koven's job, "On an average we fly 700 pounds of live lobster every 21 days to each ship." Accomplishing that job finds him on the tele-

phone chasing Australian lobster tails and Hawaiian mahi-mahi, it finds him arbitrating tastes in smoked salmon (the Norwegian officers and crew claim Norway's is best, some European chefs argue for the Scottish variety, the Americans advocate the smoked Pacific delicacy), and it finds him investigating

Fresh Alaska Salmon

possible substitutes for the extravagantly expensive Alaska King and Dungeness crab. (There aren't any acceptable substitutes, he says, at least not on Royal Viking Line.) But Koven, demanding procurer though he is, pales next to the toughest critics of all—the Royal Viking Line chefs. "Each chef must approve each shipment of fresh fish," explains Koven. That approval process can be nerve-wracking for the suppliers. "The delivery meets us at port, and the chef makes his personal inspection and taste tests. If he's not happy, he can reject the whole shipment." What does the chef

look for? "He looks for freshness, for color in the gills, for bright eyes, for firm, non-flabby flesh. He'll pop open a few oysters and taste."

Getting the fish to shipside is no small task. At many ports, local suppliers and distributors bring the fish in. There's salmon,

Swordfish

halibut and rockfish in Alaska; salmon, shrimp, haddock, lobster and smoked fish in Scandinavia; beautiful rainbow trout, just one hour out of the water, in Greece;

delicate crab legs and sea bass in Chile; live lobster, orange ruffy and John Dory in Australia; and Pacific specialties like mahi-mahi, ono-skipjack tuna, and ahi-yellowfin in Hawaii. In other ports, Koven maintains quality control by air freighting everything

Red Snapper

from oysters and top neck clams to salmon, swordfish, and snapper to ships in the Orient and the Mediterranean.

"We give the chefs a long, long list of what's available, and they order from that."

That list varies according to the weather, food fashions, and the creativity of local suppliers. Part of the challenge of Koven's job comes from the dazzling variety Mother Nature herself supplies. We live in a watery

world, with the world's oceans covering more than two-thirds of the planet's surface. Inhabiting those oceans are nearly 25,000 species of fish and shellfish. From the cold, seemingly inhospitable waters of the North Atlantic come herring and cod, haddock and halibut,

John Dory Fish

skate and witing; from the Mediterranean, sardines and anchovies, red mullet, anglerfish, bass, swordfish, and some varieties of tuna; from warmer tropical waters, sweet red snapper, croaker and shrimp.

Serious fish enthusiasts claim almost everything is edible in the sea, and will wax euphoric over the joys of pickled whelks and sea urchins on toast. Though these may never show up on Royal Viking Line menus, the variety is boundless—and best of all, surprisingly, reassuringly, good for you.

What's special nutritionally about fish is that it marries the complete protein of the animal kingdom with the low fats of the vegetable kingdom. What fat there is in fish is the best variety—unsaturated,

Norway Haddock

easily digested, and eagerly used by the body's tissues. The protein is high quality, rich in amino acids, and, except for shellfish, remarkably low in cholesterol.

Legend has long maintained that eating seafood has a salutary effect on one's love life. That belief, as luck would have it, is grounded in some fact. Seafood is rich in the elements—Vitamins

A and D, phosphorus, iron, copper, and iodine—that nutritionists believe contribute to both libido and performance. Little wonder then, that Lord Byron and Casanova were great lovers of both seafood and ladies. Madame Pompadour, no minor light in affairs of the heart, was reported to have cooled up filet of sole a la Pompadour before her liaisons. Claims scientist Dr. Nicholas Vinette, "Those who live almost entirely on shellfish and fish are more ardent in love than all others."

Living entirely on seafood seems like a blessing rather than a deprivation when you travel. There's salmon to enjoy off Sitka's coast, smoked eel at the fjords, and delicious sea bass from the waters near Puerto Montt. For those who love to travel, to eat, and to love, fish is a triple delight.

328

Distinctive Merit

Art Director	Deborah Hardison
Designer	Deborah Hardison
Photographer	Robert Benson
Writer	Robert A. Hamilton
Editor	George Spencer
Agency	13-30 Corporation, Knoxville, TN
Publication	Connecticut's Finest
Senior Art Director	Bett McLean

329

Art Director	Merrill Cason
Designer	Merrill Cason
Photographer	José Azel
Writer	José Azel
Editor	Al Vogl
Publisher	MD Publications, Inc., New York, NY
Publication	MD Magazine
Design Director	Al Foti

330

Art Director	Sharon L. Tooley
Designer	Sharon L. Tooley
Photographer	Frank White
Writer	Therese Griffiths
Editor	Margaret Roberts
Agency	Sharon Tooley Design, Houston, TX
Client	The Methodist Hospital, Houston, Texas

331

Art Director	Cristina Botta & Robert L. Lascaro
Illustrator	Jonathan Milne
Writer	Michael Karol
Editor	Robert Lindstrom
Publisher	U.S. Business Press, New York, NY
Publication	ACPM

332

Art Director	Judy Whitt
Photographer	Ryan Roessler
Editor	Jane Tougas
Publisher	Cahners Publishing Co., Des Plaines, IL
Director Art Department	Tony Pronoitis

333

Art Director	Don Johnson
Designer	Bonnie Berish
Illustrator	David Lesh
Writer	Dana Lee Wood
Editor	Dana Lee Wood
Agency	Johnson & Simpson Graphic Designers, Newark, NJ
Client	Nabisco Brands, Inc.
Publication	nbeye

334

Art Director	William Cadge
Designer	William Cadge
Photographer	Jeff Cadge
Writer	Chuck Boyer
Editor	Chet Hansen
Publisher	IBM
Publication	THINK Magazine
Design Firm	Cadge Productions, Dobbs Ferry, NY

335

Art Director	Judy Whitt
Photographer	Ryan Roessler
Editor	Jane Tougas
Publisher	Cahners Publishing Co., Des Plaines, IL
Director Art Department	Tony Pronoitis

336

Art Director	Burkey Belser
Designer	Burkey Belser
Photographer	Debbie Bell
Editor	Anne Grant
Agency	Greenfield Belser Inc., Washington, DC
Publisher	Trial Magazine

337

Art Director	Kit Hinrichs
Designer	Kit Hinrichs/Karen Berndt
Photographer	Terry Heffernan
Writer	Peterson & Dodge
Editor	George Cruys
Agency	Jonson Pedersen Hinrichs & Shakery, San Francisco, CA
Client	Royal Viking Line
Publisher	Royal Viking Line

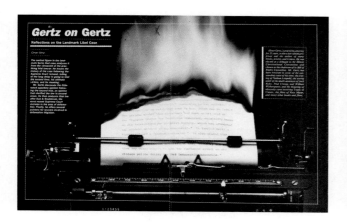

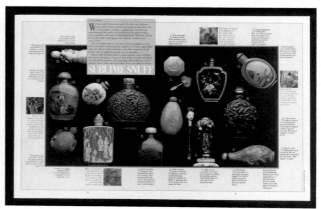

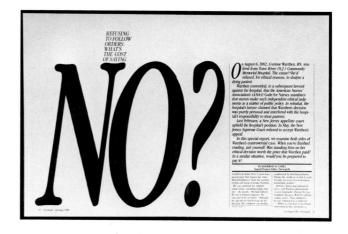

338

Art Director	Edward W. Rosanio
Designer	Edward W. Rosanio
Writer	Katherine W. Carey
Editor	Tony DeCrosta
Publisher	Springhouse Corporation, Springhouse, PA
Publication	NursingLife

Gold Award

Art Director	Kit Hinrichs
Designer	Kit Hinrichs/Lenore Bartz
Photographer	Terry Heffernan
Writer	Delphine Hirasuna
Editor	Delphine Hirasuna
Agency	Jonson Pedersen Hinrichs & Shakery, San Francisco, CA
Client	Potlatch Corporation
Publisher	Potlatch Corporation

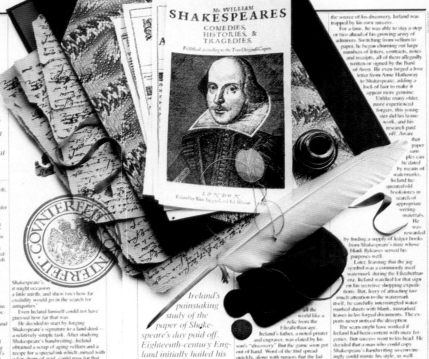

Paper Forgeries

Forgery has threatened the integrity of historical records since ancient times. In fact, it has thrived since humans learned to scratch their thoughts on clay tablets in the bazaars of Mesopotamia over 5,000 years ago. But paper — the very medium that makes modern forgery possible — also presents the would-be forger with a variety of pitfalls.

Ireland's painstaking study of the paper of Shakespeare's day paid off. Eighteenth-century England initially hailed his Shakespearean forgeries as "the find of the ages."

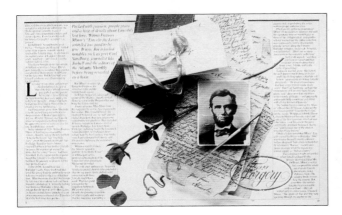

Silver Award

Art Director Merrill Cason
Designer Al Foti
Illustrator Bernard Durin
Writer Elsie Rosner
Editor Al Vogl
Publisher MD Publications, Inc., New York, NY
Publication MD Magazine
Design Director Al Foti

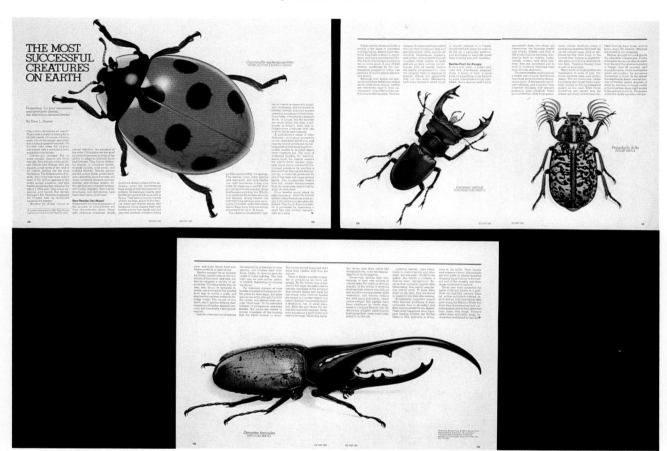

341

Silver Award

Art Director	Kit Hinrichs
Designer	Kit Hinrichs/Karen Berndt
Photographer	Bettmann Archives
Writer	Peterson & Dodge
Editor	George Cruys
Agency	Jonson Pedersen Hinrichs & Shakery, San Francisco, CA
Client	Royal Viking Line
Publisher	Royal Viking Line

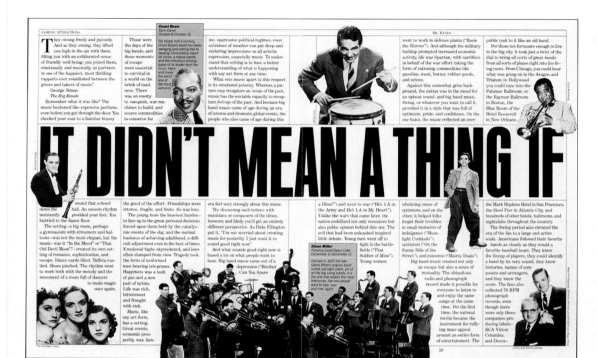

IT DIDN'T MEAN A THING IF

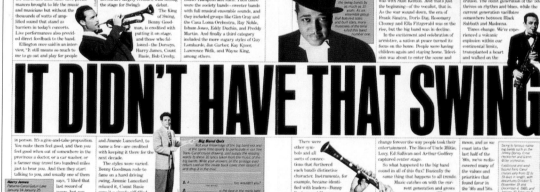

IT DIDN'T HAVE THAT SWING

Distinctive Merit

Art Director	Kit Hinrichs
Designer	Kit Hinrichs/Karen Berndt
Illustrator	Dugald Stermer
Photographer	Harvey Lloyd
Writer	Kathy Glass
Editor	George Cruys
Agency	Jonson Pedersen Hinrichs & Shakery, San Francisco, CA
Client	Royal Viking Line
Publisher	Royal Viking Line

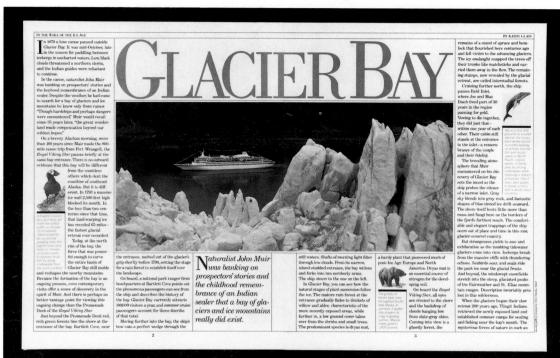

IN THE WAKE OF THE ICE AGE

BY KATHY GLASS

GLACIER BAY

Naturalist John Muir was banking on prospectors' stories and the childhood remembrance of an Indian sealer that a bay of glaciers and ice mountains really did exist.

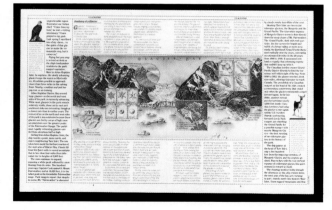

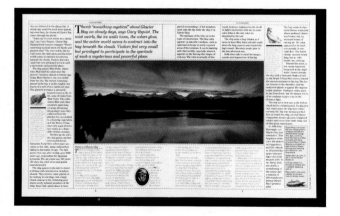

343

Art Director	Deborah Lewis
Photographer	Jayme Odgers; Richie Williamson; Howard Bjornson; Perry Ogden; Bob Ebel; Cosimo; Dennis Manarchy
Writer	Patricia Maye Goldstein
Editor	Patricia Maye Goldstein
Client	Lakewood Publications, Minneapolis, MN
Publisher	James Secord
Publication	Photo/Design (seventh issue), New York

344

Art Director	Sharon L. Tooley
Designer	Sharon L. Tooley
Photographer	Jim Sims
Writer	Susan Fox
Editor	Margaret Roberts
Agency	Sharon Tooley Design, Houston, TX
Client	The Methodist Hospital, Houston, Texas
Publication	The Journal

345

Art Director	Richelle Huff
Designer	Richelle Huff
Photographer	Deidi von Schaewen, Paul Hester
Publisher	Penton Publications
Publication	Progressive Architecture, Stamford, CT

Gold Award

Art Director	Andrew Kner, New York, NY
Designer	Ikko Tanaka
Illustrator	Ikko Tanaka
Writer	Martin Fox
Editor	Charles Helmkin
Client	Print Magazine
Publisher	Howard Cadel
Publication	Print Magazine

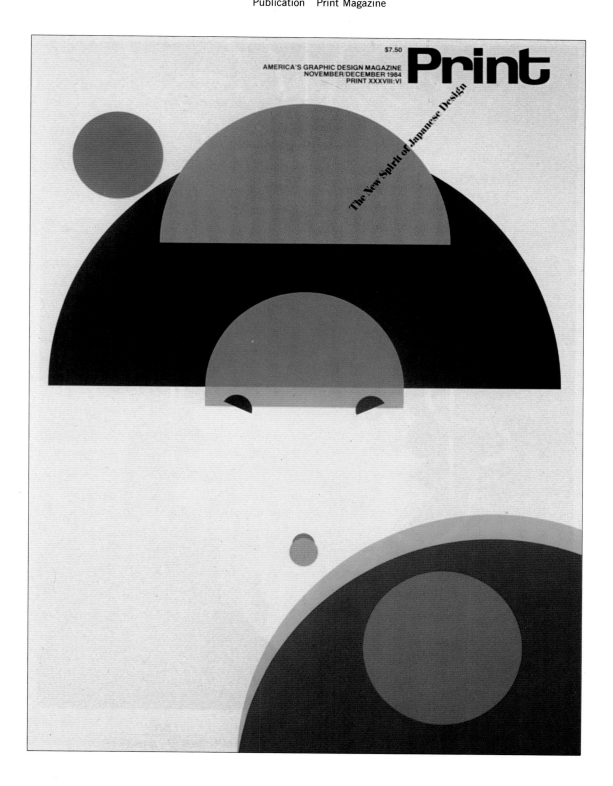

352

Art Director	Everett Halvorsen
Designer	Robert Mansfield
Illustrator	Michael Garland
Writer	Susan Lee
Editor	James W. Michaels
Publication	Forbes Magazine, New York, NY

353

Art Director	Richard Jester
Designer	Nancy Davis
Illustrator	Nancy Davis
Agency	Nancy Davis Design & Illustration, Portland, OR
Publisher	MEDIAmerica

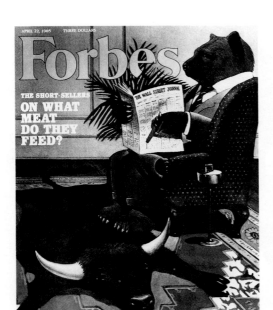

354

Art Director	Cynthia S. Alpert & Robert Grubbs
Designer	Robert Grubbs
Photographer	Michael Burzynski
Editor	Ellen T. Meyer
Agency	Alpert & Alpert, Inc., McLean, VA
Client	Association for Information & Image Management
Publisher	Association for Information & Image Management
Publication	Journal of Information & Image Management

355

Art Director	Bruno Ruegg
Designer	Bruno Ruegg
Photographer	John Alderson
Agency	Sieber & McIntyre, Chicago, IL
Client	Meiji Seika
Publisher	Sieber & McIntyre
Publication	Current Concepts in Infectious Diseases

356

Art Director	Wayne D. Hulse
Designer	Wayne D. Hulse
Photographer	Jim Finlayson
Editor	Barry Tanenbaum
Director	Virginia Murphy-Hamill
Client	Lens Magazine
Publisher	Samuel Fisher
Publication	Hearst Business Publications, Inc., Garden City, NY

357

Art Director	Tim McKeen
Design Director	John Newcomb
Photographer	Stephen E. Munz
Publisher	Medical Economics Co., Oradell, NJ
Publication	RN Magazine, Tim McKeen

358

Art Director	Gordon Mortensen
Designer	Gordon Mortensen
Photographer	R.J. Muna
Editor	Denise Hutson
Agency	Mortensen Design, Palo Alto, CA
Client	Sentry Schlumberger

359

Art Director	Alexander Atkins
Designer	Alexander Atkins
Illustrator	Dave Lesh
Agency	Alexander Atkins Design, Palo Alto, CA
Client	Stanford University Hospital

Art Director	Jack Lefkowitz
Designer	Jack Lefkowitz
Illustrator	Virginia Strnad
Writer	David Ritchey
Editor	David Ritchey
Agency	Jack Lefkowitz, Inc., Leesburg, VA
Client	Industrial Launderer
Publisher	Institute of Industrial Launderers
Publication	Industrial Launderer

Art Director	Wynn Medinger
Designer	Wynne Patterson
Photographer	George Kamper
Editor	Roger Savitt
Agency	Jones Medinger Kindschi Inc, North Salem, NY
Client	IBM Corporation

360

Art Director	Bruno Ruegg
Designer	Bruno Ruegg
Photographer	Christopher Gould
Agency	Sieber & McIntyre, Chicago, IL
Client	Dainabbott
Publisher	Sieber & McIntyre
Publication	Current Concepts in Critical Care

361

Art Director	Mitchell Shannon
Designer	R. A. Ryan
Photographer	Howard Sochurek
Editor	Mitchell Shannon
Publisher	Neil A. Hutton
Publication	MD Magazine, Toronto, Canada
Printer	LGM Graphics, Winnipeg

373

Distinctive Merit

Art Director	Terry R. Koppel
Designer	Terry R. Koppel, April Garston
Editor	David Bruel
Agency	Koppel & Scher, New York, NY
Client	Inabnit Communications
Publisher	Mark Inabnit
Publication	European Travel & Life

EUROPEAN TRAVEL & LIFE

THE MAGAZINE FOR THE SOPHISTICATED AMERICAN TRAVELER

SEPTEMBER/OCTOBER 1985 $4

STAR QUALITY

A Royal Revival of the Monaco Mystique

Princess Stephanie

EUROPE'S "SECRET CITY" · GREAT GARDENS · HOTEL STYLE · AUTUMN IN PARIS

374

Art Director	Mary Shanahan
Photographer	Richard Avedon, Olivero Toscani, Max Vadukal, Alen MacWeeney, Sheila Metzner, Elizabeth Novick, Bonnie Schiffman, Connie Hansen, Ed Sorel and various other artists
Editor	Adam Gopnik
Publication	GQ
Editor-in-Chief	Arthur Cooper

375

Art Director	Deborah Lewis
Designer	Deborah Lewis; Patricia Dunn
Editor	Patricia Maye Goldstein
Client	Lakewood Publications, Minneapolis, MN
Publisher	James Secord
Publication	Photo/Design (seventh issue), New York, NY

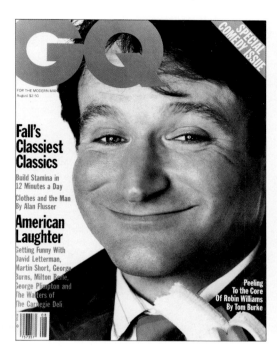

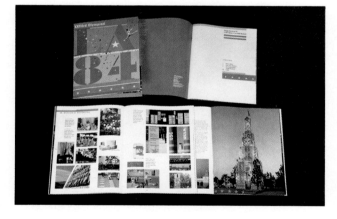

376

Art Director	Deborah Sussman & Paul Prejza
Designer	Gigi McGee, Debra Valencia, Felice Mataré
Photographer	Annette Del Zoppo
Writer	Joseph Giovannini, Eugene Treadwell
Design Firm	Sussman/Prejza & Co., Inc., Santa Monica, CA
Client	Walker Art Center
Publisher	MIT Press

377

Art Director	Rudy Hoglund
Designer	Tom Bentkowski
Illustrator	Richard Hess (Cover)
Editor	Henry Muller
Publisher	Time Incorporated, New York, NY
Publication	Time Magazine

378

Art Director	Marilyn Rose
Designer	Marilyn Rose
Illustrator	various
Photographer	various
Editor	Joseph Gribbins
Agency	Marilyn Rose Design, New York, NY
Publisher	C. S. Lovelace
Publication	Nautical Quarterly
Chairman	Donald C. McGraw, Jr.

379

Art Director	Fred O. Bechlen, Honolulu, HI
Designer	Fred O. Bechlen
Photographer	various
Editor	Richard V. Bryant
Agency	Dentsu Inc.
Client	Minolta Camera Co., Ltd.
Publisher	Katsusaburo Nakamura
Publication	Minolta Mirror, 1985

Gold Award

Art Director	Kit Hinrichs
Designer	Karen Berndt/Kit Hinrichs
Illustrator	various
Photographer	covers only: Tom Tracy, Lee Boltin, Brian Vikander
Writer	various
Editor	George Cruys
Agency	Jonson Pedersen Hinrichs & Shakery, San Francisco, CA
Client	Royal Viking Line
Publisher	Royal Viking Line
Publication	Royal Viking Line

381

Silver Award

Art Director	Ed Benguiat
Designer	Ed Benguiat
Illustrator	Ed Benguiat
Editor	George Sohn
Director	George Sohn
Client	Photo-Lettering, Inc.
Publisher	Photo-Lettering, Inc., New York, NY
Publication	PLINC (Vol. Two, No. One)

Distinctive Merit

Art Director Kit Hinrichs
Designer Kit Hinrichs/Lenore Bartz
Illustrator Hank Osuna/Kinuko Craft (cover)
Photographer Terry Heffernan, Henrik Kam, Tom Tracy
Editor Delphine Hirasuna
Agency Jonson Pedersen Hinrichs & Shakery, San Francisco, CA
Client Potlatch Corporation
Publisher Potlatch Corporation

383

Art Director	Ken Koester, Chuck Johnson
Designer	Ken Koester, Chuck Johnson
Illustrator	Chuck Johnson, Ken Koester
Photographer	Mike Malloy
Writer	Cheryl McCue, David Martin
Creative Director	Bob Dennard
Agency	Dennard Creative, Inc., Dallas, TX
Client	Herring Marathon Group

384

Art Director	Bob Dennard, Glyn Powell
Designer	Glyn Powell
Illustrator	Glyn Powell
Photographer	John Wong, Keith Bardin
Writer	Cheryl McCue
Agency	Dennard Creative, Dallas, TX
Client	Herring Marathon Group

385

Art Director	Bob Dennard, Ken Koester
Designer	Ken Koester
Illustrator	Ken Koester, Bryan Collins
Writer	Cheryl McCue, Ken Koester
Agency	Dennard Creative, Inc., Dallas, TX
Client	Herring Marathon Group

386

Art Director	Massimo Vignelli and Michael Bierut
Designer	Michael Bierut and Lucy A. Cossentino
Photographer	various
Editor	Fern Mallis
Agency	Vignelli Associates, New York, NY
Client	The International Design Center, New York

387

Art Director	Barbara Goss
Designer	Tom Lewis
Editor	Wayne Hopkins
Agency	Tom Lewis, Inc., Del Mar, CA
Production	Linda Roberts
Client	The Signal Companies
Publisher	The Signal Companies
Publication	"Signal World"

388

Art Director	Bob Dennard, Jan Wilson
Designer	Jan Wilson
Illustrator	Jan Wilson, Ken Koester, Glyn Powell, Chuck Johnson
Writer	Cheryl McCue
Agency	Dennard Creative, Inc., Dallas, TX
Client	Herring Marathon Group

Client Micom Systems, Inc.

Agency Belies Communications, Lexington, MA
Client Shawmut Bank

394

Art Director John Van Dyke
Designer John Van Dyke
Photographer Steve Welsh, Steve Firebaugh
Agency Van Dyke Company, Seattle, WA

395

Art Director John Van Dyke
Designer John Van Dyke
Photographer David Watanabe
Agency Van Dyke Company, Seattle, WA

426

Art Director Ron Jefferies
Designer C. Claudia Jefferies
Illustrator Steve Allen
Writer Frederick Fajardo
Agency The Jefferies Association, Los
Angeles, CA
Client Fluor Corporation

427

Art Director Ellen Ziegler
Designer Heidi-Marie Blackwell
Photographer Walter Hodges
Writer Tom McCarthy
Editor Stewart Parker
Design Firm Ellen Ziegler/Designers, Seattle,
WA
Client Immunex Corporation

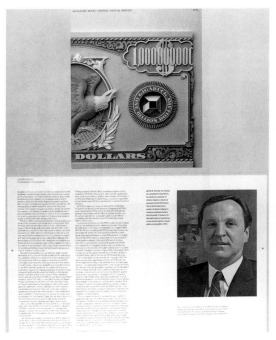

428

Art Director John Cleveland
Designer James Marrin
Photographer Steven Rothfeld
Writer Lori Berg/Diana Krause
Agency John Cleveland, Inc., Los Angeles,
CA
Client Nelson Research

429

Art Director Laurie Blessen/Steven Jacobs
Designer Laurie Blessen
Photographer Becker-Bishop
Writer Ann Fenimore
Agency Steven Jacobs, Fulton & Green,
Palo Alto, CA
Client David Powell Inc.

Art Director	Carol Fulton, Steven Jacobs
Designer	Clay Williams
Illustrator	Pat Allen, Allen Reingold, Marvin Mattelson, Dennis Luzak, Kirk Caldwell, Dugald Stermer, Bruce Wolfe
Photographer	Becker-Bishop
Agency	Steven Jacobs, Fulton & Green, Palo Alto, CA
Client	Advanced Micro Devices

Art Director	Leslie Segal/Beverly Schrager
Designer	Beverly Schrager
Photographer	Jeff Smith
Agency	Corporate Annual Reports, Inc., New York, NY
Client	Marsh & McLennan Companies, Inc.
Publication	1984 annual report

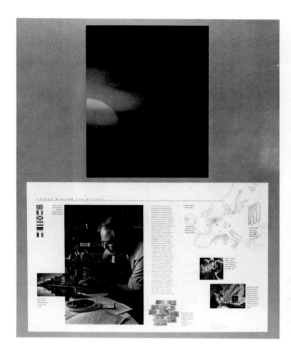

Art Director	Steve Gibbs
Designer	Steve Gibbs
Photographer	Greg Booth
Writer	Mark Perkins
Agency	Pharr Cox Communications, Dallas, TX
Client	Sunbelt Savings Association of Texas

Gold Award

Art Director	Kit Hinrichs
Designer	Kit Hinrichs/Francesca Bator
Illustrator	Doug Stevenson, Antonio Lopez, Gary Overacre, Danny Pelavin, John Craig, Will Nelson, Ward Schumaker, Doug Smith
Photographer	Terry Heffernan, Charly Franklin, John Blaustein
Agency	Jonson Pedersen Hinrichs & Shakery, San Francisco, CA
Client	Simpson Paper Co.

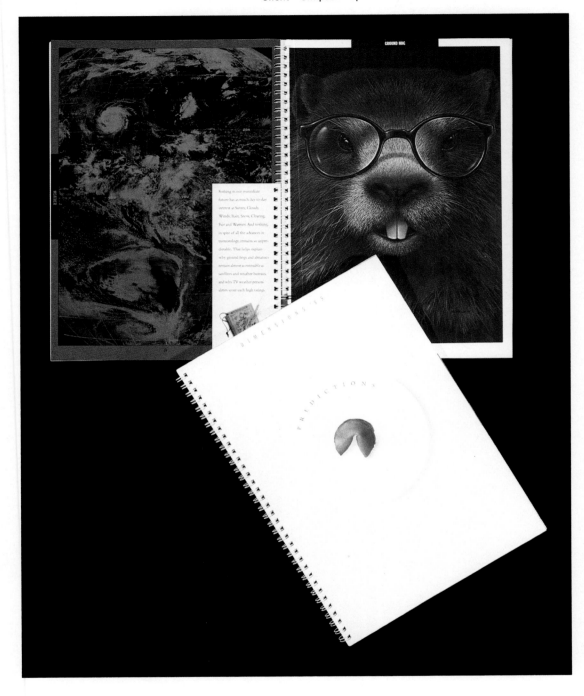

434

Gold Award

Art Director	B. Martin Pedersen/Adrian Pulfer
Designer	B. Martin Pedersen/Adrian Pulfer
Illustrator	John Batchelor
Writer	David Konigsberg
Agency	Jonson Pedersen Hinrichs & Shakery, Inc., New York, NY
Client	Hopper Papers—Sally Nathans

435

Silver Award

Art Director Jennifer Morla
Designer Jennifer Morla
Photographer Elaine Faris Keenan
Agency Morla Design, San Francisco, CA
Client Common Man's Apparel

Distinctive Merit

Art Director	Don Sibley, Steve Gibbs
Designer	Don Sibley, Steve Gibbs
Illustrator	Kelly Stribling
Photographer	Thom Jackson, John Parrish
Writer	Laura Rivers
Design Firm	Sibley/Peteet Design, Inc., Dallas, TX
Client	Neiman-Marcus

Distinctive Merit

Art Director Paul Black, Don Sibley
Designer Paul Black
Illustrator Don Sibley, Paul Black
Writer Janet Howe
Design Firm Sibley/Peteet Design, Inc., Dallas, TX
Client West End MarketPlace Developers

Distinctive Merit

Art Director Ron Sullivan
Designer Willie Baronet
Illustrator Ron Sullivan
Photographer Geoff Kern
Writer Mark Perkins
Agency Sullivan Perkins, Dallas, TX
Client Mantz & Associates/The Selwyn
School

439

Art Director	McRay Magleby
Designer	McRay Magleby
Illustrator	McRay Magleby
Writer	Norman A. Darais
Editor	Norman A. Darais
Agency	BYU Graphics, Provo, UT
Client	University Publications, BYU
Type	Jonathan Skousen
Research Assistant	Clifford A. Miles

440

Art Director	Jack Summerford
Designer	Jack Summerford
Photographer	John Katz
Writer	Jack Summerford
Design Firm	Summerford Design, Inc., Dallas, TX
Client	Summerford Design, Inc.

441

Art Director	Young & Laramore
Designer	Jeff Laramore
Photographer	Dick Spahr Photography
Writer	John Young
Agency	Young & Laramore, Indianapolis, IN
Client	Indiana Bell

442

Art Director	B. Martin Pedersen/Adrian Pulfer
Designer	B. Martin Pedersen/Adrian Pulfer
Agency	Jonson Pedersen Hinrichs & Shakery, Inc., New York, NY
Client	Hopper Papers—Sally Nathans

443

Art Director	Lowell Williams
Designer	Lowell Williams/Bill Carson
Photographer	Ron Scott
Writer	Lowell Williams
Agency	Lowell Williams Design, Inc., Houston, TX
Client	Lowell Williams Design, Inc.

444

Art Director	John C. Jay
Designer	John C. Jay, Ken Matsubara
Illustrator	Tim Girvin—logo
Photographer	Sheila Metzner, Francois Halard
Writer	Brian Leitch, Beverly Rydell
Creative Director	John C. Jay
Agency	Bloomingdale's, New York, NY
Client	Bloomingdale's

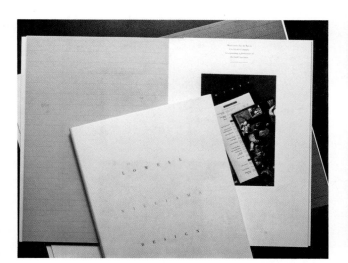

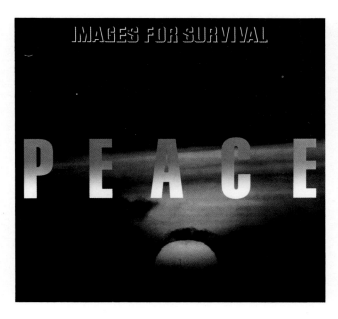

445

Art Director	Charles Michael Helmken
Designer	Ikko Tanaka
Editor	Charles Michael Helmken
Publisher	The Shoshin Society, Washington, DC
Printer	Dai-Nippon Printing Company, Tokyo, Japan

446

Art Director	Cheryl Heller
Designer	Cheryl Heller
Photographer	Helmut Newton
Writer	Peter Caroline
Agency	Design Group, HBM/Creamer, Boston, MA
Client	S. D. Warren Paper Co.

447

Art Director Craig Mierop/Greg Simpson
Designer Greg Simpson
Photographer Tom McCavera
Agency Mierop Design, Inc., New York, NY
Client J. P. Stevens & Co., Inc.

448

Art Director Michael McGinn
Designer James Sebastian, Michael McGinn
 & Nancy Hoefig
Photographer Neil Selkirk
Writer Francis Piderit
Agency Designframe Incorporated, New
 York, NY
Client Queens Group

449

Art Director Steven Sessions
Designer Steven Sessions
Illustrator Barry Gremillion
Photographer Jim Sims
Writer Greg Bolton
Agency Steven Sessions, Inc., Houston,
 TX
Client Printing Resources, Inc.

450

Art Director Arnold Goodwin
Designer Arnold Goodwin/Chris Cacci
Illustrator Bobbye Cochran
Writer Judy Silverman
Agency Arnold Goodwin Graphic
 Communications, Chicago, IL
Client Williams Gerard Productions, Inc.

451

Art Director	Toshiaki Ide
Designer	Toshiaki Ide/Richard Haymes
Photographer	Tohru Nakamura
Writer	Gloria Mintz
Agency	Wells, Rich, Greene Inc., New York, NY
Client	Warner's

452

Art Director	David Edelstein/Nancy Edelstein/ Lanny French
Designer	David Edelstein/Nancy Edelstein/ Lanny French/Norman Hathaway & Tom Bissett
Illustrator	Norman Hathaway
Photographer	Ben Kerns
Writer	Jeremy Wolff
Agency	Edelstein Associates Advertising Inc., Seattle, WA
Client	Generra Sportswear

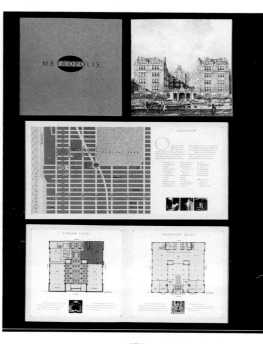

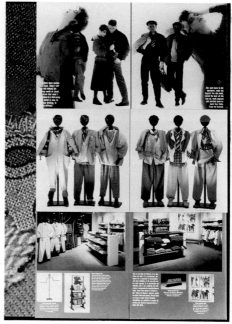

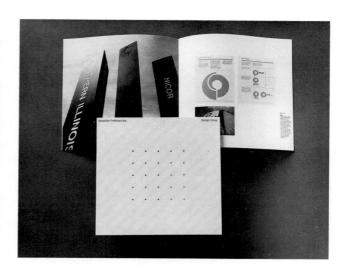

453

Art Director	Richard Foy
Designer	David Shelton
Illustrator	Stan Doctor
Photographer	Doug Dubler
Writer	Richard Foy
Agency	Communication Arts Incorporated, Boulder, CO
Client	Metropolis Studios Associates
Printer	Communigraphics

454

Art Director	Peter Grube
Designer	Peter Grube
Photographer	Ed Nagel
Writer	Bill Wilson
Agency	Handelan-Pedersen, Chicago, IL
Client	Handelan-Pedersen

461

Art Director	Bruce Kreps
Designer	Bruce Kreps, Julie Davis
Illustrator	Bruce Kreps
Photographer	Ben Young
Writer	Fred McTaggert, Bruce Kreps, Julie Davis
Agency	Traver and Associates, Inc., Battle Creek, MI
Client	Traver and Associates, Inc.

462

Art Director	Beau Gardner/Tom Guerrieri
Designer	Beau Gardner/Tom Guerrieri
Photographer	Jim Barber
Writer	Bernard Abrams
Agency	Beau Gardner Associates, New York, NY
Client	Kollberg Johnson

455

Art Director Tibor Kalman
Designer Stephen Doyle, Alexander Max
 Isley
Writer Danny Abelson
Agency M&Co., New York, NY
Client Aaron Green Companies/Alvin
 Preiss, Inc.

456

Art Director Richard Foy
Designer Susan Kinzig
Illustrator Carlos Diniz
Writer Richard Foy/Brum & Anderson
Agency Communication Arts Incorporated,
 Boulder, CO
Client Siena Company
Printer Frederic Printing

463

Art Director Dennis Russo
Designer Ann O'Brien/Dennis Russo
Photographer Jack McConnell
Writer Ellie McDougall
Agency Wondriska Associates Inc.,
 Farmington, CT
Client Connecticut Art Directors Club
Publisher Allied Printing Services
Type Eastern Typesetting Company

464

Art Director Jim Lienhart
Designer Julia Dunlop
Photographer Von
Design Firm James Lienhart Design, Chicago,
 IL
Client Regensteiner Printing Group

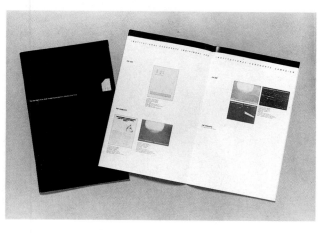

465

Art Director Jay Loucks/Loucks Atelier, Inc.,
 Houston, TX
Designer Paul Huber/Tommy Oddo
Photographer Joe Baraban
Writer Mark Edwards/Gary White
Agency Craig, Lamm, Hensley & Alderman
 Advertising
Client Adams & Porter Associates, Inc.

466

Art Director Kenneth G. Hess/Graphis, Inc.
Designer Dave Nanni
Illustrator Dale Hess
Photographer Alan Birnbach
Writer Kenneth G. Hess, Jennifer
 Woodhull
Agency Graphis, Inc., Boulder, CO
Production Michael Weston
Client American Residential Properties,
 Inc.

467

Art Director	Brad Copeland
Designer	Brad Copeland
Photographer	Jonathan Hillyer
Writer	George Hirthler
Agency	Cooper/Copeland, Inc., Atlanta, GA
Client	Charleston Carpets

468

Art Director	Tom Roth
Designer	Various
Writer	Vinny Urbanowski, Steve Trygg
Agency	Anderson & Lembke, Stamford, CT
Client	Pastore DePamphilis Rampone
Publisher	Pastore DePamphilis Rampone
Printer	Van Dyke
Paper	Mohawk

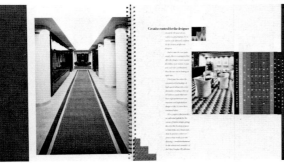

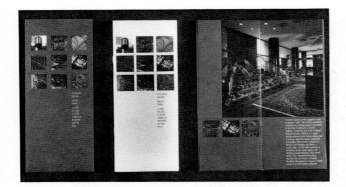

469

Art Director	Adrienne Allen
Designer	Adrienne Allen
Artist	Laura Downing
Photographer	Albert Porter
Writer	Adrienne Allen
Agency	Adrienne Allen & Associates, Dallas, TX
Client	Woodbine Development Corporation

470

Art Director	Tom Gilday
Designer	Tom Gilday, Bob Brown
Illustrator	Bob Brown, Rick Turner, Andy Kesselem
Writer	Tom Nalesnik
Agency	Griswold, Inc., Cleveland, OH
Production	George Kestranek
Client	BF Goodrich/Aerospace Division

471

Art Director	Jennie Pugh
Designer	Ken Pugh
Illustrator	Ken Pugh
Writer	Ken Pugh
Agency	Pugh and Company, Dallas, TX
Client	Aguirre-Hastings Architects
Printer	Yaquinto Printing

472

Art Director	Terry L. Watson, Portage, MI
Designer	Terry L. Watson
Photographer	Jim Powell
Writer	Harry Randall
Client	The Selmer Company

473

Art Director	Sharon L. Tooley
Designer	Sharon L. Tooley
Photographer	Frank White
Writer	Paule Sheya Hewlett
Agency	Sharon Tooley Design, Houston, TX
Client	Index, The Design Group, Laventhol & Horwath

474

Art Director	Christi Daniel
Designer	Christi Daniel
Photographer	Geof Kern
Writer	Kathy Browne
Agency	Oldfield Davis, Inc., Dallas, TX
Client	Binkley-Richardson, Inc.
Printer	Brodnax

475

Art Director	Ivan Chermayeff/Joe Guertin
Designer	Ivan Chermayeff/Joe Guertin
Photographer	Chris Maynard & others
Agency	Chermayeff & Geismar Associates, New York, NY
Client	Scripps Howard

476

Art Director	Gordon Fisher
Designer	Siran Kaprielian
Illustrator	Siran Kaprielian
Writer	Siran Kaprielian
Agency	Wiliam Eisner Associates, New York, NY
Client	Neenah Paper
Publisher	Neenah Paper

477

Art Director	Walter J. Ender
Designer	Walter J. Ender
Photographer	Charles Thatcher, Mike Newman, Scott Nowling
Writer	Phyllis Guest
Agency	Ender Associates Inc., Dallas, TX
Client	Vantage Companies

478

Art Director	Antony Milner/Mark Anderson
Designer	Earl Gee
Photographer	Henrik Kam/Tom Tracy
Writer	Louise Lewis
Agency	Mark Anderson Design, Palo Alto, CA
Client	Pacific Gas and Electric Company
Printer	James H. Barry Company

479

Art Director	Bennett Robinson
Designer	Bennett Robinson
Writer	Lawrence Locke
Agency	Corporate Graphics Inc., New York, NY
Client	Mead Paper Corporation
Printer	Gardner Fulmer

480

Art Director	Elaine Zeitsoff
Designer	Barbara Shapokas
Photographer	NBC Staff Photographers
Writer	Steve Jaffe
Agency	NBC In-house, New York, NY
Client	NBC Sales Marketing Department

481

Art Director	Ginger Krantz
Designer	Ginger Krantz
Illustrator	Andrzej Olejniczak
Photographer	Bill Miller
Writer	Patricia W. Rich
Agency	J. P. Lohman Organization, Inc., New York, NY
Client	Cross & Brown Company
Printer	The Hennegan Company
Type	Samuel Bolhack, Inc.

482

Art Director	Design Source
Designer	Richard Kerr, Les Holloway, Nita Wallace
Photographer	Steven Evans Photography, Ronald Baxter Smith
Agency	Society of Graphic Designers of Canada, Toronto, Canada
Client	Society of Graphic Designers of Canada
Publisher	Society of Graphic Designers of Canada, Toronto, Canada
Publication	The Best of the 80s
Coordinator	Tiit Telmet

483

Art Director	William Wondriska
Designer	David Banks/Laura Smith
Illustrator	Cover: William Wondriska
Photographer	Various
Writer	Steven Ledbetter
Editor	John Marksbury
Director	Caroline Smedvig
Agency	Wondriska Associates, Farmington, CT
Client	Boston Pops/The Signal Companies
Publisher	The Boston Pops
Printer	Allied Printing Service

484

Art Director	Kevin B. Kuester
Designer	Kevin B. Kuester
Photographer	Greg Booth
Agency	Madsen and Kuester, Inc., Minneapolis, MN
Client	Litho Specialties, Inc.

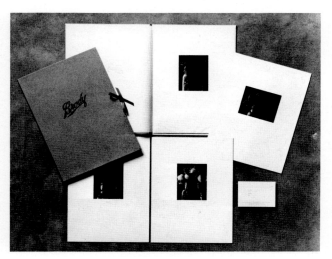

485

Art Director	Jack Odette
Designer	Mike Focar
Agency	Citibank Communication Design, New York, NY
Client	Sheridan Steinberg, Citicorp/ Citibank

486

Art Director	Gerald O'Hara
Photographer	Bob Brody
Client	Bob Brody Photography Inc., New York, NY

487

Art Director	Don Crum
Designer	Mo Martin
Photographer	Phil Hollenbeck
Agency	Don Crum and Co., Dallas, TX
Client	Dallas Society of Visual Communications
Printer	Riverside Press
Separations	Sanford Litho

488

Art Director	Steff Geissbuhler
Designer	Steff Geissbuhler/Susan Schunick
Photographer	Alan Shortall
Writer	Rose DeNeve
Agency	Chermayeff & Geismar Associates, New York, NY
Client	Richard Kerans, Crane & Co

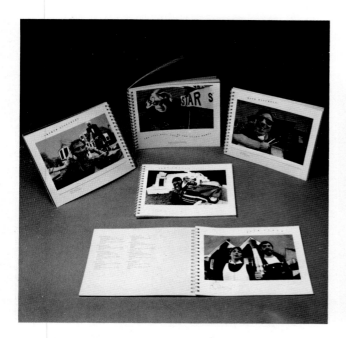

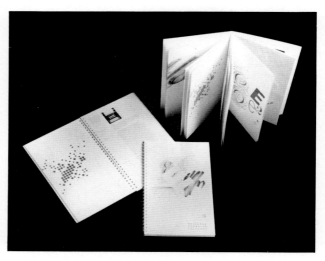

489

Art Director	Don Trousdell
Designer	Don Trousdell, Atlanta, GA
Illustrator	Nancy Hoefig, Christy Mull, BB Sams
Writer	Rich Maender
Client	Kimberly Clark

490

Art Director	Bill Gardner
Designer	Bill Gardner
Writer	Bill Gardner
Agency	Gardner's Graphic Hands, Wichita, KS

491

Art Director	Rod Richmond
Designer	Rod Richmond
Writer	Leslie Simons
Agency	The Davis Group, Seattle, WA
Client	Seafirst Bank

492

Art Director	Kurt Meinecke
Designer	Kurt Meinecke
Illustrator	Bobbye Cochran and Associates
Photographer	various
Writer	Donald Manelli & Associates
Agency	Group/Chicago, Chicago, IL
Client	Dearborn Land Company

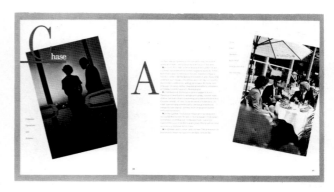

493

Art Director	Michael Martorelli
Designer	Kurt Meinecke
Photographer	Jeff Schewe
Agency	Group/Chicago, Chicago, IL
Client	Woolf-Reitman Company

494

Art Director	Robert Meyer/Jean Page
Designer	Jean Page
Photographer	Ted Kawalerski
Writer	Rhonda Kay Hill
Agency	Robert Meyer Design, Inc., Stamford, CT
Client	Chase Manhattan Bank, N.A.
Printer	Case-Hoyt Corporation

495

Art Director	George Halvorson
Photographer	Marvy Photography, George Hall Photography
Writer	Richard Briner
Agency	George Halvorson Advertising, Minneapolis, MN
Client	Markhurd Corporation

496

Art Director	Kurt Meinecke
Designer	Barbara Lynk
Illustrator	Barbara Lynk
Writer	Donald Manelli & Associates
Agency	Group/Chicago, Chicago, IL
Client	Blue Cross Blue Shield Association

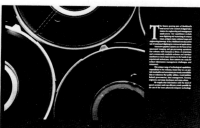

497

Art Director	Jewell Homad/Robert Robinson
Designer	Jewell Homad
Illustrator	Jewell Homad
Writer	Diane Hoover
Agency	Los Angeles Times In-House, Los Angeles, CA
Client	Los Angeles Times

498

Art Director	Randall S. Smith
Designer	Randall S. Smith
Illustrator	Larry G. Clarkson; Randall S. Smith
Photographer	Susan Makoff, Mike Schoenfeld, Scott Tanner
Writer	Elizabeth Hallstrom
Agency	Smith & Clarkson, Salt Lake City, UT
Client	Quality Press
Printer	Quality Press

503

Art Director	Rex Peteet
Designer	Rex Peteet, Paul Black
Illustrator	Paul Black, Rex Peteet
Photographer	Gary McCoy
Writer	Paul Black, Rex Peteet
Agency	Sibley/Peteet Design, Inc., Dallas, TX
Client	Dallas Museum of Art

504

Art Director	Cathy Seay
Designer	Cathy Seay
Photographer	Max Hirshfield, Freddie Lieberman
Writer	Alice Harding
Agency	Williams Whittle Associates, Inc., Alexandria, VA
Client	Savage/Fogarty Companies, Inc.

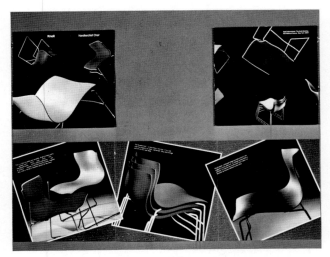

505

Art Director	Harold Matossian & Takaaki Matsumoto
Designer	Takaaki Matsumoto
Photographer	Mario Carrieri
Agency	Knoll Graphics, New York, NY
Client	Knoll International

506

Art Director	Harold Matossian & Takaaki Matsumoto
Designer	Carrie Berman & Takaaki Matsumoto
Photographer	Mikio Sekita
Agency	Knoll Graphics, New York, NY
Client	Knoll International

507

Art Director James Stanton
Designer James Stanton
Illustrator various
Photographer various
Editor Jan Van Meter
Agency Hill and Knowlton, Inc., New York, NY
Client Hill and Knowlton, Inc.
Printer Crafton Graphic Company, Inc.

508

Art Director Paul Meehan
Designer Paul Meehan
Photographer Peter Jones
Writer John Keenum
Agency Sheaff Design Inc., Needham Hts., MA
Client Boston Symphony Orchestra
Printer W. E. Andrews

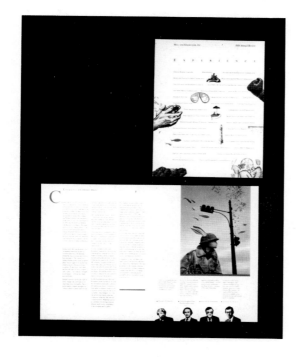

509

Art Director Dan Marcolina
Designer Dan Marcolina
Photographer Cover: Seymour Mednick Inside: Jerome Lukowicz
Editor Ruth Henkels
Agency Design Resource, Philadelphia, PA
Client Cigna
Publication Cigna Capabilities Brochure
Project Director Bev Widas

510

Art Director Wendy Hilgert
Designer Wendy Hilgert
Illustrator Wendy Hilgert
Writer Gail Schoenbrunn
Agency Ingalls, Quinn & Johnson Design Group, Boston, MA
Client John Hancock Mutual Life Insurance Company
Publisher United Litho

511

Art Director	Don Sparkman
Designer	Don Sparkman, Sarah Clarke Hollander, Linda Rolla
Illustrator	various
Photographer	Bob Grove
Agency	Sparkman & Bartholomew Associates, Washington, DC
Client	Sparkman & Bartholomew Associates

512

Art Director	Robert L. Willis
Designer	Robert L. Willis
Photographer	Wilbur Montgomery
Writer	Rita Hupp
Agency	Design Associates, Indianapolis, IN
Client	Frank E. Irish, Inc.

513

Art Director	Ernie Perich
Designer	Janine Thielk, Wayne Pederson
Agency	Group 243 Incorporated, Ann Arbor, MI
Client	Domino's Pizza, Inc.

514

Art Director	Bryan Nimeth
Designer	Bryan Nimeth
Illustrator	Bryan Nimeth, Bob Brown, Rick Turner
Photographer	Iann-Hutchins
Writer	Bill Wendling, Mark Doyle
Agency	Griswold, Inc., Cleveland, OH
Client	Cleveland Growth Association

515

Art Director	Lowell Williams
Designer	Lowell Williams, Bill Carson
Illustrator	Lana Rigsby, Andy Dearwater
Photographer	Ron Scott, Arthur Meyerson, Fred Maroon
Writer	Lee Herrick
Agency	Lowell Williams Design, Inc., Houston, TX
Client	Cadillac Fairview

516

Art Director	Linda L. Tom
Designer	Linda L. Tom, IBM Endicott Design Center; Michael Orr, Rachel Leviton, Michael Orr & Associates, Inc.
Illustrator	Jeffrey Terreson
Editor	Steve Quanrud
Agency	IBM Design Center, Endicott, NY
Client	IBM Endicott Communications
Printer	Flower City Printing, Inc.

517

Art Director	David B. Williamson
Designer	Lorry Kennedy
Photographer	Steven Rothfeld
Agency	Williamson + Associates, Los Angeles, CA
Client	Yamaha Electronics

518

Art Director	John Athorn
Designer	John Athorn
Photographer	Johan Westin
Writer	Vincent Urbanowski
Agency	Anderson & Lembke, Inc., Stamford, CT
Client	FFV GF Automotive

519

Art Director	Robert Miles Runyan
Designer	Douglas Joseph
Photographer	various
Agency	Robert Miles Runyan & Associates, Playa del Rey, CA
Client	Maguire Thomas Partners

520

Art Director	Leslie Smolan
Designer	Leslie Smolan, Alyssa Adkins
Photographer	various
Writer	John Ott, Rita Jacobs
Agency	Carbone Smolan Associates, New York, NY
Client	Merrill Lynch Mergers & Acquisitions

521

Art Director	Sharon Durden Moody
Designer	Sharon Durden Moody
Client	NCSU School of Design
Type	Ann Seymour, Victoria Chi, Sharon Durden Moody

522

Art Director	Jayne Burmaster
Designer	Jayne Burmaster
Illustrator	Karl Millen
Photographer	Michael Myers
Writer	Charleen Nesbitt
Agency	The Gunlocke Company, Wayland, NY
Client	The Gunlocke Company
Printer	G. M. DuBois Corporation

523

Art Director	Jamie Feldman, Cleveland, OH
Designer	Jamie Feldman
Illustrator	Fred Schrier
Writer	Sandy Pianalto
Client	Federal Reserve Bank of Cleveland

524

Art Director	Kimberly Baer
Photographer	Jeff Corwin
Writer	Jack Benke & Associates
Studio	Kimberly Baer Design, Venice, CA
Client	Planvest Development Partners

525

Art Director	James Cross
Designer	Susan Garland, James Cross
Illustrator	Susan Garland
Photographer	Russ Widstrand, Frank Charron, James Cross
Writer	Maxwell Arnold
Agency	Cross Associates, Los Angeles, CA
Client	Simpson Paper Company

526

Art Director	Michael Gunselman
Designer	Michael Gunselman
Photographer	Winterthur Museum
Writer	Michea Corridan
Agency	Michael Gunselman Inc., Wilmington, DE
Client	Winterthur Museum & Gardens
Printer	Pearle Pressman Liberty

527

Art Director Mark Geer, Richard Kilmer
Designer Richard Kilmer, Mark Geer
Photographer Sims/Boynton Photography
Writer Linda Bradford
Design Firm Kilmer/Geer Design, Houston, TX
Client Grace School
Printer Grover Printing Company

528

Art Director Paula Savage, Julia Pepper
Designer Julia Pepper
Illustrator Julia Pepper, Mark Moore
Writer Bill Large
Agency Savage Design Group, Inc.,
 Houston, TX
Client Houston International Hotels

529

Art Director Arthur Eisenberg
Designer Mark Drury
Illustrator Eisenberg Inc.
Writer Susan Rogers
Agency Eisenberg Inc., Dallas, TX
Client Eisenberg Inc.

530

Art Director Petter Thoen
Designer Petter Thoen
Illustrator Petter Thoen
Photographer Robin Robin
Writer Jim Johnston
Agency Johnston Thoen & Lindh, Los
 Angeles, CA
Client Johnston Thoen & Lindh

531

Art Director Dennis Merritt
Illustrator Elizabeth Cotton
Writer Robin Reynolds
Creative Director Charlie Thomas
Agency WFC Advertising, Phoenix, AZ
Client Mark Evers
Production Manager Jan Katayama

532

Designer Leslie Batchelder
Photographer Robert Llewellyn, Portfolio Center
 Studio
Writer Ron Seichrist
Creative Director Ron Seichrist
Agency Gordon Bailey & Assoc., Stone
 Mtn., GA
Client Iceland Seafood Corp.

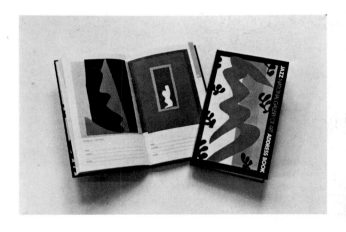

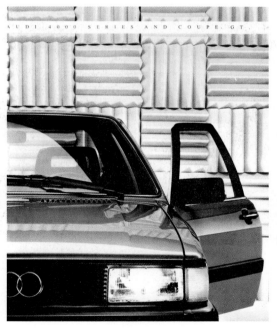

533

Art Director Marilyn Rose
Designer Marilyn Rose
Artist Henri Matisse
Editor Lisa MacDonald
Agency Marilyn Rose Design, New York,
 NY
Client The National Gallery of Art
Publisher Galison Books

534

Art Director Barry Shepard, Steve Ditko
Designer Barry Shepard
Illustrator Michael McDevitt
Photographer Rick Gayle, Rick Rusing, Tom
 Lazaravich
Writer Peterson & Dodge
Agency SHR Communications Planning &
 Design, Scottsdale, AZ
Client Audi of America, Inc.
Printer Great Lakes Press
Production Manager Roger Barger

535

Art Director	Glenn Peltz, Jim Wise
Designer	Glenn Peltz
Photographer	Richard Hoflich
Writer	Leslie Colvin
Creative Director	Jim Wise
Agency	The Eye/Burton-Campbell, Atlanta, GA
Client	Technicon Data Systems

536

Art Director	Simon Bowden
Designer	Simon Bowden
Photographer	Pete Turner, Eric Meola, David Kennerly, Sarah Moon, Neil Leifer, NASA
Writer	Marty Cooke
Agency	Scali, McCabe, Sloves, New York, NY
Client	Nikon

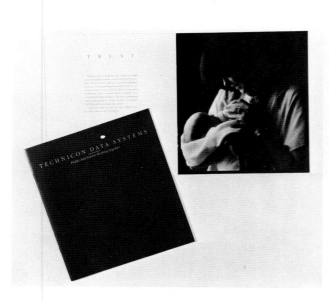

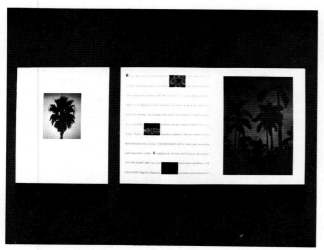

537

Art Director	Chris Hill
Designer	Chris Hill, Jeffrey Mckay
Photographer	various
Writer	Mary Langridge
Agency	Hill/A Marketing Design Group, Houston, TX
Client	Hipp/Holland Development

538

Art Director	Robert L. Willis
Designer	Robert L. Willis
Photographer	Tom Casalini
Writer	James C. Keenan
Agency	Design Associates/Indianapolis, IN
Client	Kauffman Engineering, Inc.

539

Art Director	Kathryn Wooley
Designer	Kathryn Wooley
Writer	Paul Schofield & Company
Agency	Magratten Wooley, Inc., Newport, RI
Client	The Bank of Bermuda Ltd.
Printer	Knowles Screen Printing Co., Inc., The Island Press Ltd., Recording & Statistical Corporation
Production	Linda Cangelosi

540

Art Director	Michael Mabry
Designer	Michael Mabry, Peter Soe Jr.
Illustrator	John Collier
Writer	Guy Bommarito
Editor	Sherry Smith
Agency	Sherry Matthews Advertising, Austin, TX
Client	Parklane Development Company

541

Art Director	Gene Rosner
Designer	Gene Rosner
Photographer	Ron Seymour
Writer	Alan Brown
Agency	Brown, Rosner & Rubin, Chicago, IL
Client	Jewish Federation of Metropolitan Chicago
Project Coordinator	Jill Weinberg

542

Art Director	Marilyn Rose
Designer	Marilyn Rose
Illustrator	Unknown 19th century artist
Editor	Lisa MacDonald
Agency	Marilyn Rose Design, New York, NY
Client	The National Gallery of Art
Publisher	Gerald Galison, Galison Books

543

Art Director	Barry Shepard, Steve Ditko
Designer	Barry Shepard
Illustrator	Rick Kirkman
Photographer	Dennis Grey, Rick Gayle, Rick Rusing
Writer	Peterson & Dodge
Agency	SHR Communications Planning & Design, Scottsdale, AZ
Client	Audi of America, Inc.
Printer	Great Lakes Press
Project Manager	Roger Barger

544

Art Director	John Gaudreau, Benjamin Roos
Designer	Benjamin Roos
Illustrator	Karmen Effenberger
Writer	Booms
Agency	Primidea, Denver, CO
Client	Homart Development Co.

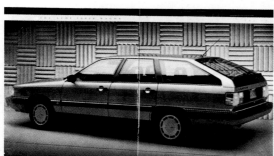

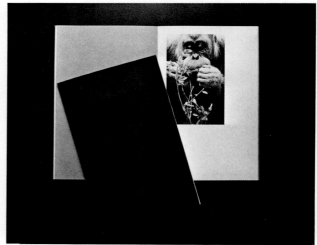

545

Art Director	Lowell Williams
Designer	Lowell Williams, Bill Carson, Lana Rigsby
Illustrator	Lana Rigsby
Photographer	Ron Scott, Bob Harr
Writer	Lee Herrick
Agency	Lowell Williams Design, Inc., Houston, TX
Client	Cadillac Fairview

546

Art Director	Lowell Williams
Designer	Lowell Williams, Bill Carson, Lana Rigsby
Photographer	Michael Bowerman
Writer	Steve Barnhill
Agency	Lowell Williams Design, Inc., Houston, TX
Client	Zoological Society of Houston

547

Art Director	James Cross
Designer	Susan Garland, James Cross, Ann Burdick
Writer	Maxwell Arnold
Agency	Cross Associates, Los Angeles, CA
Client	Simpson Paper Company

548

Art Director	Lowell Williams
Designer	Lowell Williams, Bill Carson
Illustrator	Andy Dearwater
Photographer	Ron Scott, Bob Harr
Writer	JoAnn Stone
Agency	Lowell Williams Design, Inc., Houston, TX
Client	Cadillac Fairview

549

Art Director	Robert Cipriani
Illustrator	Fred Otnes
Photographer	Bruce Peterson
Writer	Barbara Nelson/Peter Stavropulos
Agency	Cipriani Advertising, Inc., Boston, MA
Client	Honeywell Information Systems
Printer	Acme Printing

550

Art Director	Woody Pirtle/Alan Colvin
Designer	Alan Colvin
Illustrator	Alan Colvin
Photographer	Arthur Meyerson
Writer	T.G.I. Friday's Inc.
Agency	Pirtle Design, Dallas, TX
Client	T.G.I. Friday's Inc.

551

Art Director	Woody Pirtle
Designer	Jeff Weithman/Woody Pirtle
Photographer	various
Writer	Janet Wright
Agency	Pirtle Design, Dallas, TX
Client	Mead Paper Company

552

Art Director	Rich Silverstein
Designer	Rich Silverstein/Mary Ann Booth
Photographer	Will Mosgrove
Writer	Jeffrey Goodby, Andy Berlin
Agency	Goodby, Berlin & Silverstein, San Francisco, CA
Producer	Yvonne Israel
Client	Bradmill U.S.A/Wallaman's

553

Art Director	Rich Silverstein
Designer	Rich Silverstein
Photographer	Peter Ogilvy
Writer	Jeffrey Goodby, Andy Berlin
Agency	Goodby, Berlin & Silverstein, San Francisco, CA
Producer	Yvonne Israel
Client	Bradmill U.S.A./Stubbies

554

Art Director	Pete Rundquist, Atlanta, GA
Designer	Pete Rundquist
Photographer	Ted Rodgers
Writer	Jeff Lapidus
Agency	ABOA

555

Art Director	Ron Sullivan
Designer	Willie Baronet
Photographer	Jim Sims, Gerry Kano
Writer	VMS Realty
Agency	Sullivan Perkins, Dallas, TX
Client	Childs Communications/VMS Realty

556

Art Director	Warren Johnson/Chris Vice
Photographer	Kent Severson/Tom Berthiaume
Writer	Harry Beckwith
Agency	Carmichael-Lynch, Minneapolis, MN
Client	PLATO/WICAT Educational Systems

557

Art Director	Slusan Slover
Designer	Mario Pulice, Thomas Bricker, Susan Huyser
Illustrator	Bonnie Glasser
Studio	Susan Slover Design, New York, NY
Client	Excelsior Club

558

Art Director	Ron Sullivan
Designer	Diana McKnight, Ron Sullivan
Illustrator	Don Roy
Writer	Marlys East, Ned Daniels
Agency	Sullivan Perkins, Dallas, TX
Client	The Rouse Company

589

Art Director James Cross
Designer Michael Mescall, Sheri Gray
Agency Cross Associates, Los Angeles, CA
Client Simpson Paper Company

590

Art Director David Edelstein/Nancy Edelstein/
 Lanny French
Designer David Edelstein/Nancy Edelstein/
 Lanny French, Norman Hathaway
 & Tom Bissett
Photographer Jim Cummins/Karl Bischoff
Writer Jeremy Wolff
Agency Edelstein Associates Advertising
 Inc., Seattle, WA
Client Generra Sportswear

591

Art Director Massimo Vignelli
Illustrator Mona Brown
Photographer Bruce Weber, Carol Huebner
Agency Vignelli Associates, New York, NY
Client The John B. Coleman Company

592

Art Director Mark E. Swisher
Illustrator Stan Doctor
Photographer Chuck Burggraf
Writer Patricia Moore
Agency Design and Image Associates,
 Inc., Denver, CO
Client Jan Rosenthal

593

Art Director	John Avery
Illustrator	Andrew Berry
Writer	Neill Ray, Ed Bernard
Agency	Hill, Holliday, Connors, Cosmopulos, Boston, MA
Client	Lotus Development Corporation

594

Art Director	Kuan Chang
Designer	Kuan Chang
Writer	Elizabeth T. Massey
Editor	Elizabeth T. Massey
Publisher	American Craft Council, New York, NY

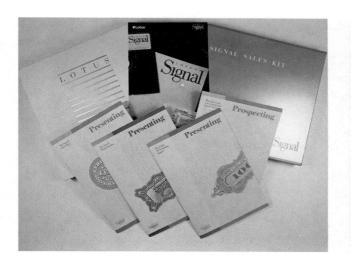

595

Art Director	Sam Smidt
Designer	Sam Smidt, Linda Wong
Writer	Morgan Thomas
Agency	Sam Smidt Inc., Palo Alto, CA
Client	ixi:z

596

Art Director	Jeffrey Abbott
Designer	Jeffrey Abbott
Illustrator	John Hull, Michael Bull, Jeffrey Spear, Richard Williams
Photographer	Bettman Archives, Will Krupa, Jeffrey Abbott
Writer	Jack Soos
Agency	Keiler Advertising, Farmington, CT
Client	Strathmore Paper Company

Gold Award

Art Director	Paul Cade
Designer	Paul Cade
Illustrator	Karen Cheeseman
Photographer	Doug Roberts
Agency	Goodtypes, Inc., Toronto, Canada
Client	Goodtypes, Inc./Karen Cheeseman

598

Silver Award

Art Director James Sebastian
Designer James Sebastian & Pen-Ek
Ratanaruang
Photographer Bruce Wolf
Agency Designframe Incorporated, New
York, NY
Client Martex/West Point Pepperell
Interior Designer William Walter

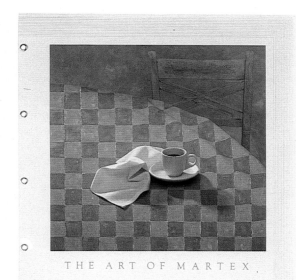

THE ART OF MARTEX

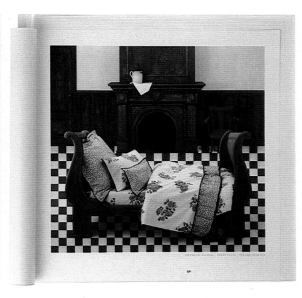

599

Distinctive Merit

Art Director Nancy Rice
Designer Nancy Rice
Writer Bill Miller
Agency Fallon McElligott, Minneapolis, MN
Client Rolling Stone

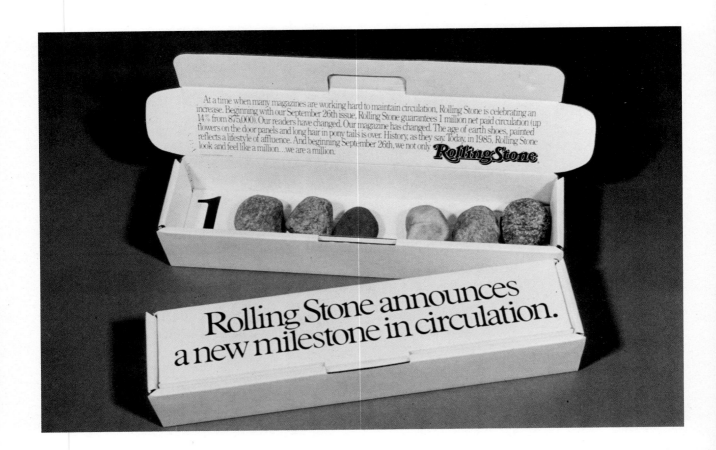

600

Distinctive Merit

Art Director	Massimo Vignelli
Designer	David Dunelberger and Michael Bierut
Photographer	Jim Thomas and Leah Bird
Agency	Vignelli Associates, New York, NY
Client	Kroin Incorporated
Technical Illustrator	Peter Constable

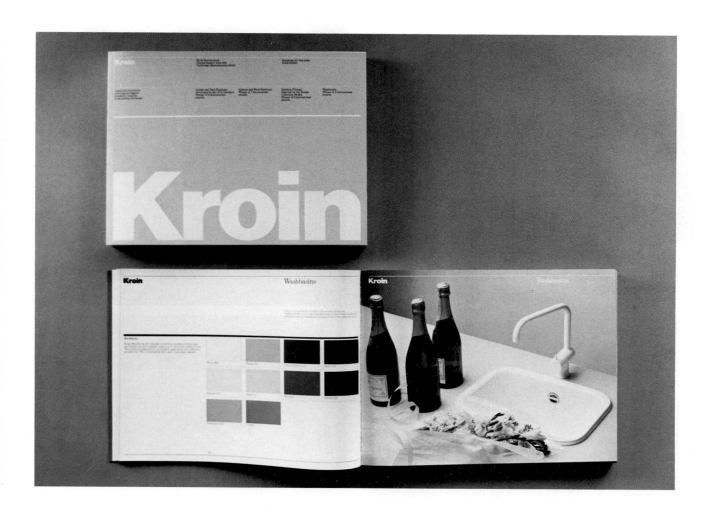

641

Art Director Tyler Smith
Designer Tyler Smith
Photographer John Goodman, Myron
Writer Geoff Currier (Welch, Currier)
Studio Tyler Smith, Providence, RI
Client Louis, Boston

642

Art Director Cheryl Heller
Designer Cheryl Heller
Photographer Helmut Newton
Writer Peter Caroline
Agency Design Group, HBM/Creamer,
Boston, MA
Client S. D. Warren Paper Co.

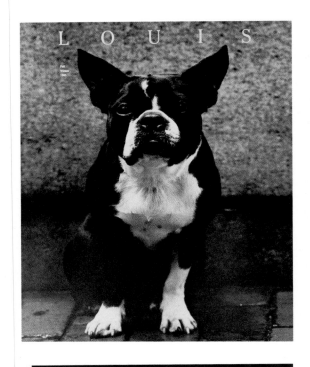

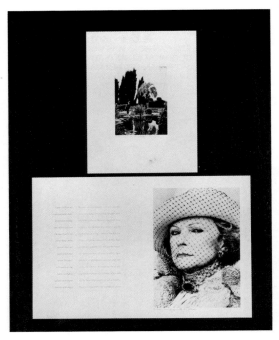

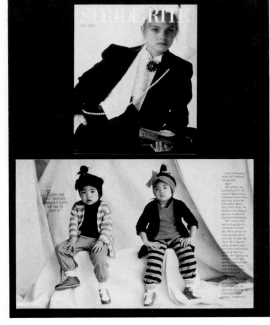

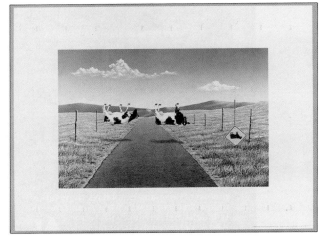

643

Art Director Cheryl Heller
Designer Cheryl Heller
Photographer Bob Murray; Myron
Writer Fred Bertino & Michael Ward
Agency Design Group, HBM/Creamer,
Boston, MA
Client Stride Rite Corporation

644

Art Director Bob Peters
Designer Forrest & Valerie Richardson
Illustrator Bob Peters
Agency Richardson or Richardson/
Phoenix, AZ
Client Bob Peters
Lithographer Woods Lithographics/Phoenix, AZ

645

Art Director	Harold Matossian & Takaaki Matsumoto
Designer	Takaaki Matsumoto
Agency	Knoll Graphics, New York, NY
Client	Knoll International

646

Art Director	Sam Smidt
Designer	Sam Smidt
Photographer	Thomas Heisner, Raja Muna, Sam Smidt
Writer	Morgan Thomas
Agency	Sam Smidt Inc., Palo Alto, CA
Client	ixi:z

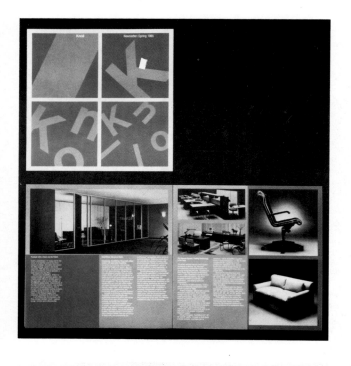

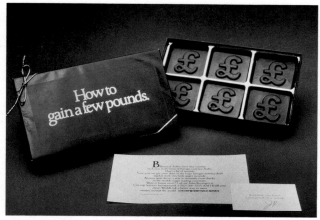

647

Art Director	Cabell Harris
Designer	Cabell Harris
Writer	John Mahoney
Agency	Drinking Buddies Advertising, Richmond, VA
Client	Silverman Productions

648

Art Director	Bob Meagher
Designer	Bob Meagher
Writer	Maureen Moore
Agency	Cramer-Krasselt/Chicago, Chicago, IL
Client	Citicorp Services Inc.

649

Art Director Christi Daniel
Writer Holly Oldfield
Agency Oldfield Davis, Inc., Dallas, TX
Client Murray Properties Company

650

Art Director Cheryl Heller
Designer Cheryl Heller & Paul Grace
Illustrator Cheryl Heller
Writer Baxter Taylor & David Wecal
Agency Design Group, HBM/Creamer, Boston, MA
Client Lily Truck Leasing

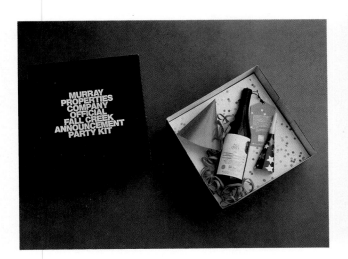

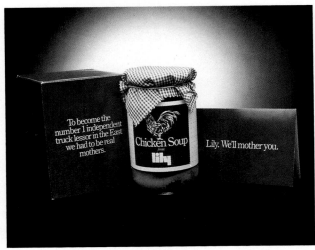

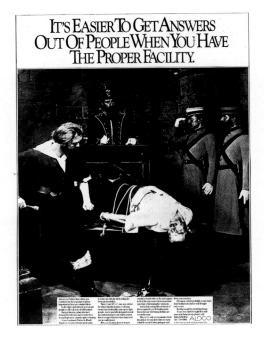

651

Art Director Bob Saabye
Photographer Bettmann Archives
Writer Ernie Schenck
Agency Leonard Monahan Saabye, Providence, RI
Client Aloco

652

Art Director Tom Kelly
Writer Bill Borders
Agency Borders, Perrin & Norrander, Inc., Portland, OR
Client Pendleton Woolen Mills/Menswear Div.

653

Art Director	Jim Raycroft
Designer	Poster design: Frank Weitzman
Photographer	Ned McCormick
Writer	Jim Raycroft/Frank Weitzman
Client	Raycroft/McCormick Photography Inc., Boston, MA
Printer	Prolith Int'l
Stylist	Lesley B. Fenton
Backdrop	Sammons Associates
Hair & Makeup	Pisces Unlimited

655

Art Director	Bob Defrin
Designer	Bob Defrin
Photographer	Roy Volkmann
Client	Atlantic Records, New York, NY

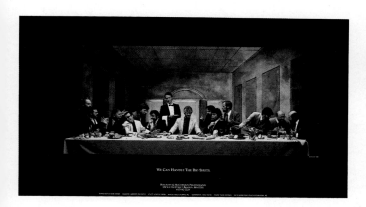

656

Art Director	Christopher Austopchuk
Designer	Christopher Austopchuk
Photographer	Duane Michals
Client	Epic Records
Publisher	CBS Records, New York, NY

657

Art Director	Andrea Klein, New York, NY
Designer	Andrea Klein
Photographer	E. J. Camp
Client	Profile Records, Inc.
Recording Artist	Run DMC

Gold Award

Art Director	Keith Bright
Designer	Raymond Wood
Illustrator	Raymond Wood
Project Director	Lynn Bar-Lev, Teri Hannigan
Agency	Bright and Associates, Los Angeles, CA
Client	Kaepa, Inc.

660

Silver Award

Art Director | Robert Bornhoeft
Designer | Robert Bornhoeft
Agency | AD3, Incorporated, Los Angeles, CA
Client | Black Tie Roses

661

Art Director | Chip Kettering
Designer | Stan Evenson
Agency | J. Walter Thompson
Client | Filevision
Design Firm | Stan Evenson Design, Inc., Los Angeles, CA

662

Art Director | James Clark
Designer | James Clark
Illustrator | James Clark
Writer | Bev Manning
Agency | The Davis Group, Seattle, WA
Client | Weyerhaeuser Company

663

Art Director | Jim Markle
Designer | Jim Markle, Judy Junewick
Photographer | Phil Gray
Writer | Chuck Hasek
Agency | Aves Advertising, Inc., Grand Rapids, MI
Client | Wolverine World Wide

664

Art Director John Benelli
Designer John Benelli
Writer David Lewinson
Agency Crouch + Fuller, Inc., Del Mar, CA

665

Art Director Carson Pritchard
Designer Carson Pritchard
Photographer Donald Miller, Inc.
Studio Carson Pritchard Design, Los Angeles, CA
Client Arita Dishware

666

Art Director	John Van Dyke
Designer	John Van Dyke
Agency	Van Dyke Company, Seattle, WA
Client	Geneve Cosmecueticals

667

Art Director	Dennis Thompson
Designer	Dennis Thompson & Elizabeth Berta
Illustrator	Dennis Thompson
Agency	The Thompson Design Group, San Francisco, CA
Client	Michael Dellar, Spectrum Foods
Proprietors	Larry Mindel & Jerry Magnin

Distinctive Merit

Art Director	Paul Hanson
Photographer	Chris Mead, New York, NY
Writer	Mary Emmerling
Editor	Sally Kovalchick
Publisher	Workman Publications

669

Art Director	Kit Hinrichs
Designer	Kit Hinrichs/Belle How
Photographer	Terry Heffernan
Writer	Peterson & Dodge
Agency	Jonson Pedersen Hinrichs & Shakery, San Francisco, CA
Client	American President Lines

670

Art Director	Chihiro Moriya/Gaku Ohta
Designer	Chihiro Moriya/Gaku Ohta
Studio	Chihiro Moriya/Gaku Ohtu, San Francisco, CA
Client	Japonesque, Inc.
Calligraphy	Koichi Hara

671

Art Director	Ken White
Designer	Petrula Vrontikis
Photographer	Marc Feldman
Writer	Vicki Thomas
Agency	White + Associates, Los Angeles, CA
Client	Commuter Computer

672

Art Director Woody Pirtle
Designer Kenny Garrison/Woody Pirtle
Writer Woody Pirtle
Agency Pirtle Design, Dallas, TX
Client Pirtle Design

673

Art Director McRay Magleby
Designer McRay Magleby
Illustrator McRay Magleby
Writer Norman A. Darais
Agency BYU Graphics, Provo, UT
Client BYU Print Services
Printer BYU Print Services

674

Art Director Greg Samata
Designer Greg Samata/Jim Hardy
Illustrator Frank Lloyd Wright
Writer Joy Margolis
Agency Samata Associates, Dundee, IL
Client IC Industries
Printer Great Northern Design Printing Co.
Consultant The Art Institute of Chicago

677

Art Director	Ron Sullivan
Designer	Ron Sullivan
Writer	Mark Perkins
Agency	Sullivan Perkins, Dallas, TX
Client	The Friends of Duffy Weir

678

Art Director	Mike Schroeder
Designer	Mike Schroeder
Illustrator	Mike Schroeder
Writer	Woody Pirtle/Mike Schroeder
Agency	Pirtle Design, Dallas, TX
Client	Tom & Rhonda Dimperio

679

Art Director	Roger Cook/Don Shanosky
Designer	Roger Cook/Don Shanosky
Illustrator	Roger Cook/Don Shanosky
Writer	David Eynon
Agency	Cook and Shanosky Assoc., Inc., Princeton, NJ
Client	Mead Paper
Printer	Lebanon Valley Offset, Pomco Graphics

680

Art Director	Bob Gill, New York, NY
Designer	Bob Gill
Photographer	Marty Jacobs
Client	NY Art Directors Club
Publisher	NY Art Directors Club

681

Art Director	Carol Burke
Designer	Carol Burke
Writer	Ben Johnson
Agency	Pharr Cox Communications, Dallas, TX
Client	Exeter

682

Art Director	Howard Goldthwaite
Designer	Howard Goldthwaite
Illustrator	Howard Goldthwaite
Writer	Howard Goldthwaite
Agency	Betsy Berger and Associates, Dallas, TX
Client	Andrew Goldthwaite

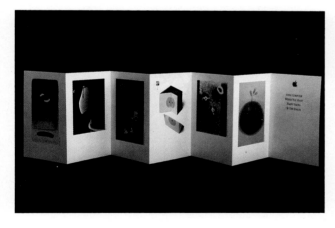

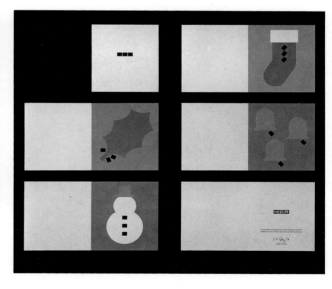

683

Art Director	Clement Mok, Tom Suiter
Designer	Lindy Cameron
Illustrator	James McMullan, Milton Glaser, Katsu Kimura, Michael Cronan
Photographer	Brad Guice
Writer	Jayne Greenstein
Agency	Apple Creative Service, Cupertino, CA
Client	Apple Computer, Inc.

684

Art Director	Alan Colvin/Woody Pirtle
Designer	Alan Colvin
Illustrator	Alan Colvin
Writer	NCR Corporation
Agency	Pirtle Design, Dallas, TX
Client	NCR Corporation

685

Art Director Chuck Johnson
Designer Chuck Johnson
Illustrator Chuck Johnson
Writer Ken Koester, Cheryl McCue
Creative Director Bob Dennard
Agency Dennard Creative, Inc., Dallas, TX
Client Cheryl and Wolfford McCue

686

Art Director Arthur Eisenberg/Scott Ray/Don Arday
Designer Scott Ray/Shannon Patterson
Illustrator Don Arday
Agency Eisenberg Inc., Dallas, TX
Client Raphael's Restaurant

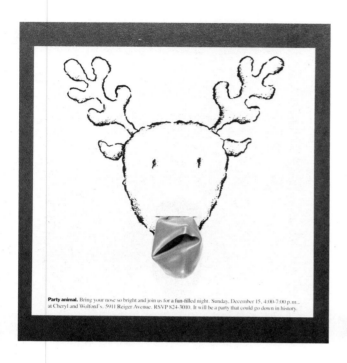

687

Art Director Rex Peteet
Designer Rex Peteet
Illustrator Rex Peteet
Writer Sharon Larkin
Agency Sibley/Peteet Design, Inc., Dallas, TX
Client International Association of Business Communicators, Dallas, TX

688

Art Director Jack Anderson/John Hornall/Cliff Chung
Designer Jack Anderson/John Hornall/Cliff Chung
Writer John Hornall
Design Firm Hornall Anderson Design Works, Seattle, WA
Client Weyerhaeuser

689

Gold Award

Art Director	Rick Eiber
Designer	Rick Eiber
Writer	Sam Angeloff
Agency	Rick Eiber Design (RED), Seattle, WA
Client	Sam Angeloff
Printer	Artcraft Printing

690

Art Director	R. Christine Hershey
Illustrator	Stephen Gallegos
Photographer	Susan Van Horn
Agency	Hershey Associates, Los Angeles, CA
Client	Van Horn Photography
Type	Amy Inouye

691

Art Director	Cecilia A. Conover, David W. Conover
Designer	Cecilia A. Conover
Illustrator	Cecilia A. Conover
Studio	Evans & Conover, Solana Beach, CA
Client	Design Line Interiors Inc.
Printer	Image Printing and Envelope
Type	Central Graphics

692

Art Director	John Box Bricker
Designer	John Box Bricker
Agency	Gensler Graphics Group, San Francisco, CA
Client	Oasis/Ric Wogisch
Publisher	Forman/Liebrock

693

Art Director	Wendy Szeto Lee
Agency	Wendy Szeto Lee Design, San Francisco, CA
Production	Maryann Chin
Client	Wellington Wong

694

Art Director	Lou Dorfsman, New York, NY
Designer	Lou Dorsman & Yasuo Kubota
Illustrator	Richard Hess
Client	Classic American Foods/Burt Wolf

695

Art Director	Robert Warkulwiz, Michael Rogalski, William F. Smith, Jr.
Designer	Robert Warkulwiz, Michael Rogalski, William F. Smith, Jr.
Agency	Warkulwiz Design Associates, Phila delphia, PA
Client	Warkulwiz Design Associates

696

Art Director	April Greiman
Designer	April Greiman
Agency	April Greiman Incorporated, Los Angeles, CA
Client	Akbar Alijamshid

697

Art Director	Doug Akagi
Designer	Doug Akagi, Sharrie Brooks, Karen Ann
Agency	Akagi Design, San Francisco, CA
Client	Yosemite National Institutes

Gold Award

Art Director	Robert Wages
Designer	Robert Wages
Illustrator	Walt Floyd
Agency	Wages Graphic Design, Atlanta, GA
Client	Hardin Construction Company

Art Director Jeff Kimble
Designer Jeff Kimble
Illustrator Susie Potvin
Agency Marketing Communications Group,
Inc., Toledo, OH
Client LOF Glass

ECLIPSE

701

Art Director Ken Hegstrom
Designer Ken Hegstrom
Illustrator Ken Hegstrom
Agency Hegstrom Design Incorporated,
San Jose, CA
Client Final Touch Painting

702

Art Director Scott A. Mednick
Designer Scott A. Mednick
Illustrator Zengo Yoshida
Agency Scott Mednick and Associates, Los
Angeles, CA
Client Vestron, Inc.

703

Art Director Scott A. Mednick
Designer Scott A. Mednick
Illustrator Daniel J. Simon
Agency Scott Mednick and Associates, Los
Angeles, CA
Client Prefam, Inc.

704

Art Director Bob Dennard
Designer Bob Dennard
Agency Dennard & Associates, Inc.,
Dallas, TX
Client The Westland Group

705

Art Director	Mark Galarneau
Designer	Mark Galarneau
Illustrator	Mark Galarneau
Agency	Galarneau & Sinn, Ltd., Palo Alto, CA
Client	Art Directors Heaven/Fred Vanderpoel

706

Art Director	Peter Bertolami
Designer	Peter Bertolami
Agency	Graphic Identity, Inc., New York, NY
Client	Kasper Group Inc. (Umbrella Group of Architectural & Engineering Firms)

707

Art Director	Bill Gardner
Designer	Bill Gardner
Agency	Gardner's Graphic Hands, Wichita, KS
Client	Mitch's Lawn Care and Landscaping

708

Art Director	Bob Mynster
Designer	Bob Mynster
Agency	Studiographix, Irving, TX
Client	Columbia Brokerage and Investments

709

Art Director	Paul Black
Designer	Paul Black
Illustrator	Paul Black
Agency	GSD&M (Dallas), Dallas, TX
Client	One Realty Corporation
Design Firm	Sibley/Peteet Design, Inc.

710

Art Director	Charles Michael Helmken
Designer	Michael Nelson
Client	Council for Advancement and Support of Education, Washington, DC
Printer	Goetz Printing Company, Springfield, VA

The mythological Pegasus personifies
the pursuit of excellence and
symbolizes flight of the imagination.
Your own achievements in creative
planning, producing, and promoting of
programs and communications for
your institution merit the accolades
of your colleagues and peers and
it is with great pride that the
Council for Advancement and Support
of Education recognizes your
achievements in presenting to you
and your associates this national
GOLD MEDAL AWARD
for

711

Art Director	Dennis Tabor
Designer	Robin Rickabaugh, Jerry Soga, Don Rood
Agency	Pihas Schmidt Westerdahl, Portland, OR
Client	Pacific Power

712

Art Director	Michael Smilanic
Designer	Mick Barron
Illustrator	Mick Barron
Agency	Lance Jackson & Associates, Inc., Denver, CO
Client	Dr. Mark Huff, Jr., M.D., P.A.
Promotional Agency	Kagan & Associates, Dallas, TX

713

Art Director	Amy Fread
Designer	Nancy Merish
Agency	In-house Promotion Department/ Business Publications Division, New York, NY
Client	Murdoch Magazines Publishing Company
Promotion Director	Martin Broder

714

Art Director	Barbara Shimkus
Designer	Barbara Shimkus
Illustrator	Ken Howell
Agency	Shimkus Design, San Antonio, TX
Client	Hudson Pierce Motor Co.

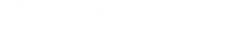

715

Art Director	Van Hayes, Diane Gillis
Designer	Van Hayes
Agency	The Dallas Morning News, Dallas, TX
Client	The 500, Inc.

716

Art Director	Tom Geismar, Ivan Chermayeff
Designer	Ivan Chermayeff, Tom Geismar, Steff Geissbuhler
Agency	Chermayeff & Geismar Associates, New York, NY
Client	PBS

717

Art Director John & Mary Condon
Designer John & Mary Condon
Agency J & M Condon Inc., New York, NY
Client City Volunteer Corps

718

Art Director Robert Wages
Designer Robert Wages
Illustrator Walt Floyd
Agency Wages Graphic Design, Atlanta, GA
Client Plus Development Corporation

CITY VOLUNTEER CORPS

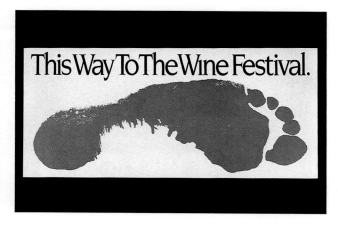

720

Art Director Primo Angeli
Designer Primo Angeli, Darryl Reed
Studio Primo Angeli Inc., San Francisco, CA
Retoucher John Coletti

721

Art Director Pam Conboy
Illustrator Pam Conboy
Writer Dick Thomas
Agency Bozell, Jacobs, Kenyon & Eckhardt/ Minneapolis, MN
Client Radisson Hotel Corporation

727

Art Director	Gene Butera, Bill Morgan, Nick Sekulich, Ron Tosh, Tom Upshur and Ken Welch
Photographer	Larry Dale Gordon, Jim Haefner, Andre LaRouche, Marshall Lefferts, Don Levy, Dick Reed, Don Sudnik, Bob Traniello and Dennis Wiand
Writer	Sue Barber, Tony Hossain, Kathy Speck, Jerry Burton
Creative Director	Sean K. Fitzpatrick
Agency	Campbell-Ewald Co., Warren, MI

728

Art Director	Cheryl Heller & Paul Grace
Designer	Cheryl Heller & Paul Grace
Illustrator	Michael Orzech
Photographer	Clint Clemens
Agency	Design Group, HBM/Creamer, Boston, MA
Client	Codex Corporation

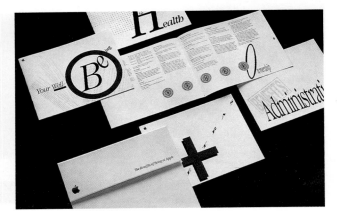

729

Art Director	Robert Cipriani
Illustrator	Fred Otnes
Photographer	Bruce Peterson
Writer	Barbara Nelson/Peter Stavropulos
Agency	Cipriani Advertising, Inc., Boston, MA
Client	Honeywell Information Systems
Printer	Acme Printing/The Nimrod Press

730

Art Director	Clement Mok
Designer	Ellen Romano
Writer	Sue Wutheridge
Editor	Mary Anne Beckford
Agency	Apple Creative Service, Cupertino, CA
Production	Cindy Iwamura
Client	Apple Computer Human Resource

731

Art Director Bob Jensen
Designer Bob Jensen
Illustrator Barbara Gerber
Writer Scott McCormick, Rob Price
Creative Director Bob Jensen
Agency Valentine-Radford Advertising
Agency, Kansas City, MO
Client Valentine-Radford Advertising
Agency

732

Art Director Lisa Thomas
Designer Young & Laramore
Photographer Darlene Delbecq
Writer David J. E. Young
Agency Young & Laramore, Indianapolis,
IN
Client Johnson County Memorial Hospital

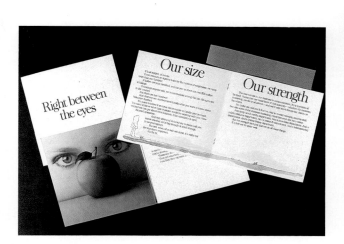

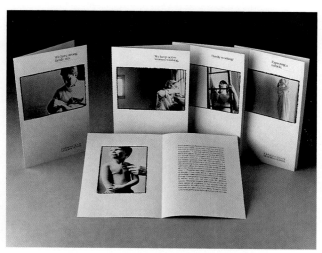

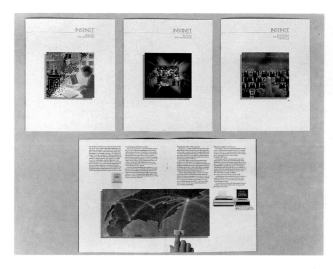

733

Art Director Jery Bonar
Designer Jerry Bonar
Illustrator Jeff Wack
Photographer Glen Wexler
Writer Jack Cromer and Pamela Leven
Agency Wilshire Creative Group, Culver
City, CA
Client Instinet

734

Art Director Young & Laramore
Designer Young & Laramore
Photographer Dick Spahr Photography/Casalini
Photography/Carter Allen
Writer John Young
Agency Young & Laramore, Indianapolis,
IN
Client Ameritech Systems

Distinctive Merit

Art Director	Mark McGeoch
Designer	Mark McGeoch/Debra Bubb
Illustrator	Mark McGeoch/Debra Bubb
Agency	Mark McGeoch Design Group, Palo Alto, CA
Client	Apple International
Printer	Geographics Corporation

736

Gold Award

Art Director	Tamotsu Yagi
Designer	Tamotsu Yagi
Photographer	Architecture/Ballo & Ballo, People/ Toscani, Still Life/Roberto Carra
Agency	Esprit Graphic Design Studio, San Francisco, CA

Silver Award

Art Director Jerry Berman
Designer Jerry Berman
Writer Alex Cishy
Agency Sidjakov Berman & Gomez, San
Francisco, CA
Client Sidjakov Berman & Gomez
Printer Warren's Waller Press

Distinctive Merit

Art Director	Sue Crolick
Designer	Sue Crolick
Illustrator	Nancy Johnson
Photographer	Rod Pierce
Writer	Sue Crolick
Agency	Sue Crolick Advertising & Design, Minneapolis, MN
Client	Nancy Johnson
Keyliner	Nancy Johnson

Keylines without the personal touch.

Call Nancy Johnson at 332-1285 for good, clean work.

Is your keyliner editing the c␣py?

It's one thing to lose a great headline because the client didn't like it.

It's another thing to lose it because it fell off the keyline.

For type that sticks, call Nancy Johnson. She uses 2-coat cement, to give the best possible bond.

And, instead of simply pasting type corrections on top, she cuts a mortise.

So even a one-letter change stays firmly in place. Remember: when Nancy Johnson keylines your ad, she wants your idea to come off. Not your type.

Nancy Johnson, Keyliner. Phone 332-1285

Ifyouaskedfornormalwordspacingandthisiswhatyougot withnotimetoresetcallNancyJohnsonat332-1285.

739

Art Director	Jack Anderson
Designer	Richard Hess/Jack Anderson
Illustrator	Jim Hays
Writer	Beth Brousseau
Design Firm	Hornall Anderson Design Works, Seattle, WA
Client	Heritage Group Ltd.
Printer	Atomic Press

740

Art Director	Tom Corey
Designer	Susan Gilzow, Scott Nash, Kim Halliday, Tom Corey
Photographer	Skolos Wedell & Raynor
Writer	Tom Corey
Design Firm	Corey & Company: Designers, Boston, MA
Printer	Reynolds-DeWalt Printing

741

Art Director	Gordon Hochhalter
Designer	Georgene Sainati/Bob Meyer
Writer	Gordon Hochhalter
Agency	R. R. Donnelley & Sons Company, Chicago, IL
Client	R. R. Donnelley & Sons Company
Production Manager	Joe Cosgrove/Maryann Novak

742

Art Director	McRay Magleby
Designer	McRay Magleby
Illustrator	McRay Magleby & Linda Sullivan
Writer	Norman A. Darais
Agency	BYU Graphics, Provo, UT
Client	Brigham Young University—President's Office; BYU Public Affairs—George H. Bowie
Printer	BYU Print Services
Type	Jonathan Skousen

Gold Award

Art Director Charles Spencer Anderson
Designer Charles Spencer Anderson
Illustrator Charles Spencer Anderson
Agency The Duffy Design Group,
 Minneapolis, MN
Client Prince Foods—Canning Division

Silver Award

Art Director Nicolas Sidjakov and Jerry Berman
Designer James Nevins
Illustrator David Stevenson
Writer Julie Ambrose
Agency Sidjakov Berman & Gomez, San
Francisco, CA
Client Hills Bros. Coffee, Inc.
Printer Continental Can

748

Art Director	David Au/John C. Jay
Illustrator	Sergio Baradat, Per Arnoldi, John Pirman, Mark Kostabi, Sottsass Associates
Creative Director	John C. Jay
Agency	Bloomingdale's, New York, NY
Client	Bloomingdale's

749

Art Director	Bill Swearingen, P.W., Inc.
Illustrator	Mark Cable, P.W., Inc.
Writer	Clemente Conde
Agency	Design Elements, Inc., Lexington, KY
Client	Reuter Laboratories
Design Director	Clemente Conde
Consultant	Dick Grandy

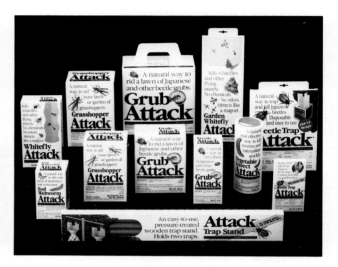

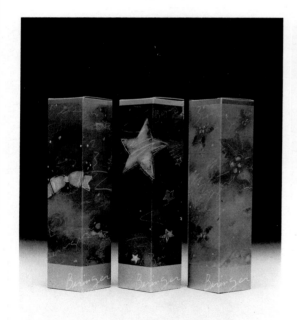

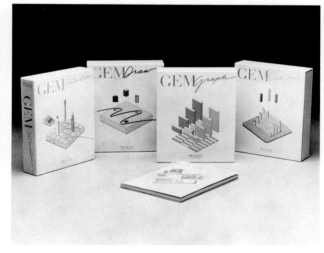

750

Art Director	David Broom
Designer	David Broom, Kimiko Murakami
Illustrator	Cathy Barancik
Agency	Broom & Broom Inc., San Francisco, CA
Client	Beringer Vineyards

751

Art Director	Alan Senzaki
Designer	Alan Senzaki
Illustrator	Alan Senzaki
Writer	Michael Dashe
Agency	Picket Communications, Inc., San Francisco, CA
Production	Beatrice Lau
Calligraphy	Jan Schockner

752

Art Director	Bill Manns/Glenn Groglio
Designer	Glenn Groglio
Illustrator	Carol Haley
Photographer	Fotograf Lotzbeck
Writer	Carol Haley
Client	Dansk International Designs, Ltd., Mt. Kisco, NY

753

Art Director	Forrest & Valerie Richardson
Designer	Forrest & Valerie Richardson
Writer	Forrest & Valerie Richardson
Agency	Richardson or Richardson, Phoenix, AZ
Client	Woods Lithographics, Phoenix, AZ
Baker	Cookies From Home

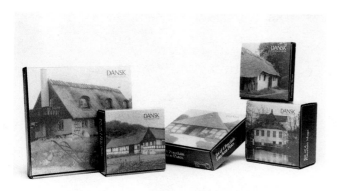

754

Art Director	S. A. Habib
Designer	S. A. Habib
Illustrator	Jim Hsieh, Laurie Ellis, Tom Milner
Writer	Martha DuBose
Creative Director	Jeffrey Buntin
Agency	Buntin Advertising, Inc., Nashville, TN
Client	Gourmet Foods, Inc.

755

Art Director Glenn Groglio
Designer Glenn Groglio
Illustrator Glenn Groglio
Agency Glenn Groglio Graphics, Rye, NY
Client Botanic Garden Seed Company

756

Art Director Charles Spencer Anderson
Designer Charles Spencer Anderson
Illustrator Charles Spencer Anderson
Agency The Duffy Design Group,
Minneapolis, MN
Client Perrin's

757

Art Director Ronald Emmerling
Designer Ronald Emmerling
Illustrator Harry Peterson
Agency Emmerling Design, New City, NY
Client Sparkomatic Corporation

760

Art Director	Marie McGinley
Designer	Marie McGinley
Illustrator	John Coles
Writer	Jean-Yves Loizance/Food & Wine Research, Inc.
Agency	McGinley Design, Boston, MA
Client	Gumby Bay at the Long Island Resort, Antigua
Publisher	Todd Printing

761

Art Director	Marianne Tombaugh
Designer	Marianne Tombaugh
Illustrator	Kip Lott
Writer	Mark Perkins
Agency	The Hay Agency, Inc., Dallas, TX
Client	Mental Health Association in Texas
Printer	Heritage Press

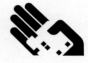

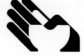

762

Art Director	Jim Berte
Designer	Vanig Torikian
Agency	Robert Miles Runyan & Associates, Playa del Rey, CA
Client	Caremark, Inc.

763

Silver Award

Art Director	Woody Pirtle
Designer	Woody Pirtle/Mike Schroeder/Jeff Weithman
Illustrator	Mike Schroeder/Jeff Weithman
Writer	Dana Collins
Agency	Pirtle Design, Dallas, TX
Client	Trammell Crow Company/Dallas Market Center

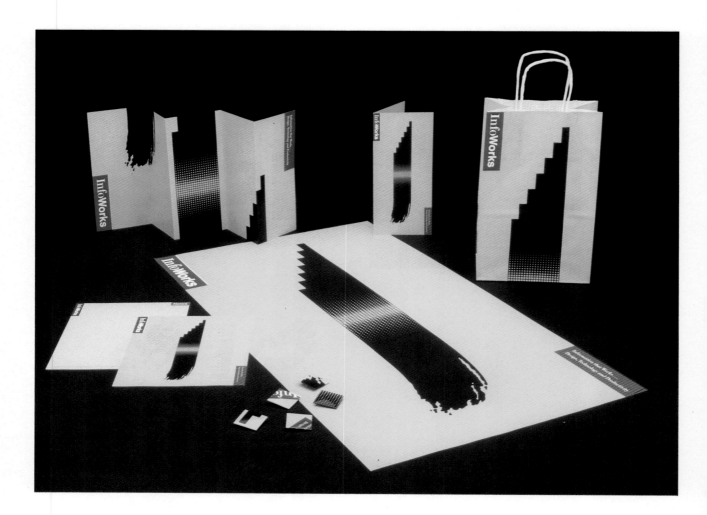

Gold Award

Art Director	Tamotsu Yagi
Designer	Tamotsu Yagi
Agency	Esprit Graphic Design Studio, San Francisco, CA

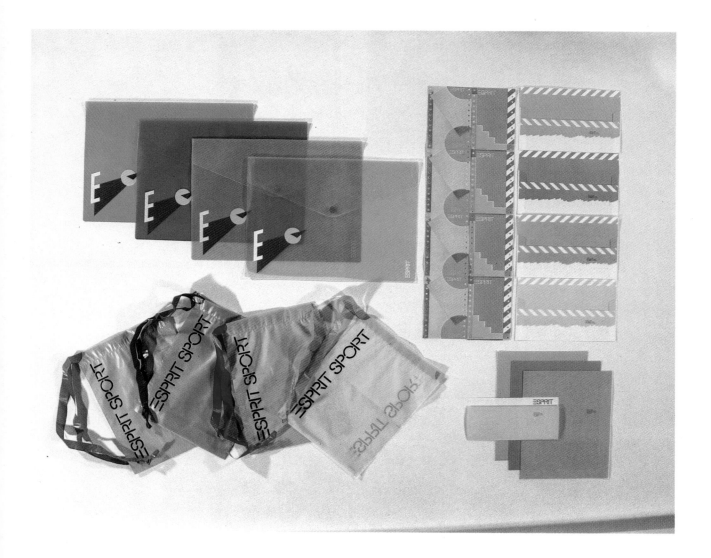

765

Art Director	Ken Cooke, Willi Kunz
Designer	Willi Kunz, Joseph Guglietti, Dean Wilcox
Photographer	Brad Guice
Agency	Landor Associates Inc., New York, NY
Client	The Black & Decker Corporation

766

Art Director	Robert Greenebaum/Jamie Greenebaum
Designer	Robert Greenebaum
Illustrator	Robert Greenebaum
Writer	Robert Greenebaum
Agency	Greenebaum Design, Natick, MA
Client	Hannah Robinson Collection

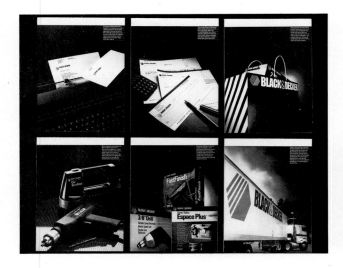

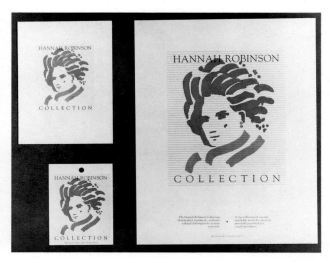

767

Art Director	Robert P. Gersin
Designer	Robert P. Gersin, Pamela Virgilio, Johann Schumacher
Writer	Lydia Ferrabee
Editor	Lydia Ferrabee
Project Director	Daniel Murphy
Agency	Robert P. Gersin Associates, Inc., New York, NY
Client	Sears, Roebuck and Company
Publication	Graphics Standards Manual
Printer	S. D. Scott Printing

768

Art Director	Steff Geissbuhler
Designer	Steff Geissbuhler/Julia Unger
Agency	Chermayeff & Geismar Associates, New York, NY
Client	Gerald Schneiderman—Anchor Engraving

769

Art Director	Jeff Rich, Wayne Webb
Designer	Fred Biliter
Photographer	Dave Jordano
Writer	Wayne Webb, Jeff Rich
Client	Beatrice Companies, Inc., Chicago, IL
Publisher	The Hennegan Company

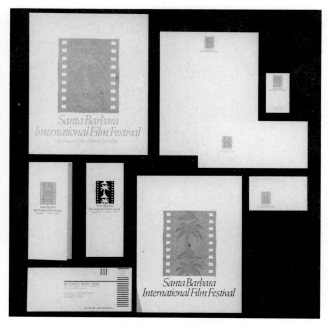

770

Art Director	Ernie Perich
Designer	Chris Purcell
Photographer	Cheri Smith
Agency	Group 243 Incorporated, Ann Arbor, MI
Client	MERCYCARE Corporation
Account Executive	Marti Coplai

771

Art Director	Mark Oliver
Designer	Mark Oliver
Illustrator	Mark Oliver
Agency	Mark Oliver, Inc., Santa Barbara, CA
Client	Santa Barbara International Film Festival

Books

Jackets

General trade book
Special trade book
Juvenile book
Text or reference book
Book jacket
Book jacket campaign

773

Art Director Walter Horton
Designer Walter Horton
Photographer Doug Tomlinson
Writer David Dillon
Editor Mary Hill
Agency Sibley/Peteet Design, Dallas, TX
Publisher Texas Monthly Press
Design Director Cathy S. Casey

774

Art Director Harrison Shaffer III
Designer Linnea Gentry Sheehan
Illustrator Paul Mirocha
Writer Gary Paul Nabhan
Editor Gregory McNamee
Director Stephen F. Cox
Publisher The University of Arizona Press,
Tucson, AZ

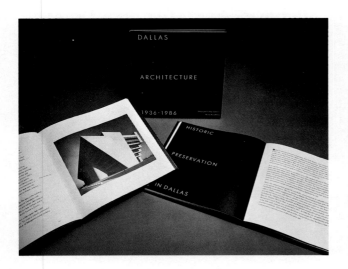

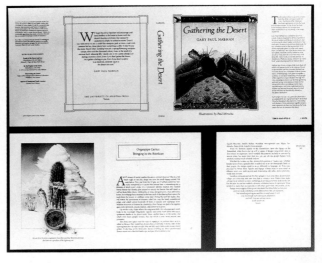

775

Art Director Susan Mitchell
Designer Susan Mitchell
Editor Wendy Wolf
Production Marlene Zack, Helen D. Mitchell,
Mother
Publisher Pantheon Books, New York, NY

776

Art Director Bill Feeney, John Williams
Designer Bill Feeney, John Williams
Illustrator Bill Feeney, Bill Magyar, Matthew
DeMayo
Photographer Karen Heerlein
Writer Nancy DeFelice
Agency Feeney Design, Stamford, CT
Client Beauvais Printing
Publisher Doubleday/Dolphin Books

Gold Award

Art Director Walter Bernard, Milton Glaser
Designer Walter Bernard, Milton Glaser
Illustrator Photos hand-painted by Sydnie
Michelle Salmieri
Photographer Stephen Salmieri
Writer Owen Edwards
Editor Bill Dworkin
Publisher Rizzoli International Publications,
Inc., New York, NY

Silver Award

Art Director Kit Hinrichs
Designer Kit Hinrichs, Lenore Bartz, D. J. Hyde
Illustrator various
Photographer Tom Tracy
Writer Delphine Hirasuna
Agency Jonson Pedersen Hinrichs & Shakery, San Francisco, CA
Client Chronicle Books
Publisher Chronicle Books

Silver Award

Art Director	Paul Rand
Designer	Paul Rand
Writer	Paul Rand
Editor	Judith Metro
Publisher	Yale University Press, New Haven, CT
Production Manager	Christopher Harris

780

Silver Award

Art Director Samuel N. Antupit
Designer Bob McKee and Nicolas Hugnet
Writer T. C. McLuhan
Editor Robert Morton
Publisher Harry N. Abrams, Inc., New York,
NY

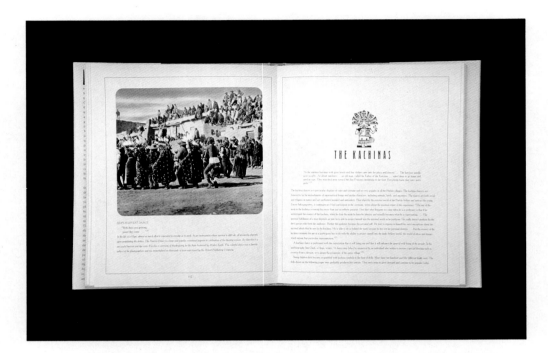

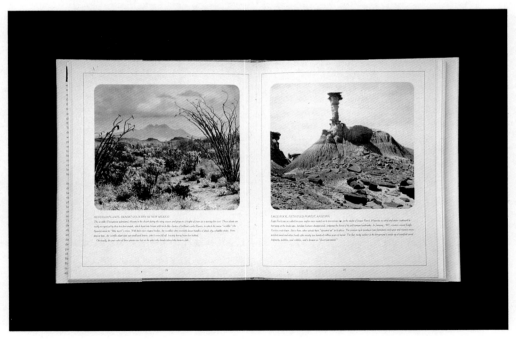

Art Director Amy Nathan
Designer Jacqueline Jones
Photographer Kathryn Kleinman
Writer Kelly McCune, Amy Nathan
Editor Carolyn Miller
Publisher David Barich, Chronicle Books,
San Francisco, CA
Food Styling Amy Nathan

Art Director Samuel N. Antupit
Designer Seymour Chwast
Illustrator Seymour Chwast
Writer Seymour Chwast
Editor Robert Morton
Publisher Harry N. Abrams, Inc., New York,
NY

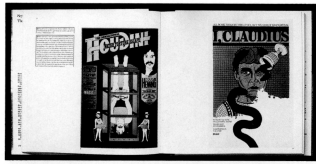

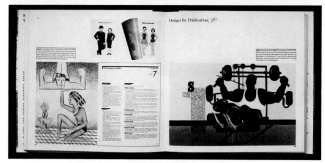

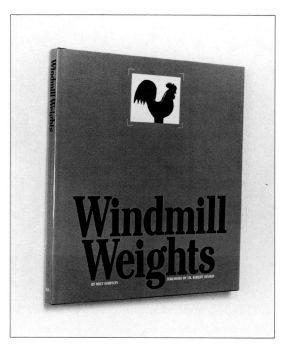

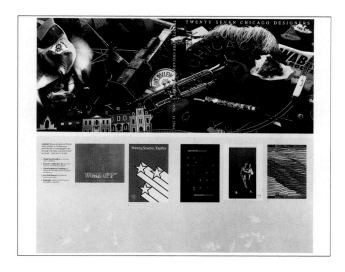

Art Director Don Johnson
Designer Bonnie Berish, Anne Giacalone
Illustrator Bill Wood
Photographer Bob Krist, Solomon Devoe Butcher
Writer Milt Simpson
Editor Maury Bates, Mary Sue Sweeney
Agency Johnson & Simpson Graphic
Designers, Newark, NJ
Publisher Johnson & Simpson Graphic
Designers

Art Director Joseph Michael Essex
Designer Cover: Joseph Michael Essex,
Text: The Twenty Seven Chicago
Designers
Photographer Tom Vack, Corinne Pfister
Writer Rhodes Patterson
Editor Joseph Michael Essex
Agency Burson-Marsteller/Chicago, IL
Client The Twenty Seven Chicago
Designers
Publisher The Twenty Seven Chicago
Designers

785

Art Director	Marc Alain Meadows, Robert Wiser
Designer	Marc Alain Meadows, Robert Wiser
Photographer	Balthazar Korab
Editor	Diane Maddex
Agency	Meadows & Wiser, Washington, DC
Client	The Preservation Press, National Trust for Historic Preservation
Publisher	The Preservation Press

786

Art Director	Samuel N. Antupit
Designer	Samuel N. Antupit
Illustrator	Jennifer Bartlett
Photographer	Geoffrey Clements
Writer	Robert Smith and Jennifer Bartlett
Editor	Anne Yarowsky
Publisher	Harry N. Abrams, Inc., New York, NY

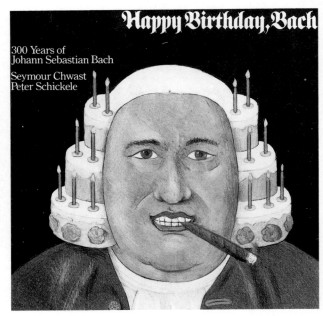

787

Art Director	R. D. Scudellari
Photographer	Tom Eckerle
Writer	Christopher Idone
Publisher	Random House, New York, NY
Lettering	Tom Carnase

788

Art Director	Seymour Chwast
Designer	Seymour Chwast
Illustrator	Seymour Chwast
Writer	Peter Schickele
Producer	Steven Heller, Pushpin Editions, New York, NY
Publisher	Doubleday & Company, Inc.

789

Art Director Stafford Cliff
Designer Stafford Cliff
Photographer Gilles De Chabaneix
Writer Suzanne Slesin
Editor Nancy Novogrod
Director Carol Southern
Publisher Clarkson N. Potter, Inc. (Crown Publishers), New York, NY

790

Designer Marvin Israel and Elizabeth Avedon
Photographer Richard Avedon
Writer Laura Wilson
Editor Beverly Fazio
Project Director Robert Morton
Publisher Harry N. Abrams, Inc., New York, NY

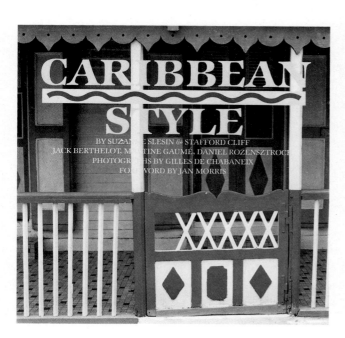

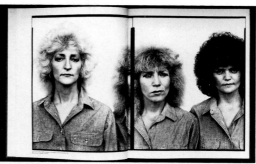

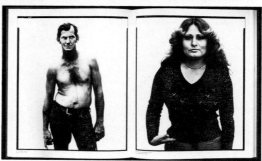

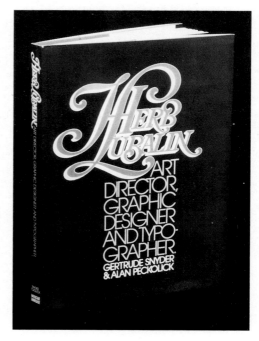

791

Art Director Alan Peckolick
Designer Alan Peckolick/Doris Neulinger
Illustrator various
Photographer various
Writer Gertrude Snyder
Publisher American Showcase, Inc., New York, NY

792

Gold Award

Art Director Lark Carrier
Designer Lark Carrier
Illustrator Lark Carrier
Writer Lark Carrier
Agency Lehman Millet Incorporated,
Boston, MA
Client Picture Book Studio USA
Publisher Alphabet Press

Silver Award

Art Director	Beau Gardner, Shelly Creech
Designer	Beau Gardner
Illustrator	Beau Gardner/Shelly Creech
Director	Dorothy Briley
Agency	Beau Gardner Associates, New York, NY
Publisher	Lothrop Lee & Shepard, NY

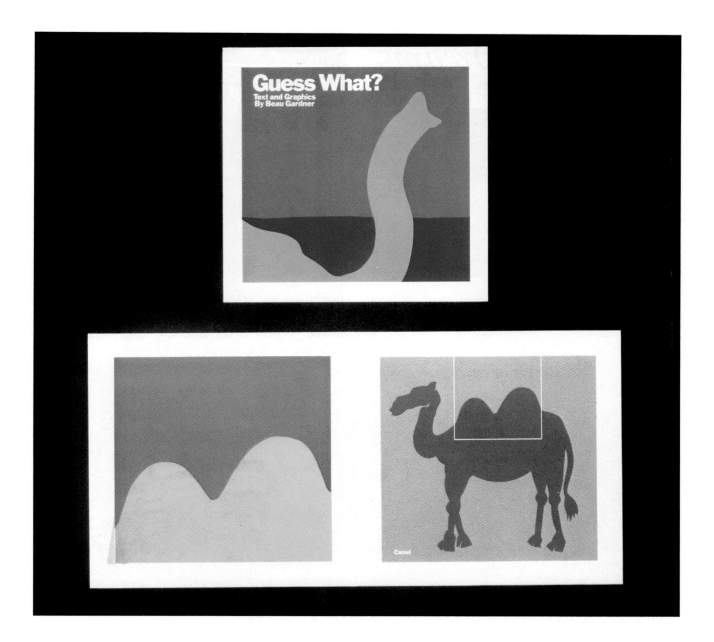

796

Silver Award

Art Director	Steven R. Grigg
Designer	Steven R. Grigg
Illustrator	Laurie Downing
Writer	F. Nephi Grigg
Agency	Tandem Studios, Salt Lake City, UT
Client	F. Nephi Grigg
Publisher	F. Nephi Grigg
Type	Whipple & Associates

Distinctive Merit

Art Director	Charles R. Gailis
Designer	Charles R. Gailis, Susan Martz
Illustrator	Susan Martz
Writer	IRS Technical Publications Branch
Editor	IRS Taxpayer Service Division
Agency	Sparkman & Batholomew
	Associates, Washington, DC
Client	IRS Design Group
Publisher	IRS Publishing Services Branch
Publication	Understanding Taxes 1986

Distinctive Merit

Art Director Sara Eisenman
Designer Marc Cohen
Illustrator Marc Cohen
Writer Hob Broun
Editor Gordon Lish
Client Alfred A. Knopf
Publisher Alfred A. Knopf, New York, NY

800

Art Director Neil Stuart
Designer Paul Gamarello
Publisher Viking Penguin Inc., New York, NY

801

Art Director Marjorie Anderson
Designer Marjorie Anderson
Photographer Wilma Ervin
Publisher Times Books, New York, NY

802

Art Director Louise Fili
Designer Louise Fili
Illustrator Robert Goldstrom
Editor Dan Cullen
Publisher Pantheon Books, New York, NY

803

Art Director Jackie Merri Meyer
Designer Fred Marcellino
Illustrator Fred Marcellino
Editor Lindley Boeghoeld
Publisher Macmillan Publishing Company,
New York, NY

826

Art Director	Alex Gotfryd
Designer	Michael Flanagan

827

Art Director	Judith Loeser
Designer	David Botwinik

846

Art Director	Tod Seisser
Photographer	Greg Gorman
Writer	Stephanie Arnold
Agency	Levine, Huntley, Schmidt & Beaver, New York, NY
Client	McCall's

847

Art Director	Robert C. Lyons
Designer	Robert C. Lyons
Illustrator	Robert C. Lyons
Creative Director	Nick Nappi
Agency	Serino, Coyne & Nappi, New York, NY
Client	Jack Garfein & Byron Lasky

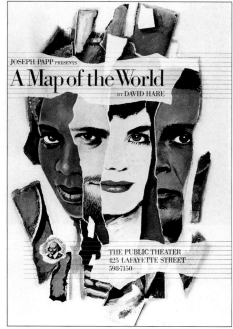

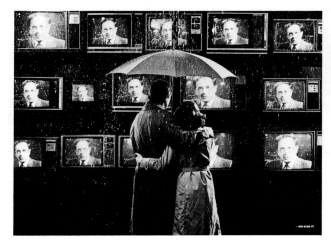

848

Art Director	Paul Davis
Designer	Paul Davis/José Conde
Illustrator	Paul Davis/Paul Davis Studio, New York, NY
Client	Joseph Papp's New York Shakespeare Festival

849

Art Director	Ken Zierler
Photographer	David Langley
Writer	Jim Bosha
Agency	Della Femina, Travisano & Partners Inc., New York, NY
Client	David LaFountaine

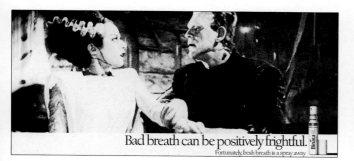

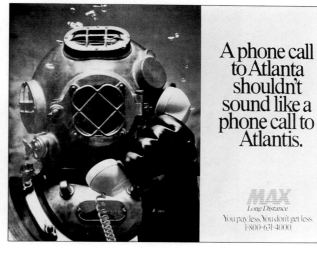

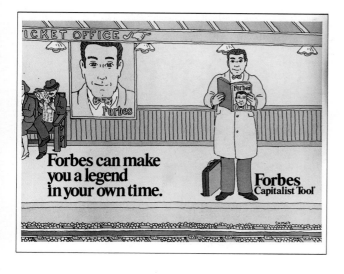

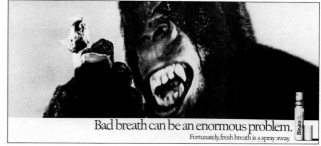

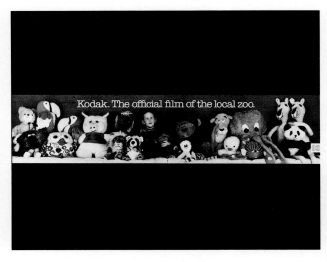

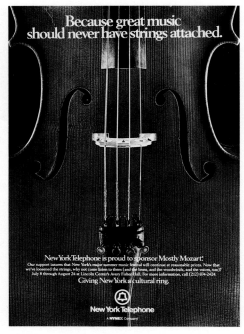

858

Art Director	Geoff Hayes
Illustrator	Andy Warhol
Writer	Evert Cilliers
Agency	TBWA Advertising, Inc., New York, NY
Client	Carillon Importers, Ltd.
Concept	Michael Roux, President, Carillon Importers, Ltd.

859

Art Director	Jeff Layton
Designer	Jeff Layton
Illustrator	Sharpshooter Productions/Bullet Graphics
Writer	Jim Catlin
Creative Director	Keith Hillmer
Agency	Grey Advertising Ltd., Toronto, Canada
Client	Airwick of Canada Ltd.
Production Manager	Ian McLean

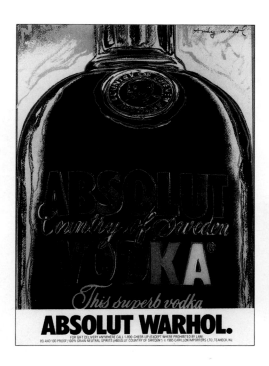

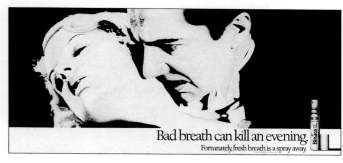

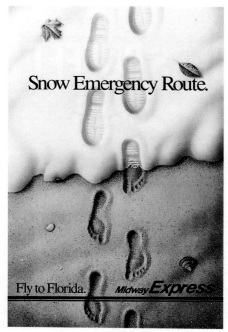

860

Art Director	Terrell Daniels
Illustrator	Dan Craig
Writer	Patrick Hanlon
Creative Director	Bill Mueller
Agency	Campbell-Mithun, Inc., Minneapolis, MN
Client	Midway Airlines, Midway Express

Distinctive Merit

Art Director McRay Magleby
Designer McRay Magleby
Illustrator McRay Magleby
Agency BYU Graphics, Provo, UT
Client Shoshin Society, Washington, DC
Silkscreener Rob Carawan

Art Director Craig Thompson, Memphis, TN
Designer Craig Thompson
Illustrator David Moses
Writer Craig Thompson
Client Traffic Safety Coordinating
 Commitee
Separations DCR Graphics

Art Director Bob Dennard
Designer Bob Dennard
Illustrator Bryan Collins
Writer Bible, David Martin
Editor David Martin
Agency Dennard Creative, Inc., Dallas, TX
Client Shoshin Society

Art Director Art Paul
Designer Art Paul
Writer Suzanne Seed
Agency Art Paul Design, Chicago, IL
Client The Shoshin Society
Printer Congress Printing Co.

Art Director Keith Helmetag
Agency Keith Helmetag Designs, New
 York, NY
Client New York Vietnam Veterans
 Memorial Commission/Robert
 Santos
Architects Peter Wormser & William Fellows

870

Art Director	Don Weller
Designer	Don Weller
Illustrator	Don Weller
Writer	Don Weller
Agency	The Weller Institute for the Cure of Design, Inc., Park City, UT
Client	Shoshin Society
Publisher	The Weller Institute for the Cure of Design, Inc.

871

Art Director	Milton Glaser
Designer	Milton Glaser
Illustrator	Milton Glaser
Studio	Milton Glaser Inc., New York, NY
Client	Indiana State University School of Music

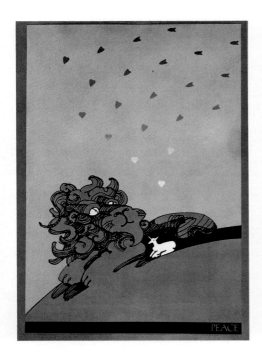

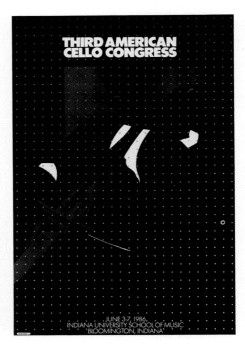

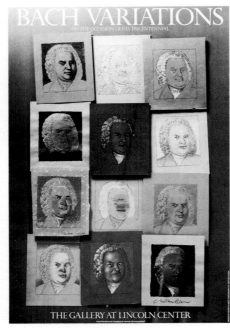

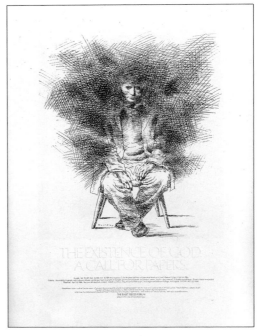

872

Art Director	Milton Glaser
Designer	Milton Glaser
Illustrator	Milton Glaser
Photographer	Matthew Klein
Studio	Milton Glaser Inc., New York, NY
Client	Lincoln Center, United Technologies

873

Art Director	Donna Griffin Albert
Illustrator	Brad Holland
Writer	Joseph Palmo, Pittsburgh, PA
Client	Basic Issues Forum, Washington and Jefferson College

874

Art Director	Milton Glaser
Designer	Milton Glaser
Illustrator	Milton Glaser
Director	Charles Michael Helmken
Publisher	The Shoshin Society, Washington, DC
Printer	Virginia Lithograph

875

Art Director	Bob Conge
Designer	Bob Conge
Illustrator	Bob Conge
Agency	Conge Design, Rochester, NY
Client	Community College of the Finger Lakes

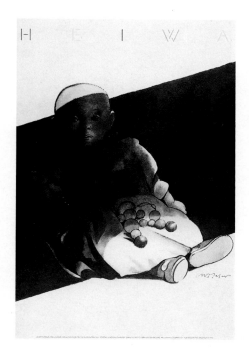

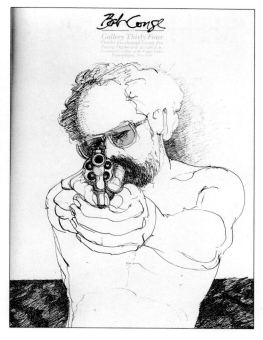

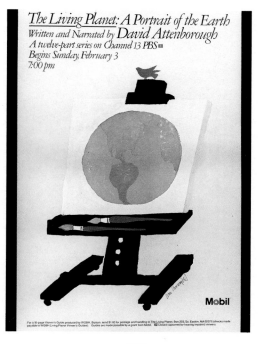

876

Art Director	Thomas A. Thill
Designer	Thomas A. Thill
Illustrator	William Sackston Atkinson, Sherman Foote Denton, Charles Bradford Hudson, Kumataro Ito, Kako Mortia, Henry Raschen
Agency	National Museum of Natural History—Office of Exhibits, Washington, DC
Client	Smithsonian Institution Traveling Exhibition Service

877

Art Director	Ivan Chermayeff
Designer	Ivan Chermayeff
Agency	Chermayeff & Geismar Associates, New York, NY
Client	Sandra Ruch—Mobil Oil Corporation

878

Art Director | Ron Sandilands
Illustrator | Larry Duke
Writer | Bernie Hafeli
Agency | Livingston & Company, Seattle, WA
Client | Seattle Aquarium

879

Art Director | Richard Varney
Designer | Richard Varney
Agency | Dept of Design, University of Kansas, Lawrence, KS
Client | Hallmark Symposium, Department of Design, the University of Kansas

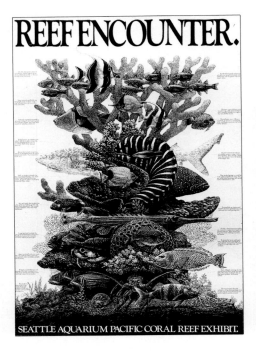

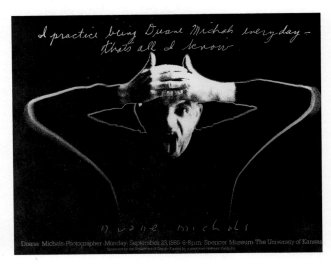

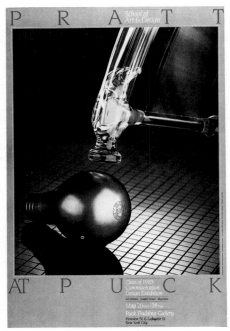

880

Art Director | Minoru Morita, Gerry Contreras
Designer | Minoru Morita
Illustrator | Guy Kudo, Milon Townsend
Photographer | KAN
Director | Gerry Contreras
Agency | Creative Center, Inc., New York, NY
Client | Pratt Institute

Silver Award

Art Director	Randall Hensley
Designer	Stephen Wolf
Illustrator	Soren Arutunyan, Carol Ferrante
Agency	Muir Cornelius Moore, New York, NY
Client	IBM Entry Systems Division: Gary Conrad, Lee Green, Steve Mendonca

Distinctive Merit

Art Director Luis Acevedo
Designer Luis Acevedo
Illustrator Luis Acevedo
Writer Luis Acevedo/Woody Pirtle
Agency Pirtle Design, Dallas, TX
Client Cobb & Friend

Art Director Chris Hill
Designer Chris Hill, Margaret Kim, Jeffrey
 Mckay
Illustrator Regan Dunnick
Agency Hill/A Marketing Design Group,
 Houston, TX
Client The Shoshin Society

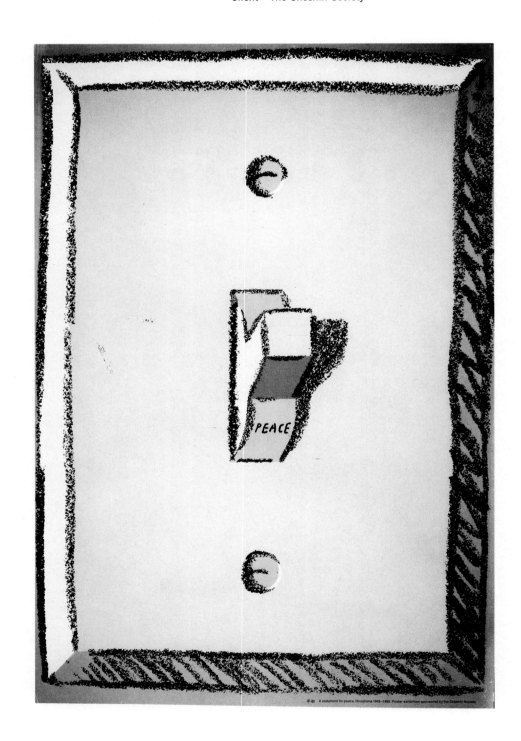

Distinctive Merit

Art Director	Saul Bass
Designer	Saul Bass, Art Goodman
Illustrator	Saul Bass, Art Goodman
Agency	Saul Bass/Herb Yager and Associates, Los Angeles, CA
Client	Sinfonia Varsovia

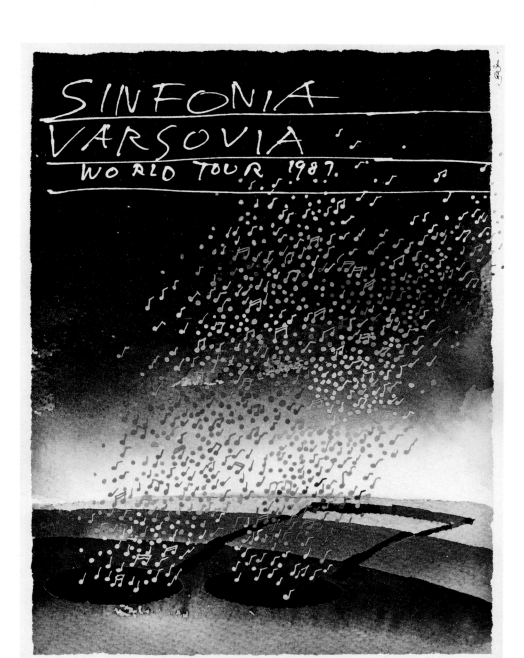

Distinctive Merit

Art Director Woody Pirtle
Designer Woody Pirtle/Jeff Weithman
Illustrator Jeff Weithman
Agency Pirtle Design, Dallas, TX
Client Dallas Society of Visual
Communications

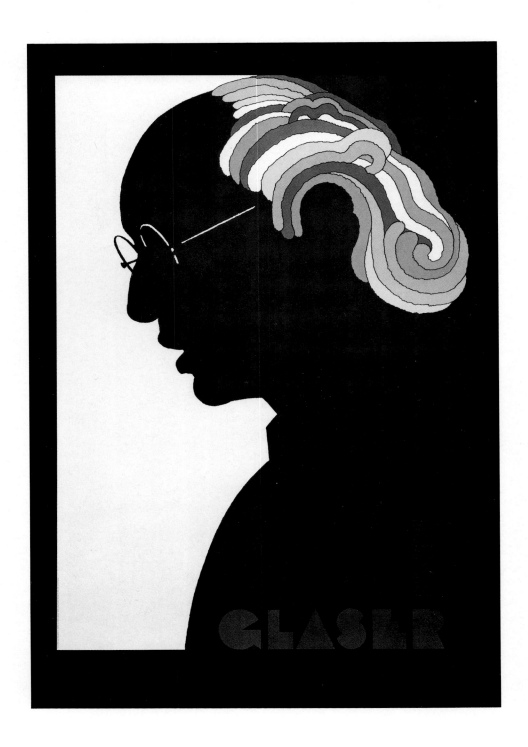

887
Art Director	Gordon Mortensen
Designer	Gordon Mortensen
Photographer	Bettmann Archive, New York
Writer	Gordon Mortensen
Agency	Mortensen Design, Palo Alto, CA
Client	Shoshin Society
Printer	Spectrum Serigraphy

888
Art Director	Neil Shakery
Designer	Neil Shakery
Photographer	Terry Heffernan
Agency	Jonson Pedersen Hinrichs & Shakery, San Francisco, CA
Client	Stanford Alumni Association

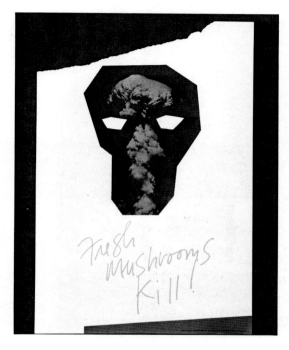

889
Art Director	Cheryl Heller
Designer	Cheryl Heller
Photographer	STAK
Writer	Peter Caroline
Agency	Design Group, HBM/Creamer-Boston, MA
Client	S. D. Warren Paper Co.

890
Art Director	Gregory Cutshaw
Designer	Gregory Cutshaw
Writer	Gregory Cutshaw
Editor	Julie C. Bergman
Agency	ICON, Dayton, OH
Client	Gregory Cutshaw
Type	DWC Enterprises

891

Art Director	Pam Conboy
Illustrator	Pam Conboy
Writer	Craig McNamara
Agency	Bozell, Jacobs, Kenyon & Eckhardt/ Minneapolis, MN
Client	Radisson Hotel Corporation

892

Art Director	Susan Slover
Designer	Thomas Bricker
Studio	Susan Slover Design, New York, NY
Client	Block Island Historical Society

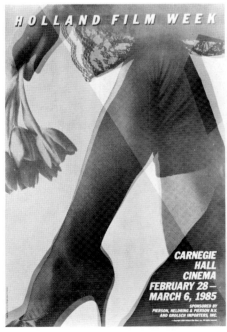

893

Art Director	Linda Stanger
Designer	Linda Stanger
Illustrator	Linda Stanger
Photographer	Steven Dolce
Agency	Linda Stanger Graphics, New York, NY
Client	Shelby Stone, Holland Film Week

894

Art Director	Chris Rovillo
Designer	Diana McKnight
Illustrator	Steve Pietzsch
Agency	Richards Brock Miller Mitchell & Associates, Dallas, TX
Client	Dallas Symphony Orchestra

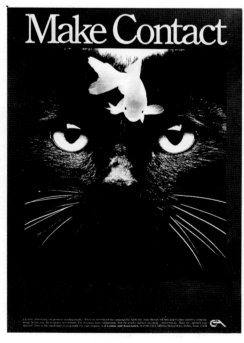

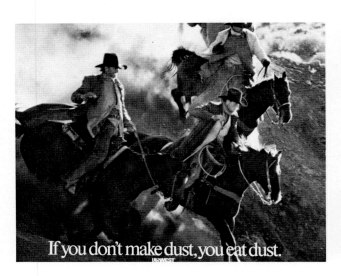

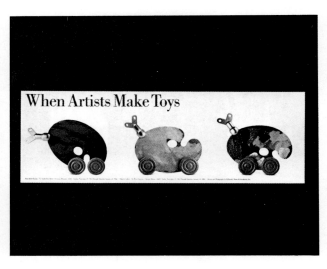

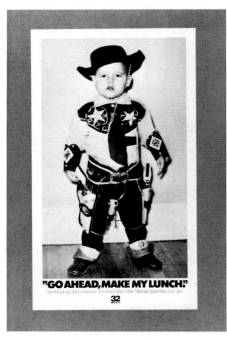

903

Art Director	Saul Bass
Designer	Saul Bass, Art Goodman
Illustrator	Saul Bass
Agency	Saul Bass/Herb Yager and Associates, Los Angeles, CA
Client	Friends of Independence National Historic Park

904

Art Director	Pat Burnham
Photographer	Archive
Writer	Bill Miller
Agency	Fallon McElligott, Minneapolis, MN
Client	US West

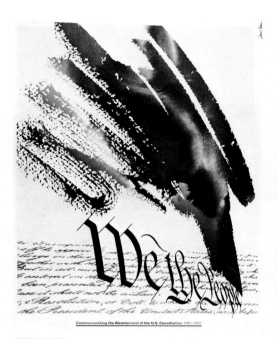

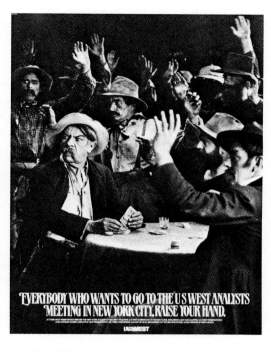

905

Art Director	Pat Samata
Designer	Pat and Greg Samata
Illustrator	Greg Samata
Agency	Samata Associates, Dundee, IL
Client	The Parker Pen Company
Printer	Great Northern Design Printing Co.

906

Art Director	Chris Hill
Designer	Chris Hill, Jeffrey Mckay
Illustrator	Regan Dunnick
Agency	Hill/A Marketing Design Group, Houston, TX
Client	Dunnick/Hill Productions

Designer	Seymour Chwast
Illustrator	Seymour Chwast
Director	Charles M. Helmken, Shoshin Society
Client	Shoshin Society, Washington, DC

Art Director	Steve Mitsch
Photographer	Clint Clemens
Writer	Frank Fleizach
Agency	HCM, New York, NY
Client	Alfa Romeo, Inc.

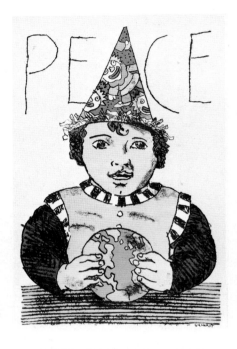

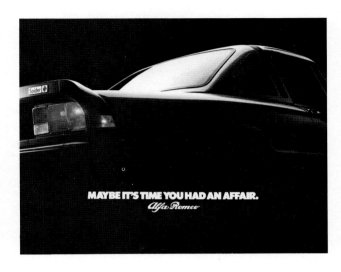

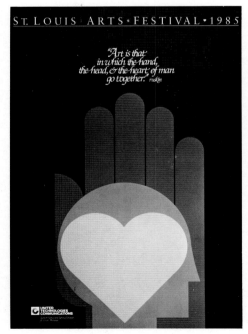

 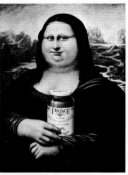

909

Art Director	Robert J. Falk, Jr.
Designer	Robert J. Falk, Jr.
Illustrator	Robert J. Falk, Jr.
Agency	The Robert Falk Group, Inc., St. Louis, MO
Client	United Technologies Communications

910

Art Director	Bob Barrie
Illustrator	Leonardo Da Vinci, Dick & Mark Hess
Writer	John Stingley
Agency	Fallon McElligott, Minneapolis, MN
Client	Prince Foods Canning Division

911

Art Director	Kathryn M. Anderson
Designer	Terry Winfield
Photographer	Carl Fowler, Mark Molesky
Client	Design Photography, Inc., Cleveland, OH

912

Art Director	Roby Odom
Designer	Roby Odom
Illustrator	Roby Odom
Writer	Mark Perkins
Creative Director	Marianne Tombaugh
Agency	The Hay Agency, Inc., Dallas, TX
Client	Lomas & Nettleton

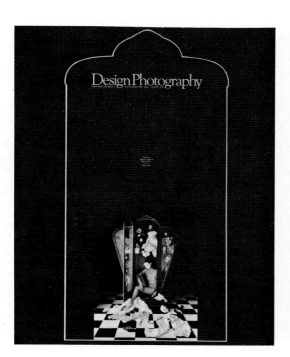

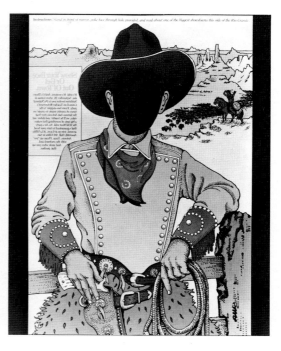

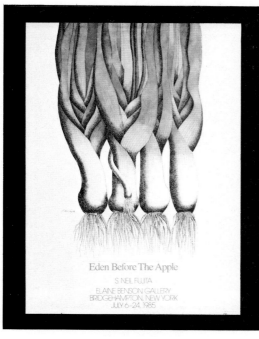

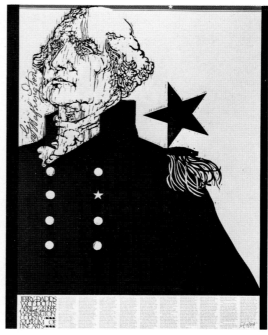

913

Art Director	S. Neil Fujita
Designer	S. Neil Fujita
Illustrator	S. Neil Fujita
Writer	Ruth Haberstroh
Agency	S. Neil Fujita Design, Inc., New York, NY
Client	S. Neil Fujita/Elaine Benson

914

Art Director	Jerry Dadds
Designer	Jerry Dadds
Illustrator	Jerry Dadds
Agency	Eucalyptus Tree Studio, Baltimore, MD
Client	Washington County Museum of Fine Arts

915

Art Director	Thomas J. Weisz
Photographer	Donald Dempsey-White Light
Design Firm	Weisz & Yang, Inc., Westport, CT
Client	Connecticut Art Directors Club
Printer	Sanders Printing

916

Art Director	Rob Dalton
Photographer	Stock
Writer	Sam Avery
Agency	Fallon McElligott, Minneapolis, MN
Client	WFLD-TV

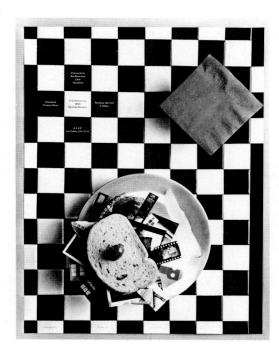

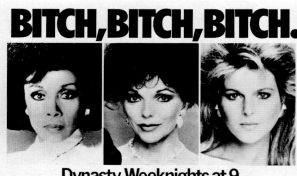

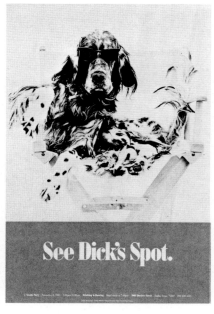

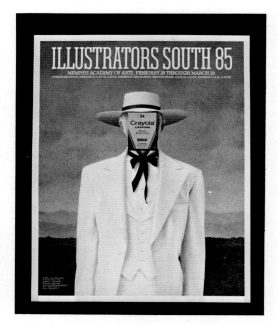

917

Art Director	James Good
Designer	James Good
Photographer	Dick Clintsman
Writer	Mary V. Kiernan
Agency	Good Design, Dallas, TX
Client	C Studio
Printer	Williamson Printing Corporation

918

Art Director	Eddie Tucker
Designer	Eddie Tucker
Illustrator	Danny Smythe
Creative Director	Eddie Tucker
Agency	Ward Archer and Associates, Memphis, TN
Client	Illustrators South

919

Art Director	Seymour Chwast
Designer	Seymour Chwast
Illustrator	Seymour Chwast
Publisher	Doubleday & Company, Inc., New York, NY

920

Art Director	Pat Burnham
Photographer	Joe Pytka
Writer	Bill Miller
Agency	Fallon McElligott, Minneapolis, MN
Client	US West

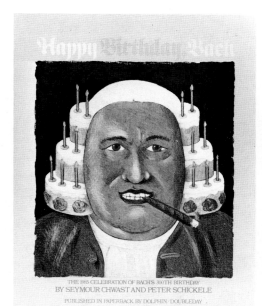

921

Art Director	David Brannan/Clemente Conde
Designer	Clemente Conde
Photographer	Image Bank
Writer	Charles Dickens
Agency	Design Elements, Inc., Lexington, KY
Client	IBM/Raleigh
Printer	Central Printing Co., Dayton, OH

922

Art Director	Ulrich Ruchti
Designer	Ulrich Ruchti
Agency	RF&R Design, New York, NY
Client	Len Schweitzer, Whirlpool Foundation

931

Art Director	Michael Fazende
Photographer	Rick Dublin
Writer	Jarl Olsen
Agency	Fallon McElligott, Minneapolis, MN
Client	WFLD-TV

932

Art Director	Bob Olson
Designer	Bob Olson
Photographer	Dale Windham
Agency	Boeing Presentation Center, Seattle, WA
Client	Museum of Flight/Pacific N.W. Section AIAA

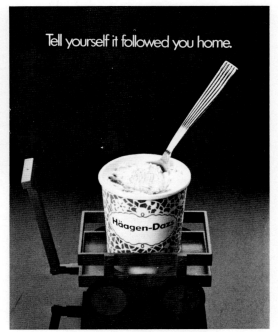

933

Art Director	Tom Kelly
Photographer	Jerry LaRocca
Writer	Bill Borders
Agency	Borders, Perrin & Norrander, Inc., Portland, OR
Client	9018 Corporation

934

Art Director	Brian Harrod
Photographer	Bert Bell
Writer	Ian Mirlin
Agency	Miller Myers Bruce DallaCosta Harrod Mirlin Inc., Advertising, Toronto, Canada
Client	William Neilson Ltd.
Studio	John O'Connell

935

Art Director	Bob Ankers, David Gauger
Designer	Bob Ankers, David Gauger
Illustrator	Bob Ankers
Writer	David Gauger, Ed Dembowski
Agency	Gauger & Silva, Inc., San Francisco, CA
Client	Bellwether, Inc.
Printer	Dai Nippon Printing Co., Ltd.

936

Art Director	Karen Madsen, Darrell Peterson
Designer	Karen Madsen
Photographer	Darrell Peterson
Agency	Karen Madsen Graphic Design, Seattle, WA
Client	Metropolitan Health Club
Lithographer	Printing Control
Type	Thomas & Kennedy

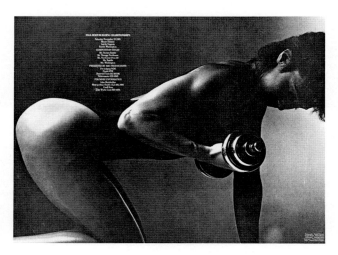

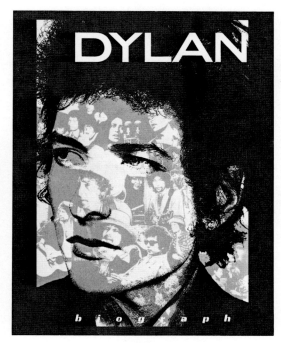

937

Art Director	Bob Barrie
Illustrator	Leland Klanderman
Writer	Phil Hanft
Agency	Fallon McElligott, Minneapolis, MN
Client	Minnesota Zoo

938

Art Director	Joesphine DiDonato
Designer	Josephine DiDonato
Client	Columbia Records
Publisher	CBS Records, New York, NY

943

Art Director	Ivan Horvath
Photographer	Mike Chesser
Writer	Bob Ancona
Agency	N W Ayer, Los Angeles, CA
Client	Yamaha International Corporation

944

Art Director	Inju Sturgeon
Designer	Ken Parkhurst
Illustrator	Denis Parkhurst
Agency	Ken Parkhurst & Associates, Inc., Los Angeles, CA
Client	U.C.L.A. Summer Sessions
Publisher	U.C.L.A. Extension Dept.

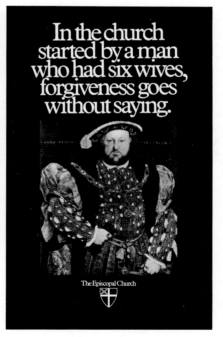

945

Art Director	Mark Anderson
Designer	Colleen Abrams
Photographer	Steve Dunwell/The Image Bank
Agency	Mark Anderson Design, Palo Alto, CA
Client	IBM
Printer	Gore Graphics

946

Art Director	Nancy Rice
Illustrator	Hans Holbein the Younger
Writer	Tom McElligott
Agency	Fallon McElligott, Minneapolis, MN
Client	Episcopal Ad Project

Art Director	Nancy Davis
Designer	Nancy Davis
Photographer	Gary Nolton
Coordination	Errol M. Beard
Agency	Nancy Davis Design & Illustration, Portland, OR
Client	Oregon Special Olympics
Publisher	Errolgraphics, Inc.
Food Stylist	Carolyn Schirmacher

Art Director	Chris Hill
Designer	Chris Hill, Jeffrey Mckay, Margaret Kim
Agency	Hill/A Marketing Design Group, Houston, TX
Client	The Shoshin Society

949

Art Director	Paul Page
Illustrator	Art Goodman
Writer	Paul Page
Design Firm	Page Design, Inc., Sacramento, CA
Client	Art Directors & Artists Club of Sacramento

950

Art Director	Mark Anderson
Designer	Earl Gee
Agency	Mark Anderson Design, Palo Alto, CA
Client	The Oakland Museum
Printer	Redwood Litho

951

Art Director Woody Pirtle
Designer Woody Pirtle/Jeff Weithman
Illustrator Woody Pirtle
Photographer Jim Olvera
Writer A.I.G.A.
Agency Pirtle Design, Dallas, TX
Client A.I.G.A.

952

Art Director Rob Dalton
Photographer Stock
Writer Sam Avery
Agency Fallon McElligott, Minneapolis, MN
Client WFLD-TV

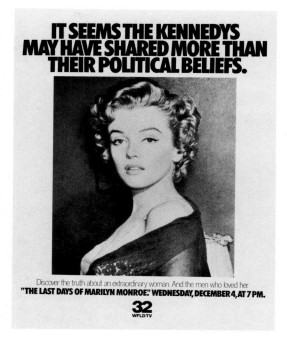

953

Art Director Jeff Laramore
Designer Jeff Laramore
Illustrator Jeff Laramore
Agency Young & Laramore, Indianapolis, IN
Client Somers & Somers, Inc.

954

Art Director Joe Duffy
Designer Joe Duffy
Illustrator Joe Duffy
Agency The Duffy Design Group,
Minneapolis, MN
Client First Tennessee Bank, N.A.

955

Art Director Michael Mabry
Designer Michael Mabry
Illustrator Michael Mabry
Design Firm Michael Mabry Design, San
Francisco, CA
Client California College of Arts and
Crafts
Silkscreener Hisako Moriyama

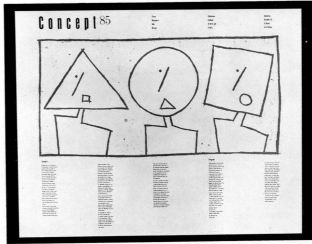

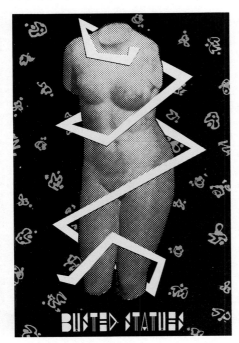

957

Art Director Cody Kinski
Designer Tom Kuchenski
Illustrator Tom Kuchenski
Photographer Unknown (adaptation/
manipulation of photo from a
book)
Agency The Graphic Workshop, Boston,
MA
Client Busted Statues
Printer Kathleen Dempsey, Bob Moses,
Felice Regan

Double-deck bus tours.

The
San Diego
Zoo

Make my day.

Visit
the San Diego
Zoo.

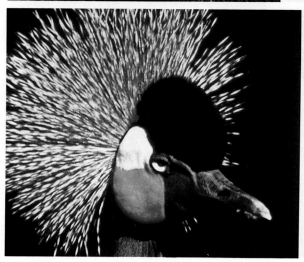

A rare tweet.

The
San Diego
Zoo

Art Director	John Vitro
Designer	Ron Van Buskirk
Illustrator	Disney Studios, George Akimoto
Writer	Rich Badami, Tony Durket
Client	The Disney Channel
Agency	Phillips-Ramsey Adv., San Diego, CA
Account Executive	Elizabeth Bell, Barbara Ostrand

Art Director	Sally Wagner
Photographer	Kent Severson
Writer	Emily Scott
Agency	Martin/Williams, Minneapolis, MN
Client	Bakers Square West

Art Director	Danny Boone
Designer	Danny Boone
Photographer	Stock photos
Writer	Jeanette Tyson
Agency	The Martin Agency, Richmond, VA
Client	City of St. Augustine (Florida)

Art Director	Stan Jones
Writer	Steve Diamant
Creative Director	Bob Kuperman
Agency	Doyle Dane Bernbach, Los Angeles, CA
Production Manager	Barry Brooks
Client	Western Airlines
Account Executive	Candy Deemer, Janine Perkal

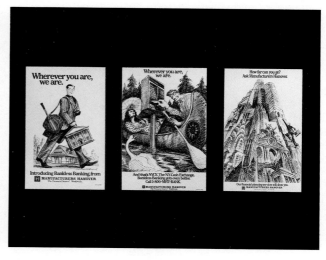

967

Art Director	Gary Goldsmith
Designer	Gary Goldsmith
Photographer	Gil Cope
Writer	Steven Landsberg
Agency	Chiat/Day inc. Advertising, New York, NY
Client	William Grant & Sons

968

Art Director	Ron Louie
Designer	Ron Louie
Photographer	Albert Watson, George Holz
Writer	Alan Jacobs
Agency	Doyle Dane Bernbach, New York, NY
Client	International Gold Corp. Ltd.

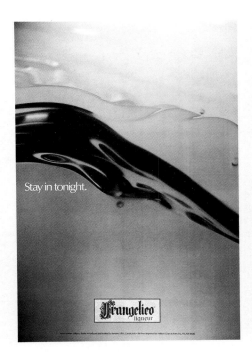

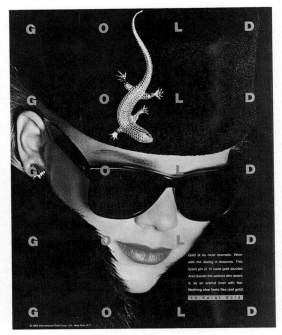

969

Art Director	Ken Zierler
Photographer	David Langley
Writer	Jim Bosha
Agency	Della Femina, Travisano & Partners, New York, NY
Client	David LaFountaine

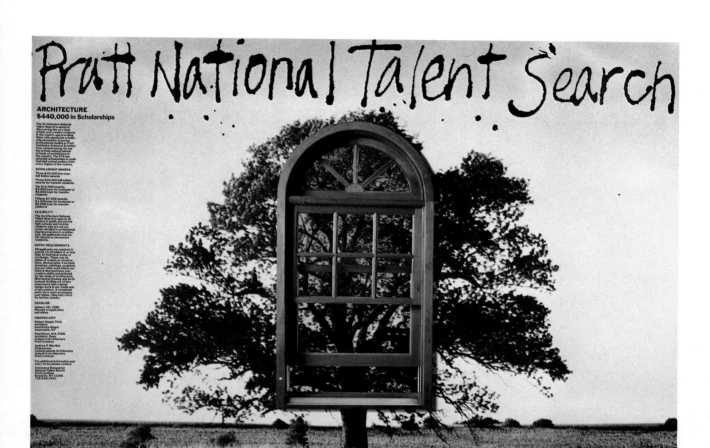

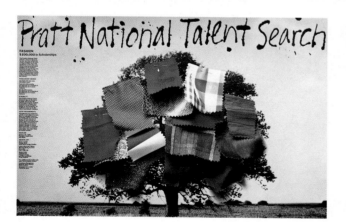

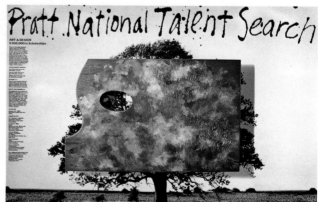

971

Silver Award

Art Director Earl Gee
Designer Earl Gee
Illustrator Earl Gee
Writer Nan Budinger
Editor S. B. Master
Agency Landor Associates, San Francisco, CA
Client The Trauma Foundation

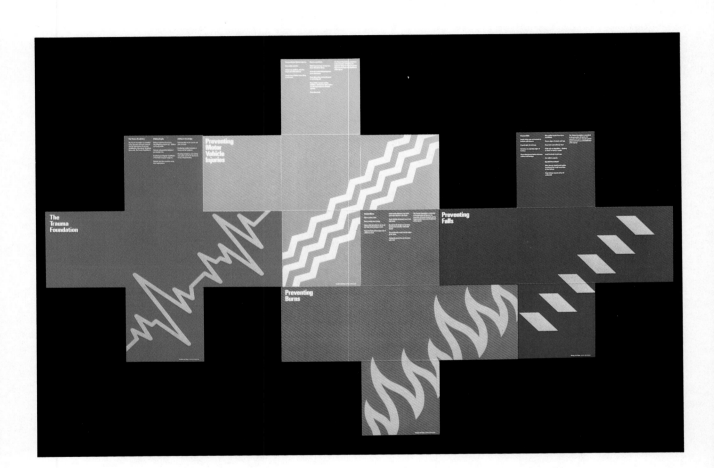

972

Art Director Viki Smith
Photographer George Hausman
Writer Bill Teitlebaum
Agency Howard, Merrell & Partners, Inc.,
 Raleigh, NC
Client Find My Child, Inc.

973

Art Director Anthony Rutka
Designer Anthony Rutka
Artist Albrecht Durer
Writer Joan Lee Weadock
Editor Cynthia K. Moran
Design Firm Rutka Weadock Design, Baltimore,
 MD
Client Drew University

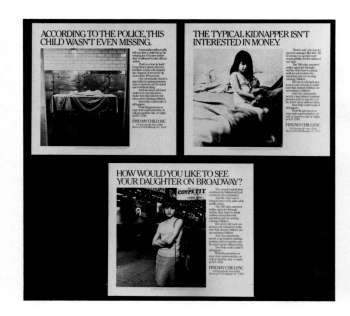

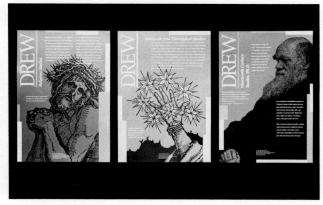

Gold Award

Art Director	McRay Magleby
Designer	McRay Magleby
Illustrator	McRay Magleby
Writer	Norman A. Darais
Agency	BYU Graphics, Provo, UT
Client	Brigham Young University— Registration
Silkscreener	Jed W. Porter

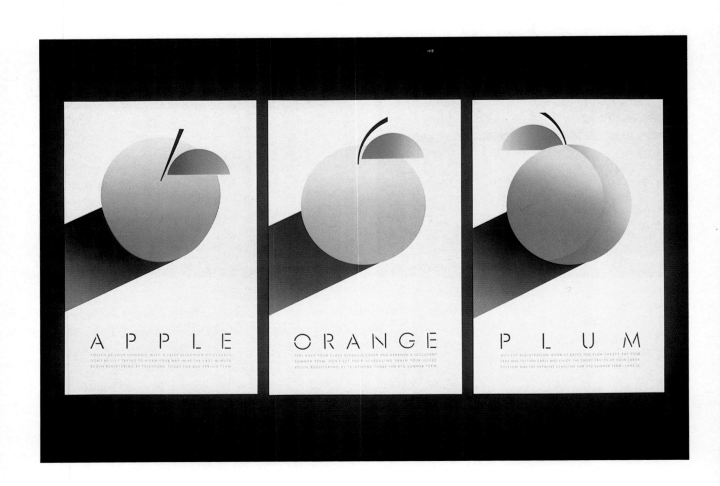

975

Silver Award

Art Director Nancy Rice
Illustrator Hans Holbein, Albrecht Dürer
Photographer Stock
Writer Tom McElligott
Agency Fallon McElligott, Minneapolis, MN
Client Episcopal Ad Project

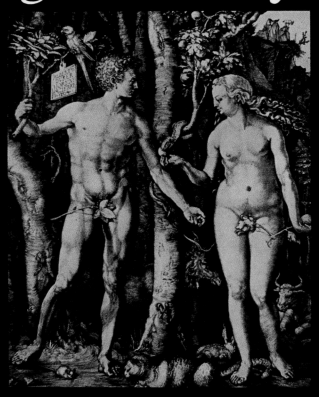

Distinctive Merit

Art Director Larry Corby
Photographer Jay Ahrend
Writer Jack Foster
Agency Foote, Cone & Belding, Los
 Angeles, CA
Executive Creative Director Michael Wagman

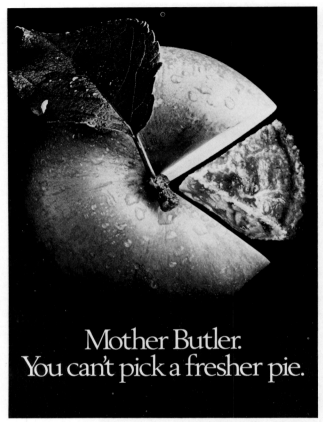

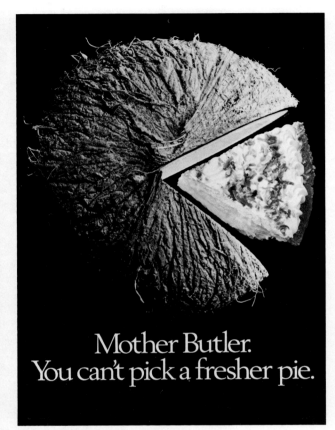

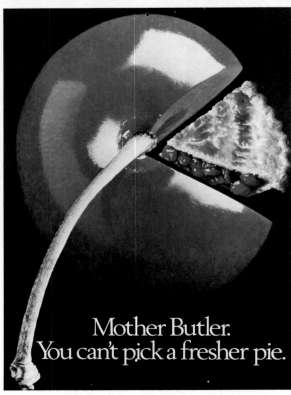

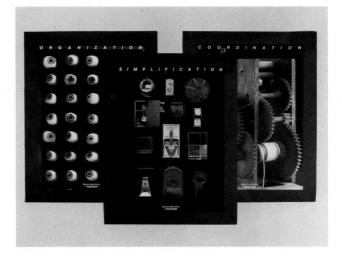

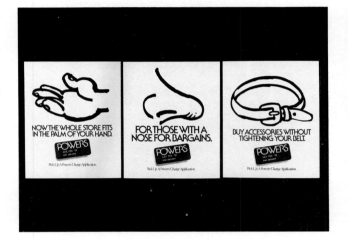

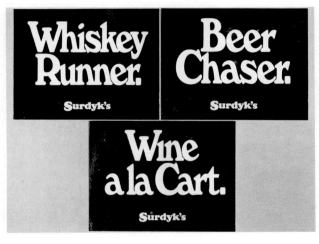

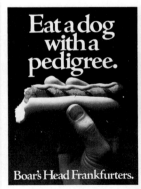

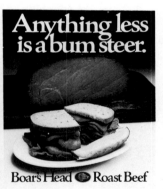

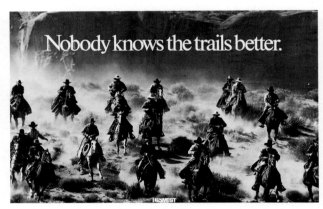

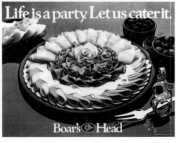

984

Art Director	Liane Sebastian, Michael Waitsman, Lisa Marks-Ellis
Designer	Liane Sebastian, Michael Waitsman, Lisa Marks-Ellis
Illustrator	George Suyeoka, Kermit Berg
Photographer	John Snyder
Director	Cristina Tabora
Agency	Synthesis Concepts, Inc., Chicago, IL
Client	Hyatt International Corporation

985

Art Director	James Jarratt
Designer	James Jarratt
Illustrator	Richard Sparks
Photographer	The Creative Department, Inc.
Writer	Gerard Reimel
Agency	The Creative Department, Inc., Philadelphia, PA
Client	CIGNA Corporation/Bev Widas

986

Art Director	Robert Petrick
Designer	Robert Petrick
Photographer	Various (Stock)
Agency	Burston-Marsteller, Chicago, IL
Client	Beatrice Companies Inc.

llustration

Single entries

Advertising, b&w
Editorial, b&w
Promotion, b&w
Advertising, color
Editorial, color
Promotion, color
Packaging or P.O.P. display
Book or book jacket
Television news graphics

Campaign entries

Advertising campaign, b&w
Advertising campaign, color
Editorial campaign, color
Promotion campaign, color
Packaging or P.O.P. display campaign
Book or book jacket campaign

988

Art Director	Alan Zwiebel
Designer	Alan Zwiebel
Illustrator	Edward Sorel
Writer	Jim Krieger
Agency	Young & Rubicam, New York, NY
Client	Manufacturers-Hanover

989

Art Director	Jerelle Kraus
Designer	Jerelle Kraus
Illustrator	Brad Holland
Editor	Bob Semple
Client	The New York Times
Publisher	The New York Times, New York, NY
Publication	The New York Times Op-ed page

990

Art Director	Robert Eisner
Designer	Jeff Massaro/G. Viskupic
Illustrator	Gary Viskupic
Writer	Various staff Business writers
Editor	Warren Berry
Client	Newsday
Publisher	Newsday, Inc., Melville, NY
Publication	Newsday Business section: Status '85
Concept	G. Viskupic

991

Art Director	Jerelle Kraus
Designer	Jerelle Kraus
Illustrator	Rafal Olbinski
Editor	Bob Semple
Client	The New York Times
Publisher	The New York Times, New York, NY
Publication	The New York Times Op-ed page

992

Art Director	James T. Walsh
Illustrator	Carter Goodrich
Client	Emergency Medicine Magazine, New York, NY

993

Art Director	Michael Keegan
Designer	James Forrest
Illustrator	Kenneth Krafchek
Writer	Jane Leavy
Editor	Mary Hadar
Client	The Washington Post
Publication	The Washington Post, Washington, DC

994

Art Director	Donna Albano
Designer	Donna Albano
Illustrator	Alexa Grace
Writer	Nora Frenkiel
Editor	Jan Warrington
Publication	The Baltimore Sun, Baltimore, MD

995

Art Director	Robert Eisner
Designer	Warren Weilbacher
Illustrator	Gary Viskupic
Writer	David Gold
Editor	Nina King
Client	Newsday
Publisher	Newsday, Inc., Melville, NY
Publication	Newsday "Book Section"
Concept	G. Viskupic

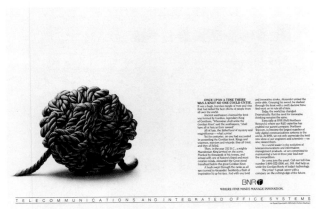

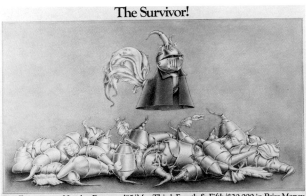

1000

Silver Award

Art Director Louise Kollenbaum
Designer Dian-Aziza Ooka
Illustrator Matt Mahurin
Publication Mother Jones Magazine, San
Francisco, CA

MOTHER JONES

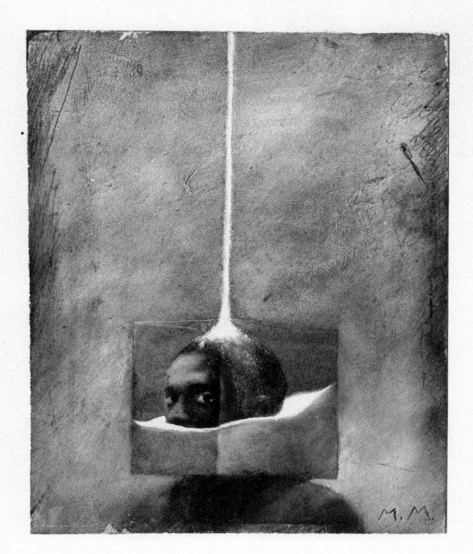

APARTHEID

JANUARY 1985
33

1001

Art Director	Wayne Fitzpatrick
Designer	Wayne Fitzpatrick
Illustrator	Andrzej Dudzinski
Writer	Sarah Rabkin
Editor	Allen Hammond
Client	SCIENCE 85/AAAS
Publisher	William Carey
Publication	SCIENCE 85 Magazine, Washington, DC

1002

Art Director	Mary Ellen Vehlow and Karen Dodds
Designer	Mary Ellen Vehlow and Karen Dodds
Illustrator	Sheldon Greenberg
Editor	Margaret Yao
Client	Mortgage Bankers Association
Publication	Mortgage Banking Magazine
Graphic Design Firm	Dual Impressions, Washington, DC

1003

Art Director	Amy Seissler
Designer	Amy Seissler
Illustrator	Armodio
Publisher	Bob Guccione
Publication	Omni Magazine, New York, NY
Graphics Director	Frank M. DeVino

1004

Art Director	Everett Halvorsen
Designer	Ronda Kass
Illustrator	Edward Sorel, New York, NY
Writer	Edward Sorel
Editor	Sheldon Zalaznick
Publication	Forbes

1005

Art Director Ken Kendrick
Designer Richard Samperi
Illustrator Anita Kunz
Client The New York Times Magazine
Publisher The New York Times, New York,
 NY
Publication The New York Times

1006

Art Director David Lesh
Designer David Lesh
Illustrator David Lesh, Indianapolis, IN
Director Charles Michael Helmken
Client Shoshin Society
Printer The Hennegan Company

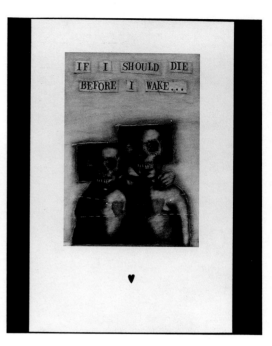

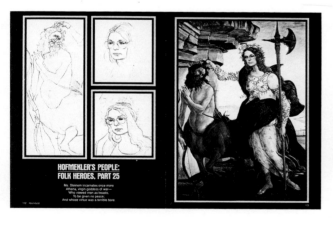

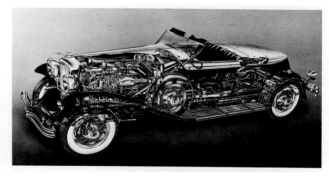

1007

Art Director Richard Bleiweiss
Designer Daryl Philips
Illustrator Ori Hofmekler
Publication Penthouse, New York, NY
Graphics Director Frank DeVino

1008

Art Director Michael Pardo
Illustrator David Kimble
Photographer Neil Nissing
Client Automobile Quarterly, Princeton,
 NJ
Publisher L. Scott Bailey

1009

Art Director Robert Best
Designer Robert Best, Josh Gosfield
Illustrator Robert Goldstrom
Publication New York Magazine, New York, NY

1010

Art Director Susan Edelman/Sara-Jo Matthys
Designer John Sposato
Artist John Sposato, New York, NY
Client Dell Champion Wordplay
Publisher Dell Magazines
Publication Dell Champion Wordplay

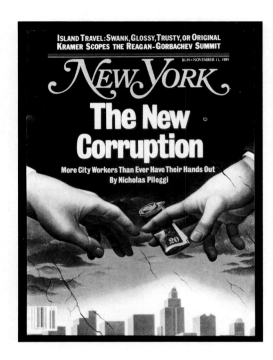

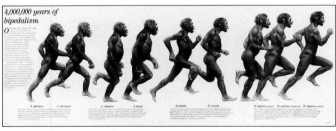

1011

Art Director J. Robert Teringo
Illustrator Jay H. Matternes
Editor Wilbur E. Garrett
Publication National Geographic Magazine,
 Washington, DC

1012

Art Director Steve Black
Designer Ted Lodigensky
Illustrator Ted Lodigensky
Editor James Rogers
Publisher Scientific American Magazine,
 New York, NY
Publication Scientific American Magazine

1013

Art Director	Jan Adkins
Illustrator	Richard Schlecht
Editor	Wilbur E. Garrett
Publication	National Geographic Magazine, Washington, DC

1014

Art Director	Sara Christensen
Designer	Sara Christensen
Illustrator	Mark Penberthy
Editor	Elizabeth H. Dossett
Agency	13-30 Corporation, Knoxville, TN
Publication	Veterinary Practice Management
Senior Art Director	Bett McLean

1015

Art Director	Jan Adkins
Illustrator	Richard Schlecht
Editor	Wilbur E. Garrett
Publication	National Geographic Magazine, Washington, DC

1016

Art Director	Douglas Steinbauer
Designer	Douglas Steinbauer
Illustrator	Peter de Seve
Writer	Mark Reiter
Editor	Bard Lindeman
Publisher	Whitney Communications Company, New York, NY
Publication	50 Plus

1017

Art Director Malcolm Frouman/Sharon Bystrek
Designer Sharon Bystrek
Illustrator Douglas Fraser
Client Business Week Magazine
Publisher McGraw Hill, New York, NY

1018

Art Director Sara Christensen
Designer Sara Christensen
Illustrator Jean Tuttle
Editor George Spencer
Agency 13-30 Corporation, Knoxville, TN
Publication Best of Business
Senior Art Director Bett McLean

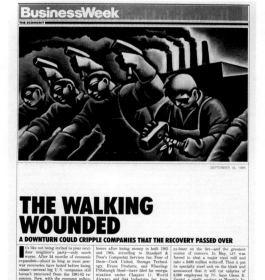

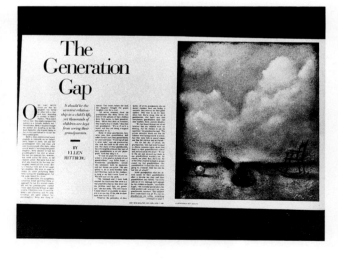

1019

Art Director Malcolm Frouman/Sharon Bystrek
Designer Sharon Bystrek
Illustrator Douglas Fraser
Client Business Week Magazine
Publisher McGraw Hill, New York, NY

1020

Art Director Thomas Ruis, Janet Froelich
Designer Thomas Ruis, Janet Froelich
Illustrator Matt Mahurin
Writer Ellen Rittberg
Editor Pucci Meyer
Publisher N.Y. Daily News, New York, NY
Publication Daily News Magazine

1021

Art Director Tom Staebler
Designer Kerig Pope
Illustrator José Luis Cuevas
Writer Sergio Ramirez
Publisher Playboy Enterprises, Inc., Chicago, IL
Publication Playboy Magazine: "Even Charles Atlas Dies"

1022

Art Director Louise Kollenbaum
Designer Dian-Aziza Ooka
Illustrator Matt Mahurin
Publication Mother Jones Magazine, San Francisco, CA

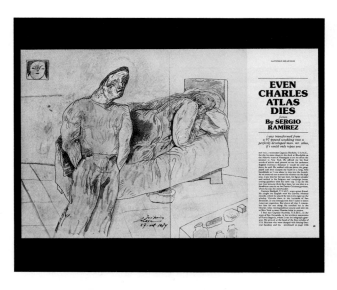

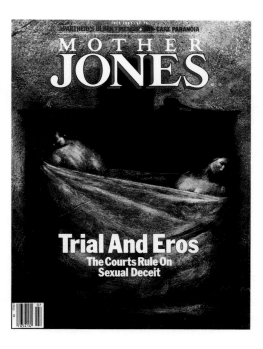

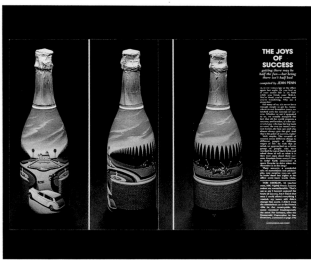

1023

Art Director Tom Staebler
Designer Bruce Hansen
Illustrator John O'Leary
Writer Jean Penn
Publisher Playboy Enterprises, Inc., Chicago, IL
Publication Playboy Magazine: "The Joys of Success"

1024

Art Director Tina Adamek
Illustrator Frances Jetter
Client The Physician and Sportsmedicine
Publisher McGraw-Hill Publishing, Minneapolis, MN

1033

Art Director	Ken Kendrick
Designer	Ken Kendrick
Illustrator	Anita Kunz
Writer	Betty Friedan
Publisher	The New York Times, New York, NY
Publication	The New York Times Magazine

1034

Art Director	Dave Steinlicht
Illustrator	Judy Pedersen, New York, NY
Publication	TWA Ambassador

1035

Art Director	Dugald Stermer
Designer	Veronique Vienne/Dugald Stermer
Illustrator	Dugald Stermer
Editor	Hal Silverman
Client	California Living
Publisher	San Francisco Examiner, San Francisco, CA
Publication	California Living

1036

Art Director	Shelley Williams
Designer	Joan Thomas
Illustrator	Bob Zuba
Writer	David Widner
Editor	Scott Pemberton
Client	13-30 Corporation
Publisher	13-30 Corporation, Knoxville, TN
Publication	Tables Magazine

1037

Art Director	Tina Adamek
Illustrator	Eric Fowler
Client	The Physician and Sportsmedicine
Publisher	McGraw-Hill Publishing, Minneapolis, MN

1038

Art Director	Judy Garlan
Illustrator	Brad Holland, New York, NY
Publication	The Atlantic Monthly

1039

Art Director	Rosslyn A. Frick
Illustrator	Eugene Mihaesco
Editor	Philip R. Lemmons
Publisher	Harry L. Brown
Publication	Byte Magazine, McGraw-Hill, Peterborough, NH

1040

Art Director	Derek W. Ungless
Illustrator	Javier Romero
Writer	Mark Coleman
Agency	Javier Romero Design, New York, NY
Publisher	Rolling Stone Magazine
Handlettering	(Records) by Javier Romero

1041

Art Director Bill Prochnow
Illustrator Brad Holland, New York, NY
Publication Sierra Magazine

1042

Art Director Tina Adamek
Illustrator Dale Gottlieb
Client Postgraduate Medicine
Publisher McGraw-Hill Publishing,
 Minneapolis, MN

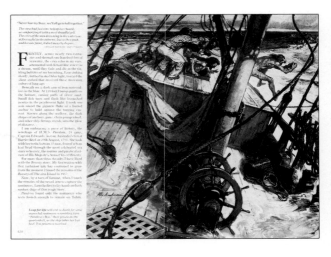

1043

Art Director Amy Seissler
Designer Dwayne Flinchum
Illustrator Etienne Sandorfi
Publisher Bob Guccione
Publication Omni Magazine, New York, NY
Graphics Director Frank M. DeVino

1044

Art Director Jan Adkins
Illustrator Roy Andersen
Editor Wilbur E. Garrett
Publication National Geographic Magazine,
 Washington, DC

1045

Art Director Allen Carroll
Illustrator Ned Seidler
Editor Wilbur E. Garrett
Publication National Geographic Magazine,
Washington, DC

1046

Art Director Amy Seissler
Designer Amy Seissler
Illustrator Evelyn Taylor
Publisher Bob Guccione
Publication Omni Magazine, New York, NY
Graphics Director Frank M. DeVino

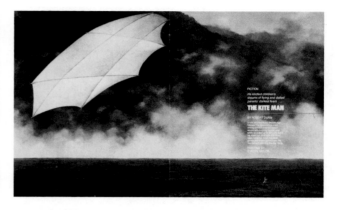

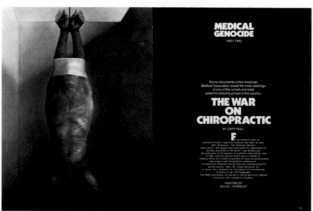

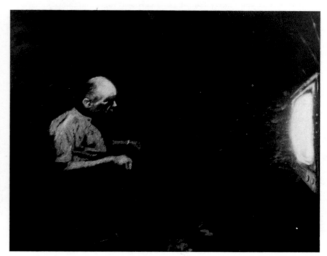

1047

Art Director Richard Bleiweiss
Designer Susan Wilder
Illustrator Michel Henricot
Publication Penthouse, New York, NY
Graphics Director Frank M. DeVino

1048

Art Director Paul Leibow
Designer Paul Leibow
Illustrator Paul Leibow
Agency Leibow Studios, Englewood, NJ
Client Paul Leibow

1102

Silver Award

Art Director	Norman Green/Glen Groglio
Designer	Norman Green
Illustrator	Norman Green
Writer	Jon L. Peterson
Design Firm	Jerry Anton, Inc., New York, NY
Client	Botanic Garden Seed Company, Inc.
Publisher	Botanic Garden Seed Company, Inc.

POPPY
· Minimum contents: 7200 pure seeds ·

·YARROW·
· Minimum contents: 6200 pure seeds ·

CORNFLOWER
· Minimum contents: 214 pure seeds ·

BLACK·EYED·SUSAN
· Minimum contents: 3800 pure seeds ·

GAZANIA
· Minimum contents: 285 pure seeds ·

BISHOP'S·WEED
· Minimum contents: 1900 pure seeds ·

1103

Art Director	Michael Weymouth, Peter Feinstein
Designer	Tom Laidlaw
Illustrator	David Lesh, Indianapolis, IN
Client	Biogen

1104

Art Director	David Frackelton
Designer	Steven Pannici
Illustrator	Seth Jaben
Writer	Marta Mellinger
Agency	Optima Group, New Haven, CT
Client	Cognitive Systems Inc.

Distinctive Merit

Art Director Susan Lusk
Designer Robin Peterson
Illustrator Robin Peterson
Publisher Harold Steinberg/Chelsea House
Publishers, New York, NY

1109

Art Director Ann Remen Willis
Illustrator Mary Jane Begin, Pelham, NY
Client Kirchoff/Wohlberg Inc.
Publisher Laidlaw, a division of Doubleday

1110

Art Director	John Morrison
Photographer	Tom Berthiaume
Agency	Fallon McElligot Rice, Minneapolis, MN
Client	AMF

1111

Art Director	Coco Connelly
Photographer	Tom Berthiaume
Agency	Carmichael-Lynch, Minneapolis, MN
Client	Jostens

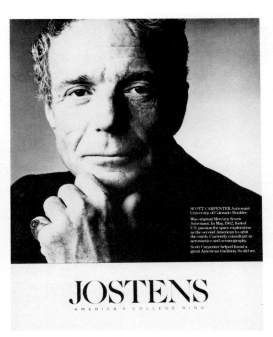

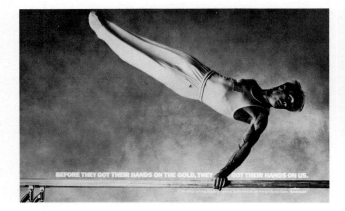

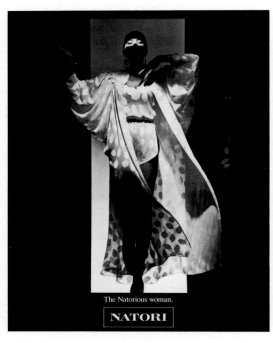

1112

Art Director	Walter Kaprielian
Designer	Walter Kaprielian
Photographer	Skrebneski
Writer	Robert Fearon
Agency	Kaprielian O'Leary Advertising, New York, NY
Client	Natori

1113

Art Director	Mark Weinberg
Designer	Bob Guccione, Jr.
Photographer	Anton Corbijn
Writer	Deidre O'Donoghue
Publication	Spin Magazine, New York, NY
Photo Editor	George DuBose

1114

Art Director	Don Rubin, Boston, MA
Photographer	Don Rubin
Production	M. A. Williamson
Publication	Stuff Magazine

1115

Art Director	Richard Kilmer/Mark Geer
Photographer	Michael Schneps
Agency	Taylor, Inc., Houston, TX
Client	Urban Interior Construction
Printer	Butch Lieber
Design Firm	Kilmer/Geer Design

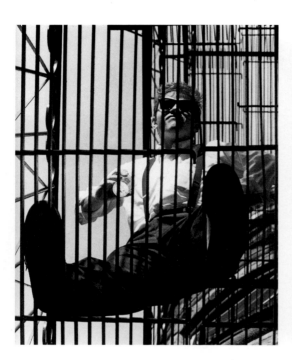

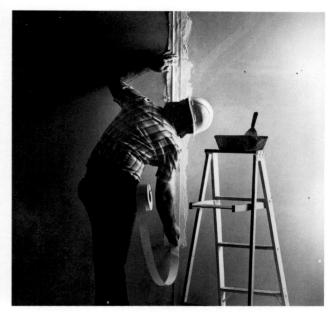

1116

Art Director	Deborah Daly, Marina Del Rey, CA
Designer	Deborah Daly
Photographer	Louise Dahl-Wolfe
Client	Museum of Contemporary Photography, Chicago, IL
Publisher	Jannes Art Publishing

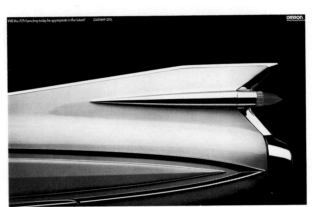

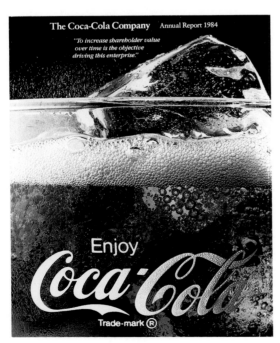

1133

Art Director	Jean Page
Designer	Jean Page
Photographer	Ted Kawalerski, Rochester, NY
Agency	Robert Meyer Design Inc.
Client	Alenax Corporation
Publication	Alenax Bicycle Catalog
Stylist	Jude Oliveri-Burde

1134

Art Director	Peter Paris
Photographer	Greg Pease, Baltimore, MD
Writer	Jack Silverman
Client	Newsweek
Publisher	Jerry Smith

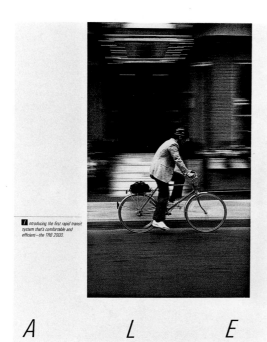

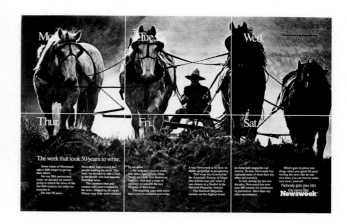

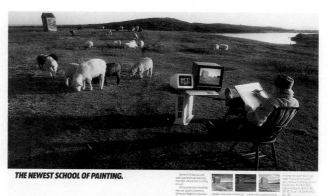

1135

Art Director	Victor Liebert
Photographer	Steen Svensson
Writer	Lesley Teitelbaum
Agency	Ina Kahn, Trevira—In-House, New York, NY
Client	Centennial Textiles, Batya
Publication	New York Times Magazine

1136

Art Director	Bill Monaghan
Photographer	Clint Clemens, Boston, MA
Agency	Schneider, Parker, Jakuc
Client	Digital Equipment Corporation

1137

Silver Award

Art Director	Shinichiro Tora
Designer	Shinichiro Tora
Photographer	Merrell Wood
Writer	Nancy Timmes Engel
Client	CBS Magazines
Publisher	Popular Photography
Publication	Popular Photography, New York, NY
Picture Editor	Monica R. Cipnic

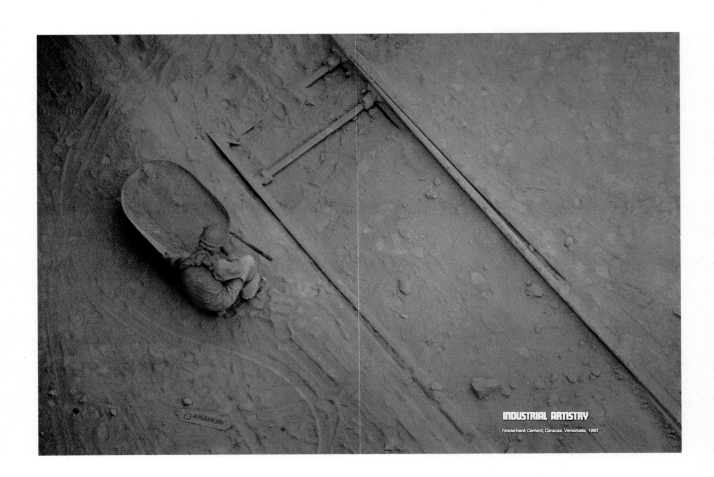

INDUSTRIAL ARTISTRY

Holderbank Cement, Caracas, Venezuela, 1983

1138

Art Director	Modesto J. Torre
Designer	Donna Bonavita
Photographer	John Uher
Publisher	The McCall Publishing Co., New York, NY
Publication	McCall's Magazine

1139

Art Director	Einar Vinje
Designer	Einar Vinje
Photographer	Pete Turner
Writer	Eileen Koontz
Editor	Eileen Koontz
Design Firm	Einar Vinje Design Studio, San Francisco, CA
Client	Pacific Telesis Group
Publisher	Pacific Telesis Group
Publication	1984 Annual Report, Pacific Telesis Group

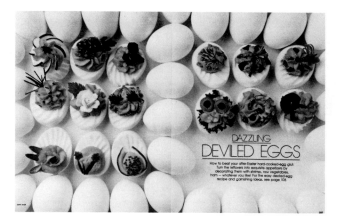

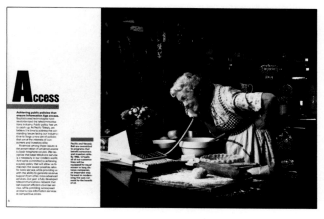

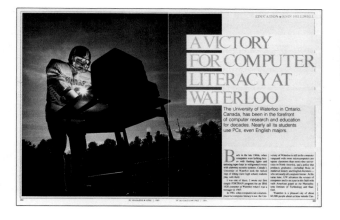

1140

Art Director	Mary Zisk
Designer	Louise White
Photographer	Brian Smale
Publisher	Ziff-Davis Publishing Company, New York, NY
Publication	PC Magazine

1141

Art Director	Robert L. Lascaro
Designer	Amy Madwed
Photographer	Roberto Brosan
Publisher	Ziff-Davis Publishing Co., New York, NY
Publication	Computers & Electronics

1142

Art Director	Tina Adamek
Photographer	Tim Davis
Client	The Physician and Sportsmedicine
Publisher	McGraw-Hill Publishing, Minneapolis, MN

1143

Art Director	Einar Vinje
Designer	Einar Vinje
Photographer	Pete Turner
Writer	Eileen Koontz
Editor	Eileen Koontz
Design Firm	Einar Vinje Design Studio, San Francisco, CA
Client	Pacific Telesis Group
Publisher	Pacific Telesis Group
Publication	Pacific Telesis Group, 1984 Annual Report

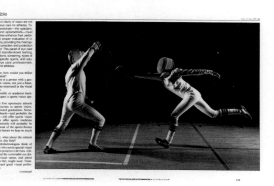

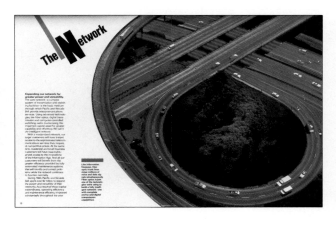

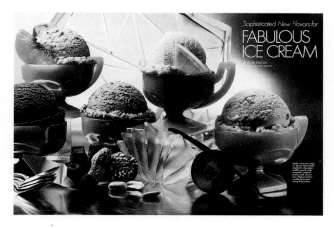

1144

Art Director	Bernard Rotondo
Photographer	Irwin Horowitz
Editor	William J. Garry
Publisher	Knapp Communications, Los Angeles, CA
Publication	Bon Appetit

1145

Art Director	Mark Jensen
Photographer	Robert Lorenz
Editor	Patrick Kenealy
Publisher	Ziff Davis Publishing, New York, NY
Publication	Digital Review

1146

Art Director	Mark Weinberg
Designer	Bob Guccione, Jr.
Photographer	David Michael Kennedy
Writer	Scott Cohen
Publication	Spin Magazine, New York, NY
Photo Editor	George DuBose

1147

Art Director	Jim Groff
Photographer	Frank White Photography, Houston, TX
Editor	Eldon Libby
Client	Shell Oil Company

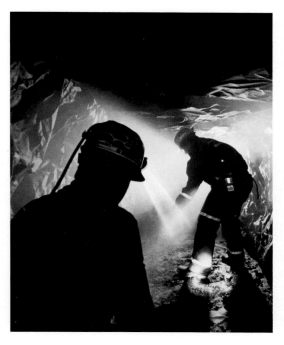

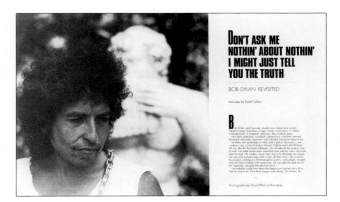

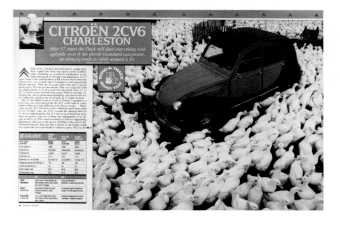

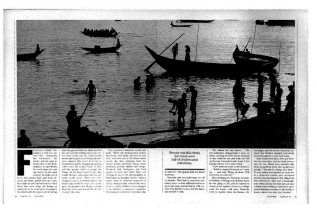

1148

Art Director	Wm. A. Motta
Designer	Richard R. Baron
Photographer	Jeffrey R. Zwart
Writer	Jonathan Thompson
Editor	John Dinkel
Client	Road & Track Magazine
Publisher	CBS Magazine
Publication	Road & Track Magazine, Newport Beach, CA

1149

Art Director	Wayne Fitzpatrick
Designer	Wayne Fitzpatrick
Photographer	Kevin Bubriski/Archive
Writer	June Goodfield
Editor	Allen Hammond
Client	SCIENCE 85/AAAS
Publisher	William Carey
Publication	SCIENCE 85 Magazine, Washington, DC
Photo Editor	Barbara Moir

1150

Art Director	Richard M. Baron
Designer	Richard M. Baron
Photographer	Jeffrey R. Zwart
Writer	Dennis Simanaitis
Editor	Thos. L. Bryant
Client	Road & Track Presents Exotic Cars 3
Publisher	CBS Magazines
Publication	R & T Presents Exotic Cars 3, Newport Beach, CA

1151

Art Director	Mark Jensen
Photographer	Robert Lorenz
Editor	Patrick Kenealy
Publisher	Ziff Davis Publishing, New York, NY
Publication	Digital Review

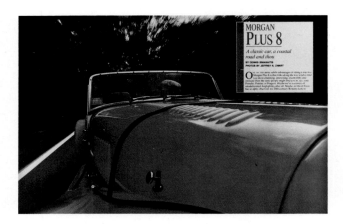

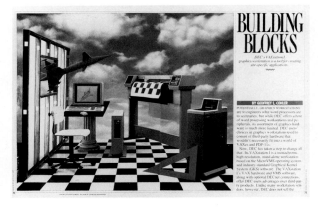

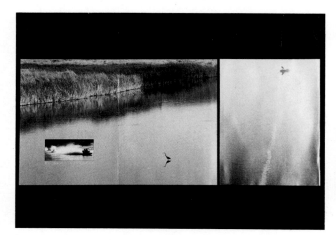

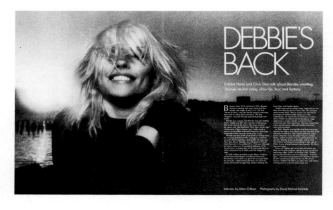

1152

Art Director	Gary Bennett
Photographer	Jack Dykinga
Agency	Arizona Highways Magazine, Phoenix, AZ
Picture Editor	Peter Ensenberger

1153

Art Director	Mark Weinberg
Designer	Bob Guccione, Jr.
Photographer	David Michael Kennedy
Writer	Glenn O'Brien
Publication	Spin Magazine, New York, NY
Photo Editor	George DuBose

1154

Art Director	Richelle J. Huff
Designer	Richelle J. Huff
Photographer	William E. Mathis
Publisher	Penton Publications
Publication	Progressive Architecture, Stamford, CT

1155

Art Director	Suren Ermoyan
Designer	Suren Ermoyan
Photographer	Richard Rodamar
Writer	Peter Oberlink
Editor	John Chervokas
Publisher	Madison Avenue Publishing Corp., New York, NY
Publication	Madison Avenue Magazine

1156

Art Director	Will Hopkins, Ira Friedlander
Photographer	Philippe-Louis Houze
Writer	Tom Hager
Editor	T. George Harris
Agency	Will Hopkins Group, New York, NY
Publisher	Owen J. Lipstein
Publication	American Health

1157

Art Director	Victor Closi
Photographer	Bob Brister
Publisher	CBS Magazines, New York, NY
Publication	Field & Stream Magazine

1158

Art Director John Vandover
Designer Christopher Haller
Photographer Scott Smith
Design Firm Obata Design, Inc., St. Louis, MO
Client Charles F. Knight/David N. Farr, Emerson Electric Co.

1159

Art Director Ken Kendrick
Designer Richard Samperi
Photographer Michael O'Neill
Publisher The New York Times, New York, NY
Publication The New York Times Magazine
Photo Editor Peter Howe

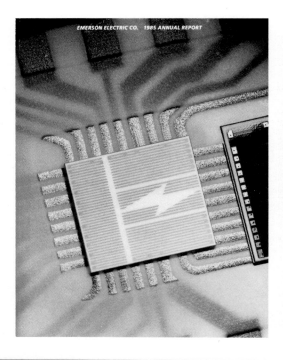

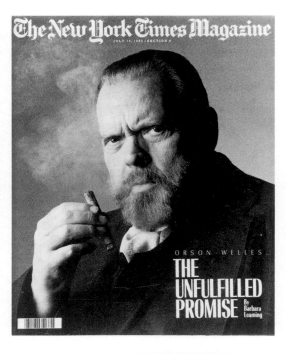

1160

Art Director Michael Valenti
Designer Michael Valenti
Photographer Michael O'Neill
Publisher Hearst Magazines, New York, NY
Publication Science Digest

1161

Art Director Lloyd Ziff
Designer Lloyd Ziff
Photographer Langdon Clay
Writer Suzanne Stephens
Editor Heather Smith MacIsaac
Publisher William F. Bondlow/The Conde Nast Publications, Inc., New York, NY
Publication House & Garden

1162

Gold Award

Art Director Douglas Boyd
Designer Paul Pruneau
Photographer Michael Ruppert
Studio Douglas Boyd Design & Marketing,
Los Angeles, CA
Client Condat Paper Company

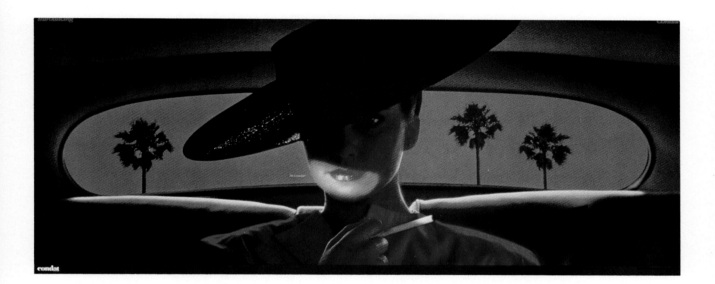

1163

Silver Award

Art Director Kevin McCarthy
Photographer David Kramer
Writer Cheryl Bailey
Agency Reiser Williams deYoung/
 Cunningham & Walsh, Inc., Irvine,
 CA
Client Art Direction and Design in Orange
 County

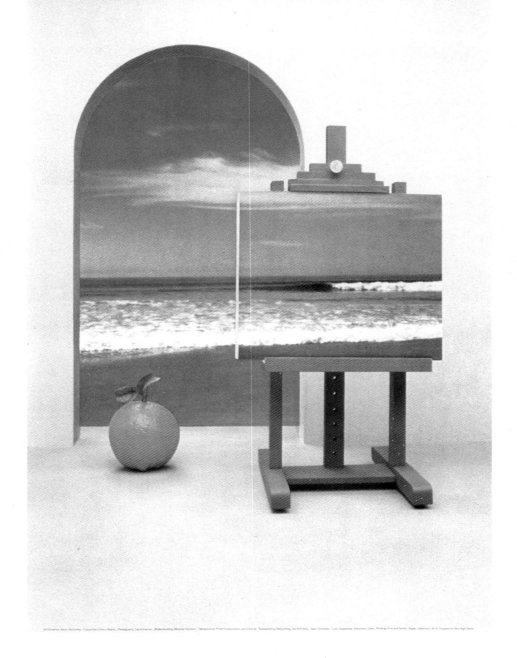

Silver Award

Art Director	Harry De Zitter/Graham Lamont
Designer	Harry De Zitter
Photographer	Harry De Zitter
Agency	Collett Dickenson Pearce
Client	Haig Whiskey/SFW and De Zitter
	Photography, New York, NY
Printer	Beith Process

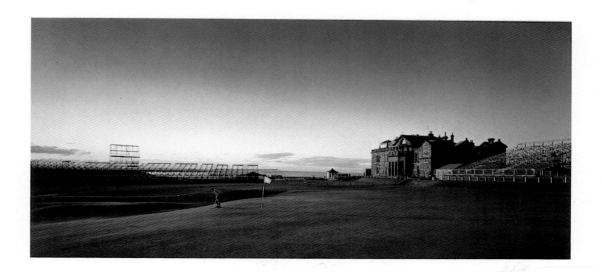

De Zitter Photography, 57 West 19th Street, New York, N.Y. 10011. Tel.(212)242 3124 Telex. 645 334.

New York Representative: Michael Ash. London Representative: Chrissie Andresen. Tel. (01)352 67 81.

1165

Distinctive Merit

Designer	Peter Moore
Photographer	Chuck Kuhn, Seattle, WA
Design Firm	Nike Design
Producer	Francine Gourguechon
Client	Nike

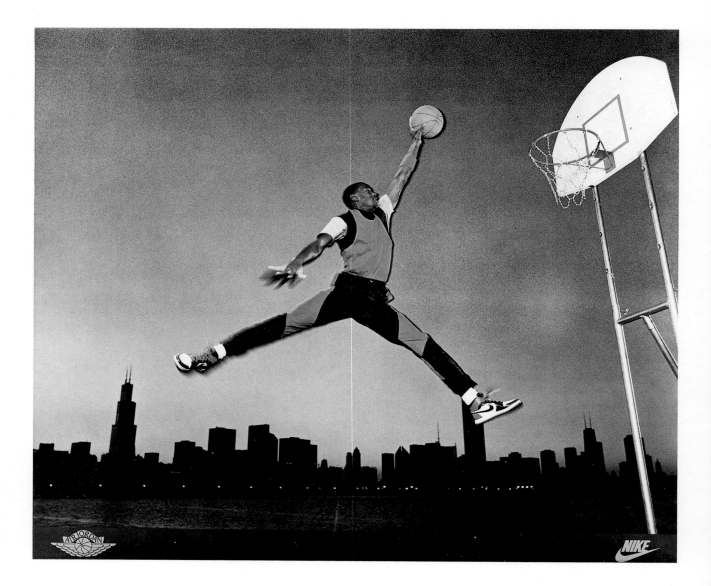

1166

Art Director Jim Raycroft
Poster Design Frank Weitzman
Photographer Ned McCormick
Writer Jim Raycroft/Frank Weitzman
Client Raycroft/McCormick Photography
 Inc., Boston, MA
Printer Prolith Int'l
Prop Stylist Lesley B. Fenton
Backdrop Sammons Associates
Hair & Makeup Pisces Unlimited

1167

Art Director Harry De Zitter
Designer Harry De Zitter
Photographer Harry De Zitter
Client De Zitter Photography, New York,
 NY
Publication Nautical Quarterly
Printer Beith Process

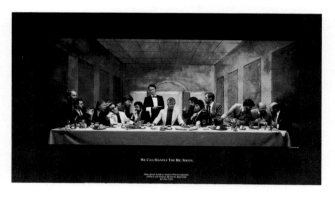

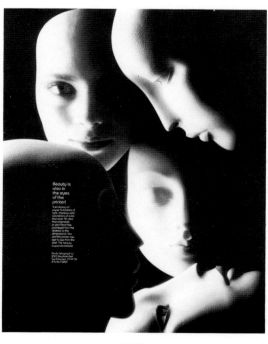

1168

Art Director Jim Moon
Photographer David Tise, San Francisco, CA
Client Pacific Lithograph; Michael John,
 Vice President

1169

Art Director Harry De Zitter
Designer Harry De Zitter
Photographer Harry De Zitter
Publisher De Zitter Photography, New York,
 NY
Publication Nautical Quarterly
Printer Beith Process

1170

Art Director	Joe Baraban
Designer	Bill Carson
Photographer	Joe Baraban
Agency	Lowell Williams Design, Houston, TX
Client	Joe Baraban
Publication	Archive Magazine

1171

Art Director	Walter Kaprielian
Designer	Walter Kaprielian
Photographer	Peter B. Kaplan
Writer	Walter Kaprielian
Agency	Jensen/Boga Inc., New York, NY
Client	Daphne King, Air Jamaica

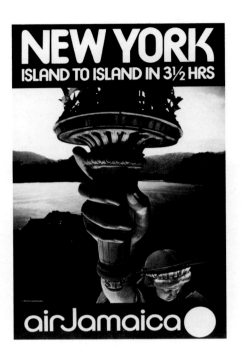

1172

Art Director	Mr. Carmine Ballarino
Photographer	Nick Samardge
Writer	David Rudnitsky
Agency	Dancer Fitzgerald Sample, New York, NY
Client	Entre Computer Center

1173

Art Director	Tyler Smith, Tyler Smith Art Direction, Inc.
Photographer	Clint Clemens, Boston, MA
Client	Sergio Bustamante

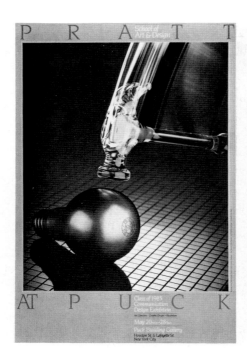

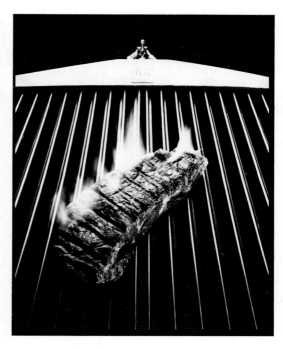

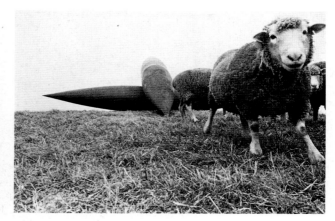

1182

Art Director	John F. Cooper
Designer	Anne Robinson
Photographer	John F. Cooper, Summit, NJ
Client	Windham Hill Productions, Inc.

1183

Art Director	Harry De Zitter
Designer	Harry De Zitter
Photographer	Harry De Zitter
Client	De Zitter Photography, New York, NY
Printer	Beith Process

1184

Art Director	Marsha Loerke
Designer	Marsha Loerke
Photographer	William Huber
Design Firm	Marsha Loerke Design
Client	William Huber Photographer, Boston, MA

1185

Designer	Harper Prints (in house)
Photographer	Jimmy Williams, Jimmy Williams Photography, Raleigh, NC
Client	Jimmy Williams Photography/ Harper Prints
Publication	Harper Prints Calendar

1186

Art Director	Joe Baraban
Designer	Bill Carson
Photographer	Joe Baraban
Agency	Lowell Williams Design, Houston, TX
Client	Joe Baraban
Publication	Archive Magazine

1187

Art Director	Andrew Kner
Photographer	Onofrio Paccione/Paccione Photography, Inc., New York, NY
Client	Carrie Donovan/The New York Times
Printer	Collier Colortype, Inc.

1188

Art Director	Sharon Tooley
Designer	Sharon Tooley Design
Photographer	Frank White
Writer	Paule Sheya Hewlett
Agency	Sharon Tooley Design, Houston, TX
Client	House Reh Architects

1189

Art Director	Kathy Grubb, Ronald Layport
Designer	Kathy Grubb, Ronald Layport
Photographer	Mark May
Writer	Kelly Simmons
Agency	Gray Baumgarten Layport, Inc., Pittsburgh, PA
Client	KDKA-TV 2

1190

Designer Robin Ukes
Photographer Tony Garcia, Los Angeles, CA

1191

Art Director Woody Pirtle, Arthur Meyerson
Designer Woody Pirtle, Mike Schroeder
Photographer Arthur Meyerson
Writer Woody Pirtle
Agency Pirtle Design, Dallas, TX
Client Arthur Meyerson

1192

Art Director Tom Upshur
Photographer Jim Haefner
Creative Director Sean K. Fitzpatrick
Agency Campbell-Ewald Co., Warren, MI
Associate Creative Director Gene Butera

1193

Art Director Harry De Zitter
Designer Harry De Zitter
Photographer Harry De Zitter
Publisher De Zitter Photography, New York, NY
Publication Nautical Quarterly
Printer Beith Process

1194

Art Director	Ralph Senzamici
Designer	Ralph Senzamici
Photographer	Ralph Senzamici
Agency	Raphael Inc., Brooklyn, NY
Fashion Designer	James Dudka

1195

Art Director	Alan Dolgins
Photographer	Alan Dolgins, San Francisco, CA
Client	Studio/Alan Dolgins
Type	Letters, Inc., San Francisco, CA

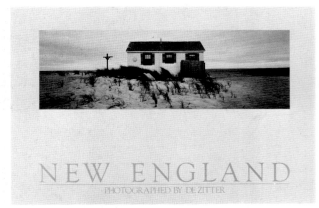

1196

Art Director	Harry De Zitter
Designer	Harry De Zitter
Photographer	Harry De Zitter
Publisher	De Zitter Photography, New York, NY
Publication	Nautical Quarterly
Printer	Beith Process

1197

Art Director	Peter Toth
Photographer	Larry Volbruck
Writer	Don Johnson
Agency	Deere & Company In-House, Moline, IL
Client	Deere & Company

1198

Art Director	Tim Meraz
Designer	Tim Meraz
Photographer	Jeffrey R. Zwart
Director	R. A. Bartkus
Client	Road & Track Magazine
Publisher	CBS Magazines
Publication	Road & Track Magazine, Newport Beach, CA

1199

Art Director	John Katz
Designer	Chris Rovillo
Photographer	John Katz, John Katz Photography, Dallas, TX
Writer	John Katz
Client	John Katz

1200

Art Director	Ken White/Lisa Levin Pogue
Designer	Lisa Levin Pogue/Petrula Vrontikis
Photographer	Jayme Odgers
Agency	White + Associates, Los Angeles, CA
Client	Mead Paper

1201

Art Director	Michael Barile
Photographer	Michael Barile
Agency	Michael Barile & Associates, Oakland, CA
Lithographer	Graphic Impressions

1202

Art Director	Joe Baraban
Designer	Bill Carson
Photographer	Joe Baraban
Agency	Lowell Williams Design, Houston, TX
Client	Joe Baraban
Publication	Archive Magazine

1203

Art Director	Ralph Senzamici
Designer	Ralph Senzamici
Photographer	Ralph Senzamici
Agency	Raphael Inc., Brooklyn, NY
Client	Ralph Senzamici

1204

Art Director	Gene Butera
Photographer	Larry Dale Gordon
Creative Director	Sean K. Fitzpatrick
Agency	Campbell-Ewald Co., Warren MI

1205

Art Director	Harry De Zitter
Designer	Harry De Zitter
Photographer	Harry De Zitter
Publisher	De Zitter Photography, New York, NY
Publication	Nautical Quarterly
Printer	Beith Process

1206

Art Director Ken Ovryn/Chicago
Designer Ken Ovryn
Photographer Bruce Van Inwegen
Client Van Inwegen Photography
Design Firm Ken Ovryn/Chicago, Chicago, IL

1208

Art Director Dean Hanson
Photographer Tom Berthiaume
Agency Fallon McElligott Rice,
 Minneapolis, MN
Client AMF

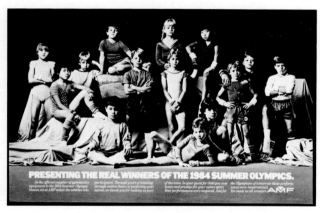

1209

Art Director Carol Friedman
Designer Carin Goldberg
Photographer Carol Friedman
Client Elektra Records, New York, NY

1210

Art Director C. Bryant Loftis
Designer C. Bryant Loftis, Ted Larson
Photographer Gillian Proctor
Agency Cecil West & Associates,
Jacksonville, FL
Client Labatt's Breweries
Engraver Hes Reliance

1211

Art Director Carol Friedman
Designer Janet Perr
Photographer Carol Friedman
Client Elektra Records, New York, NY

1212

Art Director Ron Wolin/Eric Gardner
Designer Anne Paul
Photographer Matthew Rolston
Writer Dudley Fitzpatrick
Creative Director John Mead
Agency Dancer Fitzgerald Sample, Inc./S.
Calif., Torrance, CA
Production Manager Ellee Klics
Client Pioneer Electronics (USA) Inc.
Associate Creative Director Larry Rosenberg

1213

Gold Award

Art Director	Robert J. Post
Designer	Robert J. Post
Photographer	Stephen Shames
Editor	Steven Gittelson
Publisher	WFMT, Inc., Chicago, IL
Publication	Chicago Magazine

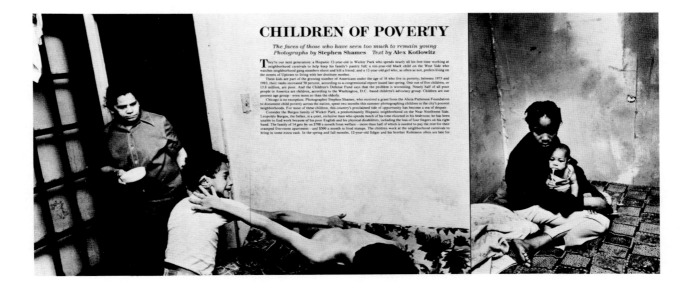

CHILDREN OF POVERTY

The faces of those who have seen too much to remain young
Photographs by Stephen Shames Text by Alex Kotlowitz

They're our next generation: a Hispanic 12-year-old in Wicker Park who spends nearly all his free time working at neighborhood carnivals to help keep his family's pantry full; a ten-year-old black child on the West Side who watches neighborhood gang members shoot and kill a friend; and a 12-year-old girl who, as often as not, prefers living on the streets of Uptown to living with her destitute mother.

These kids are part of the growing number of Americans under the age of 18 who live in poverty; between 1973 and 1983, their ranks increased 50 percent, according to a congressional report issued last spring. One out of five children, or 13.8 million, are poor. And the Children's Defense Fund says that the problem is worsening. Nearly half of all poor people in America are children, according to the Washington, D.C. based children's advocacy group. Children are our poorest age group—even more so than the elderly.

Chicago is no exception. Photographer Stephen Shames, who received a grant from the Alicia Patterson Foundation to document child poverty across the nation, spent two months this summer photographing children in the city's poorest neighborhoods. For most of these children, this country's proclaimed tide of opportunity has become a sea of despair.

Consider the Burgos family of Wicker Park, a predominantly Hispanic neighborhood on the Near Northwest Side. Leopoldo Burgos, the father, is a quiet, reclusive man who spends much of his time closeted in his bedroom; he has been unable to find work because of his poor English and his physical disabilities, including the loss of four fingers on his right hand. The family of 14 gets by on $700 a month from welfare—more than half of which is needed to pay the rent for their cramped five-room apartment—and $500 a month in food stamps. The children work at the neighborhood carnivals to bring in some extra cash. In the spring and fall months, 12-year-old Edgar and his brother Robinson often are late for

1214

Silver Award

Art Director	Shinichiro Tora
Designer	Shinichiro Tora
Photographer	Andre Kertesz
Writer	Harvey V. Fondiller
Client	CBS Magazines
Publisher	CBS Magazines
Publication	Popular Photography, New York, NY
Picture Editor	Monica R. Cipnic

1215
Distinctive Merit

Art Director	Fred Woodward
Designer	Fred Woodward
Photographer	Richard Avedon
Writer	Larry McMurtry
Editor	Gregory Curtis
Agency	Texas Monthly, Austin, TX
Client	Texas Monthly
Publisher	Michael R. Levy
Publication	Texas Monthly

BOYD FORTIN, THIRTEEN-YEAR-OLD RATTLESNAKE SKINNER

Sweetwater, Texas

146 · SEPTEMBER 1985

Photography by Richard Avedon

Faces of the
WEST

In these faces you can see the wind, the sun, and
the heat. You can see the power of the West.

*This is a fictional West. I don't think the West
of these portraits is any more conclusive than
the West of John Wayne.* –RICHARD AVEDON

IN THE SPRING OF 1979 RICHARD Avedon came to Texas and began to make a sequence of portraits. He did not stop in Highland Park or River Oaks, to revisit any of the clothes he had photographed for fashion magazines over the years, but went instead to the Sweetwater Jaycees' Rattlesnake Round-up, where he took a picture of a young man named Boyd Fortin holding a gutted diamondback.

For the next five and a half years, in the summers particularly, Avedon returned to the West. He visited truck stops, rodeos, ranches, mines, and stockyards. He made two remarkable portraits in the San Antonio jail, two more in a mental hospital in New Mexico, several in a Hutterite community in Montana, and four–of extraordinary power–in slaughterhouses.

He photographed miners, drifters, cowhands, roughnecks, couples, teenagers, old folks, and many, many people who would probably be content to be described as just folks.

By late October 1984 he had traveled in seventeen states, photographed 752 people, and created, very much on his own terms, his fictional West. All his Westerners were shot against a sheet of white paper and in natural light because Avedon wanted the "source of light to be invisible so as to neutralize its role in the appearance of things." Whether such lighting plays a neutral role may be questioned, but certainly it is consistent, as the Western sun is not: if a fiction is being made, then the fictionist, whether writer or photographer, has a right to the style of his choice.

Avedon stood beside the camera, close to the person or persons being photographed, seeing them but not the image the camera was about to give him. In a lucid and interesting introduction to *In the American West*, the soon-

INTRODUCTION BY LARRY McMURTRY

TEXAS MONTHLY · 147

1216

Art Director Richard Bleiweiss
Designer Richard Bleiweiss
Photographer David Kennedy
Publication Penthouse, New York, NY
Graphics Director Frank DeVino

1217

Art Director Shinichiro Tora
Designer Shinichiro Tora
Photographer Henri Cartier-Bresson
Writer Arthur Goldsmith
Client CBS Magazines
Publisher Popular Photography
Publication Popular Photography, New York,
 NY
Picture Editor Monica R. Cipnic

1218

Art Director Ken Kendrick
Designer Richard Samperi
Photographer Angel Franco
Publisher The New York Times, New York,
 NY
Publication The New York Times Magazine
Photo Editor Peter Howe

1219

Art Director Greg Paul
Designer Greg Paul
Photographer Roman Sapecki
Editor Lee Fowler
Client New Age Journal, Brighton, MA
Publisher Rising Star Associates

1220

Art Director George Hartman
Photographer Wayne Maser
Editor Phyllis Posnick
Publication Glamour Magazine, New York, NY

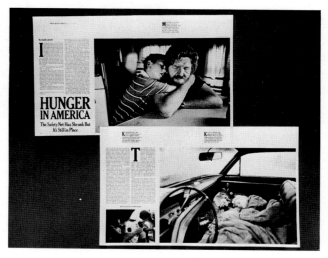

1221

Art Director Ken Kendrick
Designer Ken Kendrick
Photographer Stephen Shames
Client The New York Times Magazine
Publisher The New York Times, New York,
NY
Publication The New York Times
Photo Editor Peter Howe

Art Director Ron Sullivan
Designer Ron Sullivan
Photographer Geof Kern
Writer Mark Perkins
Agency Sullivan/Perkins, Dallas, TX
Client Selwyn School

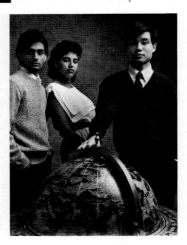

1224

Art Director	Steve Brady
Designer	Smith/Cook Design
Photographer	Steve Brady, Steve Brady Photography, Houston, TX
Writer	Debra K. Maurer and Hildy B. Caplan/Memorial Care Systems
Client	Memorial Care Systems
Publication	Memorial Care Systems Annual Report

1226

Art Director	Mark Geer, Richard Kilmer
Designer	Richard Kilmer, Mark Geer
Photographer	Jim Sims
Writer	Judith Broadhurst
Agency	Kilmer Geer Design, Houston, TX
Client	Big Brothers & Sisters of Houston
Printer	Grover Printing Co.

1227

Art Director	Scott Eggers
Designer	Scott Eggers
Photographer	Jim Sims
Writer	Owen Page
Agency	Richards, Brock, Miller, Mitchell, & Assoc., Dallas, TX
Client	Statex Petroleum

1228

Art Director Lanny Nagler
Designer Cathy Falwell
Photographer Lanny Nagler, Hartford, CT
Client United Way of the Capital Area
Printer W. E. Andrews

1229

Art Director Denny Gagarin
Designer Denny Gagarin
Photographer Butler/Matoso
Writer Denny Gagarin
Agency Lena Chow, Inc., Palo Alto, CA
Client Butler/Matoso
Publisher GraphiCenter

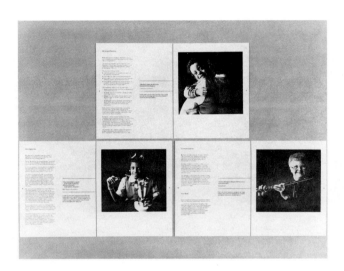

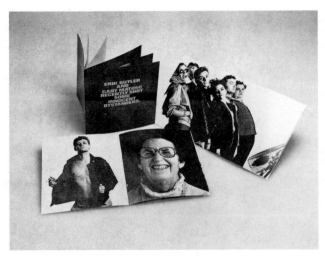

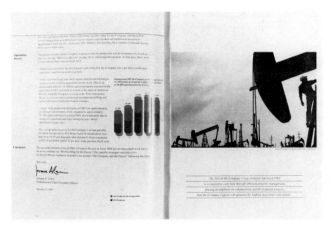

1230

Art Director Joe Baraban
Designer Mike Miller
Photographer Joe Baraban
Agency Genesis, Denver, CO
Client Petro Lewis

1236

Art Director Russ Richter
Photographer Ralph King, Boston, MA
Creative Director Chuck Brunner
Client Parker Brothers

1237

Art Director Lynne Court, Tim Bridger, Mike
 Voornas
Designer Jim Doyle
Illustrator Konrad Kahl
Photographer Vern Hammarlund, Bob Grigg,
 Gerald Trafficanda, Doug Taub,
 Boulevard Photographic, Inc.
Writer Pat Braden, Sam Martin
Creative Director John Mead
Agency Dancer Fitzgerald Sample, Inc./S.
 Calif., Torrance, CA
Production Manager Lois Mallicoat
Client Toyota Motor Sales, U.S.A., Inc.
Associate Creative Director Jim Doyle

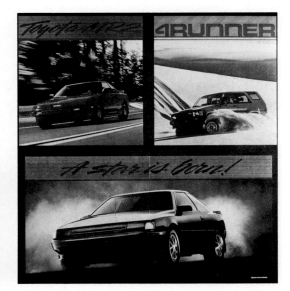

1238

Art Director Mark Geer, Richard Kilmer
Designer Richard Kilmer, Mark Geer
Photographer Jim Sims
Agency Kilmer Geer Design, Houston, TX
Client Howard Gossett

1239

Art Director Mark C. Zapico
Creative Director Noel Nauber
Agency D'Arcy Masius Benton & Bowles,
 Inc., Bloomfield Hills, MI
Client Pontiac Division
Copy Supervisor Paul E. Stawski

1240

Art Director Victor Liebert
Photographer Steen Svensson
Writer Lesley Teitelbaum
Agency Ina Kahn, Trevira-In-House, New
 York, NY
Publication New York Times Magazine

1241

Art Director Paul Cournoyer
Photographer Chuck Kuhn
Writer Michele Stonebraker
Agency Cole & Weber, Seattle, WA
Producer Phyllis Ritting
Client Chateau Ste. Michelle

1258

Silver Award

Art Director Tyler Smith, Tyler Smith Art
 Direction, Inc.
Photographer Clint Clemens, Boston, MA
Client Sergio Bustamante

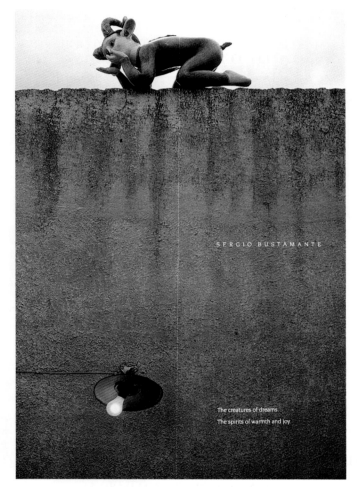

SERGIO BUSTAMANTE

The creatures of dreams.
The spirits of warmth and joy.

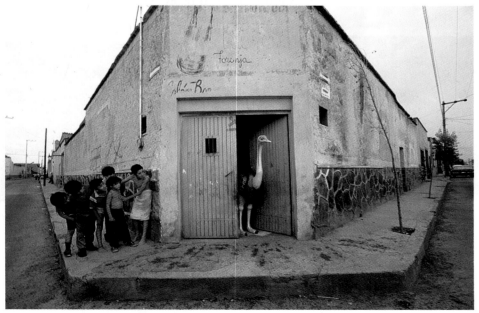

1259

Art Director Joe Baraban
Designer Bill Carson
Photographer Joe Baraban
Agency Lowell Williams Design, Houston, TX
Client Joe Baraban
Publication Archive Magazine

1260

Art Director Gene Butera and Nick Sekulich
Photographer Jim Haefner
Creative Director Sean K. Fitzpatrick
Agency Campbell-Ewald Co., Warren, MI

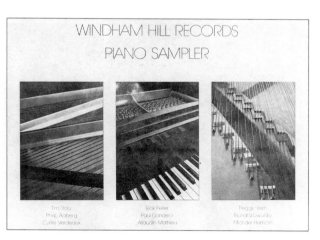

1261

Art Director Arnold Saks
Designer Ingo Scharrenbroich
Photographer Eric Meola, New York, NY
Director Ed Simon
Client Sikorsky Aircraft Co.

1262

Art Director John F. Cooper
Designer Anne Robinson
Photographer John F. Cooper, Summit, NJ
Client Windham Hill Productions, Inc.

1271

Art Director	David Wenman
Designer	Patricia Tobin
Photographer	Andrew Unangst
Writer	Carol Wenman
Agency	David Wenman Associates, Inc., New York, NY
Client	David Wenman Associates, Inc.

1272

Art Director	Jennifer Morla
Designer	Jennifer Morla
Photographer	Elaine Faris Keenan
Agency	Morla Design, San Francisco, CA
Client	Levi Strauss & Co.

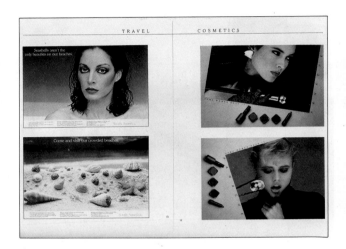

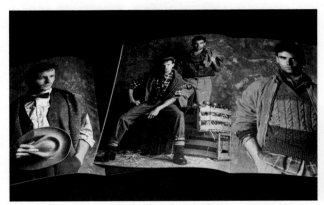

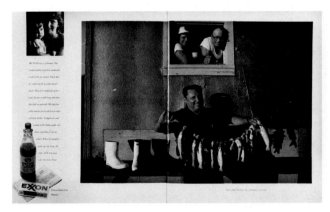

1273

Art Director	Joe Baraban
Designer	Mike Toth
Photographer	Joe Baraban
Writer	Paula Heck
Agency	Toth Design, New Orleans, LA
Client	Upton Printing

1274

Art Director	Brad Ghormley
Designer	Steve Smit
Photographer	Craig Wells, Phoenix, AZ
Writer	Sara Harrell
Client	Noel Plastering & Stucco Inc.
Lithographer	Woods Lithographics

1275

Art Director	Kiyoshi Kanai
Designer	Kiyoshi Kanai
Photographer	Francois Halard
Agency	Kiyoshi Kanai, Inc., New York, NY
Client	Cannon Mills

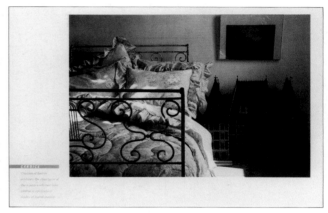

1276

Art Director	Frank White
Photographer	Frank White Photography, Houston, TX
Client	Color Separators, Inc.
Color Separator	Roger Dresch, Color Separators, Inc.

1277

Art Director Steven Sessions
Designer Steven Sessions
Photographer Jim Sims
Writer Greg Bolton
Agency Steven Sessions Design, Houston, TX
Client RMI

1278

Art Director Deborah Sweet
Designer Janis Koy
Photographer Michael Schneps, Houston, TX
Client Tesoro Petroleum Corporation, William M. Sims, V.P.

1279

Designer Conrad Jorgensen
Photographer Terry Heffernan
Agency Jorgensen Design—San Francisco, CA
Client Sinar Camera
Publication 1986 Sinar Calendar

1280

Gold Award

Art Director	Gretchen Goldie
Designer	Keith Bright
Photographer	Michael Going
Agency	Bright & Associates, Los Angeles, CA
Client	Princess Cruises

1281

Distinctive Merit

Art Director Lon Clark
Designer Sara Bunnag
Photographer Lon Clark
Publisher North Beach Press, San Francisco, CA
Publication Itinerary

1282

Art Director John F. Grant
Designer Marilyn F. Appleby
Photographer Robert Llewellyn, Charlottesville, VA
Editor Ross A. Howell, Jr.
Director Frank L. Thomasson, III
Client Thomasson-Grant, Inc.

1283

Art Director Donald G. Paulhus
Photographer Robert Llewellyn, Charlottesville, VA
Editor James B. Patrick
Director Ross Webber, University of Pennsylvania
Client Fort Church Publishers, Inc.

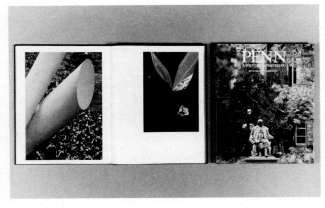

1308

Art Director	Steve Mitsch
Writer	Patti Goldberg
Editor	Steve Kraftsow/Morty's Film Service
Director	Ian Macdonald
Director of Photography	Nixon Binney
Creative Director	Mike Drazen
Agency	Charlie Curran/HCM, New York, NY
Production Company	Wendy Macdonald, Paul Rosen/ Macdonald Productions— Independent Artists
Client	Mita Copystar America, Inc.

1309

Art Director	Bob Barrie
Writer	John Stingley
Editor	Steve Shepard, Wilson-Griak, Minneapolis, MN
Director	Lee Lacy, N. Lee Lacy Assoc. Ltd.
Agency	Judy Brink, Fallon McElligott, Minneapolis, MN
Production Company	Barry Munchick, N. Lee Lacy Assoc. Ltd., New York, NY
Client	Prince Foods Canning Division

JUGGLER
10-second
ANNCR VO: While other copier companies are busy juggling all kinds of other products, there's one company busy making great copiers.
SFX: CRASH!
ANNCR VO: Mita. All we make are great copiers.

NUN
10-second
ANNCR: In Italy, no two people have quite the same taste. When Prince makes authentic Italian spaghetti sauce, we keep that in mind.

1310

Art Director	Bob Barrie
Writer	John Stingley
Editor	Steve Shepard, Wilson-Griak, Minneapolis, MN
Director	Lee Lacy, N. Lee Lacy Assoc. Ltd.
Agency	Judy Brink, Fallon McElligott, Minneapolis, MN
Production Company	Barry Munchick, N. Lee Lacy Assoc. Ltd., New York, NY
Client	Prince Foods Canning Division

1311

Art Director	Dennis Hagan
Writer	Rich Coad
Director	Gary Johns/Jeff Gorman
Director of Photography	Danny Ducovny
Agency	Lee Lunardi/Bozell & Jacobs/ Chicago, IL
Production Company	Sam Schapiro, Johns + Gorman Films
Client	Illinois State Lottery

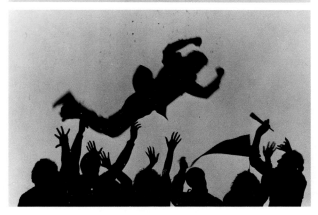

DENIM
10-second
ANNCR: In Italy, no two pepole have quite the same taste. When Prince makes authentic Italian spaghetti sauce, we keep that in mind.

JUMP
10-second
VO: Only one person can win a million in the instant lottery . . . the rest will have to settle for a hundred thousand.
SFX: MAN SHOUTING, HORNS BLOWING, ETC. THROUGHOUT

1312

Art Director	Richard Ostroff
Writer	Jeff Spiegel
Editor	Howie Lazarus/Take Five
Director	John Danza
Creative Director	Mike Drazen
Agency	Charlie Curran/HCM, New York, NY
Production Company	Nancy Early, Danza Productions, New York, NY
Client	The Connecticut Bank & Trust Company

1313

Art Director	Rick Marchesano
Artist	Michael Caplanis
Writer	Rick Marchesano
Editor	John Prescott
Creative Director	Norman Goldberg/Carole Marchesano
Producer	Rick Marchesano/Goldberg/Marchesano & Assoc, Washington, DC
Production Company	Townhouse Editing
Client	IKEA

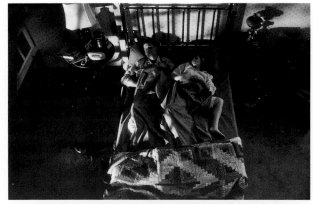

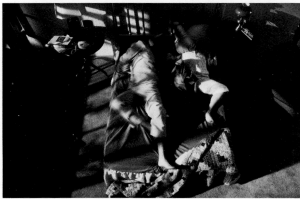

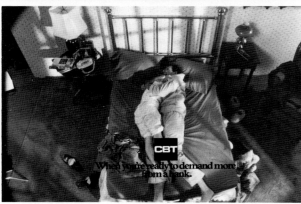

TOSSING & TURNING
10-second
ANNCR VO: CBT's one day mortgage approval lets you lose only one night of sleep. CBT.
SFX: PHONE RING
ANNCR VO: When you're ready to demand more from a bank.

TEASER
10-second
ON JUNE 12
EYE
KEY
AH!
IKEA
The furnishings store from Sweden comes to America.

1314

Art Director	Kurt Tausche/Tom Donovan
Writer	Bert Gardner
Editor	Gregory M. Cummins
Director	Norman Seeff
Agency	Judy Wittenberg, Bozell, Jacobs, Kenyon & Eckhardt/Minneapolis, MN
Production Company	Richard Marlis Productions
Client	Swiss Miss—Beatrice
Editing Company	Editronics

1315

Art Director	Jeff Jones
Writer	Bruce Hannum
Editor	Allen Grey
Director	Allen Grey
Agency	Jack Steinmann, Bozell, Jacobs, Kenyon & Eckhardt/Minneapolis, MN
Production Company	Emcom
Client	Malrite Communications

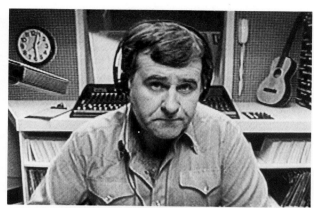

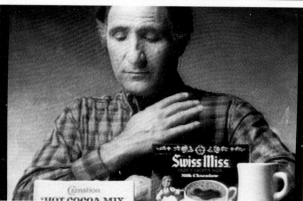

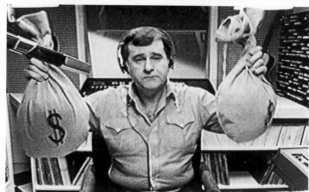

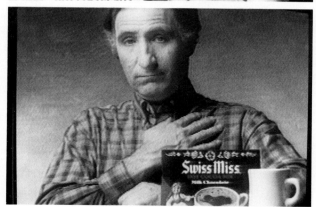

TAPS/REV. IV
15-second
JUDD: In a national taste test, Swiss Miss Hot Cocoa mix was compared with Carnation.
JUDD: What happened?
(TAPS MUSIC UP & CONTINUES)
JUDD VO: Swiss Miss. It beat Carnation almost 2 to 1.

JINGLE
10-second
(MUSIC: CRYSTAL GAYLE, ''BROWN EYES BLUE'')
ANNCR VO: So, K102's got a new jingle, huh?
WALTER THE DJ (OC): Yup.
ANNCR VO: Let's hear it.
(SFX: JINGLING OF MONEY)
2ND ANNCR VO) Win a $102,000 government security. Listen to K102 FM.

1316

Art Director	Bob Macy
Writer	Bob Macy
Editor	Bob Macy
Director	Bob Macy
Agency	Sandy Mislang/W. B. Doner & Company Adv., Baltimore, MD
Client	Pimlico Racecourse

1317

Art Director	Harvey Baron
Designer	Harvey Baron
Writer	John Noble
Editor	Morty's
Director	Michael Berkofsky
Director of Photography	Simon Ransley
Agency	Joe Scibetta/Doyle Dane Bernbach, New York, NY
Production Company	Berkofsky/Barrett
Client	Audi

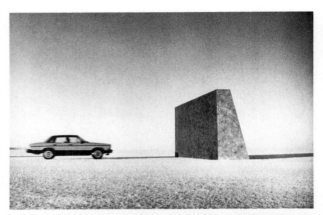

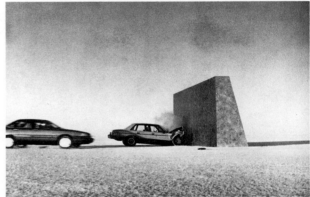

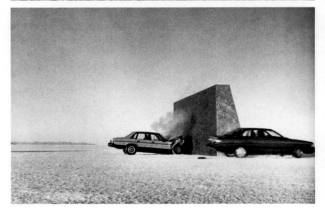

BALTIMORE COLTS
10-second
SUPER: You can still see Baltimore Colts.
SUPER: Pimlico
Posttime: 1 P.M.

WALL
15-second
(MUSIC THROUGHOUT)
The law requires all manufacturers to drive their cars
into walls. At Audi, we also concentrate
on going around them.
Audi, the art of engineering.

1318

Art Director	Paul Jervis
Writer	Roger Feuerman
Director of Photography	Gary Perweiler
Agency	Lisa Pailet, Backer & Spielvogel, New York, NY
Client	Red Lobster

1319

Art Director	Jim Weller
Writer	Jim Weller
Director	Nestor Almendros
Director of Photography	Nestor Almendros
Agency	Shannon Silverman, Della Femina, Travisano & Partners of California Inc., Los Angeles, CA
Production Company	DFT & WE
Client	American Isuzu Motors, Inc.

RED LOBSTER-LOBSTER TUESDAY
10-second
ANNCR VO: People have always known how to catch lobsters.
But now the lobsters have found a way to catch people.
VISUAL: REVEAL LOBSTER HOLDING CARD WITH $9.95
WRITTEN ON IT.
LOGO: RED LOBSTER

CAN'T DRIVE
10-second
ANNCR VO: In 1914, Isuzu test drove their first car.
And from painful experience has come one of the world's toughest trucks.
SUPER: Isuzu. The first car builders of Japan.

1320

Art Director	Jim Weller
Writer	Jim Weller
Director	Jim Weller
Director of Photography	Nestor Almendros
Agency	Shannon Silverman, Della Femina, Travisano & Partners of California Inc., Los Angeles, CA
Production Company	DFT & WE
Client	American Isuzu Motors, Inc.

1321

Art Director	Jim Weller
Writer	Jim Weller
Director	Jim Weller
Director of Photography	Nestor Almendros
Agency	Shannon Silverman, Della Femina, Travisano & Partners of California Inc., Los Angeles, CA
Production Company	DFT & WE
Client	American Isuzu Motors, Inc.

RICE FIELDS
10-second
ANNCR VO: Isuzu was building off-road vehicles before Japan was building roads.
Isuzu Trooper II, from the first car builders of Japan.
SUPER: Isuzu. The first car builders of Japan.

HORSE RACE
10-second
ANNCR VO: In 1914, Isuzu lost the first car race in Japan . . . to a horse.
SFX: CAR ZOOMING BY
ANNCR VO: Today, Isuzu's Turbo is getting even.
SUPER: Isuzu. The first car builders of Japan.

Art Director	Bob Barrie
Writer	John Stingley
Editor	Steve Shepard, Wilson-Griak, Minneapolis, MN
Director	Lee Lacy, N. Lee Lacy Assoc., Ltd.
Agency	Judy Brink, Fallon McElligott, Minneapolis, MN
Production Company	Barry Munchick, N. Lee Lacy Assoc. Ltd., New York, NY
Client	Prince Foods Canning Division

IT TAKES ALL KINDS
30-second
(ITALIAN MUSIC)
(MUSIC CONTINUES)
ANNCR: In Italy, as anywhere else,
there are different types of people.
They don't look the same . . .
or have the same taste.
That's why when Prince makes Italian
spaghetti sauce, we give you a choice.
Our original sauce with imported olive oil and cheese . . .
or our chunky homestyle with bits of tomato, herbs and spices.
Because any true
Italian knows, no two people . . .
have quite the same taste.

1324

Silver Award

Art Director	Ross Van Dusen
Writer	Dave Woodside
Director	Jim Johnston
Agency	Frank Scherma/Chiat/Day Advertising, San Francisco, CA
Production Company	Rhonda Raulston, Jim Johnston Film Co.
Client	California Cooler

MATT

30-second

MATT: I hate California.

You know what I'm saying? It's like . . . have a nice day—surf's up . . . ahah, ahah.

I mean, their idea of culture is yogurt.

Formal dinner party means you wear socks.

Blondes everywhere, pink tofu? Excuse me? Soy Burgers? I really hate it.

I even hate what they drink.

BARTENDER: What'll you have, buddy?

MATT: One of those.

1325
Silver Award

Art Director	Susan Hoffman
Writer	Jim Riswold
Editor	Dan Sweitlik/Red Car
Director	Jim Johnston
Agency	Wieden & Kennedy, Portland, OR
Production Company	Johnston Films
Client	Nike, Inc.

THE SHOOTER
30-second
(MUSIC THROUGHOUT)
ANNCR: NIKE. For those who are always on their game.

1326

Silver Award

Art Director Leslie Caldwell
Writer Mike Koelker
Editor Bob Carr
Director Leslie Dektor
Director of Photography Leslie Dektor
Agency Steve Neely/FCB
Production Company Faith Dektor, Petermann/Dektor,
Los Angeles, CA
Client Levi's 501 Jeans

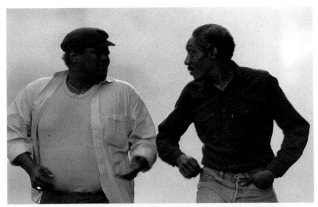

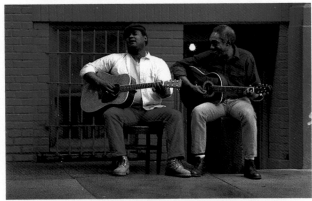

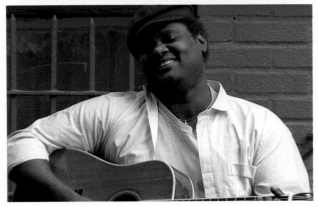

BLUESMEN
30-second
MAN 1: My, My, My said the Button Fly
MAN 2: What you say
MAN 1: Have you heard the news?
MAN 2: Na, tell me about it
MAN 1: I've got the Blues
MAN 2: Aw, deliver
MAN 1: The Levi's 501 Blues
MAN 2: They shrink to fit
MAN 1: That's it, and they're right to size
MAN 2: Do tell
MAN 1: I personalize Levi's 501 Blues
MAN 2: Lucky fly
MAN 1: Ain't I
MAN 2: My, My . . .

Art Director	Mike Ciranni, Jamie Seltzer
Writer	Jamie Seltzer, Mike Ciranni
Editor	Morty Ashkinos
Director	Henry Sandbank
Agency	Frank Scherma/Chiat/Day inc., New York, NY
Production Company	Jon Kamen, Sandbank Films Inc.
Client	Topps Chewing Gum

WIMP
30-second
SFX: CAR STARTING BUT NOT TURNING OVER
SFX: CAR STARTING BUT NOT TURNING OVER
SFX: CAR NOT TURNING OVER
SFX: CAR TURNS OVER
VO: It's harder to get started . . .
SFX: CAR IS HUMMING
VO: . . . but once it gets going, it never stops.
VO: Bazooka Bubble Gum. If you're tough enough to chew the hard stuff.

1328
Distinctive Merit
Art Director Mark Shap
Designer Mark Shap
Writer Veronica Nash
Director Terry Bedford
Creative Director Malcolm End
Agency Susan Chiafullo, Ogilvy & Mather, New York, NY
Client Avon

1329
Distinctive Merit
Art Director Harvey Hoffenberg
Writer Ted Sann
Editor Bob DeRise
Director Henry Holtzman
Agency Gene Lofaro/BBDO, New York, NY
Producer Lee Lacy
Client Pepsi-Cola Company

HOLIDAY BEAUTY
30-second
(MUSIC: MALE SINGS)
Making an entrance . . .
step out in style . . .
Light up the party with an Avon smile.
Trimming the tree . . .
Avon's jewelry dazzling to see . . .
Hear the music and dance, dance, dance!
Wearing a fragrance designed in France!
Avon's got a special way
to making a beautiful holiday
So Dance—Avon!

WILBUR II
30-second
WILBUR: I'll have a Coke.
WAITER: Sure stranger, which one?
WILBUR: Just a Coke.
WAITER: Well there's lots of them. You see the old Coke is the old Coke before it became your new Coke and the new Coke is the one that used to be your old Coke, which became your new improved Coke. Except for your Classic Coke, which is really the old Coke, and now that's your new Coke.
WILBUR: Just give me the one you like best.
WAITER: That's easy.
WILBUR: Pepsi.
ANNCR: Now more than ever, Pepsi, the choice of a new generation.
WILBUR: Glad I asked.

1330

Art Director	Lester Feldman
Writer	Nicole Cranberg
Editor	Jeff Kahn/Pelco
Director	John Pytka
Director of Photography	John Pytka
Agency	Mardi Kleppel/Doyle Dane Bernbach, New York, NY
Client	General Telephone Directories Co.

1331

Art Director	Harvey Hoffenberg
Writer	Phil Dusenberry/Shirley MacLaine/ Ted Sann/Harvey Hoffenberg/ Susan Procter
Editor	Bob DeRise
Director	Ed Bianchi
Agency	Gene Lofaro/BBDO, New York, NY
Production Company	Ed Bianchi Productions
Client	Pepsi-Cola Company

BATHTUB/YOUR TOWN/FOREST
30-second
If you should ever need new flooring . . .
new carpeting . . .
a new paint job . . . new furniture . . .
a new stereo system, or just about anything else . . . you can always find it in the GTE Yellow Pages.
the most accurate, most complete listing of business around. The official GTE Yellow Pages.
For life's little ups & downs.

RED HEAD
30-second
SHIRLEY: Sweetheart, what's the matter?
DAUGHTER: I'm drowning my sorrows.
SHIRLEY: You are depressing the scenery.
DAUGHTER: Oh Mom I really wanted that job.
SHIRLEY: I know. But listen, when one door closes another door opens.
I always learned more from my failures than I did from my success.
DAUGHTER: You mean I can learn from failure?
SHIRLEY: Yes.
DAUGHTER: Oh. (SMILES)
SHIRLEY: You don't want to get a PhD in it. But you can learn.
DAUGHTER: I'll drink to that. (SMILING)
AV: There's one soft drink that fits the spirit of today, Diet Pepsi.
The one calorie choice of a new generation.

1332

Art Director	Jack Mariucci
Designer	Jack Mariucci
Animator	Artwork created by Doyle Dane Bernbach
Writer	Barry Greenspon
Editor	The Editors
Director	Henry Sandbank
Agency	Joe Scibetta/MaryEllen Perezolla/ Doyle Dane Bernbach, New York, NY
Producer	John Kamen/Henry Sandbank
Client	Michelin Tire Corp.

1333

Art Director	Pat Burnham
Writer	Bill Miller
Editor	Tony Fischer, James Productions, Minneapolis, MN
Director	Mark Story, Pfeifer-Story
Agency	Judy Brink, Fallon McElligott, Minneapolis, MN
Production Company	Pfeifer-Story, Los Angeles, CA
Client	Metromedia

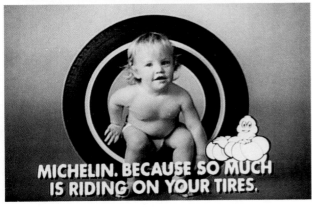

AMY
30-second
WIFE: Honey?
HUSBAND: Hmmm.
WIFE: You have Michelin tires in your car, don't you?
HUSBAND: Yeah.
WIFE: How come?
HUSBAND: I don't know. They're terrific tires. Why?
WIFE: How come I don't have Michelins in my car?
HUSBAND: Oh sweetheart, they cost more. I drive to work, I go out of town a lot.
All you use your car for is shopping, driving Amy around . . .
. . . I'll get you a set tomorrow.
WIFE: You sure you want to spend the extra money on us?
HUSBAND: Come on.
ANNCR VO: Michelin. Because so much is riding on your tires.

CANNON
30-second
VO: Your day began at sunrise.
You skipped lunch.
You put in a full day.
You paid your dues.
And yet, no matter what you do . . .
. . . or how hard you try . . .
. . . you can never make it home . . .
SFX: KABOOM
. . . in time to see the news.
Presenting the 7 o'clock news.
Finally, news that doesn't get home before you do.

1334

Art Director	Nancy Rice
Writer	Jarl Olsen
Editor	Bob Wicklund, Wilson-Griak
Director	Jim Hinton, Wilson-Griak
Agency	Judy Brink, Fallon McElligott, Minneapolis, MN
Production Company	Wilson-Griak, Minneapolis, MN
Client	Gold 'n Plump

1335

Art Director	Michael Hart
Writer	Linda Kaplan
Editor	Editors Gas
Director	Elbert Budin
Creative Director	Manning Rubin
Agency	Garry Bass/JWT, New York, NY
Production Company	Ampersand
Client	Mary Miller Bal, R. T. French

LIFT OFF
30-second
SFX: ROCKET BLAST.
MUSIC UNDER.
VO: Gold'n Plump makes history . . .
VO: . . . with the first chicken in space.
VO: Here, Gold'n Plump prepares Minnesota's finest for the dinner tables of tomorrow.
VO: A corn-rich diet builds meaty thighs and breasts, and gives this . . . chickernaut . . .
VO: . . . taste that can . . .
VO: . . . rise to any occasion.
VO: Quality is A-O-K, ensuring the future . . .
VO: . . . of this . . .
VO: . . . the best of all possible birds.
VO: Gold'n Plump Chickens Landing now in your supermarket.

BE GOOD TO YOUR FOOD
30-second
ANNCR: If you're not giving your sandwich *French's* mustard, it may not like it.
SFX: NO! NO! SANDWICH SQUEALS.
SFX: HUMOROUS KARATE SELF-DEFENSE NOISES.
SFX: THAT'S NOT FRENCH'S
SFX: SCUTTLING NOISES. NO WAY BRAKING NOISE.
SFX: MORE SCUTTLING NOISES.
ANNCR: Come on. Listen to your food.
ANNCR: *French's* is 100% all natural . . .
SFX: SIGHS OF PLEASURE.
ANNCR: . . . no sugar . . . and no artificial preservatives.
SFX: Cheering, whistling, applauding.
ANNCR: *French's* all natural mustard.
Be good to your food.

1336

Art Director	Paul Frahm, Michael Hart, Jim Patterson
Writer	Laurie Birnbaum, Frank Nicolo, Brian Sitts
Editor	Editors Gas
Director	Don Guy, Brian Cummins
Creative Director	Frank Nicolo
Agency	Gary Bass, David Schneiderman, Michael Lagattuta, JWT, New York, NY
Production Company	KIRA Films
Client	Jerry Schmutte, Miller Brewing Co.

1337

Art Director	Bob Barrie
Writer	Phil Hanft
Editor	Tony Fischer, James Productions
Director	Jim Lund, James Productions
Agency	Judy Brink, Fallon McElligott, Minneapolis, MN
Production Company	James Productions, Minneapolis, MN
Client	Minnesota Zoo
Music	John Penney

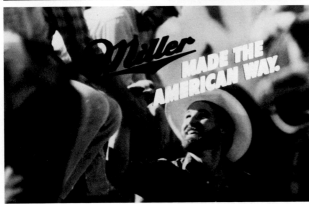

HANDS/NEW LABEL
30-second
SINGERS: Round here people seem to say it all without saying a word.
VO: There are still places where you can shake a man's hand, buy him a Miller—and you've got yourself a deal.
SINGERS: Miller's made the American way
Born and brewed in the USA
Just as proud as the people
Who are drinkin' it today
VO: Miller beer. Purity you can see. Quality you can taste.
SINGERS: Miller's made the American way

MAGNIFICENT RACING MACHINE
30-second
SFX: EITHER SOUND OF DRAGSTER PEELING OUT OR SOME KIND OF ELECTRONIC SOUND THAT BUILDS, OR A COMBINATION.
VO: Introducing a precisely-designed, racing machine that can accelerate from zero to forty-five in two seconds . . .
. . . can reach almost unheard of speeds in less than a quarter mile
. . . and . . . can stop on a dime.
SFX: SCREECH OF BREAKING AUTO.
VO: The world's fastest land animal. Now at the Minnesota Zoo.

1338

Art Director	Dean Hanson
Writer	Phil Hanft
Editor	Beth Dougherty, Wilson-Griak, Minneapolis, MN
Director	Joe Pytka, Pytka Productions
Agency	Judy Brink, Fallon McElligott, Minneapolis, MN
Production Company	Pytka Productions, Los Angeles, CA
Client	First Tennessee

1339

Art Director	Bob Barrie
Writer	Rod Kilpatrick
Editor	Beth Dougherty, Wilson-Griak
Director	Dennis Manarchy
Agency	Judy Brink, Fallon McElligott, Minneapolis, MN
Production Company	Wilson-Griak, Minneapolis, MN
Client	MedCenters Health Plan

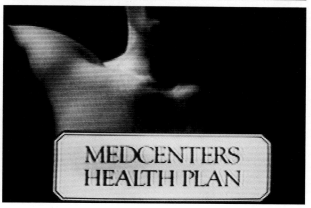

DOBRO
30-second
ANNCR: In a state where people have been passing down their music for over two hundred years . . . it's no surprise they turn to the bank that's been around for over one hundred years.
First Tennessee. An uncommon bank for uncommon people.

HEART
30-second
ANNCR VO: One hundred thousand times a day, this unassuming muscle performs an incredible feat of strength.
Pumping four thousand gallons of blood
through 75,000 miles of pipeline
without a moment's rest.
At MedCenters Health Plan, we give special care to this miracle of nature.
And we never forget that it isn't just a human heart.
It's *your* human heart.

1340

Art Director	Dean Hanson
Writer	Jarl Olsen
Editor	Mark Ryan
Director	Jim Beresford, James Gang
Agency	Judy Brink, Fallon McElligott, Minneapolis, MN
Production Company	James Gang, Dallas, TX
Client	First Tennessee

1341

Art Director	Jo Ann Meyer & Linda Vos
Writer	Dan Weitzman
Editor	Chris Horn
Director	Ross Cramer
Vice President/Creative Group Head	Julie Picard
Director of Photography	David Walsh
Agency	David Dyke, Dancer Fitzgerald, Sample, New York, NY
Production Company	Power & Light
Client	CPC/Best Foods—Mazola Margarine

CONSUMER LOAN

30-second
VO: For over 100 years, First Tennessee has been making uncommon loans in the most uncommon places on Earth.
Loans for sportscars in Rome,
and villas in Athens.
We can send dough to Paris,
And raise some cold cash for Moscow.
Someday, we'll get a new office for Nixon,
or send Stupidville to college.
Right now, First Tennessee has millions of dollars to lend.
If a loan can make Dull interesting, what could it do for you?

SPEECHLESS

30-second
SFX: MEALTIME MAYHEM
TEEN GIRL: Nobody ever cares about what I want.
GRANDMA: Isn't it wonderful to see the kids?
OFF CAMERA VOICE: Let me have some Mazola.
MOM: Honey, you're kidding . . . really?!
OFF CAMERA VOICE: Mazola, please.
DAD: Thanks, mom.
LITTLE GIRL: I know . . . but I want *your* chicken anyways.
TEEN BOY: I'm not going out with video queen 1984.
SFX: DOG WHINES
SFX: TOTAL SILENCE EXCEPT FOR CUTLERY, ETC.
VO: Ordinarily, Margarine doesn't stop conversation. But Mazola Margarine has such a fresh light Taste, it's Too Good For Words.

Art Director — John D'Asto
Designer — John D'Asto
Writer — Mark Fenske
Editor — Janice Rosenthal
Director — Jeff Jones
Creative Director — Jan Zechman
Director of Photography — Ted Bokoff
Agency — Laurie Berger, Zechman and Associates, Advertising, Inc., Chicago, IL
Producer — Kirk Hassig of McDonough/Jones
Client — Illinois Dept. of Commerce and Community Affairs—Office of Tourism

Art Director — Dean Hanson
Writer — Phil Hanft
Editor — Marcus Stevens, Pytka Productions
Director — Joe Pytka, Pytka Productions
Agency — Judy Brink, Fallon McElligott, Minneapolis, MN
Production Company — Meg Matthews, Pytka Productions, Los Angeles, CA
Client — First Tennessee
Music — Herb Pilhofer

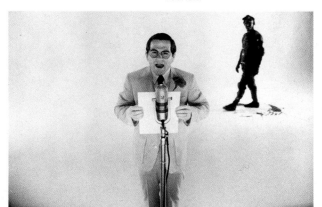

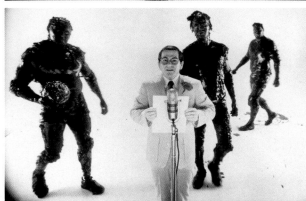

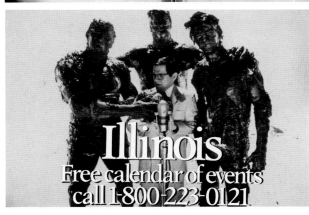

STEAMBOAT DAYS
30-second
MAN: The events for Steamboat Days in Peoria. A homemade paddle-wheel race. A Miss Peoria beauty pageant.
MAN: Steamboat rides, bratwurst . . .
MAN: . . . Fun in the sun.
(PAUSE)
And . . . volleyball games in the mud.
MUD GUY: All Right!
VO: Steamboat Days in Peoria. Join us for some good clean fun.
SONG: Illinois you put me in a happy state.

AMAZING GRACE II
30-second
MUSIC: AMAZING GRACE DRIFTS ACROSS WATER.
VO: In Tennessee . . . there are as many ways to a song as there are people.
DOBRO PICKS UP THE MELODY LINE.
BLUEGRASS CONTINUES THE MELODY.
BAGPIPE CONCLUDES THE MELODY.
VO: Interestingly . . . with all this diversity, people here do agree on one thing. Their bank.
First Tennessee. An uncommon bank for uncommon people.

1344

Art Director Bill Gangi
Writer Confidence Stimpson
Director Dick Loew
Agency Christine Cacace/DFS, Inc., New York, NY
Production Company Gomes-Loew Productions
Client Republic Airlines
Recording Producer Peter Greco

1345

Art Director Kenneth Sakoda/Randy Papke
Writer Scott Montgomery
Editor Film Care
Director Paul Keisow
Agency Salvati Montgomery Sakoda, Santa Ana, CA
Production Company Paul Keisow Productions
Client Wynn Oil Company

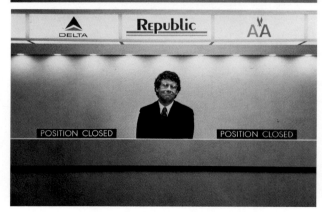

NODDING HEADS

30-second

MAN VO: Any of you guys fly to Los Angeles? Nonstop? How about San Francisco? Washington, D.C.? Boston? Phoenix? Houston?
MAN'S VOICE CONTINUES UNDER ANNCR: Philadelphia? St. Louis? Seattle?
ANNCR VO: Republic has nearly four times as many nonstops a day as both our closest competitors combined. It's just one of the perks you get with Republic. Republic's perks. They're making some so-called "big" airlines look pretty small.
SINGERS: WE MAKE YOU FEEL LIKE FLYING. REPUBLIC AIRLINES.

STOP-LEAK

30-second

VO: America, you're leaking. All over your garages, all over your driveways, all over your roads. And those leaks can lead to serious damage and extensive repairs. But Wynn's Stop-Leak products can help seal up those leaky engines, transmissions and radiators. Try Wynn's. And leave all those messy leaks and expensive repair bills . . . behind you. Wynn's. A better run for your money for over 40 years.

1346

Art Director	Glenn Sagon/Dan Kavanaugh
Designer	Rich Fernalld
Writer	Dan Kavanaugh
Editor	Don Wilson
Director	Rich Fernalld
Director of Photography	Kevin Haug
Producer	Joan Goldman
Production Company	IDR Creative/Dan Kavanaugh
Client	RCA/Columbia Pictures Home Video, Burbank, CA

1347

Art Director	Doug Lew
Writer	Bill Johnson
Editor	Editronics
Director	Greg Cummins
Agency	Mary Schultz/Ruhr/Paragon Inc., Minneapolis, MN
Production Company	Cornelius/Setterholm, Inc.
Client	Target Stores

GHOSTBUSTERS
30-second
You are witnessing a supernatural phenomenon . . .
And it's coming to your home on videocassette . . .
MURRAY: Anybody seen a ghost?
SUNG: "Ghostbusters"
Ghostbusters is now making housecalls, bringing America's favorite family movie into your home.
The supernatural spectacle has been safely contained for home use on videocassette.
Ghostbusters . . .
Now on videocassette. Get it . . . before it disappears!

DOLLAR SALE
30-second
ANNCR VO: These days a dollar will go a lot farther than you might think. Because now thru Saturday, every item you see is on sale at Target. Proof positive that a dollar still goes a pretty long way. The dollar sale at Target.

HUNTER: Not for me kid, I'm retired.
SFX: SOUND OF LAUGHTER.
AVO: Diet Pepsi. The one calorie choice of a new generation.
SUPER: The one calorie choice of a new generation.

1360

Art Director Bryan McPeak
Writer Gene Gilmore
Director Ed Buffman
Agency Leonard Monahan Saabye,
Providence, RI
Production Company Century III
Client Commonwealth Cadillac Dealers

1361

Art Director Cindy Sikorski, Karen Romeyn,
George Katsarelas
Writer John Jackson, Debbie Karnowsky
Agency Deborah Meisner, W. B. Doner &
Company, Southfield, MI
Client Chattem/Love's Baby Soft

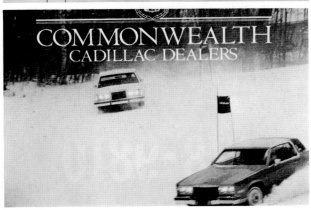

SKI SLOPE
30-second
(SFX: MUSIC THROUGHOUT, WIND)
VO: If you're wavering between a luxury import or a Cadillac . . .
stop. Cadillac Fleetwood gives you a sleek exterior . . . power rack
and pinion steering and fully independent suspension . . . plus
exceptional roominess . . . standard four year/50,000 mile warranty
. . . and an exclusive front-wheel drive, transverse-mounted V8.
Cadillac Fleetwood . . . because there's a lot on the line when you
buy a luxury car. At your commonwealth Cadillac dealer's now.

WHAT IS PINK
30-second
VOC: What is pink?
MUSIC UNDER
VOC: If white is innocent . . .
MUSIC UNDER
VOC: and red is not . . .
MUSIC UNDER
VOC: Love's Baby Soft is somewhere in between.

1362

Art Director	Jean Robaire
Writer	John Stein
Editor	Larry Bridges
Director	Stan Schofield
Agency	Francesca Cohn, Chiat/Day, Los Angeles, CA
Production Company	Sandbank Films
Client	Pizza Hut, Inc.

1363

Art Director	Marten Tonnis/Steve Beaumont
Writer	Steve Rabosky/Penny Kapousouz
Director	Brent Thomas
Agency	Richard O'Neill, Chiat/Day, Los Angeles, CA
Production Company	Avery Film Group
Client	Apple Computer, Inc.

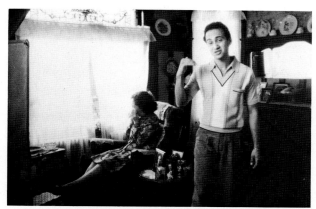

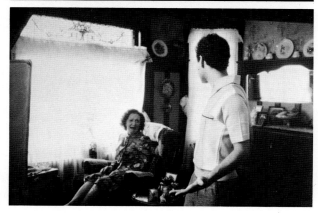

YOU STILL GOTTA ME
30-second
SON: My momma's so upset. She found out that her special Italian turnover . . . Pizza Hut's now got one for lunch, too.
Calizza (TM) they call it. How they got the recipe, I don't know. Maybe my cousin Angelo gave it to 'em.
It's got sausage and green peppers, a delicious tomato sauce—even a light crust just like momma's.
And they serve it in five minutes—guaranteed.
ANNCR: Calizza (TM) Italian turnover. At Pizza Hut.
SON: Momma, they might have a Calizza (TM), but you still gotta me.
MOMMA: (CRIES)

MAJOR IMPROVEMENT
30-second
MUSIC: UNDER THROUGHOUT.
ANNCR VO: We'd like to announce a major improvement to IBM mainframe computers:
The Macintosh Office.
Now you can use Macintosh to talk to your company's mainframe. Which means you can do something with all that data you may never have been able to do before:
Understand it.

1364

Art Director Joe Minnella
Writer Dale Silverberg
Agency Deborah Meisner, W. B. Doner & Company, Southfield, MA
Client United Foundations

1365

Art Director Gary Johns
Writer Jeff Gorman
Director Steve Horn
Agency Morty Baran, Chiat/Day, Los Angeles, CA
Production Company Steve Horn, Inc.
Client Nike, Inc.

THE PEN
30-second
VO: There is an instrument so incredibly versatile it can be used to treat heart disease, arthritis, cancer, leukemia, epilepsy, alcoholism, kidney disease. It's proven invaluable in cases of auditory and speech disorders, cystic fibrosis, multiple sclerosis. It's an instrument everybody has. And now is the time to use it. Give to the Torch Drive for all the good it can do.

MICHAEL JORDAN-FLYING
30-second
SFX: RUMBLE.
SFX: EXPLOSION.
SFX: WHISTLE OF RACING JET ENGINE.
SFX: ROCKET FIRE.
JORDAN (VO): Who says man was not meant to fly?
SFX: JET BREAKING SOUND BARRIER.
ANNCR VO: Air Jordans.
Basketball by Nike.

1366

Art Director	Leta Warner
Writer	Dick Tarlow
Editor	Power Post/Morty Schwartz
Director	Neil Tardio
Creative Director	Sandy Carlson
Agency	Sarah Fader, Geers Gross Advertising, New York, NY
Production Company	Lovinger, Tardio, Melsky/Larry Dubin
Client	Warner Cosmetics, Inc.

1367

Art Director	Mark Yustein/Ron Travisano
Writer	Jim Weller
Editor	Bob Smalheiser
Director	Ron Travisano
Director of Photography	Michael Butler
Agency	Peter Yahr, Della Femina, Travisano & Partners, New York, NY
Client	David LaFountaine, WCBS-TV

POLO COUNTRY
30-second
MUSIC UP (PLAYS THROUGHOUT)
ANNCR VO: Polo isn't just a game it's a tradition.
A way of life.
Polo by Ralph Laruen.
MUSIC OUT

HEALTH & SCIENCE
30-second
The New York area offers more ways to benefit from modern medicine and science than any place else on earth.
Where else could you find more theories on how to lose weight?
More cures for the common cold?
Or more ideas on how to clean up the environment?
Yet with all the ways to improve your body and mind,
there's just one place to find a second, or third opinion on what's good for you.
Doctor Frank Field, Earl Ubell, Peter Salgo, M.D.
Channel 2 News.
Because anything can happen in New York.

1368

Art Director	Paul Walter/Mike Schwabenland
Writer	John Greenberger/Lance Mald
Editor	Steve Schreiber
Director	Dick Sorenson
Agency	Russell Hudson/BBDO, New York, NY
Production Company	Lofaro & Assoc.
Client	Black & Decker

1369

Art Director	Doug Bartow
Writer	Ed Taussig
Director	James Moore
Creative Director	Agency: Judy Frisch, Kurt Haiman; Client: John C. Jay
Agency	Grey Advertising
Client	Bloomingdale's, New York, NY

FIREHOUSE
30-second
ANNCR VO: You probably wouldn't be surprised to find Black & Decker products in a place like this.
(SFX: BELL)
But there is one that might surprise you.
It's an iron. And it does something no other iron does—
it warns you when you leave it unattended.
(SFX: BEEP, BEEP, BEEP, BEEP, BEEP)
Then if you don't come back, it shuts itself off.
(SFX: CLICK)
The Automatic Shut-Off Iron,
from Black & Decker. Ideas at work.

ECCO L'ITALIA
30-second
ANNCR: Bloomingdale's presents Ecco L'Italia.
Featuring Italian designs in pure wool.
LORENZO: Buon Giorno.
PAOLA: Buon Giorno, papa.
LORENZO: Ciao, Paola.
LORENZO: Tutto bene cara?
ALDA: Ha, hico tanto, non no dormito tanto bene.
LORENZO: Non ti presccuapre, potrai domaire in areo.
ALDA: Ma, gli altri dove sono?
MARK: Haivisto il mio?
DAINIELLA: Sei sempre in ritardo, eh?
VO (ALDA): Gabriella!
ALDA: Gabriella, dai, vieni!
GABRIELLA: Arrivo subito . . .

1370

Art Director	Eduardo Zayas
Writer	Robert Woolcott
Editor	Ciro Denettis
Director	Steve Horn
Agency	Bob Samuel, Liza Leeds, Rumrill Hoyt Advertising, New York, NY
Production Company	Steve Horn—Steve Horn Production
Client	Unicorn Publishing House, Inc.

1371

Art Director	Gary Wolfson
Writer	Mark Cummins
Agency	Hugh Broder, W. B. Doner & Company, Southfield, MI
Client	Michigan Lottery

ADAM ANT
30-second
Hello, this is Adam Ant and this is the LIVE-AID book. When my mum saw it, she said, ''Adam, you finally done something good with that horrible Rock 'N Roll. Saving all those lives, it's wonderful. I'm showing the book to all my friends so that they could see what a love you *really* are.'' You see, you don't have to like music to buy the LIVE-AID book. All the profits go to the African Famine Relief and that should make anyone feel good. Even my mum.

I WON I WON
30-second
WOMAN: I won! I won! Irving, I won! Marty, I won! Sybil, I won!
VO: If you win a $1,000 a week for life playing Michigan Summer, you'll want to tell everyone . . .
WOMAN: Sidney, I won!
VO: Of course, you're gonna have to figure out what to tell your boss . . .
WOMAN: Boss?
VO: . . . eehh, you'll think of something.
WOMAN: (RASPBERRY) I quit.

1376

Art Director	Donna Tedesco
Writer	Yoni Mozeson
Editor	Michael Charles
Director	Dick Miller
Creative Director	Mike Pitts
Agency	Mootsy Elliot/Ogilvy & Mather Inc., New York, NY
Client	Duracell, Inc.

1377

Art Director	Dennis Hagan
Writer	Rich Coad/Jeff Gorman
Director	Gary Johns/Jeff Gorman
Director of Photography	Danny Ducovny
Agency	Lee Lunardi/Bozell & Jacobs/Chicago
Production Company	Sam Schapiro/Johns + Gorman Films, Los Angeles, CA
Client	Illinois State Lottery

BALLOON

30-second

ANNCR VO: Introducing the new highly improved Copper Top battery. So improved it'll last up to 30% longer than any battery we've ever made. Once again Duracell reaches a new height. Duracell. When it comes to making them last longer. We never stop.

BLACK COUPLE

30-second

MAN: A million bucks in the lottery . . . probably move directly to the ocean.
WOMAN: Mountains.
MAN: We've always wanted to live near the ocean.
WOMAN: Mountains.
MAN: Baby, we could have that brick house you've always wanted.
WOMAN: Wood.
MAN: Brick.
WOMAN: Wood.
MAN: And that long black car.
WOMAN: Red.
MAN: Black.
WOMAN: Red.
MAN: You know what, go on and just keep the million . . .

1378

Art Director	Gary Johns
Writer	Jeff Gorman
Editor	Charlie Chubak
Director	Mark Coppos
Director of Photography	Peter Brown
Agency	Elaine Hinton/Chiat/Day, Los Angeles, CA
Production Company	Bill Bratkowski/Coppos Films
Client	800-Flowers
Music	John Trivers Music Production

1379

Art Director	Kurt Tausche/Tom Donovan
Writer	Bert Gardner
Editor	Gregory M. Cummins
Director	Norman Seeff
Agency	Judy Wittenberg, Bozell, Jacobs, Kenyon & Eckhardt, Minneapolis, MN
Production Company	Richard Marlis Productions
Client	Swiss Miss—Beatrice
Editing Company	Editronics

TULIPS
30-second
VO: Our flowers are so elegant . . . because our florists are hand-picked.
Eight-hundred-flowers. Phone twenty-four hours a day, seven days a week.

WILTED PACKAGE
30-second
JUDD: If you're a Carnation Hot Cocoa drinker, you know it's good. No question about it. But we thought you should know that . . .
JUDD: . . . Swiss Miss is better.
(TO CARNATION) Sorry.
JUDD (TO CAMERA): In fact, in a national taste test, women preferred Swiss Miss to Carnation.
JUDD: By almost 2 to 1.
JUDD (TO CARNATION PKG): I'm not saying Carnation is second *rate.*
JUDD (WRYLY, TO CAMERA): Just second best.
JUDD (VO): Try Swiss Miss. A better hot cocoa.
WOMAN VO: We're Beatrice.

That's 6 weeks . . . SFX: ZAP . . . or more!
Long-lasting ORTHO Home Pest Insect Control!
ORTHO works wonders.

1380

Art Director Pam Conboy

1381

Art Director Gary Johns

1384

Art Director	Gary Johns
Writer	Jeff Gorman
Editor	Charlie Chubak
Director	Gary Johns/Jeff Gorman
Director of Photography	Amir Hamed
Agency	Bill Donnelson/Vic Olseson & Partners
Production Company	Sam Schapiro/Johns + Gorman Films, Los Angeles, CA
Client	Chevrolet Nova
Music	John Trivers Music Production

1385

Art Director	Mike Lawlor
Writer	Richard Russo
Editor	Jeff Dell
Director	George Gomes
Agency	JoAnn Diglio, Della Femina, Travisano & Partners, New York, NY
Production Company	Gomes Loew Productions
Client	Ted Haslam, Patricia McDonald, Health America

IMPORTED FROM AMERICA
30-second
VO: Early each morning, we come to build the new Nova.
It is a unique idea in imported cars.
Each team takes great pride in its work.
The result is Nova—a new car imported from . . . America.

FATHER
30-second
FATHER: Please listen because this is critical to your future. You have to finish all your um ums. Come on, Mum Mum made these um ums.
VO: Parents do some strange things in the name of love.
But they also do some pretty smart things. Like getting the finest health care possible.
With Healthamerica, besides great coverage, you'll see some of the finest doctors and medical professionals around.
Join Healthamerica. You'll feel smarter for it.
SUPER & VO: Healthamerica. We're making health care in America better.

	1386
Writer	Marvin Honig
Editor	Palastrini Associates/Bob Tuscanes
Director	Jack Piccolo
Agency	Beth McMorrow, Geers Gross Advertising, New York, NY
Producer	Christina Ritzman
Client	Kraft, Inc./Dairy Group

	1387
Art Director	Bud Watts
Writer	Greg Taubenack
Editor	Ed Hall
Director	Mike Cuesta
Director of Photography	David Castillo
Agency	Joe Mangan, Leo Burnett, Chicago, IL
Production Company	Erwin Kramer, Griner/Cuesta & Associates, New York, NY
Client	United Airlines

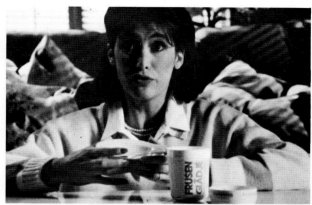

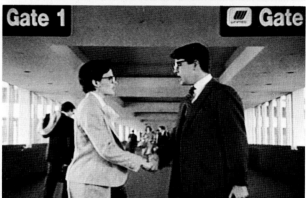

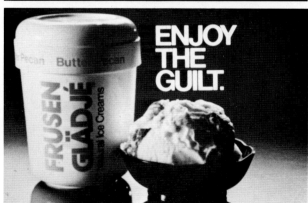

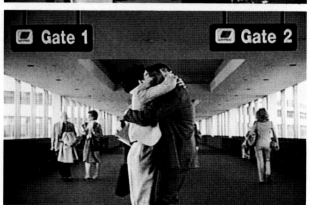

ENJOY THE GUILT
30-second
MUSIC UP
SFX: DOOR OPENS
ANNCR VO: If you don't feel guilty, it wasn't that good.
MAN VO: Hi honey.
WOMAN VO: I ate all the Frusen Glädjé.
MAN VO: You ate all the what?
WOMAN VO: I ate all the Frusen Glädjé.
ANNCR VO: Frusen Glädjé, the ice cream under the dome. So creamy; so delicious, so rewarding.
WOMAN VO: And I'd do it again.
ANNCR VO: Enjoy the guilt.
Frusen Glädjé.

COUPLE
30-second
MARTIN: We are today's typical traveling business couple.
JUDITH: Our jobs take us separate ways . . .
MARTIN: So essential to our relationship is the precise use of time.
JUDITH: And trust . . .
MARTIN: . . . and of course United Airlines.
JUDITH: United Airlines serves the top business centers.
MARTIN: And all fifty states
JUDITH: They take us wherever. . . . whenever.
MARTIN: I'm doing nine cities in seven days.
JUDITH: I'm doing eight cities in six days.
MARTIN: Only United could handle a couple like us.
JUDITH: See you in a week. Good luck Martin.
VOCALS: You're not just flying . . .
MUSIC UNDERSCORE. VOCALS: You're flying the friendly skies.

1388

Art Director	F. Paul Pracilio
Writer	Jeffrey Atlas/Diane Pohl
Editor	Phil Messina
Director	Steve Horn
Creative Director	Tom Rost
Agency	Ann Marcato/Ogilvy & Mather, New York, NY
Production Company	Linda Heuston/Steve Horn Inc.
Client	American Express

1389

Art Director	Jack Mariucci
Designer	Jack Mariucci
Animator	Artwork created by Doyle Dane Bernbach
Writer	Garry Greenspon
Editor	The Editors
Director	Henry Sandbank
Agency	Joe Scibetta, MaryEllen Perezolla/ Doyle Dane Bernbach, New York, NY
Production Company	John Kamen/Henry Sandbank
Client	Michelin Tire Corp

PROJECT HOMETOWN AMERICA
30-second
ANNCR VO: We're all born with a capacity to give, to share. But as we grow, we get busy. We forget. To help revive those childlike qualities, American Express is launching Project Hometown America. Each time you use the American Express Card, you'll help your community unite to solve its problems. For the sake of your hometown, and the child within us all, don't leave home without it.

BABY
30-second
MUSIC: UP AND THROUGHOUT.
MAN: A set of those Michelins please.
SALESMAN: Great tire, but I can let you have a set of these for a lot less than the Michelins.
MAN: Are they as good?
SALESMAN: They're good.
MAN: Do they last as long?
SALESMAN: Well, I'll tell ya, you're probably gonna sell your car before the Michelins wear out anyway.
MAN: Hmmmm. Do they handle as well?
SALESMAN: Chances are you'll never have to find out.
MAN: I don't want to take that chance. I'll spend the difference and get the Michelins.
ANNCR VO: Michelin, because so much is riding on your tires.

1390

Art Director	Gary Johnston
Writer	Phil Lanier
Director	Steve Horn
Agency	Elaine Hinton, Chiat/Day, Los Angeles, CA
Production Company	Steve Horn, Inc.
Client	Apple Computer, Inc.

1391

Art Director	Gary Johns
Writer	Jeff Gorman/Brent Bouchez
Editor	Simon Laurie/Gayle Grant
Director	Tony Scott
Agency	Richard O'Neill, Chiat/Day, Los Angeles, CA
Production Company	Fairbanks Films
Client	Pizza Hut, Inc.

SKATEBOARD
30-second
MUSIC: UNDER THROUGHOUT.
ANNCR VO: Using an Apple II is very easy.
The only hard part is getting your kid away from it.
You see, Apples are the leading computers in schools.
So, even though you bought it to help you work at home, your kid will
want to use it for his own homework. Of course, if all else fails,
there's one last thing you can try:
get him an Apple of his own.

TRAVELOG
30-second
MUSIC: ITALIAN MUSIC THROUGHOUT.
ANNCR VO: In Italy, they have different names for Italian pie. We
call it
Priazzo.
Baked fresh every day at Pizza Hut

1392

Art Director	Gail Nakasone, Lila Sternglass
Writer	Don Silbersten, Bill Hamilton
Editor	Morty Schwartz
Director	Stew Birbrower
Agency	Marilyn Cook—Matthew Borzi, Rumrill Hoyt NY Advertising, New York, NY
Production Company	Stew Birbrower—Birbrower Films
Client	New York State Lottery

1393

Art Director	Bob MaHarry
Designer	Bob MaHarry
Director of Photography	Richard Riley
Writer	Sharon Kirk
Agency	Ice Communications, Inc., Rochester, NY
Production Company	Riley Productions, Wheeler Productions
Client	Missing Children Help Center
Music	Jeff Arthur

LOU & CURTIS

30-second

LOU: Hey Curtis, remember when we hit New York's Lotto for all those millions.

CURTIS: Man, we were hot stuff!

LOU: But now they've got this new Lotto 48 Wednesday and Saturday.

CURTIS: The jackpots start in the millions!

LOU: It could really get big.

CURTIS: Makes us look like penny pinchers.

LOU: We've got to play Lotto 48.

CURTIS: Right, but first let's eat.

LOU: Two please.

CURTIS: And don't be stingy with the mustard!

ANNCR: New, bigger Lotto 48. The new way to join the family of Lotto millionaires.

CINDY

30-second

(FLASHBACK:)

MOM (TO BABY): Say Daddy . . . Daddy.

CINDY: Da Da.

(PRESENT:)

MOM: Cindy, Cindy.

(FLASHBACK:)

CINDY: Catch Mommy!

MOM & CINDY: Whee . . . Whee!

(PRESENT:)

MOM: Cindy, where are you?

ANNOUNCER: If your kids are safe at home, help us help the ones who aren't.

Call 1-800-USA-KIDS and pledge whatever you can afford.

Missing Children Help Center.

1394

Art Director	Harvey Baron
Designer	Harvey Baron
Writer	John Noble
Editor	Morty's
Director	Michael Berkofsky
Director of Photography	Simon Ransley
Agency	Joe Scibetta/Doyle Dane Bernbach, New York, NY
Production Company	Berkofsky/Barrett
Client	Audi

1395

Art Director	Rich Martel
Writer	Al Merrin
Editor	David Dee
Director	Steve Horn
Agency	Barbara Mullins/BBDO, New York, NY
Production Company	Steve Horn Pro.
Client	Pepsi-Cola Company

5001 REASONS
30-second
The new 5000
series from Audi.
The 5000 Turbo Quattro, Turbo, Sedan, Wagon.
5000 reasons to own an AUDI
Make that
5000
and one.
Now
available
with anti-lock
braking
systems.
AUDI
The Art of Engineering.

CAR CHASE
30-second
SFX: SIREN BLARING, ENGINE REVVING.
UNDERCOVER COP #1: Whoa . . . What are you doing?!
MOTORCYCLE REVVING.
No! Get the light.
(GASP)
To those . . . whose lives are filled . . .
with all the stimulation they need . . .
Hang on, hang on.
Aaaa . . .
TIRES SCREECHING, METAL SCRAPING CEMENT.
we offer Pepsi Free . . .
PEPSI FREE CAN OPENING.
made with absolutely no caffeine.
The only stimulating thing about it is that exhilarating Pepsi taste.

1400

Art Director	Gary Johns
Writer	Jeff Gorman
Editor	Charlie Chubak
Director	Mark Coppos
Director of Photography	Peter Brown
Agency	Elaine Hinton/Chiat/Day/LA
Production Company	Bill Bratkowski/Coppos Films, Los Angeles, CA
Client	800-Flowers
Music	John Trivers Music Production

1401

Art Director	Lila Sternglass
Writer	Bill Hamilton
Editor	Chuck East
Director	Chuck East
Agency	Lila Sternglass, Rumrill Hoyt NY Advertising
Production Company	Brian Bender—One Pass Video, San Francisco, CA
Client	Church of the Nazarene

ELOQUENCE
30-second
VO: Now you can say "I love you" more eloquently.
Eight-hundred-flowers. Phone twenty-four hours a day, seven days a week.

SEATTLE
30-second
Something special happened here.
Two women sat down in this Sunday School with a Bible.
Lieu was a Vietnamese refugee. A widow with two children. She had come to learn English.
Mabel was a retired school teacher who saw a new chance to help.
Together, with the Bible, they studied a language. And Lieu found God.
Welcome to the Church of the Nazarene.
Our Church can be your home.

1402

Art Director	Sandy Zachary
Writer	Jill Gaynes
Editor	Laube-Roth
Director	Jeremiah Chechik
Creative Director	Elaine Haller
Agency	Sylvan Markman/Ogilvy & Mather, Los Angeles, CA
Production Company	Jean Michel Levon/Bill Hudson Films
Client	CBS

1403

Art Director	Merv Shipenberg
Writer	Evan Stark, Brett Shevack
Editor	Bobby Smalheiser
Director	James Moore
Director of Photography	James Moore
Agency	Joanne Harvard/Calvillo, Shevack & Partners, New York, NY
Production Company	Margaret Bank/James Moore Productions, Inc.
Client	The Van Heusen Company, A Division of Phillips-Van Heusen Corp.

FIRST KISS
30-second
VERSE: Imagine, the way it's gonna be
Imagine, the perfect fantasy
A feeling you just can't resist
That moment you won't wanna miss
It's all here on CBS
'Cuz CBS is you.
CHORUS: We've got the touch
We've got the touch
We've got the touch on CBS

MY DADDY'S SHIRT
30-second
(MUSIC UP)
GIRL #1 OC: If you think *I* look good in this Van Heusen, you should see Jeffrey . . .
(PLAYFULLY) . . . after all, it's *his* shirt!
GIRL #2 OC: I bought this shirt for Michael.
(MOCK SERIOUSNESS) I think he's going to have a tough time getting it back.
LITTLE GIRL OC: I love this shirt.
(WHISPER TO CAMERA) It's my Daddy's.
ANNCR VO: Nobody puts more in a man's shirt than Van Heusen.
SUPER: Nobody puts more in a man's shirt than Van Heusen.

1408

Art Director	Mario Giua
Writer	Robin Raj
Editor	Morty Ashkinos
Director	Henry Sandbank
Creative Director	Gary Goldsmith
Agency	Frank Scherma/Chiat/Day inc., New York, NY
Production Company	Greg Carlesimo/Sandbank Films
Client	NYNEX Information Resources

1409

Art Director	Bryan McPeak, Russ Tate
Writer	Jim Gorman, Craig Piechura
Agency	Larry August, W. B. Doner & Company, Southfield, MI
Client	Hickory Farms

OFFICE
30-second
GUY: Where's the Yellow Pages? Shirley, do you know who's got the Yellow Pages?
WOMAN: No.
GUY: Frank, got the Yellow Pages?
MAN: Nope.
VO: Over the years, one book has been in more offices, helping people throughout New England find more goods and services. The Nynex Business-to-Business Yellow Pages.
SFX: WINDOW SLAMS SHUT.
VO: It's always there when you need it . . .

CANDY
30-second
ANNCR: Some of the most extraordinary hand-dipped chocolates in the world come from one of the least likely places of all. We know . . . we've been there.
HICKORY FARMS REP: Hi. I'm from Hickory Farms. Boy, those sure look good.
WOMAN: Well, would you like to try one?
ANNCR: Hickory Farms has been to a lot of places to collect unique gifts for Christmas.
HICKORY FARMS REP: I can't be in Ft. Worth. This has gotta be heaven.
ANNCR: Sweet Elegance Chocolates and other gifts from Hickory Farms. We've done your Christmas shopping for you.

1410

Art Director	Michelle Farnum
Writer	Perri Feuer
Editor	David Dee/Even Times
Director	Michael Berkofsky
Director of Photography	Michael Berkofsky
Agency	Lee Weiss/Doyle Dane Bernbach, New York, NY
Production Company	Ree Whitford/Berkofsky Barrett
Client	Betsy Means/Clairol
Music Composer	Ann McLoon/McLoony Tunes

1411

Art Director	Gerald Andelin
Writer	Hal Riney
Editor	Jacques Dury
Director	Joe Pytka
Agency	Deborah Martin/Hal Riney & Partners, Inc., San Francisco, CA
Production Company	John Turney/PYTKA
Client	Blitz-Weinhard Brewing Co.

CAMPUS REV. 2
30-second
MUSIC THROUGHOUT
VO: Sea Breeze
cleans so deep you feel it.
SINGERS: Beautiful skin can be a breeze with Sea Breeze.
VO: Deep clean.
So clean
It tingles.
SINGERS: Beautiful skin can be a breeze with Sea Breeze.
VO: No other clean feels quite like this.

BOTTLING #82
30-second
ANNCR: People often wonder why they can't find Henry Weinhard's Private Reserve . . .
. . . quite as easily as some other beers . . .
That's because we still brew Henry's only a few hundred barrels at a time . . .
So, in the same time a large brewer makes a hundred bottles of beer, we only make one.
So if you occasionally have to wait for Henry's, just remember—
MM: Hey, when are ya' gonna move that truck?
ANNCR: . . . It's because we're still doing everything we can . . .
DRIVER: . . . October . . .
ANNCR: . . . to make Henry's worth waiting for . . .
LADY: . . . November!
DRIVER: . . . November . . .

1416

Art Director	Christie Kelley
Writer	Jeanne Shorter
Editor	Rich Carroll/Optimus
Director	Michael McNamara/Filmfair
Creative Director	Doug McClatchy
Agency	Bill Davenport/Ogilvy & Mather, Chicago, IL
Client	Chicago Tribune
Music	Gary Fry/ComTrack

1417

Art Director	Paul Walter
Writer	John Greenberger/Charlie Miesmer
Editor	David Dee
Director	Steve Horn
Agency	Barbara Mullins/BBDO, New York, NY
Production Company	Steve Horn Productions
Client	HBO

ENTERTAINMENT
30-second
MUSIC UNDER
ANNCR: For a town that calls itself the city that works, Chicago has always been a great place to play.
On any given day
or night there
are literally thousands
of things
to do
How do you
sort it all out.
More and more people
reach for the Chicago Tribune.

FIGHT
30-second
SFX: HEAVY BREATHING.
1ST: No way the kid goes four
2ND: Ahh, You're crazy!
SFX: TAPE WRAPPING
ANNCR:. . . make sure he's facing the camera . . .
1ST: Hey, we'll see ya
2ND: Round one
SFX: I WANT YOU! SMACK!! TESTING, ONE, TWO . . .
GUY: Taxi!!
SFX: TRAFFIC, HORNS
MAN: C'mon we're buying tickets here . . .
ANNCR: I'll follow your lead
CROWD: Marvin, Marvin!! . . .
AVO: When it's big, nobody brings it home like HBO

1418

Art Director Jean Govoni
Writer Stanley Becker/Cliff Freeman
Director Linda Mevorach
Agency J. C. Kaufmann, DFS, New York, NY
Production Company Ray LoFaro & Associates
Client General Mills, Inc.
Recording Producer Deed Meyer

1419

Art Director Larry Frey
Writer Martin Dawson
Editor John Fogelson
Director Michael McNamara/Filmfair
Creative Director Martin Dawson
Agency Monna O'Brien/Ogilvy & Mather, Chicago, IL
Client Chicago Tribune

REAL COWBOYS
30-second
ANNCR VO: It's amazing what's happened since Yoplait, the Yogurt of France, came to America. Take Breakfast Yogurt from Yoplait. A substantial yogurt bursting with country wheat grains, walnuts, and sun ripened fruits! Who'd have imagined the effect it would have on real Americans . . .
COWBOYS: (SING) Chez moi, a la campagne!
Qu les daims et les antilopes jouant.
ANNCR VO: Lowfat Breakfast Yogurt.
Just one of the yogurts from Yoplait, the Yogurt of France.

ENDORSEMENTS
30-second
ANNCR: Last year the Chicago Tribune editorial board wrote 131 editorials supporting President Reagan. And 142 opposing him. They endorsed 67 Republican candidates. And 59 Democrats. And every issue that came along, the Tribune tried to judge on its own merits. Because the largest newspaper in Chicago can't belong to anyone but the people who buy it every day. A great city deserves a great newspaper. The Chicago Tribune.

1420

Art Director Lou Colletti
Writer Elmer Skahan
Director Gennaro Andreozzi
Creative Director Larry Vine
Agency Beth McMorrow, Geers Gross Advertising, Inc., New York, NY
Producer Lou Andreozzi
Client E. Gluck & Co.
Music Sing Song Productions

1421

Art Director Mark Shap
Designer Mark Shap
Writer Veronica Nash
Director Howard Guard
Agency Susan Chiafullo, Ogilvy & Mather, New York, NY
Client Avon Products, Inc.

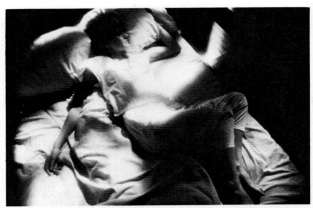

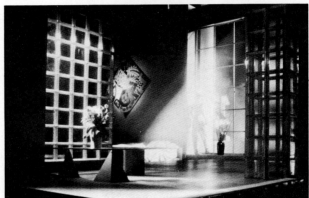

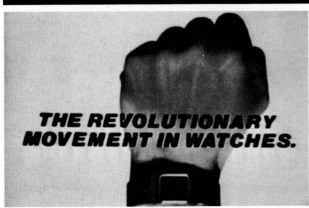

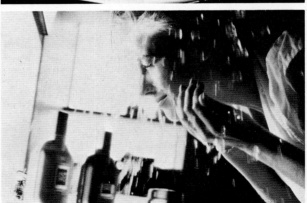

AFTER 10 YEARS
30-second
MUSIC UP
(SINGERS CHANT—ARMITRON, ARMITRON . . . THROUGHOUT)
ANNCR: After ten years it seems suddenly to be everywhere.
The movement against the artificially high prices of watches.
A revolution that has spread to over fifty million wrists.
Armitron.
Watches so beautifully made, so incredibly priced.
It has quietly become the second largest company in America.
Armitron. The revolutionary movement in watches.
MUSIC OUT

SKIN CARE
30-second
(FEMALE)
ANNCR: For one company, beauty is the balance of art and science.
It brings you space age skin care that's artfully simple to use.
A new generation of cosmetic colors that respond to the art of fashion, and fragrances that combine natural science with pure inspiration.
At Avon, beauty has entered a new age.
Avon. The art and science of beauty.

1422

Art Director — Sal DeVito
Writer — Rochelle Klein
Editor — Ed Friedman
Director — Henry Sandbank
Creative Director — Steve Penchina
Agency — Penchina, Selkowitz Inc., New York, NY

1423

Art Director — Mark Shap
Designer — Mark Shap
Writer — Veronica Nash
Director — Howard Guard
Creative Director — Malcolm End
Agency — Susan Chiafullo, Ogilvy & Mather, New York, NY
Client — Avon

POSTER

30-second
ANNCR VO: WNBC Radio's Don Imus and Howard Stern
may have stepped on the toes of a few people with their outrageous antics.
Maybe some of the things they said were a little indiscreet.
But lucky for us,
our listeners are the kind of people
who can really take a joke.
IMUS VO: Find out what everyone's so excited about.
66 WNBC.
If we weren't so bad, we wouldn't be so good.

GARDEN/COLORS

30-second
MUSIC UNDER:
VO: Every season we create . . .
exciting new colors for your eyes and nails and lips . . .
Wondrous color . . . luminous . . . stimulating . . .
Magical color that does nothing short of transforming you.
Colors. Created by art . . .
and science . . .
and Avon . . .
MUSIC: Avon. The Art and Science of Beauty.

1424

Art Director	Judy Turner-Blain
Animator	Chuck Gammage
Writer	Kathy Doherty
Editor	John Burtcher
Director	Bob Fortier
Agency	Christine Davis/Leo Burnett Company Ltd., Toronto, Canada
Production Company	Sam Gardner/The Animation House
Client	Beatrice Canada
Music	Crawford/Goldsmith Music
Voice	John Rutledge

1425

Art Director	John Short
Designer	Linda Burton
Writer	Alan Mond
Editor	Morty Perlstein
Director	Joseph Hanwright
Agency	Lee Zimmerman/Bozell, Jacobs, Kenyon & Eckhardt, Inc., New York, NY
Production Company	Janette Mercer, Barbara Mickleson/KIRA Films
Client	Chrysler Corporation

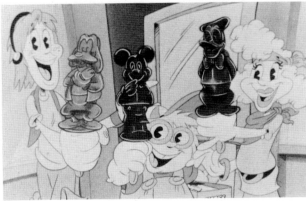

DISNEY POPS, STORE
30-second
UPTEMPO CONTEMPORARY TRACK
SINGERS: When you head to the store . . . guys,
You won't believe your eyes
We're talkin' poppin'
Cause Mickey and Donald and Goofy
are in a box of Good Humor . . .
Disney Pops. Fun to eat.
Disney Pops. Ice cool treats.
Disney Pops. 3-D shapes.
Disney Pops. Taste real great.
Disney Pops. You'll just adore.
Disney Pops. Now at your store.
VO: Disney Pops. New from Good Humor.

THE PRIDE IS BACK
30-second
CHORUS: The Pride is Back
Born in America
The Pride is Back
Born in America
AVO: The Pride is Back.
With the versatile Plymouth Voyager.
Car-like handling. Front-wheel drive.
Backed by the 5/50 Protection Plan.*
Plymouth.
The Pride is Back. Born in America.
CHORUS: The Pride is Back.
Born in America. Again.
*SUPER: See limited warranty at dealer.
Excludes leases. Restrictions apply.

1426

Art Director Mike Ciranni, Jamie Seltzer
Writer Jamie Seltzer, Mike Ciranni
Editor Morty Ashkinos
Director Henry Sandbank
Agency Frank Scherma/Chiat/Day inc.,
New York, NY
Production Company Jon Kamen/Sandbank Films Inc.
Client Topps Chewing Gum

1427

Art Director Mark Shap
Writer Veronica Nash
Director Barry Kinsmen
Creative Director Malcolm End
Agency Susan Chiafullo, Ogilvy & Mather,
New York, NY
Producer Alan Taylor
Client Avon

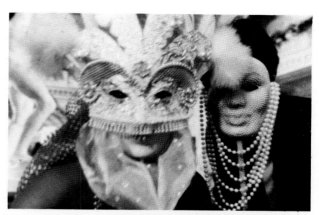

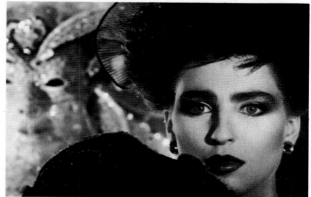

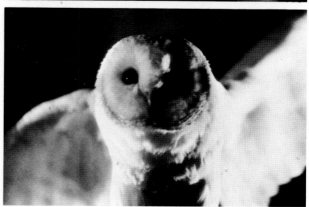

TOUGH GUY
30-second
SFX: AGONIZING GROAN.
SFX: ANOTHER AGONIZING GROAN.
SFX: ANOTHER AGONIZING GROAN.
SFX: ANOTHER AGONIZING GROAN.
VO: Bazooka Bubble Gum. If you're tough enough to chew the hard stuff.

IMAGINAGION
30-second
PARTY SFX: MUSIC UNDER
There is a place where illusion and reality become one.
MUSIC
Imari can take you there.
MUSIC UP.
A fragrance to fire the imagination.
Imari. From Avon.

1428

Art Director Beverly Martin
Writer Tom Batholomew
Editor Rick Ross
Director Richard Hoover
Creative Director Bill Waites
Director of Photography Jordan Cronenweth
Agency Mary Prchal/Ogilvy & Mather, Chicago, IL
Production Company Michael Patton, Bert Terreri/Robt. Abel & Assoc.
Client Sears, Roebuck and Co.
Music Gary Fry/ComTrack

1429

Art Director Mary Morant
Writer Eileen Sandler
Editor Alan Rozak
Director Richard Loncrain
Director of Photography Harvey Harrison
Agency Jack Harrower—LGFE. New York, NY
Production Company D. G. & H. Garrett
Client IBM-PC

BLACK CANYON
30-second
MUSIC: TENSE, UNDER
ANNCR VO: It hugs the road with bulldog tenacity . . .
It's warranted for 30,000 miles . . . yet costs under $30.
This impressive automotive accomplishment isn't *in* the car . . .
It's *on* the car.
The Sears Guardsman Radial two steel-belts and a 30,000 mile warranty.
For *less* than $30.00
SINGERS: There's more for your life . . .
ANNCR VO: Confidence installed . . .
SINGERS: at Sears.

HIGH PERFORMANCE
30-second
MUSIC THROUGHOUT
VO: When you're dealing with higher volumes of information and need answers fast . . .
you search everywhere for solutions . . .
but find it hard to stay on top of things.
That's why IBM created the Personal Computer AT . . .
with the power to push performance even higher.
With the AT, fast becomes faster.
And the capacity to handle data becomes greater.
All to help you put your business on solid ground.
The IBM Personal Computer AT.
For Advanced Technology.

1430

Art Director	Eduardo Zayas
Writer	Robin Williams/Charles Allenson
Editor	Ciro Denettis
Director	Mel Sokolsky
Agency	Bob Samuel, Liza Leeds, Rumrill Hoyt NY Advertising
Production Company	Mel Sokolsky/Sunlight Productions, Los Angeles, CA
Client	Unicorn Publishing House, Inc.

1431

Art Director	Peter Hirsch
Designer	Peter Hirsch/Peter Heath
Writer	Ken Majka
Editor	Larry Jordan/Movie Lab
Director	Peter Heath
Agency	Valerie Hutchinson/Calet, Hirsch & Spector, Inc., New York, NY
Production Company	Elio Lupe/Peter Heath & Company
Client	Toshiba

ROBIN WILLIAMS/YUPPIE
30-second
We were sitting around the other night and I said, "My God, what should we have to eat?" I said, "some unborn pairs, some hummingbird lips, God what should we do?" I said, "Hey pal, how 'bout this?" Let's buy a copy of LIVE-AID instead. 'Member that day? It was a fabulous day. Mick was there. Sting, everyone. Even Jack Nicholson. And the nice thing about it is you buy the book, some people in Africa get food. What can you say? I feel so amazing. So humanitarian. Do it if you can. Fabulous.

TOSHIBA VCR MOVIE STAR
30-second
RUDY: I can't get to sleep at night,
watching my baby.
CLARA: And when I turn out all the lights,
it drives me crazy.
WOMAN: It's every color of the rainbow,
GROUP: Toshiba VCR—
GLORIA: It's a movie star.
Keeps me up around the clock.
HUNCH: I just can't stop myself from watchin'
GROUP: Toshiba VCR.
CLARA: Watchin' it.
GROUP: It's a movie star.
Toshiba VCR.
Watchin' it.

1432

Art Director	Marcus Kemp/Joe Sedelmaier
Writer	Steve Sandoz/Joe Sedelmaier
Editor	Peggy Delay
Director	Joe Sedelmaier
Director of Photography	Joe Sedelmaier
Creative Director	Ron Sandilands
Agency	Cindy Henderson/Livingston & Company, Seattle, WA
Production Company	Marcie Wallach/Sedelmaier Productions
Client	Alaska Airlines

1433

Art Director	Mario Giua
Writer	Robin Raj
Editor	Morty Ashkinos
Director	Henry Sandbank
Creative Director	Gary Goldsmith
Agency	Frank Scherma/Chiat/Day inc., New York, NY
Production Company	Greg Carlesimo/Sandbank Films
Client	NYNEX Information Resources

EARLY FLIGHT
30-second
ANNCR: In the beginning . . . flying was a real adventure . . .
ANNCR: . . . And on most airplanes, it still is.
ANNCR: But on Alaska Airlines, we go out of our way to make sure getting there is just as pleasant as being there.

BEDROOM
30-second
GIRL: Have you seen the Yellow Pages?
WOMAN: Did you look in the closet?
GIRL: Dina, do you have the Yellow Pages?
LADY: Uh-uh. Check the desk.
GIRL: Jeff, where's the Yellow Pages?
BOY: Look upstairs.
GIRL: I looked already.
BOY: Look again . . .
SFX: BLEED-THROUGH FROM STEREO HEADPHONES.
VO: Over the years, one book has been in more homes, helping people throughout New England find more goods and services. The NYNEX Yellow Pages.
SFX: BLEED-THROUGH OF TURNTABLE SCREECHING
VO: It's always there when you need it . . .

1434

Art Director	Don Easdon
Writer	Bill Heater
Editor	Hank Corwin
Director	Joe Pytka
Agency	Mary Ellen Argentieri/Hill, Holliday, Connors, Cosmopulos, Boston, MA
Production Company	Joe Pytka/Pytka Productions
Client	John Hancock Mutual Life Insurance Company

1435

Art Director	Rick Boyko/Doug Patterson
Writer	Bill Hamilton/Ed Cole/Pat Morita
Editor	Gayle Grant
Director	Norman Seeff
Agency	Elaine Hinton, Chiat/Day, Los Angeles, CA
Production Company	Richard Marlis Prod.
Client	Pizza Hut, Inc.

MARRIED COUPLE
30-second
LAWYER: There's a lot of paperwork here. There's always paperwork when you buy a house. First one says that you lose the house if you don't make your payments. You probably don't want to think about that but . . . you do have to sign it.
Next says the property is insured for the amount of the note. And you sign that in the lower left corner.
This pretty much says that nobody's got a gun to your head . . . that you're entering this agreement freely.
Next is the house is free of termites. Last one says thatr the house will be your primary residence and that you won't be relying on rental income to make the payments.
I hope you brought your checkbook. This is the fun part. I say that all the time though most people don't think so. (CHUCKLE)

KIDS
30-second
MUSIC: UNDER THROUGHOUT.
MORITA: I like kids. Probably mostly because I used to be one. When my kids get really cookin' and they're, ya know, they burn up a lot of energy and stuff . . .
This is their favorite eating form. They'd take this over anything . . . french fries, hamburgers, ketchup . . . umm, rice.

1436

Art Director	Gary Johnston
Writer	Phil Lanier
Director	David Ashwell
Agency	Elaine Hinton, Chiat/Day, Los Angeles, CA
Production Company	David Ashwell Film Co.
Client	Apple Computer, Inc.

1437

Art Director	Frank Gentile
Writer	Milton Lowe
Director	Andy Jenkins
Agency	Henrieta Creech/NW Ayer Inc., New York, NY
Production Company	Frank Maccio/Jenkins, Covington, Newman, Rath
Supervisor	Joan Albury

COMPUTER SNEAK
30-second
ANNCR: This is how many parents, all across America, find out about the Apple IIc. Parents buy their kids an Apple IIc because Apples are the leading computers used in schools.
Then, they discover how easy it is to set up and use. How it can help them with things like business and home finance.
And how that can help them spend more time with their kids.
SFX: CLICK.
KID: Oh. Hi, Dad.

IT'S ALL HERE/NASSAU
30-second
(MUSIC UP)
SINGER: It's all here in the Bahamas . . .
(MUSIC)
SINGER: . . . you have a lot to do.
(MUSIC)
(MUSIC UNDER ANNCR.)
VO: You may not want to do it all . . .
(MUSIC)
VO: . . . but it's nice to know it's there.
(MUSIC)
SINGER: It's better in the Bahamas
(MUSIC FADES OUT)

1438

Art Director Don Nagel
Writer Don Little
Editor Warren Silverstein
Director Henry Sandbank
Creative Director Bob Latimer
Director of Photography Henry Sandbank
Agency John Pike, D'Arcy Masius/Benton
& Bowles, Bloomfield Hills, MI
Producer Jon Kamen
Client Sam Macallister
Music John Petersen

1439

Art Director Alan Chalfin/Lou Colletti
Writer Larry Vine
Editor Morty Ashkinos
Director Jimi Connolly
Creative Director Larry Vine
Agency Sarah Fader, Geers Gross
Advertising, New York, NY
Producer Myrna Connolly
Client Lea & Perrins
Music Warner Levinson

HANDS (TOOLS)
30-second
MUSIC: PUNCTUATES ACTIONS THROUGHOUT.
ANNCR: These are the hands of Mr. Goodwrench.
Hands that work.
Hands with the know-how to fix things.
Hands that are strong and sure.
Hands that are gentle.
Accurate.
Hands that can almost see where the trouble is . . . and how to make
it right again.
Hands of skill. Hands that care.
The working hands of Mr. Goodwrench.
. . . and no one knows your GM car better.
No one.

BETTER WAY
30-second
MUSIC UP AND UNDER
ANNCR VO: To get flavorful steaks takes marinating . . .
To get a superior marinade takes an abundance of select ingredients
and a large supply of time.
Presenting a better way.
Lea & Perrins Worcestershire Sauce.
It's rare, naturally aged ingredients make for a mouthwatering
marinade that takes as little as 20 minutes.
So ask for more flavorful juicy steaks.
In only 20 minutes . . .
Lea & Perrins has it all wrapped up.
The original, genuine worcestershire sauce.

1440

Art Director	Nik Ives
Writer	Bill Kurth
Editor	Ken Coleman
Director	Jeremiah Chechik
Creative Director	Charles Griffith
Agency	Jack Harrower/LGFE, New York, NY
Production Company	Hudson Films
Client	Steinway & Sons

1441

Art Director	Robert Reitzfeld
Designer	Robert Reitzfeld
Writer	David Altschiller
Editor	Randy Illowite
Director	Michael Schrom
Director of Photography	Michael Schrom
Agency	Jinny Kim, Altschiller Reitzfeld, New York, NY
Client	Boar's Head Provisions
Voice Over	Karl Weber

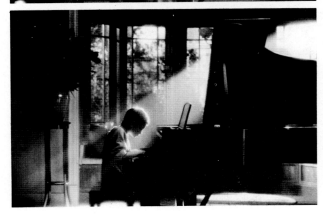

VIGNETTES
30-second
MUSIC THROUGHOUT
VO: To experience the pure and simple joy of music there is no instrument like the piano. And there is no piano like this one. Isn't it time you heard yourself on a Steinway?

SLEIGHT-OF-HAM/REVISED
30-second
ANNCR VO: Something's not kosher in the ham business.
This is a Boar's Head Ham. One of the great hams in the world.
These . . . your ordinary, everyday hams.
The question is: when you ask for Boar's Head Ham . . . and pay for Boar's Head Ham . . .
are you sure you get Boar's Head Ham?
There's only one way to know.
Ask for—no . . . demand to see the Boar's Head brand.
It's on the ham itself.
It's our way of keeping the baloney out of the ham business.

1442

Art Director	Barry Stringer
Writer	Sylvia Hughes
Editor	Mick Griffin
Director	George Morita
Director of Photography	George Morita
Agency	Christine Davis/Leo Burnett Company Ltd., Toronto, Canada
Production Company	Nancy Lee/Partners
Client	Weston Bakeries Ltd.

1443

Art Director	Mario Giua
Writer	Robin Raj
Editor	Morty Ashkinos
Director	Henry Sandbank
Creative Director	Gary Goldsmith
Agency	Frank Scherma/Chiat/Day inc., New York, NY
Production Company	Greg Carlesimo/Sandbank Films
Client	NYNEX Information Resources

SO DELICIOUS

30-second

MALE VO: The most delicious part of a sandwich is the middle.
But Country Harvest bread is so delicious, you'll be tempted to put that in the middle.
Country Harvest is made with nutritious wholesome ingredients and slow-baked to bring out all the
flavour and aroma you love.
In four delicious varieties stone milled 100% whole wheat
Prairie Bran
Harvest white
seven grain. (VOICE UNDER)
ANNCR VO: Counrty Harvest Bread. So delicious you'll be tempted to put it in the middle.

KID'S SEAT

30-second

DAD: Sally, who took the Yellow Pages?
SAL: I dunno.
DAD: (PASSES) Honey, have you seen the Yellow Pages?
MOM: No.
DAD: (PASSES) Susie, where are the Yellow oPages?
SUE: Sally had it last.
SAL: I did not.
DAD: (PASSES) C'mon. I need the Yellow Pages . . .
VO: Over the years, one book has been in more homes, helping people throughout New England find more goods and services. The NYNEX Yellow Pages . . .
SUE: Mom!
VO: It's always there when you need it.
MOM: Oh!

1444

Art Director James Good
Writer John Gruen
Editor Dennis Hayes
Director Bob Giraldi
Agency Stuart Rickey, Ogilvy & Mather Inc., New York, NY
Producer Patti Greaney
Client Sports Illustrated (of Time Inc.)

1445

Art Director Jill McClabb
Writer Margot Owett
Editor Ken Coleman
Director Jim Paisley
Director of Photography Michael Duff
Creative Director Kevin O'Neill
Agency Sue Rosenberg/LGFE, New York, NY
Production Company Barry Shapiro—Normandy Film Group
Client WNBC-TV
Creative Supervisor Bob Tore

RELIEF PITCHER
30-second
SCHAEFER: Yeah, he's ready.
QUISENBERRY: How does it feel when the phone rings and it's for me?
Who's batting? Who am I facing?
Nervous?
'Want that nervous edge.
WATHAN: C'mon Quis. Go get 'em!
QUISENBERRY: Keep cool. Keep cool.
SCHAEFER: Keep it down buddy.
QUISENBERRY: I can't trust what I've got in the bullpen.
PA ANNCR: Number 29, Dan Quisenberry.
QUISENBERRY: Here goes nothing.
ANNCR: Sports Illustrated.
Get the feeling

BEST DRESSED
30-second
MUSIC THROUGHOUT
VO: The best dressed people in New York get their weather from Al Roker.
News 4 New York. Is there any reason to watch anyone else?

1446

Art Director	F. Paul Pracilio
Writer	Robert Neuman
Editor	Phil Messina
Director	Ed Bianchi
Creative Director	Tom Rost
Agency	Ann Marcato/Ogilvy & Mather, New York, NY
Production Company	Jill Henry/Bianchi Films
Client	American Express

1447

Art Director	Nik Ives
Writer	Alec Wilkinson, Garland Bunting, Charles Griffith
Editor	Barry Stillwell/Dennis Hayes Editorial
Director	Norman Seeff
Creative Director	Charles Griffith
Agency	Ann O'Keefe/LGFE, New York, NY
Production Company	Marlis Productions
Client	The New Yorker

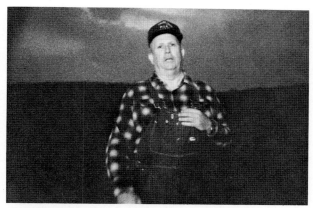

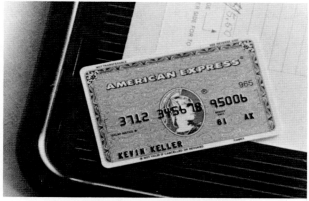

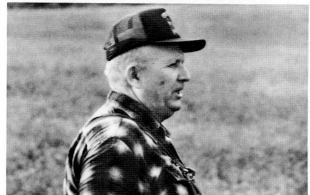

YOUNG LAWYER
30-second
FATHER: How did you like the lobster, Mr. District Attorney?
SON: Dad, I'm an assistant to an assistant to an assi . . .
FATHER: You know, I never told you this—I told your mother—how I felt when you decided not to join your old man's firm . . .
SON: I knew.
FATHER: Did you know I'm proud of you? (SON PULLS OUT AMERICAN EXPRESS CARD) American Express Card . . .
SON: Yeah. Pay's getting better over at City Hall.
ANNCR VO: Apply for the Card now. It's part of a lot of interesting lives.

MOONSHINE
30-second
The way to sneak up on a bootlegger depends a lot on the weather. A dry, quiet night with no wind blowing, you crack just one small stick, and you open up yourself for a load of buckshot, and no flowers on your grave.
Moonshiners used to say if they got a shot at a revenue agent he might get better, but he'd never get well.
ANNCR VO: From "Moonshine" by Alec Wilkinson, in a recent issue of The New Yorker. Yes, The New Yorker.

1448

Art Director	Jill McClabb
Writer	Margot Owett
Editor	Ken Coleman
Director	Jim Paisley
Director of Photography	Michael Duff
Creative Director	Kevin O'Neill
Agency	Sue Rosenberg/LGFE, New York, NY
Production Company	Barry Shapiro—Normandy Film Group
Client	WNBC-TV
Creative Supervisor	Bob Tore

1449

Art Director	Don Terwilliger
Writer	Terry Bremer
Editor	Bob Wickland
Creative Director	Ed Des Lauriers
Director of Photography	Eric Young
Agency	Bill Bandy, Campbell-Mithun, Inc., Minneapolis, MN
Production Company	Ridge Henderson, Wilson-Griak
Client	3M Scotchgard
Recording Studio	Bajus Jones
Music	Herb Pilhofer

POWER BROKERS
30-second
MUSIC THROUGHOUT
AUCTIONEER: (SFX: GAVEL HITS PODIUM)
Sold! The next item up for sale is the Upper West Side. I have 200 million to start it. Do I have 250? Ah, 250. Do I have 500? 500. 750! 1 billion! 1 billion 5. 2 billion. Do I have 2 billion? 2 billion . . . going once . . . going twice . . . Sold! At 2 billion.
VO: Many of the men who rule New York aren't elected to office. They're private citizens. They rule it with money, power and influence. Meet them on Gabe Pressman's special report: "Who Rules New York?". This week at 6 on News 4 New York.
AUCTIONEER: Now, the next item up for bid is the City Council.

CUP RUNNETH OVER
30-second
ANNCR: There's a thought that says it is indeed fortunate to have one's cup runneth over.
MUSIC: (SFX)
Fortunate, unless your cup runneth over onto your silk blouse, your fine linen tablecloth, your woolen slacks . . . whatever, wherever. Which is precisely why we make Scotchgard Fabric Protector. It keeps ordinary spills from becoming extraordinary stains. On virtually any fabric.
Use Scotchgard Fabric Protector.
And let your cup runneth over.

1450

Art Director	Mark Ashley
Writer	Ken Lewis
Director	Dean Lindberg (Bajus-Jones)
Creative Group Head	Grant Swain
Agency	J. Walter Thompson, Atlanta, GA
Production Company	Bajus Jones
Client	The Weather Channel

1451

Art Director	Rich Martel
Writer	Al Merrin
Editor	David Dee
Director	Steve Horn
Agency	Barbara Mullins/BBDO, New York, NY
Production Company	Steve Horn Pro.
Client	Pepsi-Cola Company

EVOLUTION

30-second
ANNCR: Long, long ago man had no way to forecast the weather. So he never knew what to expect.
SFX: ZAP
ANNCR: Then came television news with forecasts at noon, six and eleven. And man . . . never knew what to expect.
SFX: CHATTER
ANNCR: Today we have the Weather Channel. State of the art forecasting 24 hours a day. With local forecasts 8 times every hour. So now things are a bit more . . .
SFX: ZAP
ANNCR: civilized.
The Weather Channel.
Weather of a higher order.

FLIGHT INSTRUCTOR

30-second
SFX: PLANE CRASHING THROUGH BILLBOARD.
SFX: PLANE ENGINE, WINGS CLIPPING HEDGES.
VO: To those whose lives are filled with all the stimulation
VO: they need, we offer . . .
SFX: PEPSI FREE CAN OPENING.
Pepsi Free,
VO: made with absolutely no caffeine.
The only stimulating thing about it is that exhilarating Pepsi taste.
SFX: PLANE LANDING.
VO: Caffeine free Pepsi Free,
VO: because life is stimulating enough.
SFX: PLANE WINGS CRASHING DOWN.
VO: Available in regular and diet.
SUPER: Because life is stimulating enough.

1452

Art Director Steve Ohman
Writer Harold Karp
Editor Vito DeSario
Director Bill Hudson
Agency Mindy Gerber, Lowe Marschalk, Inc., New York, NY
Producer Jean-Michel Ravon
Production Company Bill Hudson & Associates
Client Citibank Better Bankcards
Camera/Lighting Sal Guida
Music Director Thomas Valentino

1453

Art Director Mario Giua
Writer Robin Raj
Editor Morty Ashkinos
Director Henry Sandbank
Creative Director Gary Goldsmith
Agency Frank Scherma/Chiat/Day inc., New York, NY
Production Company Greg Carlesimo/Sandbank Films
Client NYNEX Information Resources

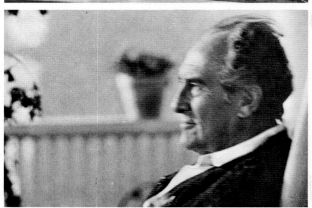

TOMMY'S TEAM
30-second
MAN: Thanks a lot, Citibank. You had to make your VISA and MasterCards better than other banks.
Only your cards offer CitiDining. It saves my boss and his wife 20% at restaurants all over town.
So now he can take a bunch of the guys out to dinner....
But he still can't take his mind off of work.
TOMMY LASORDA: All right, boys. Let's all step up to the plate.
Dig in.
And remember it's all in the wrist.
In the wrist.
ANNCR VO: VISA and MasterCard from Citibank.
TOMMY LASORDA: (UNDER) Keep your eye on the meatball.
ANNCR VO: It's the bank that makes them better.

ROCKING CHAIR
30-second
WOMAN: Billy, Bobby, have you seen the Yellow Pages?
KID: Ask Dad.
WOMAN: Hon, where's the Yellow Pages?
MAN: Ask Billy.
WOMAN: I asked Billy.
MAN: Ask Bobby.
WOMAN: I asked Bobby.
MAN: Ask Gramps . . .
SFX: SNORING; SCREEN DOOR OPENING.
VO: Over the years, one book has been in more homes, helping people throughout New England find more goods and services.
VO: The Nynex Yellow Pages.
SFX: CHAIR STARTS ROCKING . . .
VO: It's always there when you need it.

1454

Art Director F. Paul Pracilio
Writer Robert Neuman
Editor Phil Messina
Director Steve Horn
Creative Director Tom Rost
Agency Ann Marcato/Ogilvy & Mather, New York, NY
Production Company Linda Heuston, Steve Horn Inc.
Client American Express

1455

Art Director Amy Mizner
Writer Donald Deutsch
Editor Bobby Smalheiser
Director Martin Bell
Agency Amy Mizner/David Deutsch Associates, New York, NY
Production Company THT Productions
Client People's Bank

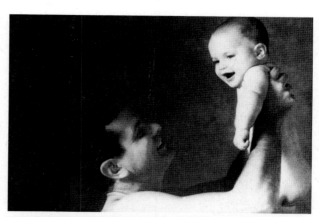

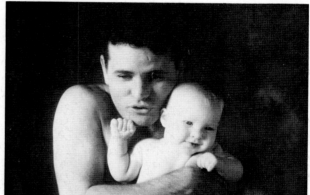

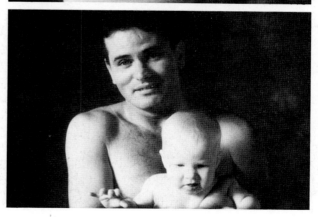

DO YOU KNOW ME?/MORITA
30-second
MORITA: Do you know me? This may seem puzzling, but you know me by sight and by sound.
You know my TVs, my stereos.
But to be really wired in, I carry the American Express Card.
As chairman of Sony, I expect great reception.
ANNCR VO: To apply for the Card, look for an application, and take one.
MORITA: The American Express Card.
Don't leave home without it.

FATHER (SAVINGS)
30-second
MAN: If you'd have told me 5 years ago I'd have one of these, boy I would have laughed. But now I've got my little princess. I'm going to start saving for her education now. She's going to Yale.
Funny, when it came to saving before I used to say "What difference does it make." But now there's more at stake. I want to make sure I'm doing everything right for her. Cause she's all I'm about now.
FREEZE
VO: People's Bank
We hear you
We have a savings plan to fit your needs.

Art Director	Dick Pantano
Writer	Tony Winch
Director	Joe Pytka
Agency	Gary Streiner/HHCC, Boston, MA
Client	Lotus Development Corporation
Music	Ed Kalehoff

Art Director	Candace Van Stryker
Writer	Karen Mallia
Director	Thom Higgins
Creative Director	Malcolm End
Agency	Ogilvy & Mather, Inc., New York, NY
Producer	Susan Chiafullo
Client	Schering

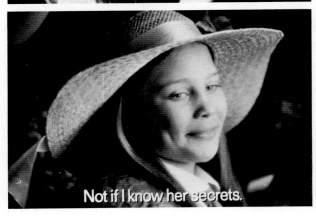

YOU MADE ME LOVE YOU
30-second
VO: For all those people who never could warm up to computers, Lotus introduces . . . Jazz.
MUSIC UP: You made me love you, I didn't want to do it, I didn't want to do it. You made me want you, and all the time you knew it, guess you always knew it . . .
(MUSIC UNDER)
VO: Jazz . . . the business software Macintosh was invented for.
MUSIC UP: You made me love you.

FRENCH GIRLS
30-second
(MUSIC UNDER)
SIMONE: Ssh.
(GIRLS GIGGLE)
(MUSIC)
(GIRLS GIGGLE)
MARTA: Ta mere est si belle . . . si mince.
Est-ce qu'elle mange?
SIMONE: N'est Betes un peu moins avec ca.
MARTA: Fibre Trim . . . Fait de grain et citrus.
Ca t'embete qu'elle soit si belle?
SIMONE: Non, parce que je connais ses secrets.
W/ANNCR: Fibre Trim . . . the European way to slim.

1458

Art Director Amy Mizner
Writer Donald Deutsch
Editor Bobby Smalheiser
Director Martin Bell
Agency Amy Mizner/David Deutsch
Associates, New York, NY
Production Company THT Productions
Client People's Bank

1459

Art Director Richard Silverstein
Writer Jeffrey Goodby & Andy Berlin
Editor Miadrag Certic/One Pass
Director Jon Francis
Director of Photography Dean Cundey
Agency Debra King/Goodby, Berlin &
Silverstein, San Francisco, CA
Production Company Sandra Marshall, Jon Francis
Films
Music Piece of Cake, Inc.

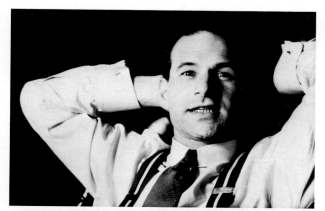

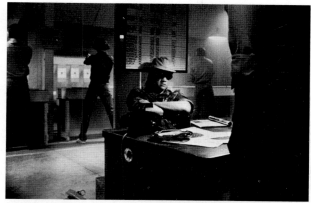

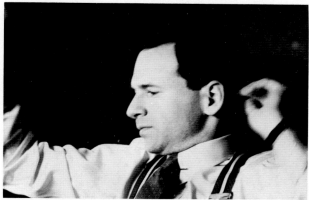

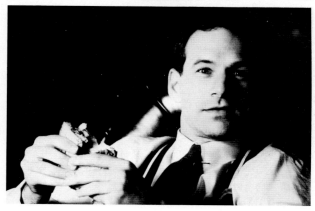

OREOS
30-second
MAN AGED 32: I never planned ahead, I hated kids who kid. Like Nancy Spector—she'd always save her Oreos from lunch so in the afternoon she could eat them in front of me while I was starving. She knew I had eaten my lunch on the way to the school in the morning. I still don't plan ahead. I make good money—but I spend it all. I'm sure Nancy Spector has all her investments and IRAs lined up—I'd probably still hate her.
FREEZE
VO: People's Bank
We hear you
We have the right IRA to help you plan ahead

HUNTER
30-second
(MUSIC UNDER THROUGHOUT)
WILL: I'm looking for Hunter Thompson.
WILL: Hi, I'm uh, Will Hearst.
HUNTER: Hello.
WILL: I'm the new publisher of the San Francisco Examiner.
HUNTER: Hey, I love you.
WILL: Well, I was hoping you'd want to write something for us.
HUNTER: Why not. We will chase them like rats across the tundra.
ANNCR: The next generation. At the San Francisco Examiner.

1460

Art Director	Tom Wai-Shek
Animator	Liberty Studio/Tony Lover & David Bruce
Writer	Joe Tantillo
Editor	DJM/Ed Friedman
Director	Bob Gaffney
Agency	Dorothy Franklin, Geers Gross Advertising, Inc., New York, NY
Producer	Sherry Gaffney
Client	Fuji Photo Film, USA

1461

Art Director	Jean Robaire/Lee Clow
Writer	John Stein/Brent Bouchez/Herbie Hancock
Editor	Brian McCann
Director	Norman Seeff
Agency	Elaine Hinton, Chiat/Day, Los Angeles, CA
Production Company	Richard Marlis Prod.
Client	Pizza Hut, Inc.

FUJI BLIMP-COLOR LAYERS
30-second
(MUSIC UP & UNDER)
ANNCR VO: You are about to see a remarkable demonstration.
Here comes . . . Fuji Film . . .
With color pictures so true to life it's a real breakthrough.
Fuji HR Films. Fuji's advanced technology has developed ultra-thin color layers . . .
Unlike any other film in the world.
SFX: CAMERA SHUTTER CLICK
ANNCR VO: The thinner the layers . . . the sharper the picture . . . and the truer the color.
Get extraordinary Fuji high resolution films and get the true picture.
Fuji 35mm, disc and 110.
(MUSIC OUT)

PIZZA-PUTER
30-second
HANCOCK: I'm really excited. You know, ummm, I got a new instrument. I have a . . . a brand new . . .
. . . what we call a
pizza-putter and . . . uh . . . you can . . .
you can play it like this.
But the, but it won't make any sound though, until you . . .
MUSIC: UNDER.

1462

Art Director	Frank Haggerty
Writer	Jack Supple
Director	Eric Young
Agency	Julie Sadeghi/Carmichael-Lynch, Minneapolis, MN
Production Company	Wilson/Griak
Client	Blue Fox Tackle Company

1463

Art Director	Frank Fraser
Writer	Bill Stenton
Editor	Laube/Roth—Scott Wollin
Director	Sylvan Markman
Director of Photography	Marcel Shain
Creative Director	Jerry McGee
Agency	Sylvan Markman/Ogilvy & Mather, Los Angeles, CA
Production Company	Silver Bullet Productions
Client	California Federal

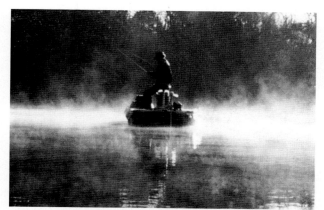

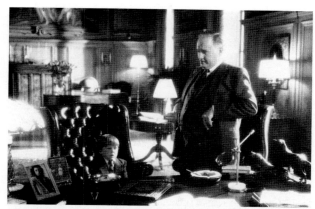

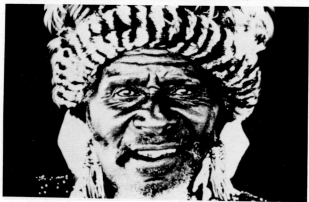

DR. JUICE MAGIC
30-second
ANNCR VO: Dr. Juice. One drop is powerful magic.

GRANDPA
30-second
GRANDPA: Someday all this will be yours. So you have to learn to manage your money well. This is California Federal's new Tiered Checking Account. The more money you put into Tiered Checking, the higher the interest rate you earn.
Remember, higher balance, higher rate.
And also remember there are some things money can't buy.
Just kidding.

1464

Art Director	Lee CLow
Writer	John Stein/Ed Cole/Bill Hamilton/ Martin Mull
Editor	Brian McCann
Director	Norman Seeff
Agency	Elaine Hinton, Chiat/Day, Los Angeles, CA
Production Company	Richard Marlis Prod.
Client	Pizza Hut, Inc.

1465

Writer	Bill Hamilton
Editor	Charlie Chuback
Director	Peter Moore
Agency	Susan Ashmore, Chiat/Day, Los Angeles, CA
Production Company	Nike Sports Prod.
Client	Nike, Inc.

DESSERT
30-second
MUSIC: UNDER THROUGHOUT.
MULL: This is a piece of olive . . . probably my favorite part, so we put that up by the end of the crust.
I'm going to go through breakfast. That's to here. Lunch. Dinner. I think I'm going right for dessert.

FLIGHT 23
30-second
SFX: JET ENGINE ROARS TO LIFE. JET TAXIS.
STEWARDESS VO: Good morning, ladies and gentlemen. Welcome to Flight 23.
Please make sure your seat belts are securely fastened, and extinguish all smoking materials.
SFX: JET ENGINE BUILDS IN INTENSITY.
SFX: SQUEAL, ROCKET ROAR, FULL JETS. DIMINISHING IN PERSPECTIVE.
ANNCR VO: Basketball, by Nike.

1466

Art Director	Rick Boyko/Jean Robaire
Writer	John Stein/Ed Cole/ Brent Bouchez/Bill Hamilton/Hoyt Axton
Editor	Brian McCann
Director	Norman Seeff
Agency	Elaine Hinton, Chiat/Day, Los Angeles, CA
Production Company	Richard Marlis Prod.
Client	Pizza Hut, Inc.

1467

Art Director	Mike Malatak
Writer	Don Heagy
Editor	Larry Bridges/Bob Furem
Creative Director	Bob Welke
Agency	Michael Birch—Leo Burnett Co., Inc., Chicago, IL
Client	Angelo Pagano/Hewlett-Packard

OKLAHOMA
30-second
MUSIC: UNDER THROUGHOUT.
AXTON: I'm from Oklahoma. I'm a cowboy. Got the hat. Got the boots. Got a pickup truck.
I wrangled this pizza myself. You know, they say spaghetti come from China. Pizza come from Oklahoma. Cultural center of the universe.
I wouldn't lie to you friend.

SHOWER/REV
30-second
SFX: SHOWER.
VO: An idea.
can happen anytime.
And when you work for Hewlett-Packard,
you don't just sell business computing systems,
you solve problems.
So when you have an idea,
you do something
about it.
You never stop asking "what if . . ."
GUY: Dan? Mike.
Listen, y'know that electronic mail project for the bank?
What if . . . (FADE UNDER) we used HP Message in a custom
software package so they can exchange budgeting information . . .

1468

Art Director	Paul Behnen
Designer	David Scott
Animator	Film Fair
Director of Photography	Glen Swanson
Writer	Tom Townsend
Editor	Steve Gottlieb
Director	Glen Swanson
Creative Director	Steve Puckett
Agency	Wendy Littlefield, Gardner Advertising, St Louis, MO
Producer	Ted Goetz, Anita Miller
Client	Southwestern Bell Yellow Pages

1469

Art Director	Terry Iles
Designer	Roy Smith
Writer	Rick Davis
Editor	Kari Skogland
Director	Stephen Amini
Client	The Quaker Oats Company of Canada Limited
Agency	Louise Blouin, Doyle Dane Bernbach Advertising Ltd., Toronto, Canada
Production Company	Elizabeth Quigg/Ann Henney— Shooters Film Co.
Music	Harris Cole Productions

BLINDERS I
30-second
ANNCR: When you shop Greater Baltimore with your local Yellow Pages . . .
you might as well have blinders on.
You may never see some of the best businesses in the area . . .
. . . because you only get part of the picture.
But next year you'll have one, convenient Yellow Pages . . .
. . . for all the best shopping areas around.
Look for the Baltimore Metropolitan Yellow Pages from Southwestern Bell Media.
And put the others . . .
. . . out to pasture

CHEWY BAR FEELIN'
30-second
MUSIC: (GOSPEL-ROCK THROUGHOUT)
LEAD SINGER(S) VO: I got a feelin'
That Quaker Chewy Bar feelin'
Tastes so good deep down inside.
CHORUS VO: Quaker Chewy Bars.
MUSIC BECOMES TREMENDOUSLY UP-BEAT, UP-TEMPO
LEAD SINGER(S) VO: Ain't nothin; better . . .
CHORUS VO: Quaker Chewy Bars . . .
LEAD SINGER(S): Gonna get me . . .
CHORUS VO: Quaker Chewy Bars . . .
EVERYONE VO: Come on and taste it brother,
Come on and taste it sister, gimme them
(SLOWS DOWN FOR FINALE) fine-tastin'
Quaker Chewy Bars.

1470

Art Director	Bob Barrie
Writer	Phil Hanft
Editor	Tony Fischer, James Productions, Minneapolis, MN
Director	Henry Sandbank, Sandbank Films
Agency	Judy Brink, Fallon McElligott, Minneapolis, MN
Production Company	Jon Kamen, Sandbank Films, New York, NY
Client	MAX Long Distance

1471

Art Director	Don Easdon
Writer	Bill Heater
Editor	Hank Corwin
Director	Joe Pytka
Agency	Marry Ellen Argentieri/Hill, Holliday, Connors, Cosmopulos, Boston, MA
Production Company	Joe Pytka, Pytka Productions
Client	John Hancock Mutual Life Insurance Co.

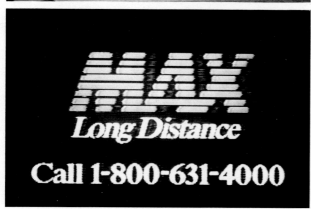

TIGHTROPE
30-second
VO: Ever wonder why some bargain long distance companies are such a bargain?
Too many customers . . . crowded onto too few lines.
But at MAX Long Distance, we don't overload our lines . . . because we don't oversell them.
So come on . . . just because you signed up for bargain rates doesn't mean you have to take a dive.
GRANNY: MAX Long Distance. You pay less. You don't get less.

SINGLE
30-second
DAVE: So . . . how much you making now? Hunh? (CHUCKLE)
MIKE: I'm doing fine.
DAVE: You gotta be making at least twenty-five.
MIKE: I'm fine. Maybe a little better than that.
DAVE: Thirty? Tell me . . . yes or no . . . are you making thirty?
MIKE: Yes.
DAVE: Thirty?
MIKE: Around thirty.
DAVE: You got any investments, any stuff?
MIKE: Got the car.
DAVE: That's not an investment. You got an IRA, life insurance?
MIKE: (SIGH.) Not really.
DAVE: You're making thirty and you don't have anything like that? What d'ya think? You're eighteen years old or something?

1472

Art Director	Rick Boyko
Writer	John Stein/Bill Hamilton/Rita Moreno
Editor	Brian McCann
Director	Norman Seeff
Agency	Elaine Hinton, Chiat/Day, Los Angeles, CA
Production Company	Richard Marlis Prod.
Client	Pizza Hut, Inc.

1473

Art Director	Don Easdon
Writer	Bill Heater
Editor	Hank Corwin
Director	Joe Pytka
Agency	Mary Ellen Argentieri/Hill, Holliday, Connors, Cosmopulos, Boston, MA
Production Company	Joe Pytka, Pytka Productions
Client	John Hancock Mutual Life Insurance Company

EATING
30-second
MUSIC: UNDER THROUGHOUT.
RITA: (IN SPANISH): What a beautiful thing.

PLANNING OWN BUSINESS
30-second
MAN: Did you pay the mortgage?
WIFE: Yes. Of course.
MAN: Good. That's good. I was just going to say that I . . . you know . . . Kath . . . there's two kinds of people in the world.
WIFE: Yeah, men and women.
MAN: Yeah, that. But there are those that work for themselves and those that work for somebody else and I think that I'm that kind of person who ought to be working for himself. . . . I'm saying, let's plan, you know, plan.
WIFE: That's the only way to do it.
MAN: I think that's smart. I think we'll be a lot happier. We'll have a goal.
QUIET FOR ABOUT THREE SECONDS
MAN: Did you tuck Kevin in?
WIFE: Yes.

1474

Art Director	Lee Clow
Writer	John Stein/Bill Hamilton/Ed Cole/ Martin Mull
Editor	Brian McCann
Director	Norman Seeff
Agency	Elaine Hinton, Chiat/Day, Los Angeles, CA
Production Company	Richard Marlis Prod.
Client	Pizza Hut, Inc.

1475

Art Director	Richard Silverstein
Director of Photography	Dean Cundey
Writer	Jeffrey Goodby & Andy Berlin
Editor	Miadrag Certic/One Pass
Director	Jon Francis
Agency	Debra King/Goodby, Berlin & Silverstein, San Francisco, CA
Production Company	Sandra Marshall, Jon Francis Films
Music	Piece of Cake, Inc.

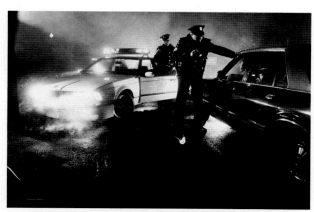

ETIQUETTE
30-second
MUSIC: UNDER THROUGHOUT
MULL: Hello, I'm here to tell you a little bit about pizza etiquette. Can you do this? Yes. It's acceptable.
It's good cold in the morning for breakfast. I've done that. I mean how many of you . . . how many have done that? Can you take it and go from the other end? Crust first? No. I'm sorry. You have to start at the point.

CYRA
30-second
CYRA: What's going on here, officer?
COP #1: We're looking for a Cyra McFadden. Wrote that thing called "The Serial."
CYRA: Uh huh . . .
COP #1: Made Marin look pretty bad.
CYRA: Well, I don't really . . .
COP #1: Word is, she's back in the area, working for that Hearst guy.
CYRA: Gosh, officer, wasn't "The Serial" written in a spirit of fun? I mean it is a little *different* up here.
COP #1: Different, ma'am?
COP #2: What kind of car is this?
CYRA: It's a Plymouth.
COP #2: I've never seen one before.
ANNCR: The next generation. At the San Francisco Examiner.

1476

Art Director	Gary Johns
Writer	Jeff Gorman/Brent Bouchez
Editor	Simon Laurie/Gayle Grant
Director	Tony Scott
Agency	Richard O'Neill, Chiat/Day, Los Angeles, CA
Production Company	Fairbanks Films
Client	Pizza Hut, Inc.

1477

Art Director	F. Paul Pracilio/Stan Smith
Writer	Robert Neuman
Editor	Dennis Hayes, James Garrett & Partners
Director	Richard Longcraine/Michael Shackleton
Creative Director	Tom Rost
Agency	Sandra Breakstone/Ogilvy & Mather, New York, NY
Production Company	Geoffrey Forster, James Garrett & Partners
Client	American Express

SOCCER
30-second
MUSIC: "LA BOHEME" ADAPTATION UNDER THROUGHOUT.
SFX: ANNOUNCER CALLING GAME IN ITALIAN. CROWD
CHEERING.
ANNCR VO: In Italy, when the
soccer game . . .
is on,
everything comes to a stop.
Except . . .
for one thing. We call it
Priazzo (TM) . . .
Italian
pie.
Baked fresh every day . . .

THE BLACK HOLE
30-second
ANNCR VO: The black hole of American business. Where travel and
entertainment dollars often vanish without a trace.
To help end this financial drain comes a whole new way of booking,
tracking and paying for your company's business travel.
Introducing the American Express Travel Management System. It
puts you in control. Not the black hole.

1478

Art Director	Roy Grace
Designer	Roy Grace
Director of Photography	Caleb Deschanel
Writer	Tom Yobbagy
Editor	Howie Lazarus/Take 5
Director	Caleb Deschanel
Agency	Lorraine Schaffer/Doyle Dane Bernbach, New York, NY
Producer	David Stolz, Kaleidoscope Films
Client	Volkswagen

1479

Art Director	Jill McClabb
Designer	Jill McClabb
Writer	Kevin O'Neill
Editor	Lenny Davidowitz
Creative Director	Kevin O'Neill
Agency	Sue Rosenberg/LGFE, New York, NY
Creative Supervisor	Bob Tore, Bob Nadler
Client	WNBC-TV

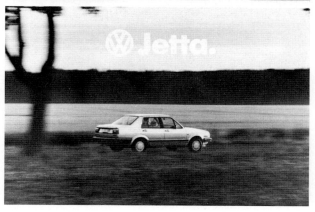

JETTA: SFX/40 STATE
30-second
SFX: BIRDS CHIRPING, MAN WALKING
CORN POPPING, DOOR OPENING
ORCHESTRA INSTRUMENTAL
WHISTLE
LION ROAR, HORSES NEY, AND HORSES GALLOPING.
BAND WITH CROWD. CROWD CHEERING
MUSIC BOX
JET FLYING BY
WIND, JET FLYING BY
VO: The affordable German road car
SFX: APPLAUSE
VO: The Volkswagen Jetta

PRAYER
30-second
KID: Our Father
who art in Heaven
what about the earthquake in Mexico
the Japan Airline crash that killed 520 people
the AIDS epidemic
and the starvation in Africa?
Is the world really without end?
Amen.
ANNCR: Is God Punishing Us? A special report by Chuck Scarborough. This week at 6 on Channel 4.

1480

Art Director	Ron Louie
Designer	Ron Louie
Writer	Mike Rogers
Editor	Ciro/The Editors
Director	Dick James
Director of Photography	Dick James
Agency	Jim DeBarros/Doyle Dane Bernbach, New York, NY
Producer	Dick James
Client	Audi of America

1481

Art Director	Howie Cohen/Paul Frahm/Tad Dewree
Writer	Laurie Birnbaum
Editor	Editor's Gas
Creative Director	Frank Nicolo
Agency	Don Brown/JWT, New York, NY
Production Company	Michael Daniel Prod
Client	Jim Godsman, Emery

TRIUMPH OF TECHNOLOGY
30-second
SFX UNDER THROUGHOUT
This car commercial has no majestic mountains
quaint country roads
or
shimmering sunsets
for a very good reason
to fully appreciate
an Audi
all you need
is to drive an Audi
The 4000S Sedan
It's the only scenery a purist requires
Audi
The art of engineering

EMERY PEOPLE
30-second
(MUSIC)
SINGERS: Send the art to Boston
Get the part to Corning.
Working through the night so you have it by morning.
Call Emery and it's as good as there!
Emery's everywhere from Paris France to Pasadena.
Emery gets it there
from New York to Argentina.
From the Biggest
to the smallest it's as good as there,
just call us.
EMERY PERSON: Thank you for calling Emery . . .
SINGERS: It's as good as there.

1482

Art Director	Rick Boyko
Writer	John Stein/Bill Hamilton/Rita Moreno
Editor	Brian McCann
Director	Norman Seeff
Agency	Elaine Hinton, Chiat/Day, Los Angeles, CA
Production Company	Richard Marlis Prod.
Client	Pizza Hut, Inc.

1483

Art Director	Bob Tucker
Designer	Bob Tucker
Writer	Mike Rogers
Editor	Stuart Wachs/Howie Lazarus—Take 5
Director	Mike Berkofsky
Director of Photography	Simon Ransley
Agency	Ellyn Epstein/Doyle Dane Bernbach, New York, NY
Producer	Sonia Webster
Client	Audi

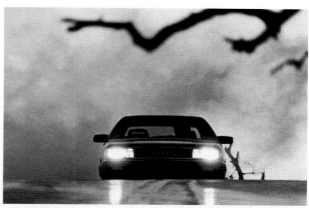

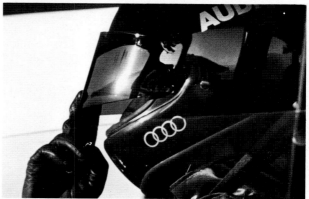

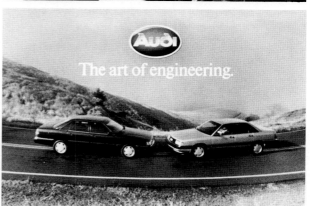

MOODS
30-second
MUSIC: UNDER THROUGHOUT.
MORENO: If I'm feeling mellow, I just want cheese and tomatoes.
If I'm feeling attractive, I say, "Put on some pepperoni." You know?
If I'm feeling wild and crazy, I just tell the guy behind the counter,
"Throw it all on."
I'm fair game tonight

JOUSTING
30-second
MUSIC UNDER THROUGHOUT
VO: Introducing the 5000 CS turbo Quattros
from Audi
There are no cars like them in the world
Permanent . . . all-wheel drive
0 to 50 in 5.7 seconds
and with their anti-lock
braking system . . .
they go
from
50-0
even quicker
Audi
The art of engineering

1484

Art Director	John Short
Designer	Linda Burton
Writer	Alan Mond
Editor	Morty Perlstein
Director	Joseph Hanwright
Agency	Lee Zimmerman/Bozell, Jacobs, Kenyon & Eckhardt, New York, NY
Production Company	Janette Mercer, Barbara Mickleson, KIRA Films
Client	Chrysler Corporation

1485

Art Director	Jerry Roach
Writer	Marvin Waldman
Editor	Jerry Bender
Director	Henry Holtzman
Director of Photography	R. Taylor
Agency	Chris Jones/Young & Rubicam, New York, NY
Producer	N. Lee Lacy
Client	Southland Corporation—7-Eleven

THE PRIDE IS BACK
30-second
CHORUS: I want to live in the land of the free.
Teach my children what my Daddy taught me.
The Pride is Back
Born in America
AVO: The Pride is Back
Plymouth Reliant K.
Front-wheel drive. 6-passenger room.
5/50 Protection Plan.*
Plymouth Reliant K.
Born in America.
Reliant K. Born in America.
CHORUS: The Pride is Back.
Born in America. Again.
*SUPER: See limited warranty at dealer. Excludes leases.

COFFEE BEAN
30-second
ANNCR VO: When you're in a hurry,
MAN: (UNDER) Be right back . . .
ANNCR VO: does the rest of the world slow down?
(MUSIC UNDER)
MAN: Three coffees to go, please.
VO: Could I have three . . .
(MUSIC) Three coffees to go.
MAN 2: One coffee bean;
VO: two coffee bean . . .
STORE CLERK: Hi!
ANNCR VO: But at 7-Eleven, you get your coffee fast.
MEN: Bye.
STORE CLERK: Bye.
ANNCR VO: No one keeps you revvin' like 7-Eleven.

1486

Art Director	Jim McComb
Writer	Rob Nolan
Creative Director	Gerry Miller
Agency	Norry Nelson—Leo Burnett Co., Inc., Chicago, IL
Client	Charlie Pierce/Procter & Gamble/ Cheer

1487

Art Director	Bob Taylor
Writer	Bob Taylor
Editor	Jim Mudra
Creative Director	Bob Taylor
Agency	Dave Musial—Leo Burnett Co., Inc., Chicago, IL
Client	Tom Leonard/Beatrice-Samsonite

LAUNDRY EDUCATION
30-second
HIM: Hey, I went to college, I know how to do laundry.
HER: Sure, your girlfriends did your laundry . . .
HIM: How do *you* know?
HER: I was your girlfriend.
HIM: Oh.
HER: So, do the laundry.
HIM: Hey, it's simple.
Everything goes in warm.
SHE: BEEP! Not *that* simple.
HIM: What's this, a quiz show? (Alt. Ah, a quiz show.)
SHE: Look, warm is for a lot of stuff. But white
socks, yuck. They go in hot or they won't get clean.
HIM: Gotcha, whites in hot.
HER: BEEP . . .

STORE-30
30-second
CUSTOMER: Hello, I'm looking for some lightweight, soft-sided
luggage.
SALESMAN: May I point out features that should be checked
carefully . . .
like the zipper,
the handle.
CUSTOMER: Very sturdy.
SALESMAN: Now look at the construction.
Of course the wheels should operate smoothly.
CUSTOMER: I'll take the Samsonite.
SALESMAN: Excellent.
ANNCR VO: Or just look for this feature and you'll be assured it has
all the others.
ANNCR VO 2: We're Beatrice.

1488

Art Director	Hector Robledo
Writer	Ted Littleford
Director	Mark Story
Agency	Lewis Kuperman, Foote, Cone & Belding Inc., New York, NY
Production Company	Pfeifer Story Piccolo Gullinor
Client	Frito-Lay

1489

Art Director	Richard Mahan/Phil Guthrie
Writer	Phil Guthrie/Richard Mahan
Agency	Michael Berkman/Backer & Spielvogel, New York, NY
Producer	David Ashwell
Client	Miller Brewing Company/Meister Brau

PARLOR
30-second
ANNCR VO: The only thing more boring than eating a Granola bar would be eating a Granola bar while Uncle Jerome tells you about Lester's bone spur.
JEROME: Did I tell you about Lester's bone spur?
ANNCR VO: With news Rumbles™ Granola Nuggets, Granola isn't a bore.
It's a bite-sized—rolled in cracklin' granola—glazed caramel—toasted nuts *ball*.
Who says Granola has to be a bore? New Rumbles™ Brand Granola Nuggets from Frito-Lay.
It's a *ball*.

NITE CLUB
30-second
OWNER #1: Hey Marty, you seen the monthly receipts?
OWNER #2: No, how we doin?
OWNER #1: Oh, beautiful! Frankie's spendin' money on Meister Brau like it's goin' outta style!
OWNER #2: It's a quality beer, it's expensive.
OWNER #1: Oh, yeah? Sollie at the Kit Kat says it ain't expensive. Says it just tastes expensive.
OWNER #2: So?
OWNER #1: So what's that little weasel doin' with the do-re-me he says he's spendin' on the beer!
(CUT TO FRANKIE BUYING GIRLFRIEND A MINK COAT)
FRANKIE: Oh, baby, that mink is makin' you look like a fox!
(CUT TO PRODUCT)
ANNCR: Rich, smooth Meister Brau. It only tastes expensive.

1490

Art Director	John Sapienza
Writer	Jim Kochevar
Agency	Enid Katz/Young & Rubicam, Chicago, IL
Client	The Eureka Company

1491

Art Director	Steve Graff
Designer	Steve Graff
Writer	Mike Mangano
Editor	Pelco
Director	Tibor Hirsch
Director of Photography	Tibor Hirsch
Agency	Barbara Benedict/Doyle Dane Bernbach, New York, NY
Producer	Tibor Hirsch
Client	Sylvania

QUICK UP
30-second
ANNCR VO: Pizza crumbs on the floor in the kitchen. Quick! Get 'em with the Quick Up.
Cracker crumbs on the floor in the bedroom. Quick! Get 'em with the Quick Up.
Potato chips on the floor in the living room. You know what to use.
The Eureka Quick Up vacuum cleaner. It's cordless, rechargeable, and mounts on the wall.
There's no quicker way to get a mess.
The Eureka Quick Up. It's cordless!

HECKLER V DEALER
30-second
MAN 1: Well, this year there's something different to say about Sylvania Superset.
MAN 2: Really? 19" Sylvania Superset didn't beat Sony again?
MAN 1: Well, no.
You see, this year, instead of the 19, we tested the new 20 inch Sylvania Superset.
MAN 2: 20 Inch?
MAN 1: Yes, and when we asked over a thousand people which 20 inch had the best overall color picture, more chose the Sylvania Superset over RCA and Zenith. And Sony, too.
MAN 2: MUMBLING IN JAPANESE
—AND THEN IN ENGLISH—
"Sylvania beat Sony again"
HE MUMBLES SOME MORE IN JAPANESE

1492

Art Director	Terry O'Leary
Writer	Mike Pitts
Editor	Allen Rozek
Director	Sarah Moon
Agency	Bill Chororos/Ogilvy & Mather Inc., New York, NY
Music Composer	David Dundass

1493

Art Director	Mike Malatak
Writer	Dan Heagy
Editor	Larry Bridges/Bob Furem
Creative Director	Bob Welke
Agency	Michael Birch—Leo Burnett Co., Inc., Chicago, IL
Client	Angelo Pagano/Hewlett-Packard

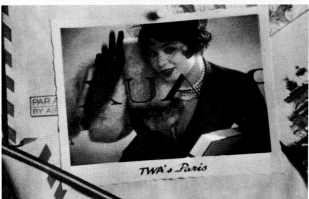

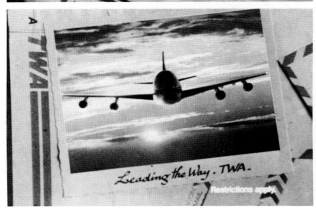

FACES
30-second
(MUSIC UNDER)
SINGER: Lead me away.
Show me a smile. Light up my face . . .
ANNCR VO: No one can show you the face of Europe like TWA,
leading the way, year after year.
To London, just $189.
To Paris, $325.
To Rome, $350. Irresistible.
SINGERS: Leading the Way. TWA!

PAPER AIRPLANES/REV
30-second
VO: Here at Hewlett-Packard,
we believe that the best way to solve
your business computing problem
is to make it *our* problem.
Because we know
that whatever system we design for your company,
we're going to live with it too.

1494

Art Director	Richard Silverstein
Writer	Jeffrey Goodby & Andy Berlin
Editor	Miadrag Certic/One Pass
Director	Jon Francis
Director of Photography	Dean Cundey
Agency	Debra King/Goodby, Berlin & Silverstein, San Francisco, CA
Production Company	Sandra Marshall, Jon Francis Films
Music	Piece of Cake, Inc.

1495

Art Director	Marisa Accocella
Writer	Marty Friedman, Linda Kaplan, Gerry Kileen
Editor	First Edition
Director	Greg Weinschenker
Creative Director	Greg Weinschenker/Linda Kaplan
Agency	Debby White/JWT, New York, NY
Producer/Production Company	The DXTRS
Client	Bruce Wilson/Ann Winkler, Eastman Kodak Co.

GHOST
30-second
(MUSIC UNDER THROUGHOUT)
GHOST: . . . or is this Warren Hinckle fellow some kind of leftist?
WILL: I'm not worried about those kinds of labels. I think he's interesting.
GHOST: Who is this Hunter S. Thompson?
WILL: He's irreverent, a little risky, but fun to read, you know?
GHOST: No.
WILL: Come on Grandpop. Lighten up.
GHOST: Are you sure you know what you're doing, Will?
WILL: I don't know. Did you?
ANNCR: The next generation. At the San Francisco Examiner.

OLD LOVERS
30-second
SINGER: I look in your eyes and see
So many years of you and me
AVO: Kodacolor VR 200 film. Why trust your golden moments to anything less?
SINGER: And after all that we've been through
I'm still so in love with you
Glad you're mine
As time goes by.
AVO: Kodak film. Because time goes by.

1496

Art Director	Jon Parkinson
Writer	Mike Drazen
Editor	Howie Lazarus/Take Five
Director	Dick McNeil
Creative Director	Mike Drazen
Agency	Charlie Curran/HCM, New York, NY
Production Company	Spots
Client	Orangina International

1497

Art Director	Gary Ciccati
Writer	Eileen Sandler
Editor	Morty Ashkinos
Director	Jerome Ducrot
Agency	Mardi Kleppel/Doyle Dane Bernbach, New York, NY
Client	Weight Watchers

PANDEMONIUM
30-second
WAITER: Your Orangina, sir. Shall I shake it?
ANNCR VO: We don't mean to shake anyone up. But to truly appreciate Orangina, that delightfully different carbonated soft drink from France, you must shake it up. Mixing all of Orangina's real orange and tangerine fruit juice with its natural pulp. And because Orangina is only lightly carbonated, you can shake it . . .
SFX: PSSSST!
ANNCR VO: and do nothing but enjoy the consequences. Orangina. It's shaking things up.

HAPPY FACES REV. 2
30-second
(MUSIC IN BACKGROUND)
Last year
Weight Watchers New Quick Start Program
helped millions of people
lose millions of pounds
faster than ever before.
This year, Weight Watchers
has improved Quick Start, made it even easier,
By adding brand new menu plans
that help make losing weight much simpler.
So come join
Weight Watchers New Improved Quick Start Program.
Now, it's even easier.

1498

Art Director	Steve Perrin
Writer	John Parlato
Editor	Jeff Linville/Spicer Productions
Director	Harry Hamburg
Agency	Bonnie Herman/W. B. Doner & Company Adv., Baltimore, MD
Production Company	Madelyn Curtis, N. Lee Lacy & Assoc.
Client	McCormick & Co/Tio Sancho

1499

Art Director	Dave Martin
Designer	Dave Martin
Writer	Jeff Linder
Editor	Ray Chung
Director	Pat Kelly
Agency	Paula Santa-Donato/Doyle Dane Bernbach, New York, NY
Production Company	Sandra Waggoner, Kelly Pictures
Client	Miles Labs

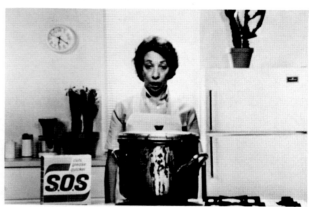

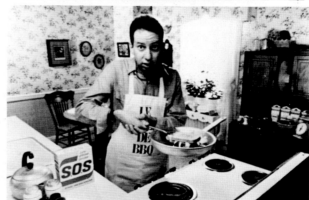

FOOL PROOF/ENCHILADA
30-second
ANNCR: Tio Sancho Enchiladas are absolutely fool-proof. Here's proof:
GEORGIA: I made them.
ANNCR: You made those delicious Tio Sancho Enchiladas?
GEORGIA: It was simple. Except for the hard part.
ANNCR: Browning the ground beef?
GEORGIA: No, no that wasn't the hard part.
ANNCR: Our authentic seasoning mix?
GEORGIA: No, no.
ANNCR: Well, it wasn't the enchilada shells.
GEORGIA: I'm afraid so.
ANNCR: But they're pre-rolled.
GEORGIA: Yes. But you never say which end to fill them from.
ANNCR: Tio Sancho. Delicious Mexican meals that are fool-proof.

BIG JOB/SMALL CHANGE
30-second
ANNCR VO: For just pennies a pad, S.O.S. is . . .
SFX: TOP BLOWS OFF POT
ANNCR VO: perfect when your pots and pans . . .
get a little messy . . . or a little sticky.
SFX: BELL RINGS FROM PAN POPPING OFF STOVE.
ANNCR VO: or even a little overcooked. Because whether you
sear, . . . scorch, singe or sizzle,
nothing cleans it up better....
than a super grease-....cutting S.O.S. soap pad.
So, it saves . . . you work and money.
S.O.S. can't help your cooking, but it can sure help your cleaning.
S.O.S. It cleans your big jobs . . . for small change

_____ **1500** _____

Art Director	Gary Johns/Lee Clow
Writer	Lee Clow/Jeff Gorman
Director	Steve Horn
Agency	Francesca Cohn, Chiat/Day, Los Angeles, CA
Production Company	Steve Horn, Inc.
Client	Nike, Inc.

_____ **1501** _____

Art Director	Rick Boyko
Writer	John Stein/Bill Hamilton/Rita Moreno
Editor	Brian McCann
Director	Norman Seeff
Agency	Elaine Hinton, Chiat/Day, Los Angeles, CA
Production Company	Richard Marlis Prod.
Client	Pizza Hut, Inc.

MCENROE-SOCKS
30-second
SFX: LOCKER ROOM AMBIENCE.
MCENROE VO: I got to play well today.
Last time I played this guy he was tough.
Start fast. Get on top early.
Be aggressive.
Think . . . Think for a change.
SFX: GAME ANNOUNCER UNDER.
MCENROE VO: Hope my socks match.
SFX: APPLAUSE UNDER.

SPANISH
30-second
MUSIC: UNDER THROUGHOUT.
RITA: The only thing I don't like about pizza, is that I talk a lot with my hands. And when I talk with my hands, I can't eat the pizza. Then I can't talk as much. My husband always tells me,
*[Rita, stop eating with your hands full.]
*ONLY THIS SEGMENT IN ENGLISH—ALL OTHER AUDIO IN SPANISH LANGUAGE.

1502

Art Director	Gary Johnston
Writer	Laurie Brandalise/Steve Kessler
Director	Steve Horn
Agency	Elaine Hinton, Chiat/Day, Los Angeles, CA
Production Company	Steve Horn, Inc.
Client	Apple Computer, Inc.

1503

Art Director	Pat Burnham
Writer	Bill Miller
Editor	Tony Fischer, James Productions, Minneapolis, MN
Director	Mark Story, Pfeifer-Story
Agency	Judy Brink, Fallon McElligott, Minneapolis, MN
Production Company	Pfeifer-Story, Los Angeles, CA
Client	Metromedia

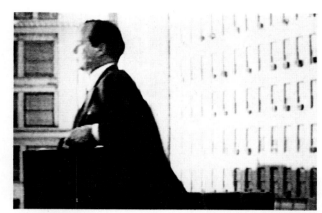

TEACHER
30-second
MUSIC: UNDER THROUGHOUT.
ANNCR: Even though teaching tools have changed over the years, two things about teachers
haven't:
They still care about kids. And their day still doesn't end at 3 o'clock.
ANNCR VO: The Apple II.
There's no telling how far it can take you.

BIRD
30-second
VO: You're on your way to the top.
You keep your nose to the grindstone.
You don't knock off at the normal time.
And yet,
no matter what you do . . .
. . . or how hard you try . . .
You can never make it home . . .
. . . in time to see the news.
SFX: WHISTLE
Presenting the 7 o'clock news.
Finally, news that doesn't get home before you do.

1504

Art Director	Kathy McMahon
Writer	Gerry Kileen/Kathy McMahon
Editor	First Edition
Agency	Sid Horn/JWT, New York, NY
Production Company	The DXTRS
Creative Director	Greg Weinschenker/Linda Kaplan
Client	Eastman Kodak Co.

1505

Art Director	Pat Burnham
Writer	Bill Miller
Editor	Tony Fischer, James Productions, Minneapolis, MN
Director	Mark Story, Pfeifer-Story
Agency	Judy Brink, Fallon McElligott, Minneapolis, MN
Production Company	Nick Wollner, Pfeifer-Story, Los Angeles, CA
Client	KRON-TV, San Francisco, CA

HENRY
30-second
SINGER: When you were just a pup
I never thought that you'd grow up
But we'll always be together
Forever side by side
My best friend as time goes by.
ANNCR VO: Kodacolor VR 200 film, so versatile it captures life's little changes in shifting light or with sudden movement.
Kodak film. Because time goes by.

JONESES
30-second
ANNCR VO: They got trucks.
We got trucks.
They got a helicopter.
We got a helicopter.
They got a seismograph.
We got a seismograph.
They got reporters.
We got reporters.
They got typewriters.
We got typewriters.
In this keep up with the Joneses world of television news . . .
. . . we here at NewsCenter 4 think it's important to remember . . .
. . . that what you really need to keep up with . . . is the news.
NewsCenter 4. At 5, 6 and 11.

1506

Art Director	Peter Farago/Fred Lind
Writer	Gerry Kileen/Mark McNeil
Editor	First Edition
Creative Director	Greg Weinschenker
Agency	Pamela Maythenyi/JWT, New York, NY
Client	Eastman Kodak Co.

1507

Art Director	Rudy Valentini/Winkie Donovan
Writer	Ritch Kassof
Editor	Bob Lynch
Director	Michael Schrom
Agency	Betty DeBello—D'Arcy Masius Benton & Bowles, New York, NY
Production Company	Maddi Carlton, Christine Stefani, Griner Cuesta
Client	Proctor & Gamble—Dawn

SMILE, PARDNER
30-second
VO: Smile, boys!
SFX: CLICK OF CAMERA
COWBOY #1: Now look at this dang picture! We got bad developing again. My hat ain't even white!
COWBOY #2: I always said you was yellow.
COWBOY #1: Now that's funny, coming from a greenhorn with a green horse.
COWBOY #2: My horse is green!
GEEZER: Now boys. Should've used Kodak's new Colorwatch system. Could've had a great picture then. Try it again.
AVO: Look for the Colorwatch seal where you get your film developed. For bright, vivid color prints time after time. And if you don't see that sign . . . keep on riding!!

UNFAIR, TOO/FP
30-second
MUSIC VO: Dawn.
MUSIC
VO: It's almost unfair the advantage Dawn has over grease.

1508

Art Director	Gerald Andelin
Writer	Hal Riney
Editor	Jacques Dury
Director	Joe Pytka
Agency	Deborah Martin/Hal Riney & Partners, San Francisco, CA
Production Company	John Turney, Pytka
Client	Blitz-Weinhard Brewing Co.

1509

Art Director	Gary McKee
Writer	Nell McCarren
Director	Bob Hulme
Agency	Deb Wagner/DFS, Inc., New York, NY
Production Company	Michael Daniels Productions
Client	General Mills, Inc.

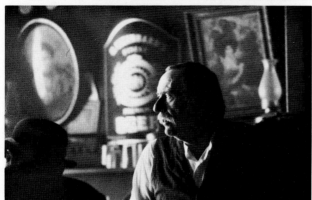

SALOON
30-second
ANNCR: A hundred years ago, Henry Weinhard was making the West's finest premium beer . . .
. . . serving it in the West's finest eating and drinking establishments . . .
COWBOY: Beer . . .
ANNCR: and charging just a little more
BARTEND: A nickel.
than the price of ordinary beers . . .
COWBOY: A *nickel?*
ANNCR: Because Henry made his beer just 400 barrels at a time . . .
BARTEND: It's Henry's.
ANNCR: Just like we still do today . . .

REAL CRAZY EDDIE
30-second
ANNCR: What happens when . . . a real New Yorker happens upon Yoplait Yogurt.
CRAZY EDDIE GUY: What is this-what is this?
ANNCR: Yoplait Original. He may be reluctant to try it. But once he sinks his spoon into that creamy, all natural yogurt, full of real fruit . . . Once he gets a little taste of Yoplait . . .
CRAZY EDDIE GUY: C'est marveilleux! Une occasion a ne pas manquee! Mangez . . . mangez maintenant . . . c'est derange!
ANNCR: Yoplait, the Yogurt of France . . . and New York.
CRAZY EDDIE GUY: C'est derange!

1510

Art Director	Pat Burnham
Writer	Bill Miller
Editor	Tony Fischer, James Productions, Minneapolis, MN
Director	Mark Story, Pfeifer-Story
Agency	Judy Brink, Fallon McElligott, Minneapolis, MN
Production Company	Nick Wollner, Pfeifer-Story, Los Angeles, CA
Client	KRON-TV, San Francisco, CA

1511

Art Director	B. A. Albert/Keir Beard
Writer	Sharon Rapoport
Editor	First Edition
Director	Sid Myers
Creative Director	Joey Reiman
Agency	Carol Hardin/D'Arcy Masius Benton & Bowles/Atlanta, GA
Production Company	Sid Myers Films
Client	Heritage Federal Savings & Loan/ Florida

SATELLITE UPLINK
30-second
ANNCR: We got cameras. They got cameras.
We got a seismograph. They got a seismograph.
We got reporters. They got reporters.
We got typewriters. They got typewriters.
We got a helicopter. They got a helicopter.
We got a pencil sharpener. They got a pencil sharpener.
We got haircuts. They got haircuts.
We got a telephone. They got a telephone.
We got a mobile satellite uplink.
(SCREECH)
They don't.
In this keep up with the other guys world of television news . . .
. . . it's important to remember who the other guys are trying to keep up with. NewsCenter 4. At 5, 6 and 11.

CHICKENS
30-second
VO: Heritage says that other bankers today are chicken. Is that true?
FIRST BANKER: Ba-Ba-Bak! Ba-Ba-Ba-Bak! (CHICKEN SOUNDS)
VO: Are you afraid to offer discount brokerage services like Heritage has?
SECOND BANKER: Ba-Ba-Ba-Ba-Ba-Ba-Ba-Baw! (CHICKEN SOUNDS)
VO: Are you scared to offer 8% savings?
THIRD BANKER: Bawk. Ba-Ba-Bak-Bak! (CHICKEN SOUNDS)
VO: How about IRA home delivery?
FOURTH BANKER: Baaak-Ba-Ba!
(CHICKEN SOUNDS)
VO: Obviously, banking anywhere but Heritage is for the birds.
(CHICKEN SOUNDS UNDER)
VO: Heritage. Where no bank has gone before.

1512

Art Director	Pat Burnham
Writer	Bill Miller
Editor	Tony Fischer, James Productions, Minneapolis, MN
Editor	Mark Story, Pfeifer-Story
Agency	Judy Brink, Fallon McElligott, Minneapolis, MN
Production Company	Nick Wollner, Pfeifer-Story, Los Angeles, CA
Client	KRON-TV, San Francisco, CA

1513

Art Director	Hal Nankin
Writer	Alan Barcus
Editor	Dick Stone
Director	Sid Myers
Agency	Arthur English—D'Arcy Masius Benton & Bowles, New York, NY
Production Company	Bonnie Marvel, Myers Films
Client	Corning Microwave
Casting Director	Karen Goldberg

PEABODY AWARD
30-second
ANNCR VO: We got a helicopter. They got a helicopter.
We got a seismograph. They got a seismograph.
We got cameras. They got cameras.
We got typewriters. They got typewriters.
We got trucks. They got trucks.
We got a pencil sharpener. They got a pencil sharpener.
We got reporters. They got reporters.
We got a Peabody Award for broadcast journalism.
(THUMP)
They don't.
In this keep up with the other guys world of television news . . .
. . . it's important to remember who the other guys are trying to keep up with.
NewsCenter 4. At 5, 6 and 11.

HUNAN (GOULASH ALT)
30-second
SFX: PHONE RINGING
MAN: Hunan
WOMAN: Me Mom. Listen. My new Corning microwave plus cookware you sent is fantastic.
I freeze, cook, serve in it.
It's real cookware. Not that plastic stuff
And it's made of Corning microtherm glass.
It cleans so easily . . . And Ma
I'm reheating your favorite tonight.
Oh. I gotta go. It's ready.
It's goulash. Bye.
MAN: Goulash. No goulash. Too spicy.
AVO: Microwave plus by Corning. That little blue flower and a whole lot more.

1514

Art Director	Barbara Schubeck
Animator	Perpetual Animation
Writer	Fred Siegel
Editor	Randy Illowite
Director	Michael Schrom
Director of Photography	Michael Schrom
Agency	Jinny Kim, Altschiller Reitzfeld, New York
Client	Georgia Pacific

1515

Art Director	Warren Eakins
Writer	Bill Borders
Director	Tom MacNeil
Agency	Bill Borders, Warren Eakins/ Borders, Perrin & Norrander, Inc., Portland, OR
Production Company	Northstar Productions
Client	Burgerville, USA

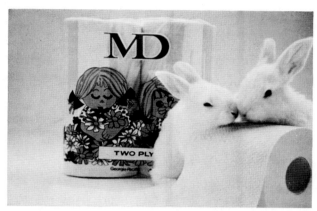

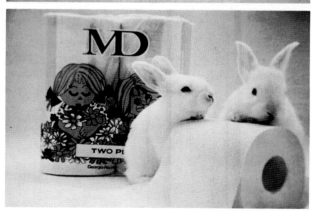

TWO BY TWO
30-second
ANNCR VO: You know the old saying, "Two is always better than one?"
Well, at MD, we believe two is always, *softer* than one.
That's why, with MD Bath Tissue, you always find fluffy twin layers.
Deep twin quilting.
And twin-ply softness, roll after roll.
And when you consider the fact that MD has more sheets per roll than most other 2-ply tissue . . . when it comes to softness . . . MD is the most you can get.
ANNCR VO: Also available in a six-roll pack.

TURN INTO
30-second
KID: When you order a burger, fries and drink at Burgerville . . . there's no telling what you might turn into.
(KID MAKES SOUNDS OF CREATURES; MUSIC UNDER ALL)
Gr-r-rrr. Me-e-e-eooow. R-e-a-a-a-arnn.
(SILENT)
Roooarr.
(WHIMPERS)
(MENACING GROWL/BREATH)
It's the Masked Meal Deal.
So when you're out driving around, remember, turn into a Burgerville.
(SFX: BING)
Nooo, I mean drive into a Burgerville.
LIVE ANNOUNCER: A different mask every two weeks. This week, a cuddly teddy bear.

1516

Art Director Pat Burnham
Writer Bill Miller
Editor Tony Fischer, James Productions, Minneapolis, MN
Director Mark Story, Pfeifer-Story
Agency Judy Brink, Fallon McElligott, Minneapolis, MN
Production Company Nick Wollner, Pfeifer-Story, Los Angeles, CA
Client KRON-TV, San Francisco, CA

1517

Art Director Sy Schreckinger
Writer Victor Levin
Editor Jerry Bender/Craig Warnick
Director Jim Connolly
Director of Photography Jim Connolly
Agency Elaine Mixson/Young & Rubicam, New York, NY
Production Company Close-Up Productions
Client Peter Paul Cadbury
Rabbit Trainers Dawn Animal Trainers

COMPUTER NEWSROOM
30-second
ANNCR VO: We got a seismograph. They got a seismograph.
We got a helicopter. They got a helicopter.
We got reporters. They got reporters.
We got a pencil sharpener. They got a pencil sharpener.
We got a parking spot. They got a parking spot.
We got a telephone. They got a telephone.
We got cameras. They got cameras.
We got a computerized newsroom.
(COMPUTER SFX)
They don't.
In this keep up with the other guys world of television news . . .
. . . it's important to remember who the other guys are trying to keep up with.
NewsCenter 4. At 5, 6 and 11.

SNOW BUNNY
30-second
(SFX)
ANNCR VO: Houston's in town a little early this year, with his Creme Eggs from Cadbury . . . they've got a shell of pure thick Cadbury's milk chocolate . . .
(SFX)
in a sweet creamy yellow yolk surrounded by delicious white filling.
(SFX)
They're here now and now make you feel like spring is just around the corner. But when Easter's gone so are the Cadbury's Creme Eggs.

1518

Art Director	Jim Weller
Writer	Jim Weller
Editor	Jacque Dury
Director	Bob Giraldi
Director of Photography	David Walsh
Agency	Shannon Silverman/Linda Tesa, Della Femina, Travisano & Partners, New York, NY
Production Company	Giraldi Productions
Client	Dennis Hayes

1519

Art Director	Barbara Stein-Lutz
Writer	Michael Chearney
Director	Phil Landek
Creative Director	Hy Rosen, Anthony Pugliese
Agency	Vinnie Infantino/Grey Advertising, Inc., New York, NY
Production Company	Landek Productions
Client	General Foods/Post Grape Nuts Cereal
Music	John Loeffler

ACABA
30-second
SFX: ARAB CHANTS
VENDOR: Camels, Camels!
ENGLISHMAN: Ah, I'm in the market for a camel.
VENDOR: Here Sir, is a fine specimen.
ENGLISHMAN: Don't you have something in a newer model?
VENDOR: Let me check the inventory.
ANNCR VO: If you're a small businessman who wants to do more business.... You should look into Microcomputer Products from Hayes. Hayes Communications Systems can turn a computer into something really useful. By allowing you to access to thousands of data bases throughout the world.
VENDOR: Yes, would you prefer one hump or two?
ANNCR VO: Microcomputer Products from Hayes. Say yes to the . . .
ANNCR VO: future with Hayes.

MORNING MAN
30-second
(MUSIC UNDER)
SINGER: Morning is your time.
The earth wakes up with you.
You always feel
that spark of life
in everything that you do.
ANNCR: Grape-Nuts: for you it's as natural as the morning.
No sugar added. No preservatives, just an honest, nutty crunch.
Post Grape-Nuts cereal.
You know when you have it good.
SINGER: Yes, you know when you have it good.
(MUSIC OUT)

1520

Art Director	Dick Johnson
Writer	Dick Johnson
Editor	Steve Schrieber
Director	Fred Petermann
Director of Photography	Fred Petermann
Agency	Bob Shannon/Saatchi & Saatchi Compton
Production Company	Sally Kraus, Petermann/Dektor, Los Angeles, CA
Client	AMC/Jeep

1521

Art Director	Sy Waldman
Writer	Bob Spero
Editor	Larry Plastrik
Director	Richard Greenberg
Director of Photography	Carl Norr
Agency	Bob Warner, Ogilvy & Mather Partners
Production Company	Robert M. Greenberg, R/Greenberg Associates, New York, NY
Client	Smith Barney
Line Producer	Brian Williams
Optical Producer	Joel Hynek

TRAIN
30-second
MUSIC AND SOUND EFFECTS THROUGHOUT SPOT
There's a new truck on the road
It's called Commanche
It's built by Jeep
It's worth a look

GULLIVER
30-second
ANNCR VO: John Houseman for Smith Barney.
HOUSEMAN (SYNC): When it comes to personal service, today's Gulliver-sized firms are often tied in knots . . .
They make their customers feel like Lilliputians.
Smith Barney is managed on a human scale.
Big enough to offer an array of investment services. Not too big to treat their clients as individuals.
Smith Barney. They make money the old-fashioned way: They earn it.

1522

Art Director	Terry Baker
Writer	Jim Glover
Editor	John Komenich
Creative Director	Gerry Miller
Agency	Bob Koslow—Leo Burnett Co., Inc., Chicago, IL
Production Company	David Oakes, Gootsen, Oakes & Schumacher
Client	Roy Bergold/McDonald's

1523

Art Director	Ed Wolper
Writer	Peter Bregman
Director	Paul Guliner
Agency	Carol Singer, Scali, McCabe, Sloves, New York, NY
Production Company	Pfeifer Story Piccolo Guliner
Client	Perdue

REFRIGERATOR
30-second
CREW GIRL VO: OK . . . that's six McDLT's, two large fries, and . . .
(BEGIN MCDONALD'S THEME UNDER: LIGHT-JAZZY)
. . . a Diet Coca-Cola?
MR. PERRY: Right!
(MUSIC THEME BRIGHTENS HERE. ACCENTS MOVEMENT).
("BUMP" SOUND)
(MUSICAL SOUND UNDERSCORES THEIR KNOWING LOOK)
MR. PERRY: Hot . . . cool . . . Mmmmmmm Mmh!
SFX: CRISP "CHOMP" SOUND OF BIG BITE OFF CAMERA.
MR. PERRY: Hmmmmmmm......Don't worry, I'll clean it up.
SFX: SUDDEN APPROPRIATE "RIPPING" SOUND OF TABLE
LEAVING ITS MOORINGS.
ANNCR VO: McDonald's . . . where the
Refrigerator . . . stocks up!

WOMAN IN KITCHEN
30-second
MUSIC UNDER: WOMAN: Hm, an Oven Stuffer might be nice.
ANNCR VO: Introducing a whole new kind of chicken from Perdue.
WOMAN: No, nuggets.
ANNCR VO: Delicious fresh oven-ready chicken dishes you heat and
eat in minutes.
WOMAN: I know, cutlets.
ANNCR VO: All superbly prepared by Perdue.
MAN: You went to all this trouble for me?
WOMAN: Oh, it was nothing.
FRANK PERDUE: Sure, I do all the work; she takes all the credit.
ANNCR VO: If you want to make great fresh chicken dishes, don't do
it. Perdue done it.

1524

Art Director	David Kennedy
Writer	Dan Wieden
Editor	Dan Sweitlik—Red Car
Director	Eric Sarenin
Agency	Steve Sterling/Wieden & Kennedy, Portland, OR
Production Company	Plum Productions
Client	Honda Scooters

1525

Art Director	Joel Machak
Writer	Jim Ferguson
Editor	Tony Izzo
Creative Director	Bob Taylor
Agency	Darr Hawthorne—Leo Burnett Co., Inc., Chicago, IL
Client	Bill Rhatican/Rick Smith/U.S. Safety Belts

BOUNCING BED
30-second
SFX: BEDSPRINGS CREAKING.
VO: You've been trying to get there since the day you were born . . .
VO: . . . don't stop now.

POST CRASH
30-second
LARRY: You can't quit, Vince. No crash dummy takes out a utility pole like you do.
VINCE: Larry, for years I'm been proving how safety belts save lives. But nobody's listening.
LARRY: Sure, they are.
VINCE: Yeah, That's why thousands die in car accidents every year? I feel like I'm bangin' my head against the wall.
LARRY: Come on, Vince. Tomorrow's the big day. Two compacts. Head on.
VINCE: High speed?
LARRY: Could save a life.
VINCE: I'll be there.
ANNCR: You could learn a lot from a dummy. Buckle your safety belt.

Art Director Ed Wolper
Writer Edward McCabe
Agency Carol Singer, Scali, McCabe,
Sloves, New York, NY
Production Company Phil Marco Productions
Client Perdue

Art Director Denise O'Bleness
Writer Andrew Bohjalian
Director Cosimo
Creative Director Hy Rosen, Anthony Pugliese
Director of Photography Cosimo
Agency Vinnie Infantino/Grey Advertising,
Inc., New York, NY
Production Company Morty Dubin, Iris Films
Client 3M Scotch Videocassettes

TIE
30-second
ANNCR VO: Whose breasts are the plumpest you've ever seen?
Whose breasts are always consistently tender?
Whose breasts have more meat and less bone than any others?
Whose breasts?
Perdue's breasts . . .
of course.

UNEXPECTED COLOR
30-second
ANNCR VO: Until this time, until this tape, you've never seen color
this bold. A breakthrough in videotape technology—color as if you
were seeing it for the first time . . . time after time. Color is why the
world watches Scotch. The new Scotch EXG Videocassette.
Guaranteed for a lifetime.

1528

Art Director Gary Goldstein
Writer Marvin Waldman
Editor Jerry Bender
Director Henry Holtzman
Director of Photography Max Mondray
Agency Roseanne Horn/Young & Rubicam, New York, NY
Producer N. Lee Lacy
Client New York Telephone

1529

Art Director Ed Wolper
Writer Larry Hampel
Agency Carol Singer, Scali, McCabe, Sloves, New York, NY
Production Company Pfeifer Story Piccolo Guliner
Client Perdue

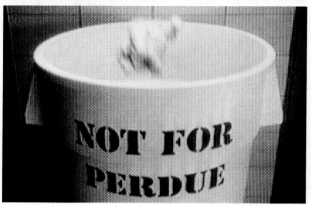

TOE NAIL
30-second
ANNCR VO: New York Telephone presents the what's up call.
GIRL: Yeah! No kidding! Really! I don't believe him! . . .
(CONTINUES UNDER)
ANNCR VO: When you want to know what's up, you have to stay in touch, which is easy to do with New York Telephone's low Regional Calling Area rates.
GIRL: He brought an accordion with him!?!
(LAUGHS)
ANNCR VO: So pick up the phone . . . and find out what's going on.
(MUSIC TAG): I CAN'T LIVE WITHOUT YOU . . .
SUPER: NEW YORK TELEPHONE A NYNEX COMPANY.

RARE BIRD
30-second
FRANK PERDUE: What we've got here is a rare bird; a white Perdue Chicken.
I don't know where it went wrong.
Maybe it caught a cold.
Maybe it went off its feed.
All I know is that somewhere along the line, it got fouled up and lost its golden yellow color.
It also lost its right to wear the Perdue name tag.
Occasionally one of my chickens disappoints me.
But I make sure of one thing . . .
(SFX: THUMP)
It will never disappoint you.

1530

Art Director	Joel Machak
Writer	Jim Ferguson
Editor	Tony Izzo
Creative Director	Bob Taylor
Agency	Darr Hawthorne—Leo Burnett Co., Inc., Chicago, IL
Client	Bill Rhatican/Rick Smith/U.S Safety Belts

1531

Art Director	Paul Basile
Writer	Rita Senders
Editor	Jeff Dell/Michael Berkofsky
Director	Michael Berkofsky
Director of Photography	Michael Berkofsky
Agency	Linda Tesa, Della Femina, Travisano & Partners, New York, NY
Production Company	Berkofsky-Barrett
Account Executive	Cordelia Wills
Senior Vice President	Mathew Mansfield

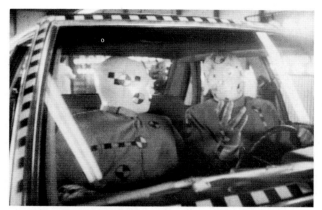

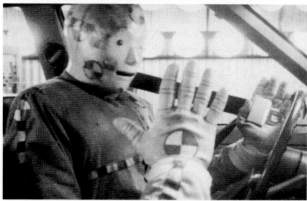

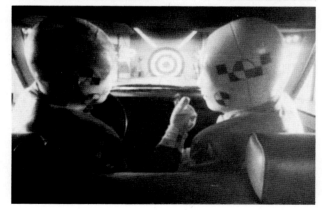

PRE-CRASH
30-second
VINCE: After this joy ride, I'm out of the crash dummy business for good.
LARRY: But Vince, it's a great job. Heck, they'd have to pry me away from it.
VINCE: Anybody home? Larry, they do pry you away from it.
LARRY: Oh, yeah.
VINCE: For years I've been eating steering wheels. For what?
LARRY: To prove how safety belts save lives.
VINCE: But thousands die every year in car accidents 'cause they don't buckle up.
LARRY: Vince, we're dummies. We don't wear safety belts.
VINCE: Larry, you really know how to hurt a guy. Hit it!
ANNCR: You could learn a lot from a dummy.
Buckle your safety belt.

GIGOLO
30-second
VO: Some men wear Le Tigre sportswear and some women think it's worth waiting for. Le Tigre for men.

1532

Art Director	Lou Carvell
Designer	Howard Barker
Writer	Abbie Simon
Editor	Alan Eisenberg
Director	Domenic Rossetti
Agency	Debbie Dunlap/Rosenfeld, Sirowitz & Humphrey, NY
Production Company	Joanne Garber/Margaux Mackay, Rossetti Films
Client	Smith-Corona
Account Supervisor	Bob Mayer/Mike Brewi

1533

Art Director	Rick McQuiston
Writer	Jim Riswold
Agency	Wieden & Kennedy, Portland, OR
Production Company	Henman Karbelnikoff Michel
Client	Honda Scooters

DR. RUTH
30-second
DR. RUTH: You think you've got problems. I've got one, too. It's psychological—I just misspelled it. But I've got help from an expert. The new Smith Corona Typewriter with Spell-Right dictionary.
(SFX: BEEP BEEP)
It beeps when I misspell a word.
Finds it. Erases it. Even helps me spell it.
With Spell-Right, I'm letter perfect. And I love it.
That's why my Smith-Corona and I have a fantastic relationship.
ANNCR: SpellRight typewriters from Smith Corona.

RATTLE
30-second
LOW RUMBLE BUILDS
VO: We all start out pretty much the same.
But where you go from there . . .
(GRACE)
. . . is entirely up to you.

Art Director Bob Barrie
Writer Jarl Olsen
Editor Steve Shepard, Wilson-Griak, Minneapolis, MN
Agency Judy Brink, Fallon McElligott, Minneapolis, MN
Production Company Pfeifer-Story, Los Angeles, CA
Client Crystal Sugar

Art Director Rick McQuisten
Writer Jim Riswold
Agency Wieden & Kennedy, Portland, OR
Production Company Henman/Karbelnikoff/Michel
Client Honda Scooters

ROSE
30-second
MAN: Roses are red, violets are blue,
Crystal Sugar is sweet . . .
. . . and it comes in brown, powdered and cubes, too.
There is *nothing* you can not do with a little inspiration and pure, natural Crystal Sugar.
WOMAN (OFF CAMERA): Did you take the trash out yet?!?
MAN: Almost nothing.

MONTAGE
30-second
VO: We all start out pretty much the same.
But where you go from there is entirely up to you. HaHaHaHaHa . . . HaHaHaHaHa . . .

1536

Art Director	B. A. Albert
Writer	Cleve Willcoxon
Editor	Jayan Films and Crawford Post Production
Director	Glenn Kirpatrick
Creative Director	Joey Reiman
Agency	Carol Hardin/D'Arcy Masius Benton & Bowles/Atlanta, GA
Production Company	Jayan Films
Client	Alliance Theatre/Atlanta

1537

Art Director	Alex Jesudowich and Teddy Borsen
Writer	Bob Feinberg, Marsha Saffian
Editor	Billy Williams
Director	Patrick Russell
Director of Photography	Jeff Kimball
Agency	Dan Kohn, Bozell, Jacobs, Kenyon & Eckhardt, Inc., New York, NY
Client	The Lee Company
Music	Mark Blatte and Rich Look

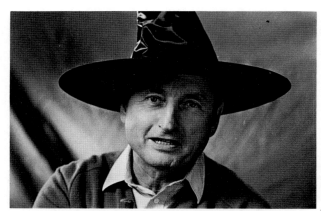

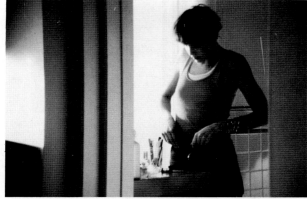

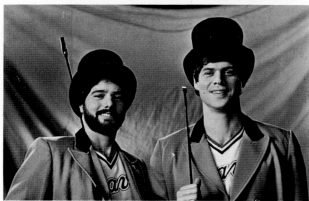

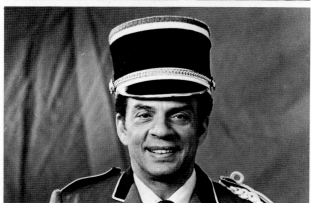

DOUBLE DOUBLE DOOLEY
30-second
DOOLEY: Double, trouble, toil and trouble. No, double double toil and trouble.
BOTH: (SINGING) You gotta have heart miles and miles and miles of heart.
LOMAX: Pleading for a lover's fee, shall we their, uh . . .
VO ANNCR: Atlanta needs the Alliance Theatre and Atlanta Children's Theatre to produce the best. The alternative is to depend on this kind of talent and that would be a tragedy.
ANDREWS: Oh Romeo, Romeo. Wherefore art thou Romeo?

SENSATION (FEMALE)
30-second
SINGERS: Such a sensation in her blue jeans.
A temptation if
you know what I mean,
Making
me crazy 'till I'm just about gone.
Is it
what she's got goin'?
Or what she's got on?
Lee Sensation
Lee Sensation
Lee
(MUSIC FADES)

1538

Art Director	Jim Scalfone
Designer	Jim Scalfone
Writer	Marvin Honig
Editor	Pierre Kahn/Pelco
Agency	Lora Nelson/Doyle Dane Bernbach, New York, NY
Client	American Greetings
Stock Footage	Film Search

1539

Art Director	Lyle Metzdorf
Writer	Lyle Metzdorf
Editor	First Edition—Randy Illowite
Director	Gerald Cotts
Director of Photography	Gerald Cotts
Agency	Lyle Metzdorf, Lowe Marschalk, Houston, TX
Production Company	Adam Gross, Cotts Films
Client	Blue Bell Creameries

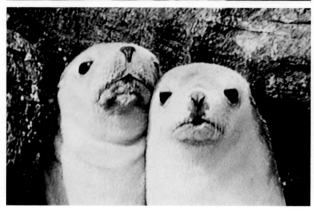

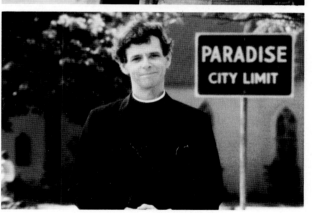

LOVING COUPLES
30-second
MUSIC: WHY DO FOOLS FALL IN LOVE?
VO: For anyone who's ever been in love.
American Greetings.

PARADISE
30-second
(MUSIC)
PICTURE 1 VO: The people in Happy, Texas are unhappy 'cause they can't get Blue Bell Ice Cream Snacks.
COWHAND: If we could, Happy would be Paradise. Right?
PICTURE 2 VO: Some residents in Needmore, Texas claim . . .
FARMER: We named our town Needmore because we need more Blue Bell Snacks.
DAUGHTER: No we didn't, Daddy.
FARMER: Yes, we did.
PICTURE 3 VO: Folks here never need more Blue Bell Snacks 'cause they get all they can eat.
PREACHER: That's why we're happy in Paradise.
VO: Blue Bell. The best tastin' ice cream in the country.

1540

Art Director	Robert McDuffey
Writer	Harold Kaplan
Editor	Ciro/The Deitors
Director	Joe Piccolo
Director of Photography	R. Henry
Agency	Charles Capuano—Young & Rubicam, New York, NY
Production Company	Pfeifer/Story/Piccolo/Guliner
Client	Johnson & Johnson

1541

Art Director	Fred Massin
Writer	Stanley Becker/Denise Kresta
Director	Bob Bierman
Agency	David Dyke/DFS, Inc., New York, NY
Production Company	Elite Films
Client	RC Cola Company
Recording Producer	Barbara Tager

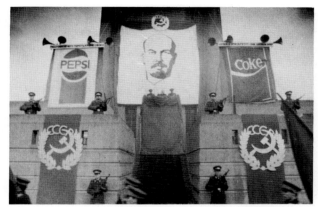

BOY

30-second

BOY: Wanna see the cut under my BAND-AID bandage?
Mommy said keep it covered and it'll be all better faster. Wanna see it?
Hey, where'd my cut go?
ANNCR VO: Johnson & Johnson has proven that cuts kept covered with BAND-AID Brand heal faster than uncovered cuts up to twice as fast.
BOY: It was here. Honest, I mean it.
ANNCR VO: Keep cuts covered with BAND-AID Brand and they'll heal up to twice as fast.
From Johnson & Johnson.

RUSSIA

30-second

ANNCR: For some years our friends overseas have been drinking. Only Pepsi-Cola. But recently they've starting drinking Coca-Cola. And now our friends drink Coke and Pepsi only. But somewhere there are people who'll go out of their way for the taste of RC Cola. A taste that's unrestrained. Yes, some people go out of their way for the taste of RC.
But sometimes . . . not far enough.

1542

Art Director	Randy Spear
Writer	Jennifer LeMay
Director	Steven Oaks
Agency	Polly Hathorn, Burton-Campbell, Inc., Atlanta, GA
Production Company	Broadcast Arts
Client	Brookwood Recovery Centers

1543

Art Director	John Speakman
Writer	Hal Kantor
Editor	Michelle Jones
Director	Richard Chambers
Creative Director	Bill Durnan
Agency	Sandy Cole, MacLaren Advertising, Toronto, Canada
Production Company	Chambers & Assoc.
Client	Molson Breweries of Canada Ltd.

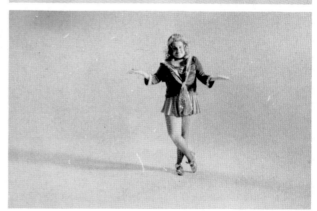

MONKEY
30-second
ANNCR: What would you do if cocaine were free?
Guess what they did?
They turned down food. Water.
Turned down all the things they loved, even sex.
And took all the cocaine they wanted. Until they died.
Don't underestimate the power of cocaine.
We don't.
We're Brookwood Recovery Center.
At Brookwood, we know from experience what it takes to stop.
Professional help.
If you need it or know someone who does, call Brookwood.
Now.

TAP DANCER
30-second
ANNCR: Introducing Molson Golden, the smooth beer. Now available here,
in a handy twist-cap bottle.
That's all we wanted to say in this commercial. So now we present . . .
tap dancing.

1544

Art Director Jean Robaire/Lee Clow
Writer John Stein/Ed Cole/Bill Hamilton/
 Marvin Hagler
Editor Brian McCann
Director Norman Seeff
Agency Elaine Hinton, Chiat/Day, Los
 Angeles, CA
Production Company Richard Marlis Prod.
Client Pizza Hut, Inc.

1545

Art Director Art Mellor
Writer Charlie Miesmer
Editor Bob DeRise
Director Gerard Hameline
Agency Gene Lofaro/BBDO, New York, NY
Producer Michael Daniel
Client Visa

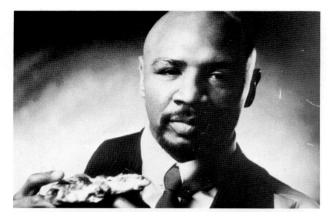

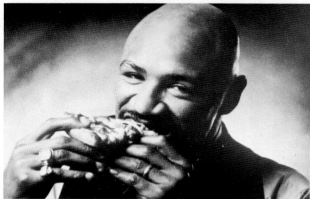

SOUP
30-second
MUSIC: UNDER THROUGHOUT.
MARVIN: Just thinking . . . I wonder what "What's-his-name" is eating tonight . . .
Probably soup.

TEXAS
30-second
You'd never expect to catch a fish down in Austin.
Yet that's the reason people
come to the Austin Angler.
One of the few places in Texas
you can get a custom-made split-bamboo fly rod
and a fresh-tied wooly-worm to go on the end.
So, if you go there, remember: Keep your rod tip up,
and put your Visa card down.
'Cause at the Angler, they don't take fishing lightly,
and they don't take American Express.
Visa. It's everywhere you want it to be.

1546

Art Director	Donna Weinheim
Writer	Cliff Freeman
Director	Peter Richardson
Agency	John Lacey/DFS, Inc., New York, NY
Production Company	Paisley Productions
Client	Wendy's International
Recording Producer	Barbara Tager

1547

Art Director	Art Mellor
Writer	Charlie Miesmer
Editor	Bob DeRise
Director	Gerard Hameline
Agency	Gene Lofaro/BBDO, New York, NY
Producer	Michael Daniel
Client	Visa

OUNCE OF GUILT

30-second

WOMAN: I don't feel one ounce of guilt when I eat . . . I eat at Wendy's. Wendy's has a new Light Menu. Hundreds of lower calorie salads . . . with new fresh fruit and pasta salad. Wendy's Light Menu even has a lower calorie multi-grain bun. I eat all I want from Wendy's Light Menu. Now do I look like I feel one ounce of guilt?
VO ANNCR: Try Wendy's new Light Menu.

BOSTON

30-second

Just a little north of Boston, in the old town of Marblehead is a place where only local people used to eat.
But the Scallopine and the Scampi were so good that word soon got out, that a night in Rosalie's was like a night in Milan.
But if you go there, remember: bring a big appetite, and bring your Visa card.
'Cause at Rosalie's
they don't take no for an answer
and they don't take American Express.
Visa. It's everywhere you want to be.

1548

Art Director	Harvey Hoffenberg
Writer	Ted Sann
Editor	Bob DeRise
Director	Joe Pytka
Agency	Gene Lofaro/BBDO, New York, NY
Production Company	Pytka Productions
Client	Pepsi-Cola

1549

Art Director	Terry Iles
Writer	Rick Davis
Editor	Olaf Relitzki/Alex Eaton
Director	Paul Cade
Agency	Louise Blouin, Doyle Dane Bernbach Advertising Ltd., Toronto, Canada
Production Company	Chris Money, Boardwalk Motion Pictures Ltd.
Client	Amstel Brewery Canada Limited
Music	Stock—Rick Shurman—The Air Company

WILBUR I
30-second
(MUSIC) 1ST MAN: What's the matter, Wilbur?
WILBUR: They changed my Coke.
1ST MAN: Something wrong with it?
WILBUR: I dunno, they sure changed it.
2ND MAN: Coulda asked.
WILBUR: I coulda.
I stuck with them through three wars and a couple of dust storms, but this is too much.
Guess something big made 'em change.
1ST MAN: Right big.
MUSIC: (SFX)
WILBUR: Right big.
MARTIN SHEEN'S VOICE: Pepsi. The choice of a new generation.
2ND MAN: Still coulda asked.

BEAR TRAP/GRIN
30-second
(GRIZZLY THEME MUSIC THROUGHOUT)
SFX OF BOTTLE SLIDING
SFX OF BOTTLE OPENING
ANNCR VO: Grizzly.
SFX OF BOTTLE OPENING

1550

Art Director — Eric Glickman
Writer — Stan Becker/Cliff Freeman
Director — J C Kaufmann
Agency — J. C. Kaufmann/DFS, Inc., New York, NY
Production Company — Bill Hudson Films
Client — General Mills, Inc.
Recording Producer — Deed Meyer

1551

Art Director — Michael Vitiello
Writer — Bob Lapides
Director — Steve Horn
Agency — Bob Nelson/Levine, Huntley, Schmidt & Beaver, New York, NY
Client — Subaru of America

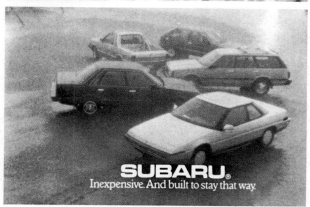

BULLPEN
30-second
ANNCR: It's amazing what's happened since Yoplait, the yogurt of France came to America. Take all natural Yoplait Original. Outrageously creamy, and it's mixed through with real ruit. Who'd have imagined the effect it would have on real Americans.
METS SING: Amene moi ou jeu de balle. Amene moi avec la foule. Achete moi des Craches Jacques.
ANNCR: Yoplait Original.
Just one of the Yogurts . . . from Yoplait, the Yogurt of France.

10 YEARS AGO
30-second
ANNCR: 10 Years ago it rained.
10 years ago there were signs like these, and roads like this.
Yet 10 years ago, only one car maker was committed to handling these conditions. Subaru, with On Demand four wheel drive. A feature we offer on every model.
Now other car makers are discovering four wheel drive. Did they finally notice the weather? Or us?
Subaru. Inexpensive. And built to stay that way.

1552

Art Director	Gunar Skillins
Writer	Eliot Riskin
Editor	Rob Tortoriello
Director	Jim Spencer
Agency	Jerry Cammisa/Alice Chevalier/ BBDO, New York, NY
Production Company	Bean Kahn with Dream Quest
Client	Black & Decker

1553

Art Director	Art Mellor
Writer	Charlie Miesmer
Editor	Bob DeRise
Director	Gerard Hameline
Agency	Gene Lofaro/BBDO, New York, NY
Production Company	Michael Daniel Productions
Client	Visa

HANDS
30-second
Black & Decker introduces
a revolution in power tool technology.
A line of tools designed specifically to work
as one with your hand.
The M47 Series.
Smaller, more compact,
for better control,
greater accuracy.
And driven by the most powerful motor
for its size we've ever built.
The M47 Series power tools.
They work with your hand
as if they were one.

BERMUDA
30-second
If you take the Somerset Road
all the way out to Mangrove Bay
you'll find a very special place.
Captain John's Boat Yard, one of the only places in Bermuda
you can rent a boat and a motor, and spend the day
out over the coral, looking for fish,
or out on the flats, just looking. But remember two things . . .
Bring some sandwiches
and your Visa card.
Because Captain John doesn't sell food, and he doesn't take
American Express.
Visa. It's everywhere you want to be.

1554

Art Director Tony DeGregorio
Writer Lee Garfinkel
Director Steve Horn
Agency Bob Nelson/Levine, Huntley, Schmidt & Beaver, New York, NY
Production Company Steve Horn Productions
Client Subaru of America

1555

Art Director Rick Boyko/Gary Johns
Writer Bill Hamilton/Jeff Gorman/Brent Bouchez
Editor Rob Watzke
Director Tony Scott
Agency Richard O'Neill, Chiat/Day, Los Angeles, CA
Production Company Fairbanks Films
Client Pizza Hut, Inc.

YOU ALWAYS HURT
30-second
MUSIC: YOU ALWAYS HURT THE ONE YOU LOVE.
ANNCR: People have a love-hate relationship with their cars. They love them, but they don't always treat them right.
Yet amazingly, over 90% of all Subarus registered since 1974 are still on the road.
Now imagine how much longer they would last if people didn't "love" them so much.
ANNCR: Subaru. Inexpensive. And built to stay that way.
SUPER: SUBARU. INEXPENSIVE. AND BUILT TO STAY THAT WAY.

ANTICIPATION
30-second
MUSIC: "LA BOHEME: ADAPTATION UNDER THROUGHOUT.
SFX: CHURCH BELLS.
ANNCR VO: Of the 24 hours in a day,
Italians look forward to one . . .
with special
anticipation.
The moment
they can once again
enjoy
Italian pie.
We call it Priazzo (TM) . . .
Baked fresh every day.
Only at
Pizza Hut.

1556

Writer Cliff Freeman
Director Joe Sedelmaier
Agency Susan Scherl/DFS, Inc., New York, NY
Production Company Sedelmaier Productions
Client Wendy's International

1557

Art Director W. Peter Koehler, Koehler Iversen, Inc., New York, NY
Writer W. Peter Koehler
Editor Don Packer
Director Bruce Van Dusen
Agency Corey E. Klein
Production Company David Frankel, Van Dusen Films, New York, NY
Client W. A. Tatum/Health Insurance Plan of Greater New York

TWELVE O'CLOCK

30-second

CUSTOMER: Yeh, I'd like a hamburger.
CREW #1: As you speak . . .
CUSTOMER: You already made it?
CREW #1: We already made it.
CUSTOMER: When?
CREW #1: What time is it?
CUSTOMER: Twelve O'clock.
CREW #1: Twelve O'clock? We made your hamburger at eleven O'clock.
CUSTOMER: So if I want a hamburger made fresh, I gotta come at eleven O'clock.
CREW #1: Our eleven O'clock hamburger we made at ten O'clock.
CUSTOMER: Ten O'clock?
CREW #2: It's like ten, eleven, twelve or vice versa . . .

NOT COVERED

30-second

SFX (RUBBER STAMP BEING APPLIED): THUMP!
CLAIMS DEPARTMENT CLERK: Not Covered!
ANNCR VO: If you get the distinct impression that your health plan has some pretty costly holes in it . . .
SFX: THUMP!
CLERK: Not Covered!
ANNCR VO: . . . look into HIP/HMO
Our fully covered health services include just about everything, from routine check-ups to major surgery.
All for one affordable monthly premium. No deductibles. No out-of-pocket expenses. No surprises.
SFX: THUMP!
CLERK: Not Covered!
ANNCR VO: The Health Insurance Plan of Greater New York.

1558

Art Director	Tom Gardner
Writer	Arthur Bijur
Director	Patrick Morgan
Agency	Pam Buckner/DFS, Inc., New York, NY
Production Company	Fairbanks Films
Client	Wendy's International
Recording Producer	Deed Meyer

1559

Art Director	Rick Boyko/Jean Robaire
Writer	John Stein/Ed Cole/Brent Bouchez/ Bill Hamilton/Hoyt Axton
Editor	Brian McCann
Director	Norman Seeff
Agency	Elaine Hinton, Chiat/Day, Los Angeles, CA
Production Company	Richard Marlis Prod.
Client	Pizza Hut, Inc.

BIRTHDAY
30-second
SINGERS: Happy Birthday to you, Happy Birthday to you—
Happy Birthday dear hamburger . . .
ANNCR: Order a hamburger at some places, chances are it's been
sitting around getting old. Wendy's believes no hamburger should
grow old. At Wendy's your hamburger is always served immediately,
fresh hot-off-the-grill. The other guys can't promise that.
SINGERS: How old are you now? How old . . .
SFX: CANDLE BLOWN OUT . . .
ANNCR: Choose Fresh. Choose Wendy's.

GOLF
30-second
MUSIC: UNDER THROUGHOUT.
HOYT: I wouldn't marry a woman who didn't like pizza . . .
I might play golf with her, but I wouldn't marry her.

1560

Art Director	Len Sirowitz
Designer	Cosimo
Writer	Ron Rosenfeld
Editor	Pat Santomauro
Director	Cosimo
Agency	Debbie Dunlap/Rosenfeld, Sirowitz & Humphrey, New York, NY
Production Company	Morty Dubin, Jeff Hansen, Iris Films, NY
Client	Yugo America, Inc.
Account Supervisor	John Slaven

1561

Art Director	Mike Moser
Writer	Brian O'Neill
Director	Stan Scofield
Agency	Vicki Blucher—Chiat/Day Advertising, San Francisco, CA
Client	Oral-B Toothbrushes

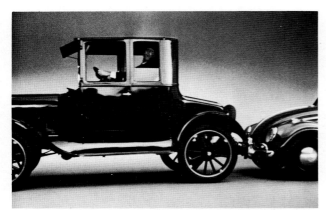

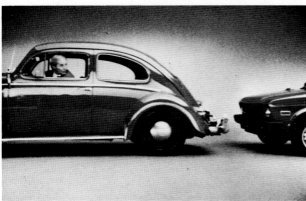

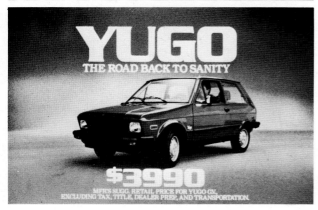

MODEL T
30-second
VO: Every generation or so, some smart guys come along . . .
who've figured out how to make basic transportation. . . .
at an affordable price.
The old "car in every garage" idea.
Well, introducing the same old idea.
The Yugo. Imported from Europe for only $3990.
Basic transportation, affordable price.
The Yugo.
At $3990, it's the road back to sanity.

CAR REVISED
30-second
ANNCR VO: Every day, dentists
see all the damage a hard toothbrush can inflict.
How it can actually remove enamel . . . and gum tissue. Maybe that's why most dentists use soft brushes, and why they use Oral-B six to one over any other leading toothbrush. Because they've known all along that a toothbrush doesn't have to hurt . . . to work.
Oral-B. The tool dentists use on themselves.

1562

Art Director	Marcus Kemp/Joe Sedelmaier
Writer	Steve Sandoz/Joe Sedelmaier
Editor	Peggy Delay
Director	Joe Sedelmaier
Director of Photography	Joe Sedelmaier
Creative Director	Ron Sandilands
Agency	Cindy Henderson/Livingston & Company, Seattle, WA
Production Company	Marsie Wallach, Sedelmaier Productions
Client	Alaska Airlines

1563

Art Director	Jeff France
Writer	Ken Hines
Editor	Morty Ashkinos
Director	Phil Marco
Agency	Jeff France, Ken Hines—Lawler Ballard Adv., Norfolk, VA
Production Company	Ingrid Lacis, Phil Marco Productions
Client	Norfolk General Hospital

AUTOMATON
30-second
ANNCR: Have you ever wondered just what flying is coming to?
WOMAN: Hi! I'm your talking ticket. Do you have luggage?
MAN: Oh. Oh. Yes.
WOMAN: Hi! I'm your talking ticket. Do you have baggage?
MAN 2: I don't have any baggage.
WOMAN: Please enter the aircraft at your left.
FLT ATTEN: Hi! Welcome aboard. Now let's adjust our seatbelts.
FLT ATTEN: Please put your seat back in a fully upright position.
ANNCR: At Alaska Airlines, our people go out of their way to show you they're only human.

HEART AND SOUL
30-second
MUSIC UNDER: "HEART AND SOUL"
ANNCR VO: There are a million ways to say I love you. But if someone you love has heart disease one speaks louder than words. Make sure they get the best medical care possible at the only hospital in the region that's been a cardiac specialist for twenty years.
Norfolk General Hospital.
Don't take a chance on love.

1564

Art Director Joe Genova
Writer Tony Chapman
Director Dick Miller
Agency Kathy Courtenay, Posey & Quest, Greenwich, CT
Client The Murphy-Phoenix Company

1565

Art Director Tom Cordner
Writer Brent Bouchez
Editor Gayle Grant
Director Stan Schofield
Client Pizza Hut, Inc.
Agency Vicki Blucher, Chiat/Day, Los Angeles, CA
Production Company Sandbank Films, Inc.

CHURCH
30-second
ANNCR: Not long ago, a group of ladies in New York State wrote us, singing the praises of Murphy's Oil Soap.
They extolled the virtues of this pure, natural cleaner, that's safe to use on almost any wooden surface.
And they were thrilled by its results.
Now, considering the magnitude and importance of their task, heaven knows:
If Murphy's Oil Soap is good enough to clean this house . . . it's surely good enough to clean yours.

MOTHER & DAUGHTER
30-second
MUSIC: UNDER THROUGHOUT.
ANNCR: Today, Maria Coletti
will make her father's favorite Italian pie
for the very first time.
An age old family recipe that includes one
rather special ingredient.
Meatballs.
At Pizza Hut, we're proud to
introduce our own . . .
version of this classic.
Priazzo (TM)
Verona Italian pie.
Perhaps today will be your first time too.

1566

Art Director	Marcus Kemp
Writer	Jim Copacino/Joe Sedelmaier
Editor	Peggy Delay/Henry Hoda
Director	Joe Sedelmaier
Director of Photography	Joe Sedelmaier
Agency	Cindy Henderson/Livingston & Company, Seattle, WA
Production Company	Marsie Wallach, Sedelmaier Productions
Client	Alaska Airlines

1567

Art Director	Jean Robaire/Lee Clow
Writer	John Stein/Bill Hamilton/Ed Cole/ Brent Bouchez/MacKenzie Bros.
Editor	Brian McCann
Director	Norman Seeff
Agency	Elaine Hinton, Chiat/Day, Los Angeles, CA
Production Company	Richard Marlis Prod.
Client	Pizza Hut, Inc.

CUTTING CORNERS
30-second
ANNCR: These days a lot of airlines are cutting corners on their meals.
MAN 1: This little beauty we'll have to call "Banquet on a Bun", right Bob?
MAN 2: Banquet on a Bun.
MAN 3: I like it.
MAN 1: Set it down, Bob. Now with this you can serve a whole planeload for just pennies.
MAN 1: Plastic parsley—you can use it over and over again . . .
MAN 3: I like it.
MAN 1: Pygmie chickens, you can get an order of 105 in an ordinary shoe box.
ANNCR: At Alaska Airlines, we spend a little more on our meals . . .
. . . And you can taste the difference.

EAT LIKE A BIRD
30-second
MUSIC: UNDER THROUGHOUT.
DOUG: You know what you got to get yourself?
BOB: What?
DOUG: A new attitude to eating.
BOB: Why?
DOUG: You eat like a bird or something. He eats like a budgie, don't you think?
BOB: That's why I don't weigh 600 pounds like guess who, eh.
DOUG: Here. Let me show you how to eat pizza. Like this.
BOB: Okay. Now I got no food, eh. See. This is why I'm so small. He's always taking my food away from me. I never eat nothing.
DOUG: Don't you hate whiners?

1568

Art Director	Bob Nisson, John Donaghue
Writer	Lynda Pearson
Director	Randy Roberts
Creative Director	Millie Olson
Agency	Sue Rugtiv-Stewart/Ketchum Advertising, San Francisco, CA
Production Company	Bob Abel & Associates
Client	National Food Processor's Association

1569

Art Director	Steve Perrin, Debbie Addison
Writer	Jim Dale
Editor	Burke Moody
Director	Ken Elam
Agency	Wendy Smith/W. B. Doner & Company Adv., Baltimore, MD
Production Company	Chris Mortenson, Greenbriar Productions, Inc.
Client	Mid-Atlantic Milk Marketing Association

BRILLIANCE REV. 3
30-second
ROBOT VO: Even in the year 3000, the question will be: ''What's for dinner?'' The answer will be in a package that saves energy, nutrients and trouble. A package that can last the three-year journey to Jupiter—and back. Even in the year 3000, we see the brilliance of food in cans.

OLYMPIC CALCIUM
30-second
VO: I was a member of the women's Olympic Team in 1948.
ANNCR: Helen Sjursen, age 62.
And I can still do a lot of what
I did then.
You see, the secret is keeping your
bones young. (STRONG) And the
secret to that is calcium. That's
why I've always been a milk drinker.
Because even though your bones stop
growing, they *never* stop changing.
So—drink your milk, get your calcium.
Especially if you're like me and like to stay . . .
ON CAMERA: . . . fairly active.
ANNCR: Milk. It's fitness you can drink.

1570

Art Director	Marcus Kemp/Joe Sedelmaier
Writer	Jim Copacino/Joe Sedelmaier
Editor	Peggy Delay/Henry Hoda
Director	Joe Sedelmaier
Director of Photography	Joe Sedelmaier
Agency	Cindy Henderson/Livingston & Company, Seattle, WA
Production Company	Marsie Wallach, Sedelmaier Productions
Client	Alaska Airlines

1571

Art Director	Jean Robaire/Lee Clow
Writer	John Stein/Bill Hamilton/Ed Cole/ MacKenzie Bros.
Editor	Brian McCann
Director	Norman Seeff
Agency	Elaine Hinton, Chiat/Day, Los Angeles, CA
Production Company	Richard Marlis Prod.
Client	Pizza Hut, Inc.

CONFERENCE ROOM
30-second
MAN 1: Gentlemen, welcome, welcome, welcome. That being so stated, onto the job at hand. Please take notes and listen carefully.
ANNCR: Everyone of these executives flew to this important meeting on a different airline, sampling various meals . . .
. . . beverages . . . on board service . . . and other amenities . . .
Can you find the one executive who flew here on Alaska Airlines?
ALASKA MUSIC UP AND OUT.

PIZZA RAID
30-second
MUSIC: UNDER THROUGHOUT.
DOUG: Oh excuse me, where did you grow up . . . in the woods?
BOB: Okay. Some things fall off of my pizza, eh. But that's only 'cause it's got so much stuff on it and I . . . losing my balance.
DOUG: I stole his cheese while he wasn't looking.
Pizza raid! Ah, ah, ah, ah, ah!
Use noise to disorient your opponent. That way you can get more of his stuff on your pizza.

1576

Art Director	Keith Chow
Designer	Keith Chow
Writer	Terry Galanoy
Editor	Phillip Gessert
Director	Jim Johnston
Creative Director	Hy Yablonka
Director of Photography	Fleming Olson
Agency	Joe Rein/Kenyon & Eckhardt, Inc., Los Angeles, CA
Production Company	Johnston Films
Client	Chrysler

1577

Art Director	Joe Bui
Writer	Wendi Kramar
Director	Bob Giraldi
Creative Director	Jean Craig, Ron Goodwin
Agency	Kresser/Craig
Production Company	Giraldi Suarez Productions, New York, NY
Client	ON/SelecTV

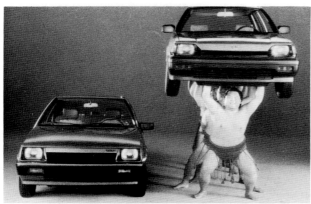

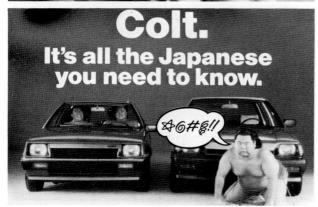

HELD UP
30-second
(MUSIC: IN, TO PUNCTUATE)
ANNCR VO: This Honda Civic is held up as the best value in a four-door import.
But now there's the '86 Colt Dee-Ell.
Same size engine.
Same front-wheel drive.
Same room for five.
But they're not the same.
The Colt is less expensive by eight hundred seventy dollars........
flat.
Colt, imported for Dodge and Plymouth, built by Mitsubishi in Japan.
Colt. It's all the Japanese you need to know.

CONFESSION
30-second
PACHELBEL CANON IN D
LADY: I started when I was 9 or 10. I've been
hooked ever since. I tried everything . . .
Double features . . . Cable . . . VCR . . .
Stood in line . . . Anything for a good movie.
I needed help.
Then a friend told me that On and SelecTV
had merged . . .
And they could treat me with up to 90 movies a month . . .
The newest movies . . .
Finally enough to satisfy me.
ANNCR: If you or someone you love is a movie addict, call the new
On/SelecTV now.

1578

Art Director	Gary Yoshida
Designer	Gary Yoshida, Bob Coburn
Writer	Bob Coburn
Editor	Jerry Weldon
Director	Michael Werk
Creative Director	Larry Postaer
Agency	Needham Harper Worldwide, Inc., Los Angeles, CA
Client	American Honda Motor Company, Inc.

1579

Art Director	Jack Eleftheriou
Writer	Jeffrey Mullen
Editor	David Dee of Even Time Editorial
Director	Graham Henman
Director of Photography	Mike Karbelnickoff
Agency	Nick Ciarlante, Cindy Lee/SSC & B Lintas, New York, NY
Production Company	Tom Mickel, HKM Productions
Client	Coca-Cola USA/diet Coke

THE ROCKET
30-second
MUSIC.
BURGESS: Introducing the fuel injected . . . Honda Civic CRX Si.
BURGESS: It's a rocket.

JUST FOR THE FUN OF IT/DEVO
30-second
SINGERS: Just for the fun of it
Just for the one of it
Just for the taste of it
diet Coke
Just for the splash of it
Just for the laugh of it
The real cola taste of it
diet coke
Just for the joy of it
Just for the smile
Just for the fun of it
diet Coke
Just for the shape of it . . .
diet Coke

1580

Art Director	Randy Mosher
Writer	Bruce Carlson
Director	David Dryer
Creative Director	Michael B. Kitei
Agency	Shelley Cowan/Sive Associates, Inc., Cincinnati, OH
Production Company	Roger Lundy, Bluebird, Inc.
Client	Murray Ohio Mfg. Co.

1581

Art Director	Dick Pantano/Rosalind Schell
Writer	Maryann Barone
Director	Michael Utterback
Agency	Maggie Hines/Hill Holliday Connors Cosmopulos, Boston, MA
Production Company	John Jorda, Avery Film Group
Client	Jordan Marsh
Music Director	J. S. Brodn/Monty Powell

Team Murray SX2, all lights are green. You are cleared for take-off.

(Dealer Tag)

Team Murray SX2. It breaks the ground barrier.

GROUND BARRIER
30-second
SFX: GARAGE DOOR MOTOR.
SFX: ECHOING FOOTSTEPS
VO: (AIR TRAFFIC CONTROLLER) Team Murray SX2, prepare for pre-flight check.
SFX: CREAK OF LEATHER, "HIGH TECH" SFX UNDER
VO: Check dual decelerator system. Begin launch sequence.
Activate directional guidance module.
Activate thrust relays.
Team Murray SX2, all lights are green.
You are cleared for take-off.
SFX: BLAST OF AFTERBURNERS CUTTING IN, AND DOPPLERING AWAY.
VO: Have a nice flight.
ANNCR: Team Murray SX2. It breaks the ground barrier.

MORNING
30-second
(SFX: SHOWER STOPS)
MUSIC CONTINUES: It's the best thing that could ever be
WIFE: Have you seen my Jordan Marsh bag?
HUSBAND: No.
MUSIC CONTINUES: Being here, with you tonight,
WIFE: How do you like this look?
HUSBAND: Mmmm, nice . . .
MUSIC CONTINUES: It's like the first time, The first time,
WIFE: Or this one . . .
HUSBAND: Come closer
WIFE: Ahhh (laughing) I'll be late . . .
HUSBAND: That's the idea.
MUSIC CONTINUES: I saw you in the morning light.

1582

Art Director Jim Weller
Writer Jim Weller
Editor Jacques Dury
Director Haskell Wexler
Agency Shannon Silverman, Della Femina, Travisano & Partners of California, Inc., Los Angeles, CA
Production Company Lisa Rich, Harmony Pictures
Client Carl's Jr. Restaurants

THEMATIC
30-second
CARL: We opened our first Carl's some forty years ago. We put in a charcoal broiler and we had charcoal broiled hamburgers.
ANNCR VO: Forty years ago Carl Karcher started out making hamburgers the old-fashioned way.
CARL VO: The first day sales were 14 dollars and 75 cents.
ANNCR VO: A lot has changed in forty years . . . but a Carl's Jr. hamburger really hasn't changed at all.
CARL: We sold an old-fashioned hamburger back then. Today we still do.
ANNCR VO: Because you'll still find old-fashioned American values at Carl's Jr.

Art Director	Harvey Hoffenberg
Writer	Ted Sann
Editor	Steve Schreiber
Director	Joe Pytka
Agency	Gene Lofaro/BBDO, New York, NY
Production Company	Pytka Productions
Client	Pepsi-Cola Company

ARCHAEOLOGY
60-second
PROFESSOR: This, class, is perhaps the greatest archaeological discovery of our time . . .
PROFESSOR: A dwelling called the split-level ranch. Marvelous!
F-STUDENT #1: What's this Professor?
PROFESSOR: Ah, a spherical object they used to hurl at each other with great velocity, while others looked on.
M-STUDENT: What's this?
PROFESSOR: Oh . . . This device produced excruciatingly loud noises to which they would gyrate in pain.
F-STUDENT #2: Professor . . . What is it?
PROFESSOR: Odd . . .
F-STUDENT #2: What is it?
PROFESSOR: I have no idea.
SUPER & VO: PEPSI. THE CHOICE OF A NEW GENERATION.

Silver Award

Art Director	Tony DeGregorio
Writer	Lee Garfinkel
Director	Steve Horn
Agency	Bob Nelson/Levine, Huntley, Schmidt & Beaver, New York, NY
Production Company	Steve Horn Productions
Client	Subaru of America

YOU ALWAYS HURT

60-second

MUSIC: YOU ALWAYS HURT THE ONE YOU LOVE.

ANNCR: People have a love-hate relationship with their cars. They love them, but they don't always treat them right.

Yet amazingly, over 90% of all Subarus registered since 1974 are still on the road.

Now imagine how much longer they would last if people didn't "love" them so much.

ANNCR: Subaru. Inexpensive. And built to stay that way.

SUPER: SUBARU. INEXPENSIVE. AND BUILT TO STAY THAT WAY.

Art Director Robert Lenz/Howard Smith
Writer Robert Meury/Ben Evans
Agency Marc Mayhew/Backer &
Spielvogel, New York, NY
Client Miller Brewing Company/Lite Beer

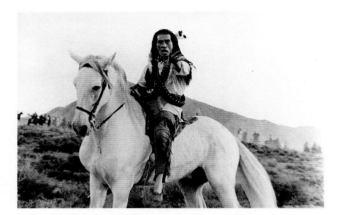

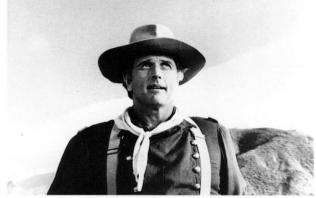

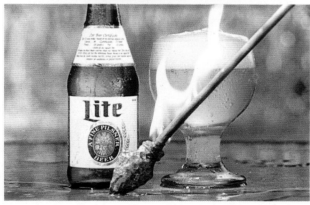

CAVALRY AND INDIANS
60-second
DRAMATIC STOCK MUSIC THROUGHOUT.
CAPTAIN: Whoa . . . Whoa . . .
CAPTAIN: Looks like we got company, Sergeant.
Hold your fire men, hold your fire.
SERGEANT: Ain't no braver man alive.
INDIAN CHIEF: Taste great!
CAPTAIN: Less filling.
CHIEF: Taste great!
CAPTAIN: Less filling.
INDIAN CHIEF SPEAKS AN INDIAN LANGUAGE.
CAPTAIN: Mount 'em up!
ANNCR VO: No one knows how long the argument has raged, but
one thing is for certain, Lite Beer from Miller will go down in history
as the world's greatest lite beer.

Art Director Tom McConnaughy
Writer Ron Hawkins
Director John Pytka
Creative Director Tom McConnaughy
Agency Ginny Washburn/Ogilvy & Mather, Chicago, IL
Production Company Sandbank Films
Client Waste Management, Inc.

Art Director Joel Levinson
Designer Kim Colfex
Writer Lou Popp
Editor Scott Hudson
Director Jeremiah Chechik
Director of Photography Richard Kline
Agency Dick Standridge, McCann-Erickson, New York, NY
Producer Blair Hayes
Client Coca-Cola USA

BUENOS AIRES REV. II
60-second
MUSIC UNDER
ANNCR: It's the end of another year.
In Buenos Aires.
Something office workers celebrate
in a way sure to warm the hearts of paper
pushers everywhere.
Even more unusual the city doesn't have to
lift a finger to clean things up.
It's all done by a private company.
Part of the operations of an
American company in the
business of keeping cities clean
the world over . . .

SLOW
60-second
A street a sun
It's the start of the day
The beat of the road
It's breaking away
It's a girl on a beach
It is awesome it's free
It's a lift
It's a wave
It's the way it should be
A kiss a glance
It is hot it is cool
A smile
A chance . . .
It's a Coke.

1589

Art Director	Tom Cordner
Writer	Brent Bouchez
Editor	Larry Bridges
Director	Steve Horn
Agency	Francesca Cohn, Chiat/Day, Los Angeles, CA
Production Company	Steve Horn, Inc.
Client	Pizza Hut, Inc.

1590

Art Director	Peter Coutroulis
Writer	Howard Krakow
Editor	Jim Edwards
Director	Fred Petermann
Director of Photography	Fred Petermann
Agency	Bert Kelley/Davis Johnson Mogul & Colombatto, Los Angeles, CA
Producer	Sally Kraus
Client	U. S. Borax

COOKING SCHOOL
60-second
MUSIC: ''LA BOHEME'' ADAPTATION UNDER THROUGHOUT.
INSTRUCTOR: Parti li funghi Marco-vieni. (Cut the mushrooms Marco-come.)
Ma Vincenzo—che hal fatto qui? (But Vincenzo, what did you do here?)
Beh! Mettilo, mettilo, mettilo. (Well, put it in, put it in, put it in.)
ANNCR VO: In Italy there are many . . .
. . . ways to make the classic Italian pie.
Each recipe a closely guarded secret.
ANNCR VO: In America . . .
INSTRUCTOR: Lavora. Lavora. (Work. Work.)
ANNCR VO: . . . there is a special Italian pie.
We call it Priazzo (TM).
at Pizza Hut.

TORPEDO/U.S. (EXPLOSION)
60-second
ANNCR: Chemical warfare is threatening the fabric of some of America's clothes.
The enemy is chlorine bleach—a liquid that can attack colors and delicate whites.
But there is a bleach that is safe for all your colors, all your whites.
Borateem Bleach. The safe, great white.

1591

Art Director	Bob Meagher
Designer	Bob Meagher
Writer	Bob Meagher, Jay Kaskel
Editor	Rich Carroll
Director	Jeff Jones
Agency	Bob Meagher, Jay Kaskel, Dave Ullman—Cramer-Krasselt, Chicago, IL
Production Company	McDonough-Jones
Client	American Charter Savings & Loans

1592

Art Director	Harvey Hoffenberg
Writer	Ted Sann
Editor	Bob DeRise
Director	Bob Giraldi
Agency	David Frankel/BBDO, New York, NY
Production Company	Giraldi Productions
Client	Pepsi-Cola Company

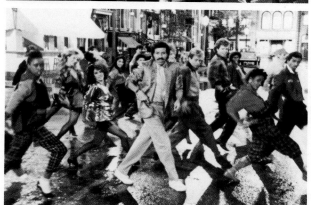

STRANGER
60-second
STRANGER: Say, excuse me. Excuse me.
Hi there. Uh, could you help me?
Could you tell me where I might find some gas?
FARMER: Gas station would be a good bet.
STRANGER: Where is the nearest gas station?
FARMER: Some distance.
STRANGER: Well, this road does go there doesn't it?
FARMER: This road? Don't go anywhere. Just stays right here.
STRANGER: Thanks for your help.
FARMER: Anytime. (CALLS DOG AS HE LEAVES MAILBOX.)
SFX: PICK-UP TRUCK.
FARMER: Hop in.
ANNCR VO: Taking the time to lend a hand, it's just part of being a Nebraskan.

RICHIE/STYLE
60-second
MUSIC BEGINS
RICHIE: You wear your style,
you wear your smile,
so free, so fine, so right,
see the new generation
flashin' through the night.
If looks could sing, the sounds would ring across a neon sky,
we're a new generation
living Pepsi style.
Oh . . . we made our choice, makin' it Pepsi,
looking Pepsi style. We made our choice, makin' it Pepsi, looking Pepsi style.
We made our choice, makin' it Pepsi.
SUPER: PEPSI. THE CHOICE OF A NEW GENERATION.

1593

Art Director	Rich Martel
Writer	Al Merrin
Editor	Dennis Hayes
Director	Graham Henman
Agency	Jeff Fischgrund/BBDO, New York, NY
Production Company	HKM Productions
Client	Pepsi-Cola Company

1594

Art Director	Donald Sterzin
Editor	First Edition/Howie Weisbrot
Director	Bruce Weber
Creative Director	Sandy Carlson
Director of Photography	Joe Consantino
Agency	Dorothy Franklin, Geers Gross Advertising, Inc., New York, NY
Production Company	Steven Cohen, KIRA Films
Client	Polo/Ralph Lauren

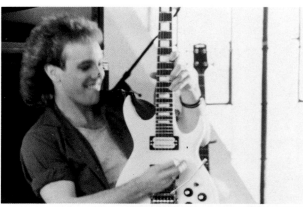

GUITAR
60-second
DEL BOY: Delivery!
GIRL: Oh great!
VO: See if he's got an opener?
GIRL: Opener? . . . No opener?
VO: Who needs an opener? Let J.J. do it.
SFX: BASS GUITAR.
VO: There's one soft drink with a taste so electrifying,
VO: it's pure . . .
SFX: BUBBLING NOISE.
VO: rock and roll.
SFX: BOTTLE TOPS POPPING.
SFX: FAST AND FURIOUS BASS GUITAR PLAYING.
SFX: REMAINING BOTTLE TOP POPS, CHEERS.
SUPER & VO: PEPSI. THE CHOICE OF A NEW GENERATION.

MONTAGE
60-second
MUSIC (HARMONICA PLAYING CROSSES INTO SONG)
Now of all the times that come to mind,
and the memories that I know,
I remember when we jumped in a pick up truck
and went bumping down a dusty road.
High lines flew by as we left behind
our blues in a lonesome town
And we laughed and loved till we were far above
all the things that held us down.
And you were close to my heart
Close to my heart, now miles could never keep us apart . . .
ANNCR VO: Dungarees by Ralph Lauren
MUSIC OUT

1595

Art Director	Olavi Hakkinen
Writer	David Johnson
Editor	Dennis Hayes
Director	Tony Scott
Agency	Nancy Perez/Arnie Blum/BBDO, New York, NY
Production Company	Fairbanks Films
Client	Pepsi-Cola Company

1596

Art Director	Bruce Dundore
Writer	Barry Udoff
Editor	Dennis Hayes
Director	Joe Pytka
Agency	Gene Lofaro/BBDO, New York, NY
Production Company	Pytka Productions
Client	Pepsi-Cola Company

ROBOTS
60-second
SFX: CRICKETS CHIRPING, WIND BLOWING, CAR
APPROACHING.
SFX: FUTURISTIC MUSIC, MOVING MACHINERY PARTS.
SFX: DOG BARKING.
SFX: CRACKLING ELECTRICITY.
SFX: RADIO MUSIC AND VOICE OF DJ, LAUGHTER.
SFX: RADIO MUSIC.
VO: In the showdown between the colas,
VO: there's only one deciding factor . . . great taste.
VO: Pepsi, the choice of a new generation.
ROBOT: Ha, Ha!
SUPER: PEPSI: THE CHOICE OF A NEW GENERATION.

SHUTTLE
60-second
GROUND CONTROLLER: Challenger, we have a gremlin in the
cooling system. We've got to put you on hold.
ASTRONAUT: Come on Gene, light this candle.
GROUND CONTROLLER: Understand Challenger, we're doing all we
can.
SFX: PEPSI CAN OPENING.
ASTRONAUT: What was that?
GROUND CONTROLLER: Relax Chuck. Just cracking open a Pepsi.
ASTRONAUT: Could I go for a cold Pepsi right now!
SFX: FIZZING SOUND OF SODA.
GROUND CONTROLLER: Wish I could help you buddy.
ASTRONAUT: You can talk me through one.
GROUND CONTROLLER: That's a can do. Lifting slow and easy.
We have condensation. Water beads skedaddling down the
sides. . . .

1597

Art Director	Harvey Hoffenberg
Writer	Ted Sann
Editor	Bob DeRise
Director	Bob Giraldi
Agency	David Frankel/BBDO, New York, NY
Production Company	Giraldi Productions
Client	Pepsi-Cola Company

1598

Art Director	Harvey Hoffenberg
Writer	Ted Sann
Editor	Bob DeRise
Director	Bob Giraldi
Agency	David Frankel/BBDO, New York, NY
Production Company	Giraldi Productions
Client	Pepsi-Cola Company

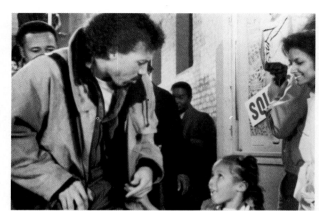

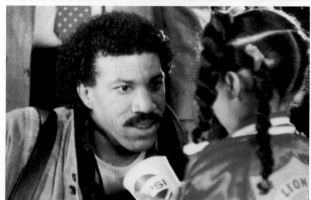

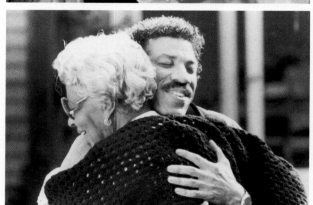

RICHIE/BLOCK PARTY
60-second
MUSIC
SFX: HAND CLAPPING, CROWD CHEERING.
RICHIE: The beat of a generation is pounding . . .
got to get down before the magic gets away.
Pepsi feels so right, dancin' till the sun shines.
Just lift it high, Pepsi feels so right . . .
Pepsi feels so right, so right. Pepsi feels so right. Pepsi feels so right.
SUPER: PEPSI. THE CHOICE OF A NEW GENERATION.

LIONEL RICHIE 3:00 VERSION
3-minute
LIONEL RICHIE: You know, we're a whole new generation.
A generation of new rhythms, feelings, new styles.
(MUSIC)
You wear your style like you wear your smile.
So free. So fine. So right.
Be the new generation passing through the night.
If looks could sing,
the sounds would ring across the neon skies.
We're a new generation.
Living Pepsi style. Oh, we made our choice.
Make it a Pepsi. Looking Pepsi style.
We made a choice. Making it Pepsi.
Looking Pepsi style.
We made a choice. Making it Pepsi . . .

1599

Art Director	Alan Chalein, Bill Yamada, Janet Greenberg
Writer	Hal Friedman/Brian Sitts
Editor	Editors Gas
Director	Toni Ficalora/Geoffrey Mayo
Creative Director	Hal Friedman
Agency	Jim DeRusha, Linda Murray/JWT, New York, NY
Production Company	Tony Ficalora Prod.
Client	Ray Hood Philips, Burger King

1600

Art Director	Tony DeGregorio
Writer	Lee Garfinkel
Director	Steve Horn
Agency	Rachel Novak/Levine, Huntley, Schmidt & Beaver, New York, NY
Production Company	Steve Horn Productions
Client	Subaru of America

HERB/CROWDS INTRO
60-second
ANNC: At this time Burger King begins a nationwide search for one man.
His name is . . . Herb.
We don't know much about Herb.
Only what his friends tell us.
FRIENDS: Herb was unusual
Herb was different.
ANNC: Only what his parents tell us.
MOTHER: Herb was never what you call . . .
FATHER: Normal
ANNC: Only what his former teacher tells us.
TEACHER: There was only one word for Herb . . . slow
ANNC: This is the best picture of Herb we have
We do know Herb is . . .

FARMBOY
60-second
SON: Remember when you were my age Dad? C'mon, you understand what I mean, it's my first car.
DAD: It's your money son, but if you want my advice, buy another Subaru. It's been good to us.
SON: (ASSURINGLY) Sure, Dad.
SFX: (MUSIC SHIFTS FROM SOFT HOMESPUN MUSIC TO HARD ROCK N' ROLL)
DAD: I thought we agreed . . . you'd buy a Subaru.
SON: But Dad . . . I did.
ANNCR: The new Subaru XT Coupe. Inexpensive. And built to stay that way.
SUPER: SUBARU. INEXPENSIVE. AND BUILT TO STAY THAT WAY.

1601

Art Director	Kimball Howell
Writer	Kimball Howell
Editor	Michael Grasso
Director	Michael Grasso
Director of Photography	Michael Duff
Producer	Angie Gordon/Rob Battles
Production Company	Grasso Productions
Client	WABC-TV, New York, NY

1602

Art Director	Howie Cohen, Mike Bade
Writer	David Hale, Darlene Cah, Frank Nicolo
Editor	Editors Gas
Director	Joe Hanwright
Creative Director	Frank Nicolo
Agency	Tom McGrath, Dan Blackman/ JWT, New York, NY
Client	Jerry Schmutte, Miller Brewing Co.

YOU'LL LOVE IT
60-second
New York's hot on Channel 7
We got a way to make your summer shine
'Gonna start out right and let the good times roll
'Cause we were born to ride.
From the Hamptons
On to Harlem
Coney Island
Upper West Side
Jersey Shore towns
To Bear Mountain
'Cause we're all a part of New York
And Channel 7 leads the way . . .
We love New York!
You'll love it! . . .

BARNEVELD ONE
60-second
SUPER: Barneveld, Wisconsin. June 8, 1984.
MAN 1: After the twister, some people said this was the end of a small town.
But the people of Barneveld said, "Not *this* small town."
MAN 2: We could have packed what little was left and moved someplace else. Instead, we decided we weren't giving up. We were going on.
SONG: Where I come from folks work hand in hand
We pull together as one
A place where people have a sense of pride . . .
And Miller's the beer
Miller's made the American way
Born and brewed in the USA
Just as proud as the people who are drinking it today.

1603

Art Director	Paul Frahm, Michael Hart, Jim Patterson
Writer	Laurie Birnbaum, Frank Nicolo, Brian Sitts
Editor	Editors Gas
Director	Don Guy/Brian Cummins/Joe Hanwright
Creative Director	Frank Nicolo
Agency	Gary Bass, David Schneiderman, Michael LaGattuta/JWT, New York, NY
Client	Miller Brewing Co.

1604

Art Director	Dean Hanson
Writer	Phil Hanft
Editor	Marcus Stevens, Pytka Productions
Director	Joe Pytka, Pytka Productions
Agency	Judy Brink, Fallon McElligott, Minneapolis, MN
Production Company	Meg Matthews, Pytka Productions, Los Angeles, CA
Client	First Tennessee
Music	Herb Pilhofer

ANTHEM/NEW LABEL
60-second
SINGERS: Where I come from folks stand proud and tall
They'll look you right in the eye
A place where pride is worth a whole lot more
Than money can buy
Where people care about their family
Where laughter's sincere
Where your word is your word
A friend's a friend
And Miller's the beer
Miller's made the American way
Born and brewed in the USA
Just as proud as the people
Who are drinkin' it today
Miller's made the American way . . .

AMAZING GRACE
60-second
MUSIC: SAXOPHONE PLAYING OPENING TO ''AMAZING GRACE.''
VO: In Tennessee . . . there are as many ways to sing a song as there are people.
LYRIC: AMAZING GRACE HOW SWEET THE SOUND . . .
MUSIC: BLUEGRASS TRIO PICKS UP THE MELODY.
DOBRO PICKS UP THE MELODY FROM BLUEGRASS.
LYRIC: I WAS BLIND BUT NOW I SEE . . .
MUSIC: SQUEEKY RENDITION OF OPENING MELODY . . .
AMAZING GRACE
MUSIC: CLOSING REFRAIN
VO: Interestingly . . . with all this diversity, people here do agree on one thing. Their bank.
First Tennessee. An uncommon bank for uncommon people.

1605

Art Director	Richard Sabean
Writer	Michael Patti
Editor	Dennis Hayes
Director	Peter Smillie
Agency	Arnie Blum/Jerry Cammisa, BBDO, New York, NY
Producer	Bob Abel
Client	Chrysler/Dodge

1606

Art Director	Ron Anderson
Writer	Bert Gardner
Editor	Travor Lalonde
Director	Greg Hoey
Agency	Lisa Jarrard, Bozell, Jacobs, Kenyon & Eckhardt, Minneapolis, MN
Production Company	Dalton, Fenski & Friends
Client	Control Data Institute
Music Composer/Scorer	Dick Boyell

EXPRESSWAY
60-second
MUSIC
Expressway.....
MUSIC STARTS
SONG: Expressway to your heart,
Expressway to your heart.
Been trying to get to you for a long time.
You've been constantly on my mind.
Expressway to your heart.
The best way to your heart.
Expressway to your heart.
ANNC: For the sheer thrill of high performance driving. A fuel injected Dodge Daytona Turbo Z is guaranteed to make your heart race.
Dodge Daytona Turbo Z.
It'll be an Expressway to your heart.

ZOMBIES
60-second
VO: A mindless job can *drain* the life right out of you.
The minute you go to work, your brain goes dead.
But one thing *could* help give you a new lease on life.
A new Career. In a field that's vital, alive and growing. The field of computer programming.
In just 6½ months, Control Data Institute could teach you the skills you need to fill a rewarding future in computer programming.
So call Control Data Institute at 1-800-TRAIN ME.
It could bring you back to life.
If you call now, we'll send you a free career planning kit filled with information on financial aid, job placement, interviewing and more.
Call Control Data Institute.
Bring your futures to life.

1607

Art Director	Nancy Rice
Writer	Tom McElligott
Editor	Tony Fischer, James Productions, Minneapolis, MN
Agency	Judy Brink, Fallon McElligott, Minneapolis, MN
Client	Wall St. Journal

1608

Art Director	Tom Cordner, Buddy Cone
Director	Peter Smillie
Creative Director	Tom Cordner
Director of Photography	Jerry Hartleben
Agency	Chiat Day, Los Angeles, CA
Producer	Leslie Johnson
Production Company	Robert Abel & Associates, Hollywood, CA
Client	Yamaha-Big Wheel Motorcycle
Assistant Director	Marlon Staggs
Executive Producer	Sherry Seckel

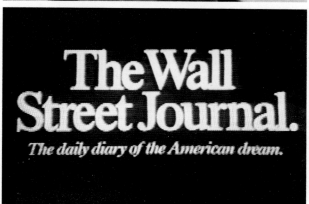

IMMIGRANTS
60-second
(MUSIC BEGINS AND BUILDS)
VO: For over 300 years they've been coming . . .
LYRICS: You are a deamer . . . until your dreams come true.
VO: And while most haven't brought riches, they have brought dreams . . .
LYRICS: Then you're a leader . . . and they are all looking up to you. You have the courage to see your dreams through.
The dreamer . . . the leader . . . they are one and the same in you.
VO: At *The Wall Street Journal,* we believe that the most precious resources a country can have . . . are the hopes of its people . . .
Because tomorrow's achievements grow out of today's dreams.
LYRICS: The dreamer, the leader, they are one and the same in you.
VO: *The Wall Street Journal* . . . the daily diary of the American dream.

CHASE-REV #2
60-second
MUSIC: FAST PACED.
ANNCR VO: The Yamaha Big Wheels come with extra-wide, extra-stable tires . . .
. . . and a low profile that makes them simple to ride. So it's fun and easy to get to places you might not go otherwise.
MOM: So what took you guys so long?
FATHER: (AS HE LOOKS AT DAUGHTER KNOWINGLY) Nothing.
ANNCR: The Yamaha Big Wheels. Perhaps they're the adventure you've been looking for.

1609

Art Director	Kurt Tausche/Tom Donovan
Writer	Bill Hillsman
Editor	Chris Clays
Director	Norman Griner
Agency	Judy Wittenberg, Bozell, Jacobs, Kenyon & Eckhardt, Minneapolis, MN
Production Company	Griner/Cuesta
Client	Northwestern Bell
Music Composer/Scorer	Rick Nowles

1610

Art Director	Bill Heatley
Writer	Dan Swanson
Editor	Morty Ashkinos
Director	Norman Griner
Director of Photography	Victor Hammer
Agency	Lynn Lyons, Ted Bates, New York, NY
Production Company	Barbara Gold, Griner/Cuesta & Associates
Client	United States Navy

EXECUTIVE
60-second
(SFX: MUSIC UP, AMBIENT NOISE, SHUFFLING PAPERS, ETC.)
WOMAN (TO HERSELF): Well . . . it's been a long and productive day. Oh listen Jerry, thanks an awful lot for the suggestion. We'll get back to this again next week, ok?
FEMALE VO ON PHONE INTERCOM: Mrs. Harrison, there's a phone call for you. It's your daughter.
WOMAN: I'll take it in my office, Pat.
SINGER VO: Drift away, drift away . . . How the time disappears . . .
Just the blink of an eye and the days turn into years . . .
SINGER VO: Drift away, drift away . . . How the time drifts away . . .
DAUGHTER VO ON PHONE: I need some advice again, Mom.
WOMAN (AD LIB UNDER): Don't pressure yourself so much, honey. You just have to try to relax and get through it.

FANTASIA
60-second
SYNTHESIZER MUSIC UP, DRIVING BEAT.
VO: Most jobs promise you the world. The navy delivers.
BILL: Outstanding!
DAN: Get a close-up, man!
BILL: Check it out. Original break dancing.
DAN: Let's go.
DAN: Yeah, Yeah.
BILL: Didn't they film Casablanca around here?
DAN VO: Nah . . . they never left the back lot of Hollywood.
BILL: Tork split between one alpha and one bravo.
DAN: That's a negative. All perimeters on normal, thanks to navy training.
BILL: I wonder what other guys do on their days off?
VO: Navy. It's not just a job, it's an adventure.

1611

Art Director Paul Regan and Robert Smiley
Writer David Greeley and Chris Lincoln
Director Fred Petermann
Agency Dennis Gray, Quinn & Johnson/
BBDO, Boston, MA
Client Honeywell

1612

Art Director Nelsena Burt
Writer Kevin O'Neill
Editor Barry Moross, Steve Silvia
Director David Grubin
Creative Director Kevin O'Neill
Director of Photography Fred Murphy
Agency Bob Smith, Kathi Calef/LGFE,
New York, NY
Producer Susan Fleisher
Client IBM Corp.

AMERICA WORKS BEST—REVISED
60-second
VO: America works best when it works together.
If you can build a whole country that way, you can do just about anything. Working together . . .
Honeywell uses this principle for computers, communications, and controls.
Right now, we're working with thousands of customers like Harley-Davidson, finding ways to increase productivity.
For DAs in Los Angeles, a Honeywell system is making sure justice is swift.
At the SeaFirst Building in Seattle, Honeywell systems control climate, communications and lights.
With NASA, we've developed on-board Honeywell systems to bring the shuttle home safely.
Honeywell. Together, we can find the answers.

BACK TO SCHOOL/HAMNER
60-second
CLAUDIA TRIPLETT: This man is crazy . . .
CRAIG GRAMMER: . . . vivacious . . .
KIM LATHAM: . . . he'll tell you . . . exactly what he feels . . .
HAMNER WILLIAMS: I want that item . . . not need . . . I want that item. Now you . . .
ANNCR VO: This is Hamner Williams, teaching business at Hampton University as part of IBM's Faculty Loan Program. He joined the faculty for a year, while IBM continued to pay his salary.
CLAUDIA TRIPLETT: He really makes you look at things the way they're gonna be.
WILLIAM LAWSON: There's no snow jobs with Ham. Either you know the answer or you don't.
ANNCR VO: Hamner Williams is one of over 600 IBM employees who have participated in the Faculty Loan Program since 1971 . . .

1613

Art Director	Joe DeMare
Designer	Joe DeMare
Animator	Shadow Light Productions
Writer	Mike Rogers
Editor	Bob Smalheiser/Paul Douglas/First Edition
Director	Mike Berkofsky
Director of Photography	Simon Ransley
Agency	Ellen Epstein/Doyle Dane Bernbach, New York, NY
Production Company	Jackie Barrett, Berkofsky Barrett
Client	Brown & Williamson, Inc.

1614

Art Director	Robert McDonald
Designer	Robert McDonald
Writer	David Cantor
Editor	Alan Rozek, LFR Editorial
Director	Ed Bianchi
Agency	Wende Sasse/Needham Harper Worldwide, New York, NY
Production Company	Bianchi Films
Client	Advertising Council

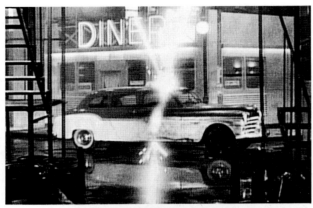

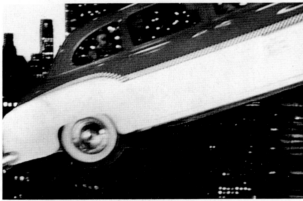

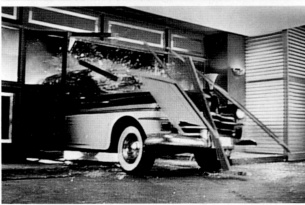

CINDERELLA
60-second
NO SCRIPT

GAUNTLET
60-second
CARLOS: Bye mom, bye dad!
MOM: Carlos, donde vas? Carlos donde vas?
CARLOS: To the Movies.
DAD: To the movies, with who?
MOM: You haven't had breakfast. Sit down.
ANNCER: You try to protect your children.
But once they walk out the door . . . they're on their own.
(MUSIC BEGINS)
GIRL: Want some reefer? It'll make you feel good.
MOM: Carlos, just say no.
CARLOS: No.
ANNCER: Talk to your kids about offers of drugs. Help them to just say no.

1615

Art Director Rick McQuiston
Writer Jim Riswold
Editor Red Car
Agency Wieden & Kennedy, Portland, OR
Producer Steve Horn
Client Honda Scooters

1616

Art Director Shelly Schachter
Writer Kurt Willinger
Editor Jay Gold
Director Bob Giraldi
Agency Bill Gross/Saatchi & Saatchi
Compton Inc., New York, NY
Assistant Producer Chuck Ryant
Production Company Giraldi Productions, New York, NY
Client Paine Webber
Cameraman Rick Waite
Music Sicurella/Smythe

DON'T SETTLE FOR WALKING
60-second
INSTRUMENTAL OF LOU REED'S "WALK ON THE WILD SIDE."
MUSIC BUILDS TO SAXAPHONE SOLO.
LOU REED VO: Hey, don't settle for walkin'.

CUT OUT
60-second
REFEREE: Time, gentlemen.
JIMMY CONNORS: I'm Jimmy Connors, and it's about time you met my partner, my financial side.
VO: All successful companies and people have a financial side.
JIMMY CONNORS: Let's go partner.
VO: It comes with success. But success in the financial world doesn't happen automatically. And sooner or later you'll find you need some help.
JIMMY CONNORS: We need some help.
VO: You need PaineWebber behind you.
With capital management teams expert in corporate, government, or individual financial matters, together, leveraging our strength in the marketplace with a dedication to the most creative financial solutions possible . . .

1617

Art Director	Mark Yustein/Ron Travisano
Writer	Jim Weller
Editor	Bob Smalheiser
Director	Ron Travisano
Director of Photography	Michael Butler
Agency	Peter Yahr, Della Femina, Travisano & Partners, New York, NY
Client	David LaFountaine, WCBS-TV

1618

Art Director	Robert McDonald
Designer	Robert McDonald
Writer	David Cantor
Editor	Alan Rozek/LFR Editorial
Director	Ed Bianchi
Agency	Wende Sasse/Needham Harper Worldwide, New York, NY
Production Company	Bianchi Films
Client	Advertising Council

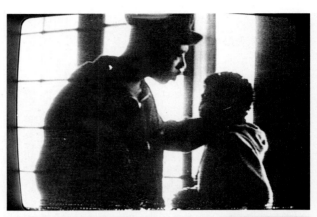

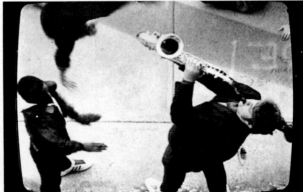

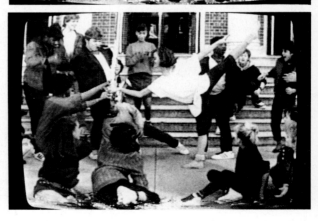

SONG
60-second
We're spreading the news
what's happening today
come on and be a part of it
New York, New York
You gotta keep up
in a city that never sleeps
from the New Jersey shore
to Manhattan streets
Because to make it here
takes more than anywhere
we're Channel 2
New York, New York

SCHOOLYARD
60-second
NO SCRIPT

1619

Art Director Mike Moser
Writer Brian O'Neill
Director Mike Cuesta
Agency Richard O'Neill—Chiat/Day
Advertising, San Francisco, CA
Client Worlds of Wonder

1620

Art Director Joe Genova
Writer James Parry
Director Rick Levine
Agency Sandy Bachom, Posey & Quest,
Greenwich, CT
Client Southern New England Telephone
Company

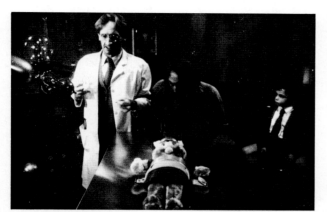

COMES TO LIFE W/OUT WOW
60-second
HUNCH: Follow me, sir.
BOY: Hi, Dad!
PROF: Ah, my son!
Now we are ready.
It's bound to work this time.
PROF: I've failed again.
HUNCH: Awww.
How about these, master? . . .

RADIO TELESCOPE
60-second
MAMMOTH MT. OBSERVATORY 23:06 HOURS
MAN: What are we on tonight?
Alpha Centauri?
MAN: Yeah, but nothing interesting.
Same old random blips.
MAN: Who was the first man to catch no hitters in both major
leagues, huh?
WOMAN: It's your move.
MAN: You know, that's a . . . hey, hey, wait a minute . . .
MAN: . . . we're getting something . . .
MAN: . . . we're forming—a circle.
What the heck is this? . . .
VO: Everything begins with communications. Are your
communications ready for everything?

1621

Art Director	W. Peter Koehler
Writer	W. Peter Koehler
Editor	Don Packer
Director	Bruce Van Dusen
Agency	Corey E. Klein, Koehler Iversen, Inc., New York, NY
Production Company	David Frankel, Van Dusen Films
Client	W. A. Tatum/Health Insurance Plan of Greater New York

1622

Art Director	Gary Johnston
Writer	Laurie Brandalise
Director	Steve Horn
Agency	Elaine Hinton, Chiat/Day, Los Angeles, CA
Production Company	Steve Horn, Inc.
Client	Apple Computer, Inc.

POLICEMAN
60-second
(MUSIC UNDER)
JAMES BARKEY: Some people say we're fighting a losing battle out there. Well, for my money, the ones doing the talking are the real losers.
ANNCR VO: James Barkey is a first class policeman. But first, he's a human being.
JAMES: They've lost sight of the good people . . . the good things happening all around them. Even worse, talk is all they do. They're not acting on any of the very real problems we're facing.
(SFX: FIRE ENGINES)
ANNCR VO: Just as all of us rely on people like James Barkey to assure our well-being, 900,000 New Yorkers have come to rely on the Health Insurance Plan of Greater New York for high-quality health care care at truly affordable, predictable cost . . .

ASTRONAUT
60-second
MUSIC: UNDER THROUGHOUT.
ANNCR VO: This morning, Gregory Helm made a career decision. He decided to be an astronaut.
His first giant step: Learning to use an Apple.
There are more Apple II's teaching more subjects in more schools than any other computer. Everything from alphabet lessons for pre-school to science programs for graduate school.
So whatever Gregory wants to be, an Apple Personal Computer can help him be it.
As of this afternoon,
that's a zoologist.
The Apple II.
There's no telling how far it can take you.

1623

Art Director	Marcia Christ
Writer	James Cohen
Director	Patrick Russell
Creative Director	Malcolm End
Agency	John Massey/Roberta Falk Pedersen, Ogilvy & Mather, New York, NY
Client	Hardee's

1624

Art Director	Howie Cohen/Paul Frahm/Tad Dewree
Writer	Laurie Birnbaum
Creative Director	Frank Nicolo
Agency	Don Brown/JWT, New York, NY
Production Company	Michael Daniel Prod.
Client	Jim Godsman, Emery

NEWSBOY
60-second
(MUSIC UNDER)
MAN SINGS: In the first hours of morning,
long before the night is through,
he wipes the sleep out of his eyes
'cause he's got a job to do.
CHORUS: As his day begins, our day's beginning at Hardees.
(MUSIC)
Our biscuits rise with the morning sun,
we cook 'em fresh for everyone. At
Hardees' . . . Where good people go for
good food.
Because we're proud of who we are,
we serve our best from near and far.
At Hardee's. Where good people go for good food.

ANTHEM
60-second
SINGERS: Send the art to Boston
Get the part to Corning
Has to be there
Tomorrow morning
Haven't got a moment left to spare
Gotta send a letter out this evening
Gonna get it in for a 10 A.M. meeting
Call Emery and it's as good as there!
Emery's on the case
So you don't have to worry
We go anyplace
And get it to you in a hurry.
Emery's everywhere

1625

Art Director	Russ Tate
Writer	John DeCerchio
Agency	Sheldon Cohn, W. B. Doner & Company, Southfield, MI
Client	Highland Appliance

1626

Art Director	David Purser
Writer	Barry Chudakov
Editor	Richard Unruh
Director	Bill Irish
Creative Director	George Anketell & Bill Durnan
Agency	Nansi Thomas, MacLaren Advertising, Toronto, Canada
Production Company	Nancy Lee, Partners
Client	Imperial Oil Limited

RICKY DEE
60-second
MC: Once again, Rickey Dee.
RICKY DEE: Thank you. Thank you.
(LIPSYNCING TO RECORD) Baby it's such a gas and with a guy like me with such class . . . (SFX: RECORD SKIPPING) . . . class . . . class
RICKY DEE: Uh . . . excuse me . . .
RICKY DEE: (BACKSTAGE) Eddie, Eddie what happened?
ASSISTANT: It just broke.
BOSS: (CHARGING IN) Hey big shot, you better get that thing fixed or you're through!
BARTENDER: Ricky, you got the record player at Highland right? They got their own service department right in the store.
VO: Only Highland has its own expert service department right in the store. So if you ever have a problem, Highland can fix it fast.

NOBODY KNOWS
60-second
SFX: TRUMPET OF LOUIS ARMSTRONG PLAYING "NOBODY KNOWS THE TROUBLE I'VE SEEN." NATURAL SFX UNDER.
VO: 22 million people a year bring us some big troubles . . . and lots of little ones.
After all,
that's what we're here for.
(LOUIS ARMSTRONG SINGS) Nobody knows the trouble I've seen
Nobody knows my sorrow
Nobody knows the trouble I've seen
Glory Hallelujah
CUSTOMER: Thank you.
MECHANIC: No trouble.

1627

Art Director	Marvin Lefkowitz
Writer	Robert Elgort
Editor	Bobby Smalheiser
Director	Mike Berkofsky
Agency	Tom McGrath/Bozell, Jacobs, Kenyon & Eckhardt, Inc., New York, NY
Production Company	Berkofsky/Barrett
Client	The Seagram Wine Company

1628

Art Director	John Short
Designer	Linda Burton
Writer	Alan Mond
Editor	Morty Perlstein
Director	Joseph Hanwright
Agency	Lee Zimmerman/Bozell, Jacobs, Kenyon & Eckhardt, Inc., New York, NY
Production Company	Janette Mercer, Barbara Mickelson, KIRA Films
Client	Chrysler Corporation

TASTE THE MUSIC
60-second
(MUSIC)
ANNCR VO: From the moment you open it, you know this is no ordinary wine.
(MUSIC)
At Taylor California Cellars, we don't just pick fine varietal grapes. We orchestrate them.
(MUSIC)
Taylor California Cellars is a better wine. But don't take our word for it. Taste the music.

THE PRIDE IS BACK
60-second
VERSE: They say you can't keep a good man down
Sooner or later he'll come back around
Risin' up on his own two feet
Might have been down
But he can't be beat.
CHORUS: The Pride is Back
Born in America
The best is born in America. Again.
AVO: The Pride is Back.
With Plymouth Front-wheel drive Voyager
Reliant K
Turismo Duster
5/50 Protection Plan.*
Plymouth. The Pride is Back.

1629

Art Director Paul Regan and Robert Smiley
Writer David Greeley and Chris Lincoln
Director Fred Petermann
Agency Dennis Gray, Quinn & Johnson/
BBDO, Boston, MA
Client Honeywell

1630

Art Director Candy Greathouse
Writer John Lyons
Editor Billy Williams
Director Ed Bianchi
Agency Karen Spector/D'Arcy Masius
Benton & Bowles, New York, NY
Production Company Jill Henry, Bianchi Films
Client Procter & Gamble—Bounce
Casting Director Karen Goldberg

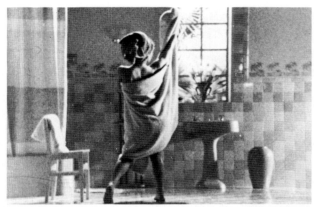

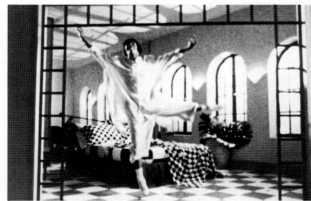

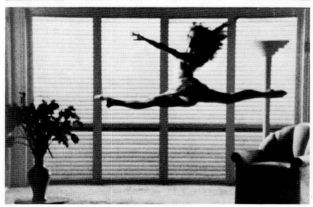

LAW ENFORCEMENT
60-second
ATTORNEY 1: As I stated before this proves that the accused and his accomplices . . .
ATTORNEY 2: Objection.
JUDGE: Sustained.
ATTORNEY 1: do show . . .
ANNCR: In Los Angeles, Honeywell is working with the district attorney's office.
ANNCR: Where a special Honeywell System is helping the right people.
Helping them get to the right place at the right time to get evidence before it's covered up. The Honeywell System then speeds the DA's into court.
ANNCR: Honeywell, together we can find the answers.

JUMP/FP
45-second
SFX: MUSIC THROUGHOUT
WOMAN'S VOICE (SONG): When towels feel this soft jumping
Sheets feel this fresh. Jump.
And there's no cling to most anything. ·
Jump. Jump.
Jump. Jump. You've got
Bounce clothes.
Clothes you can't wait to jump into. Jump.
Feel the touch. Jumping.
You are the one. You feel so good around.
You could use this or even this
but Bounce is the softener more people use . . .
Bounce.
For clothes you can't wait to jump into.

1631

Art Director Thom Higgins
Writer John Doig
Editor Jay Gold
Director Thom Higgins
Agency Ed Kleban, Ogilvy & Mather, New York, NY
Production Company Chris Meltesen, Joan Laxer B.F.C.S.
Client Hershey New Trail

1632

Art Director Marten Tonnis/Steve Beaumont
Writer Steve Rabosky/Penny Kapousouz
Director Brent Thomas
Agency Richard O'Neill, Chiat/Day, Los Angeles, CA
Production Company Avery Film Group
Client Apple Computer, Inc.

ROCK 'N ROLL
60-second
ANNCR: You've just had your first taste of a New Trail Chocolate Chip Granola Bar. How do you feel?
BOY #1: You knock me out, right off my feet.
ANNCR: What about you?
GIRL: My secret dreams have all come true.
ANNCR: And you?
BOY #2: It's the greatest, ooh, ooh, ooh, ooh.
ANNCR: What do you think of all those Hershey chocolate chips?
BOY #3: Well, it's a natural fact, I like it like that.
ANNCR: And you?
BOY #4: Ba, ba, ba, etc . . .
ANNCR: Is it big enough for you?
BOY #5: That's all I need and I'll be satisfied . . .

UNDERSTOOD
60-second
MUSIC: UNDER THROUGHOUT.
ANNCR VO: The things people go through, making their presentations more presentable . . . making their memos more memorable . . . making their conclusions more convincing . . . making themselves understood.
That's one reason we invented
The Macintosh Office.
To help people do what they spend most of their time doing: communicating.
By turning ideas that look like this . . . into ideas that look like this.

1645

Art Director Steve Beaumont
Writer Penny Kapousouz/Brent Bouchez
Editor Gayle Grant
Director Mark Coppos
Agency Morty Baran, Chiat/Day, Los Angeles, CA
Production Company Coppos Films
Client Porsche Cars North America

1646

Art Director Nick Gisonde
Writer Jeane Bice
Agency Marc Mayhew/Backer & Spielvogel, New York, NY
Client Miller Brewing Co./Lite Beer

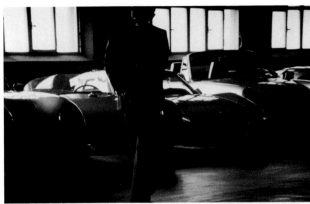

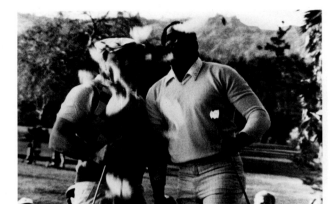

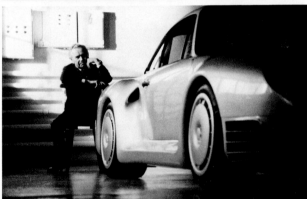

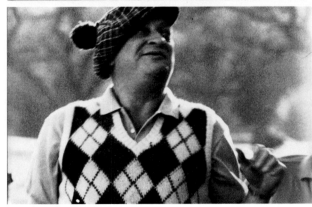

MUSEUM: A GOOD BEGINNING
60-second
MUSIC: UNDER THROUGHOUT.
ANNCR: Long before a Porsche was called a Porsche, we believed any car that merely got you from here to there, just didn't go far enough.
That belief,
a little imagination and a lot of hard work led us to build cars that set new speed records . . .
set new design standards . . . set new expectations of what a car ought to be.
All of which Professor Porsche considers . . .
a good beginning.

ALUMNI GOLF
60-second
MADDEN: We're here at the 18th hole of this Lite Beer Open. And we've seen some real unusual shots today.
TOMMY: You said it.
SFX: BIRDIE SOUNDS.
BUTKUS: Hey Bubba, I think you got a Birdie.
CROWD: Aaaah! Ooooh!
BERT: L.C. how am I supposed to hit it through this tree?
L.C.: No problem Bert.
CROWD: Ooooh!
MICKEY: How's Uecker going to get out of this?
LEE: Oooh Mickey.
BEN: This calls for another Lite Beer from Miller.
RED: Make it two.
BUCH: Three . . .

1647

Art Director	Rich Johnson
Writer	Patty Michaels
Editor	Chris Claeys
Creative Director	Gerry Miller
Agency	Bob Koslow—Leo Burnett Co., Inc., Chicago, IL
Client	Roy Bergold/McDonald's

1648

Art Director	Mary Morant
Writer	Eileen Sandler
Editor	Alan Rozak
Director	Richard Loncrain
Director of Photography	Harvey Harrison
Agency	Jack Harrower/LGFE, New York, NY
Production Company	D. G. & H. Garrett
Client	IBM-PC

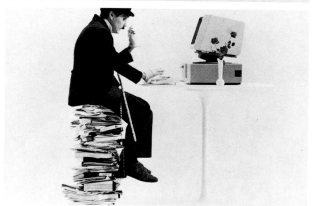

GREAT YEAR JUNIOR
30-second
SINGER: (GREAT YEAR!)
It was a good, great year
Best year yet.
Together we all got thru
Learning new trades, makin' the grades
Like only we could do
Acting so weird
Reachin' so high
Hittin' the books
With Big Mac, fries;
SINGER: It's a good time for the great taste
Of McDonald's

HIGH PERFORMANCE
60-second
MUSIC THROUGHOUT
VO: The business person who deals with higher volumes of
information . . . needs answers fast.
And just when you think you've found the solution . . .
more work piles up.
So you run back and forth and back again, searching high and low
for a way to get on top of things.
That's why IBM created the Personal Computer AT.
With the power to push high performance even higher
With the AT fast becomes faster.
The capacity to handle data becomes greater.
The IBM Personal Computer AT. For the power of Advanced
Technology.
See it at a store near you . . . or call your IBM representative.

1649

Art Director Jim Kingsley
Designer Jim Kingsley/Richard Herstek
Writer Richard Herstek
Editor Dennis Hayes
Director William Livingston
Director of Photography William Livingston
Agency Needham Harper Worldwide, Inc., McLean, VA
Producer Ron Stanford
Client Army National Guard

1650

Art Director Foster Hurley
Writer Foster Hurley
Editor Bob Kirsner
Director Fred Petermann
Creative Director Hy Yablonka
Director of Photography Fred Petermann
Agency Joe Rein/Kenyon & Eckhardt, Los Angeles, CA
Production Company Petermann/Dektor
Client Chrysler California

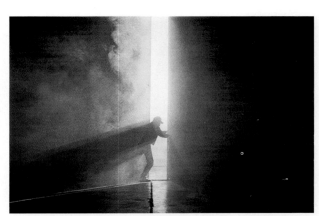

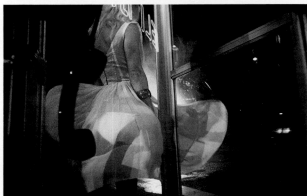

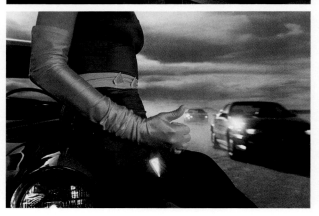

ADVENTURE TRAINING
60-second
(MUSIC THROUGHOUT)
SOLDIER: Get ready.
ANNCR: When we move, we move fast. When we hit, we hit with Irresistible Force.
Adventure Training in the Army National Guard.

CAR CHASE
60-second
MUSIC: (UP, THEN UNDER) Down the coast, Highway one, race the wind, chase the sun, We've got wheels—born to run, California just for fun!
ANNCR VO: This message was brought to you by those dull-but-dependable producers of predictability . . . the Chrysler Corporation.
MAN #1 (OC): Chrysler?
MAN #2 (OC): Naaaaaaaah.
MAN #1 (OC): Wasn't that?
Man #2 (OC): Naaaaaaah.

1651

Art Director Jean Marcellino
Writer John Schmidt
Editor Frank Cioffredi
Director Werner Hlincka
Creative Director Kevin O'Neill
Agency Ann O'Keefe—LGFE, New York, NY
Production Company HTH Productions
Client IBM Corp.

1652

Art Director Arthur Vibert
Writer Lisa Kleckner
Editor Jim Mudra aka Yamus/Optimus Editorial
Director Barry Myers
Director of Photography John Alcott
Agency Bill Clarkson/Ogilvy & Mather, Chicago, IL
Production Company Spots Films, Inc.
Client Brown & Williamson Tobacco Corp.

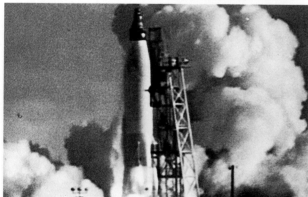

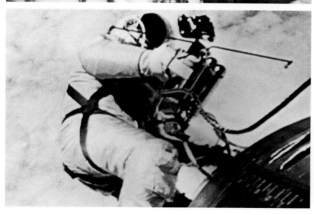

SPACE
2-minute
SFX: MUSIC—"TWINKLE, TWINKLE LITTLE STAR" PLAYED WITH ONE FINGER ON A PIANO AND FADES.
JFK: Space is there and the moon and the planets are there. And new hopes for knowledge and peace are there, and therefore as we set sail, we ask God's blessing on the most hazardous, and dangerous, and greatest adventure on which man has ever embarked . . .
ANNCR: From the early unmanned missions to the space shuttle, IBM people and IBM computers have played an important part in every space flight. And even after 25 years . . . and more than a trillion miles . . . the adventure has just begun.
MUSIC UP.

TELEPHONE
60-second
NO SCRIPT

1653

Art Director Jack Eleftheriou
Writer Jeffrey Mullen
Editor David Dee of Even Time Editorial
Director Graham Henman
Director of Photography Mike Karbelnickoff
Agency Nick Ciarlante, Cindy Lee/SSC&B
Lintas, New York, NY
Production Company Tom Mickel, HKM Productions
Client Coca-Cola USA/diet Coke

1654

Art Director Bob Fudge
Writer Monte Mathews
Editor Walter Bergman of Bergman Film
Associates
Director Leslie Dektor
Director of Photography Amir Hamed
Agency Stan Noble/SSC&B Lintas, New
York, NY
Production Company Faith Dektor, Petermann Dektor
Client Coca-Cola USA/TAB

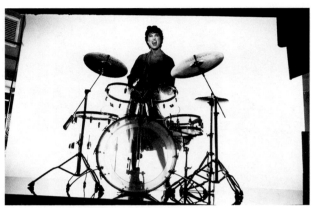

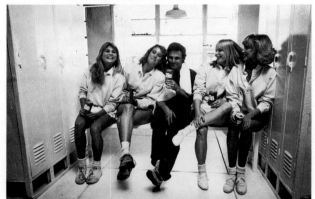

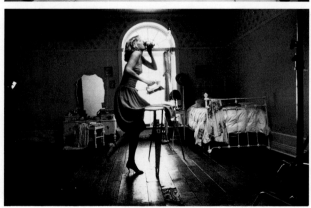

JUST FOR THE FUN OF IT/DEVO/BERRY
60-second
SINGERS: Just for the fun of it
Just for the one of it
Just for the taste of it
diet Coke
Just for the style of it
Just for the swing of it
The real cola taste of it
diet Coke
Just for the joy of it
Just for the smile
Just for the taste of it
Just for the one of it
Just for the fun of it
diet Coke

SASS DRUMMER
60-second
SINGERS: Oooh you're gonna love it
SINGERS: Oooh you're gonna love it
SINGERS: TAB's got sass
Oooh you're gonna love it
A sassy crisp taste you've been thirstin' for
TAB's got sass!
Can't get enough of it
So refreshin' there's no denyin'
TAB's outrageously satisfyin'
It's an icy and crisp sensation
A celebration! Yeah!
TAB's great taste comes shining through
TAB'll bring out the sass in you!
TAB after TAB

1655

Art Director | Jim Weller
Writer | Jim Weller
Editor | Jacques Dury
Director | Haskell Wexler
Agency | Shannon Silverman, Della Femina, Travisano & Partners of California, Inc., Los Angeles, CA
Production Company | Lisa Rich, Harmony Pictures
Client | Carl's Jr. Restaurants

1656

Art Director | Frank Kirk
Writer | Jim Weller
Editor | Jacques Dury
Director | Bob Giraldi
Agency | Shannon Silverman, Della Femina, Travisano & Partners of California, Inc., Los Angeles, CA
Production Company | Patti Greaney, Giraldi/Suarez Prods.
Client | Transamerica Corp.

THEMATIC
60-second
CARL: We opened our first Carl's some 40 years ago. We sold hamburgers for a quarter, and Cokes for a nickel. But a smile was free.
ANNCR: 40 years ago, a man named Carl Karcher started out making hamburgers the old-fashioned way.
CARL: We put in a charcoal broiler and we had charcoal broiled hamburgers. The first day our sales were 14 dollars and 75 cents.
ANNCR: A lot has changed since Carl Karcher opened his first Carl's Jr. But today, a Carl's Jr. hamburger is still made the old-fashioned way.
100% beef. Charbroiled one hamburger at a time. A good honest meal at a good honest price.
ANNCR: Because you'll still find old-fashioned American values at Carl's Jr.

IT'S TIME
60-second
MAN #1: John P. Armistead? It's time.
JOHN: But what about my family?
MAN #3: You're providing for that.
JOHN: Well, Transamerica Life Insurance.
But it can't replace me.
MAN #1: You know that humungous mortgage on your house? With Transamerica Life, it can be paid.
JOHN: It's paid???
MAN #2: And your son's college?
JOHN: It's paid???
ALL MEN: It's time, John.
JOHN: Okay. Okay, I'm ready to go.
MAN #1: No, not *that* time—your premium is due.
ANNCR: Transamerica Life Insurance. The power of the pyramid is working for you.

1657

Art Director	Antonette Portis
Writer	David Bishop
Editor	Stuart Waks
Director	Mark Rasmussen
Agency	Shannon Silverman, Della Femina, Travisano & Partners of California, Inc., Los Angeles, CA
Production Company	Dennis Connors, Riverrun Films
Client	Six Flags Magic Mountain

ROCK VIDEO
60-second
DRIVER: So, what do you wanna do?
PASSENGER: I don't know. What do you wanna do?
MUSIC: ROCK MUSIC BEGINS
ANNCR: Hey!
MR. HAND: When you're looking for excitement . . .
When you're lookin' for fun . . .
Then get out to Magic Mountain, and get some!
Ride!
Eat!
Meet!
Dance!
At Magic Mountain . . .

1660
Silver Award

Art Director	Bob Barrie
Writer	John Stingley
Editor	Steve Shepard, Wilson-Griak, Minneapolis, MN
Director	Lee Lacy
Agency	Judy Brink, Fallon McElligott, Minneapolis, MN
Production Company	Barry Munchick, N. Lee Lacy Assoc. Ltd, New York, NY
Client	Prince Foods Canning Division

NUN/RESTAURANT/CANE

10-second

ANNCR: In Italy, no two people have quite the same taste. When Prince makes authentic Italian spaghetti sauce, we keep that in mind.

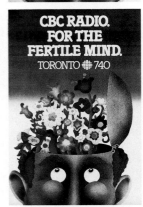

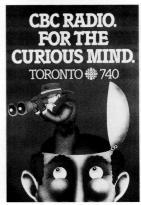

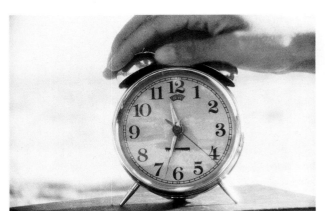

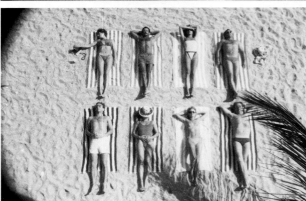

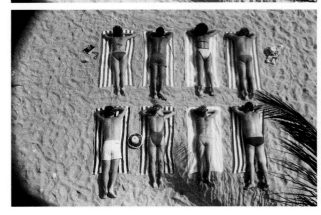

FERTILE MIND X3
15-second
MUSIC: FANFARE
SFX: CREAKING
SFX: RUSTLING FOLIAGE, BIRDS, A BEE AND POPPING.
SFX: CREAK, THUD.
SUPERS; CBC RADIO.
FOR THE FERTILE MIND.

ALARM CLOCK REV/SUNRISE
10-second
SFX: WAVES, CLOCK TICKING THEN RINGING
VO: The only people watching the clock
at Club Med are the people watching their
tan. The Club Med Summer is happening
right now. See your travel agent or
call us.

1663

Art Director	April Greiman
Designer	April Greiman
Agency	April Greiman Incorporated, Los Angeles, CA
Client	Doug Tompkins/Esprit de Corp.
Production Assistant	Claire Dishman

1664

Art Director	Dave Martin
Designer	Dave Martin
Writer	Jeff Linder
Editor	Ray Chung
Director	Pat Kelly
Agency	Paula Santa-Donato/Doyle Dane Bernbach, New York, NY
Production Company	Sandra Waggoner, Kelly Pictures
Client	Miles Labs

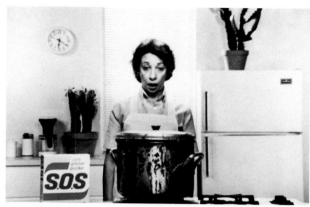

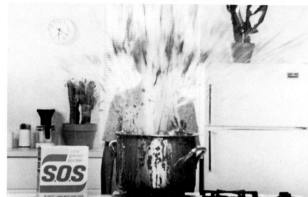

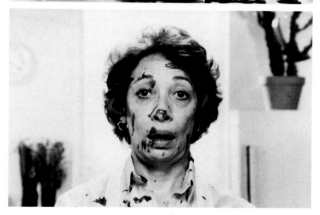

LEAPING UP/LEG KICKS/ESPRIT #6
10-second
No script

PRESSURE COOKER/SMOKED HAM/STICKEY SANDWICH
15-second
ANNCR VO: When your pots and pans . . .
. . . get a little messy, remember, for just pennies a pad ., . .
. . . nothing cuts splattered-on messes better than a super grease-cutting S.O.S. pad.
S.O.S. It cleans your big jobs . . .
. . . for small change.

1665

Art Director	Georgia Macris/Steve Hunter
Writer	Steve Hunter
Editor	Barry Geier
Director	Larry Robins
Director of Photography	Frost Wilkinson
Agency	Steve Hunter/Moss & Company, New York, NY
Production Company	Richmond Holt, Robins Productions, New York, NY
Client	Brooklyn Union Gas

1666

Art Director	Steve Rzymski
Artist	John Gamache
Animator	Mike Beck
Writer	Steve Rzymski
Editor	Tin Can Alley
Agency	Jason Grant Associates, Providence, RI
Production Company	QTB Productions
Client	Rhode Island Chevy Dealers

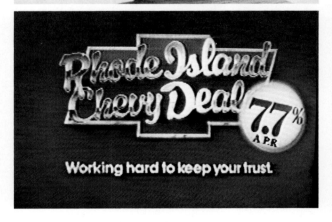

GRANDFATHER/MADONNA/BAKERS
10-second
SFX: MUSIC
GRANDFATHER: (OC) Smile for the camera.
INFANTS: (OC) BAWL
GRANDFATHER: (OC) LAUGHTER
ANNCR VO: Clean gas heat from Brooklyn Union Gas for the way you live.
SFX: CAMERA SHUTTER IN SYNC WITH FLASH
SFX: MUSIC OUT

REAL CAR/STRETCH YOUR DOLLARS/OLD FAITHFUL
10-second
VO: With 7.7% financing, you can afford to buy a real car. 7.7% financing. At your Rhode Island Chevy Dealers.

1667

Art Director	Tom Roberts
Writer	Walter Wanger
Editor	Tom Schatchte
Director	Ron Dexter
Director of Photography	Ron Dexter
Agency	Jackye Horn, Ogilvy & Mather, Los Angeles, CA
Production Company	DXTRS
Client	U. S. Forest Service

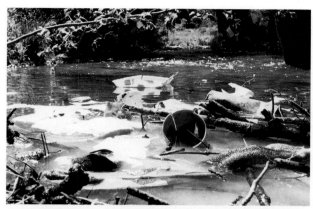

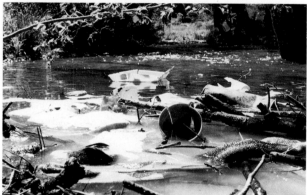

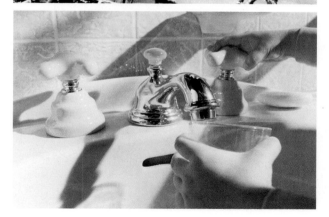

FAUCET/PICNIC/DEER
10-second
SFX: RUSHING WATER, BIRDS CHIRPING
ANNCR VO: Litter in our streams and rivers.
ANNCR VO: Where will it end?
SFX: DISSOLVE TO WATER FILLING GLASS.

Gold Award

Art Director Pat Burnham
Writer Bill Miller
Editor Tony Fischer, James Productions,
Minneapolis, MN
Director Mark Story, Pfeifer-Story
Agency Judy Brink, Fallon McElligott,
Minneapolis, MN
Production Company Nick Wollner, Pfeifer-Story, Los
Angeles, CA
Client KRON-TV, San Francisco, CA

PEABODY AWARD/SATELLITE UPLINK/COMPUTER NEWSROOM
30-second
ANNCR VO: We got a helicopter. They got a helicopter.
We got a seismograph. They got a seismograph.
We got cameras. They got cameras.
We got typewriters. They got typewriters.
We got trucks. They got trucks.
We got a pencil sharpener. They got a pencil sharpener.
We got reporters. They got reporters.
We got a Peabody Award for broadcast journalism.
(THUMP)
They don't.
In this keep up with the other guys world of television news . . .
. . . it's important to remember who the other guys are trying to keep
up with.
NewsCenter 4. At 5, 6 and 11.

1669

Gold Award

Art Director	Gerald Andelin
Writer	Hal Riney
Editor	Jacques Dury
Director	Joe Pytka
Agency	Deborah Martin/Hal Riney & Partners, Inc., San Francisco, CA
Production Company	Pytka
Client	E. & J. Gallo Winery

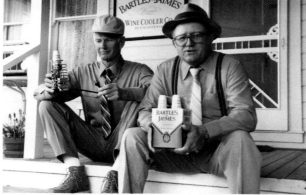

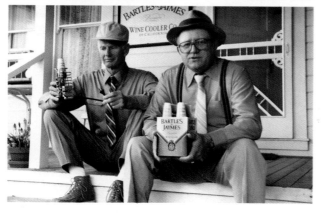

NAME/COLD BOTTLE/AGENCY
30-second
FRANK: We want to thank you for all the name suggestions for our new wine cooler. There were some really clever ones.
But we decided just to call it 'The Bartles and Jaymes Wine Cooler' because my last name is Bartles, and Ed's is Jaymes.
If you don't like the name, please don't tell us, because we have already printed up our labels.
Anyway, you could always just call it Bartles and skip the Jaymes all together.
Ed says that is okay with him.
Thanks for your continued support.

Distinctive Merit

Art Director	Ross Van Dusen, David Bigman
Writer	Dave Fields, David Woodside
Editor	Midtown Post
Director	Jim Johnston
Agency	Richard O'Neill, Frank Scherma, Chiat/Day, LA & SF, CA
Production Company	Rhonda Raulston, Johnston Films, New York, NY
Client	California Coolers

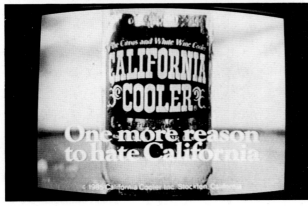

MATT/STEVE/JACK
30-second
MATT: I hate California. You know what I'm saying?
It's like . . . Have a nice day—Surf's up. Ahaa, Aha.
I mean, their idea of culture is yogurt.
Formal dinner party means you wear socks.
Blondes everywhere—Pink tofu—Excuse me!
Soy burgers—I really hate it.
I even hate what they drink.
BARTENDER: What do ya have buddy?
MATT: (POINTS TO CALIFORNIA COOLER) One of those.
Palm trees, excuse me—what ever happened to real trees?

1673

Art Director	Mike Ciranni
Writer	Jamie Seltzer
Editor	Morty Ashkinos
Director	Henry Sandbank
Agency	Frank Scherma/Chiat/Day inc. New York, NY
Production Company	Jon Kamen, Sandbank Films Inc.
Client	Topps Chewing Gum

1674

Art Director	Jack Mariucci
Designer	Jack Mariucci
Artist	Artwork created by Doyle Dane Bernbach
Writer	Barry Greenspon
Editor	The Editors
Director	Henry Sandbank
Agency	Joe Scibetta, Mary Ellen Perezolla /Doyle Dane Bernbach, New York, NY
Production Company	Jon Kamen, Henry Sandbank Studio
Client	Michelin Tire Corp.

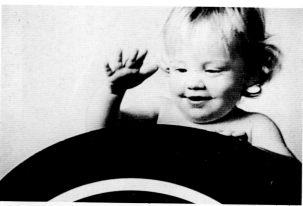

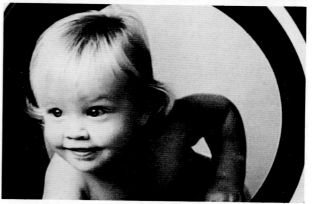

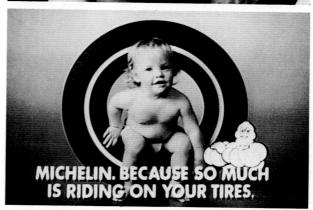

WIMP/TOUGH GUY
30-second
SFX: CAR STARTING BUT NOT TURNING OVER.
SFX: CAR STARTING BUT NOT TURNING OVER.
SFX: CAR NOT TURNING OVER.
SFX: CAR TURNS OVER.
VO: It's harder to get started . . .
SFX: CAR IS HUMMING.
VO: . . . but once it gets going, it never stops.
VO: Bazooka Bubble Gum. If you're tough enough to chew the hard stuff.

AMY/TWINS/BABIES
30-second
WIFE: Honey?
HUSBAND: Hmmm.
WIFE: You have Michelin tires in your car, don't you?
HUSBAND: Yeah.
WIFE: How come?
HUSBAND: I don't know. They're terrific tires. Why?
WIFE: How come I don't have Michelins in my car?
HUSBAND: Oh sweetheart, they cost more. I drive to work, I go out of town a lot.
All you use your car for is shopping
driving Amy around . . . I'll get you a set tomorrow.
WIFE: You sure you want to spend the extra money on us?
HUSBAND: Come on.
ANNCR VO: Michelin. Because so much is riding on your tires.

Curity's fabric is not only soft . . . It's sturdy.
And these vinyl soles really don't skid . . .
And triple-stitched elastic really keeps a guy's pants up.
VO: We put extra detail into everything we make.
Which is why the best reasons for Curity Sleepers and Bedding are little ones.
ED: In these, I could sleep like a baby.

on this kind of talent. And that would be a tragedy.
CARTER: To be or not to be. That is the question.

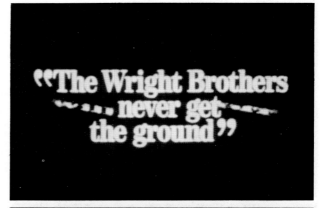

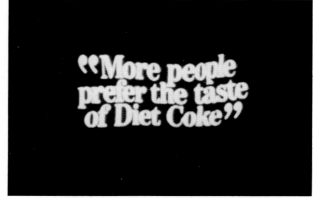

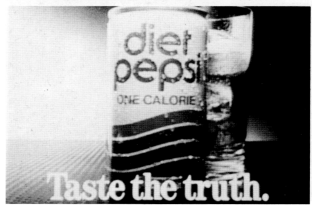

FORWARD PASS/SLIDER/FERRARO
30-second
MONTANA: Hey, Marino!
MARINO: great game, man.
MONTANA: Oh, thanks.
MARINO: That draw play in the second quarter . . . great choice.
VO: You make a choice because it feels right.
MONTANA: Can I buy you one?
MARINO: It's the least you can do.
VO: Diet Pepsi. 100 percent NutraSweet . . .
MONTANA: Here you go . . . Don't drop it!
VO: 100 percent taste.
MONTANA: See you, Dan.
MARINO: Joe, next year I'm buying.
SUPER & VO: DIET PEPSI. THE ONE-CALORIE CHOICE OF A NEW
GENERATION.

TRUTH I/TRUTH II
30-second
ANNCR: All too often man has made claims that haven't stood the
test of time.
ANNCR: Like this,
ANNCR: and this . . .
ANNCR: and this claim from Diet Coke because the truth is now
there's one diet cola that diet Coke can't beat.
ANNCR: It's Diet Pepsi.
ANNCR: You see Diet Pepsi has more real cola taste than Diet Coke.
So try it and taste the truth.

1697

Art Director	Gary Goldstein
Writer	Marvin Waldman
Editor	Jerry Bender
Director	Henry Holtzman
Creative Director	Vince Daddiego
Director of Photography	Max Modray
Agency	Rosanne Horn/Young & Rubicam, New York, NY
Production Company	David Johnson, N. Lee Lacy/Assoc.
Client	New York Telephone

1698

Art Director	James Good
Writer	John Gruen
Editor	Dennis Hayes
Director	Bob Giraldi
Agency	Stuart Rickey, Ogilvy & Mather Inc., New York, NY
Producer	Patti Greaney
Client	Sports Illustrated Magazine

THE FEEL BETTER CALL/COFFEE CUP/TOE NAIL
30-second
ANNCR VO: New York Telephone presents the feel better call.
MAN: No! I wouldn't have called. I did *not* say that last night. You . . .
(CONTINUES UNDER)
ANNCR VO: Sometimes all it takes is a simple phone call to smooth out the rough times
MAN: . . . Why are we fighting? . . .
ANNCR VO: And with New York Telephone's low Regional Calling Area rates, peace talks don't cost much at all.
MAN: Okay, I apologize. Now you apologize . . .
ANNCR VO: So call and make up. You'll feel better.
MUSIC TAG: I can't live without you . . .

RELIEF PITCHER/PASS
30-second
SCHAEFER: Yeah, he's ready.
QUIZ VO: How does it feel when the phone rings and it's for me? Who's batting? Who'm I facing?
Nervous.
Want that nervous edge.
WATHAN: C'mon, Quiz. Go get 'em!
QUIZ VO: Keep cool. Keep cool.
(MUSIC)
QUIZ: I can't trust what I've got in the bull pen.
(SFX: CROWD CHEERS)
PA ANNCR: Number 29, Dan Quisenberry.
(MUSIC)
QUIZ VO: Here goes nothing.
ANNCR VO: Sports Illustrated. Get the feeling.

1699

Art Director	Mario Giua
Designer	Mario Giua
Writer	Robin Raj
Editor	Rye Dahlman
Director	Rick Levine
Agency	Frank Scherma/Chiat/Day inc., New York, NY
Production Company	Karrie King, Rick Levine Productions
Client	Miller Brewing Co.

1700

Art Director	Don Easdon
Writer	Bill Heater
Editor	Hank Corwin
Director	Joe Pytka
Agency	Mary Ellen Argentieri/HHCC, Boston, MA
Production Company	Joe Pytka, Pytka Productions
Client	John Hancock Mutual Life Insurance Co.

ICE/BARREL/BUCKET
30-second
(MUSIC UNDER)
SFX: COLD WIND; SLUSHING THRU SNOW.
(SUPER: "PEAQUKEE LAKE, WISCONSIN, 1858")
VO: In the days of Frederic Miller's Plank Road Brewery, beermakers hoped for long winters . . .
Lots of ice was needed, to keep the fresh draft, fresh . . .
It's hard to find beer like that today. Because most bottled and canned beers are cooked to preserve them.
SFX: TAPPING KEG.
VO: Well, now there's a beer cold-filtered, instead of cooked, for that same fresh draft taste.
Plank Road.
Keg beer, in a bottle . . .

BUYING A HOUSE/FOOTBALL/BROTHERS
30-second
LAWYER: There's a lot of paperwork here. There's always paperwork when you buy a house. First one says that you lose the house if you don't make your payments. You probably don't want to think about that but . . . you do have to sign it.
Next says the property is insured for the amount of the note. And you sign that in the lower left corner.
This pretty much says that nobody's got a gun to your head . . . that you're entering this agreement freely.
Next is the house is free of termites. Last one says that the house will be your primary residence and that you won't be relying on rental income to make the payments.
I hope you brought your checkbook. This is the fun part. I say that all the time though most people don't think so.
(CHUCKLE)

1701

Art Director Leslie Caldwell
Writer Mike Koelker
Editor Bob Carr
Director Leslie Dektor
Director of Photography Leslie Dektor
Agency Steve Neely/FCB
Production Company Faith Dektor, Petermann/Dektor, Los Angeles, CA
Client Levi's 501 Jeans

1702

Art Director Bill Smith
Writer Ray Thiem
Agency Enid Katz/Young & Rubicam Chicago, IL
Client General Cigar Company/Garcia y Vega Cigars

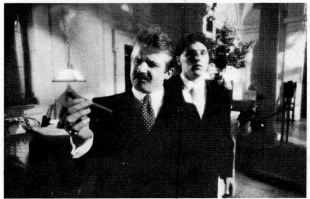

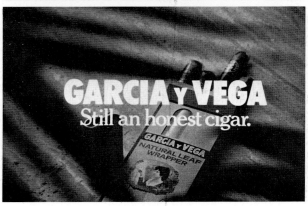

BLUESMEN/SUBWAY VISIONS/OOH BOP
30-second
MAN 1: My, My, My said the Button Fly
MAN 2: What you say
MAN 1: Have you heard the news?
MAN 2: Na, tell me about it
MAN 1: I've got the Blues
MAN 2: Aw, deliver
MAN 1: The Levi's 501 Blues
MAN 2: They shrink to fit
MAN 1: That's it, and they're right to size
MAN 2: Do tell
MAN 1: I personalize Levi's 501 Blues
MAN 2: Lucky fly
MAN 1: Ain't I
MAN 2: My, My

HOTEL LOBBY-REV. #1/SURVEILLANCE II
30-second
1ST COP: (WHISPERS) Psst. Here he comes now.
2ND COP: See anything serious?
1ST COP: I don't know. He just keeps *staring* at his cigar. Like there's something ''different'' about it.
2ND COP: Bet it's the wrapper.
1ST COP: Huh?
2ND COP: Most cigars don'g use natural leaf wrappers anymore. Now Garcia y Vega still gives you the rich tobacco taste of natural leaf wrappers.
1ST COP: He's *still* starin' at it.
2ND COP: Hey, Jimmy. Go on over and give him an honest cigar.
ANNCR: Garcia y Vega. Still an honest cigar.
1ST COP: He's doin' it again.

1703

Art Director	Alex Jesudowich and Teddy Borsen
Writer	Bob Feinberg, Marsha Saffian
Editor	Billy Williams
Director	Patrick Russell
Director of Photography	Jeff Kimball
Agency	Dan Kohn, Bozell, Jacobs, Kenyon & Eckhardt Inc., New York, NY
Client	The Lee Company
Music	Mark Blatte and Rich Look

1704

Art Director	Lester Feldman
Writer	Nicole Cranberg
Editor	Jeff Kahn/Pelco
Director	John Pytka
Director of Photography	John Pytka
Agency	Mardi Kleppel/Doyle Dane Bernbach, New York, NY
Client	General Telephone Directories Co.

SENSATION (FEMALE)/SENSATION (MALE)
30-second
SINGERS: Such a sensation
in her blue jeans.
A temptation if
you know what
I mean, making
me crazy 'till
I'm just about
gone. Is it
what she's
got goin'?
Or what
she's got
on?
Lee . . .

BATHTUB, YOUR TOWN, FOREST/SKYWRITING
30-second
If you should ever need new flooring . . .
new carpeting . . .
a new paint job . . .
new furniture . . .
a new stereo system, or just
about anything else . . .
you can always find it
in the GTE Yellow Pages.
the most accurate, most complete
listing of business around.
The official GTE Yellow Pages.
For life's little ups & downs.

1705

Art Director	Stan Jones
Writer	Steve Diamant
Creative Director	Bob Kuperman
Agency	Vicki Blucher/Doyle Dane Bernbach, Los Angeles, CA
Client	Western Airlines
Account Executive	Candy Deemer, Janine Perkal

1706

Writer	Peter M. DeLorenzo, Paul E. Stawski
Director	Fred Petermann/Tim Newman/and Neil Tardio
Agency	Jere Chamberlin/D'Arcy Masius Benton & Bowles, Bloomfield Hills, MI
Production Company	Petermann-Dektor/Jenkins, Covington, Newman, Rath and Neil Tardio Productions
Client	Pontiac Division

TROUT/BULL; EAGLE/WAVE; WHALE/GHOST TOWN
30-second
TROUT:
SFX: MURMUR OF STREAM, OTHER NATURAL OUTDOOR SOUNDS.
SFX: FRENZIED SPLASHING AS TROUT HITS HOOK AND JUMPS.
SUPER: Western's Canada.
SFX: BULLFIGHT CROWD BACKGROUND NOISES.
SFX: BULLFIGHT CROWD ROARING ''OLE!''
SUPER: Western's Mexico
SUPER: Great fares to Great Places.
Western Airlines
Call your travel agent or
1-800-THE WEST

STILL YOUNG/THE TICKET/DAD'S APPROVAL
30-second
SINGER: Pontiac!
SON: . . . so what do you think about this Sunbird, mom?
MOM: . . . it's *so red!*
SON: Yeah . . . and it's got front wheel drive.
MOM: But it's so sporty. . . ?
SON: Oh c'mon mom, you're still young!
MOM: Well . . . c'mon, let's see what else they have . . .
SON: Hey, that's my mom!
SON: Oh wow, you got the Sunbird!
MOM: What do you think?
SON: I think it's *you,* mom.
MOM: You really think so?
SON: Well . . . actually—it's more *me!*
SINGER: We build excitement . . . Pontiac!

1711

Art Director	Donna Weinheim/George Cinfo
Writer	Arthur Bijur/Cliff Freeman
Director	Larry Osborne
Agency	John Lacey, Susan Scherl/DFS, Inc., New York, NY
Production Company	KCMP Productions
Client	Wendy's International

1712

Art Director	Rob Dalton
Writer	Jarl Olsen
Editor	Dale Cooper, James Productions, Minneapolis, MN
Director	Norman Seeff
Agency	Judy Brink, Fallon McElligott, Minneapolis, MN
Production Company	Richard Marlis Productions, Los Angeles, CA
Client	Emmis Broadcasting

ONLY WENDY'S-SANDWICH TOAST/OMELET TOAST/SANDWICH BISCUIT

30-second
SINGER: Only Wendy's
ANNCR: Only Wendy's has a breakfast sandwich prepared fresh
SINGER: Only Wendy's
ANNCR: with a fried egg, cheese and your choice of bacon of sausage.
SINGER: Only Wendy's and Wendy's alone has
ANNCR: A breakfast sandwich on white or wheat toast too. So if you want a breakfast prepared fresh you know where to go.
SINGER: Only Wendy's.

REX REED (MAGIC 106)/TINY TIM/FEAR

30-second
REX: Listening to more than one hour of this kind of programming is only slightly less horrifying than sitting through the collected films of Cheech & Chong.
VO: Who doesn't have something nice to say about Magic 106.
REX: But I can think of one more nice thing to say about Magic 106. We don't get it in New York.

1713

Art Director	Mario Giua
Writer	Robin Raj
Editor	Morty Ashkinos
Director	Henry Sandbank
Creative Director	Gary Goldsmith
Agency	Frank Scherma/Chiat/Day inc., New York, NY
Production Company	Greg Carlesimo, Sandbank Films
Client	NYNEX Information Resources

1714

Art Director	Jerry Roach
Writer	Marvin Waldman
Editor	Jerry Bender
Director	Henry Holtzman
Director of Photography	R. Taylor
Agency	Chris Jones/Young & Rubicam, New York, NY
Producer	N. Lee Lacy
Client	Southland Corporation—7-11

KID'S SEAT/BEDROOM/ROCKING CHAIR
30-second
DAD: Sally, who took the Yellow Pages?
SAL: I dunno.
DAD: (PASSES) Honey, have you seen the Yellow Pages?
MOM: No.
DAD: (PASSES) Susie, where are the Yellow Pages?
SUE: Sally had it last.
SAL: I did not.
DAD: (PASSES) C'mon. I need the Yellow Pages . . .
VO: Over the years, one book has been in more homes, helping people throughout New England find more goods and services. The NYNEX Yellow Pages . . .
SUE: Mom!
VO: It's always there when you need it.

COFFEE BEAN/MILK/ONE POTATO
30-second
ANNCR VO: When you're in a hurry,,
MAN: (UNDER) Be right back . . .
ANNCR VO: does the rest of the world slow down?
MAN: Three coffees to go, please.
(MUSIC)
VO: Could I have three . . .
(MUSIC) Three coffees to go.
MAN 2: One coffee bean;
VO: two coffee bean . . .
STORE CLERK: Hi!
ANNCR VO: But at 7-Eleven, you get your coffee fast.
(UNDER) MEN: Bye.
(UNDER) STORE CLERK: Bye.
ANNCR VO: No one keeps you revvin' like 7-Eleven.

1715

Art Director Greg Clancey, Tom McConnaughy
Writer Cathy Powless, Ron Hawkins
Director John Pytka, Henry Sandbank
Creative Director Ron Hawkins, Tom McConnaughy
Agency Kim Lowell, Ginny Washburn/
Ogilvy & Mather, Chicago, IL
Production Company Pytka Films/Sandbank Films
Client Waste Management, Inc.

1716

Art Director Bryan McPeak, Russ Tate
Writer Jim Gorman, Craig Piechura
Agency Larry August, W. D. Doner &
Company, Southfield, MI
Client Hickory Farms

DAY AND NIGHT 1985 REVISED/SNOW/BUENOS AIRES
30-second
WALT: Hello, Fred.
FRED: Mornin', Walt.
VO: There ought to be something useful we can do . . .
FRED: Better hurry, Henry.
VO: . . . with all this garbage.
HENRY: I got it, I got it!
VO: Well, beginning this year, in Tampa, Florida, Waste
Management will be taking the city's trash and turning
it into . . . electricity.
HENRY: Take it easy, fellas.
VO: Now ask yourself . . .
FRED: See you tomorrow, Henry.
VO: . . . isn't that better than just throwing it all away? Waste
Management. Helping the world dispose of its problems.

CHEESE/BLUEBERRIES/CANDY
30-second
ANNCR: In a small dairy here, they make some of the best cheddar
cheese anywhere. Of course, nobody knew that except the folks who
live here, until . . .
HICKORY FARMS REP: Hi. I'm from Hickory Farms. I hear you
make some pretty good cheese.
ANNCR: Hickory Farms has been to a lot of places to collect unique
things for our Christmas gift packs.
CHEESEMAKER: Hey Walt . . . think we're going to be famous?
ANNCR: Uncle Walt's Cheddar and other gifts from Hickory
Farms . . . We've done your Christmas shopping for you.

1717

Art Director	Dick Gage
Writer	Ron Lawner
Editor	Barry Moross
Director	Ron Dektor
Director of Photography	Amir Hamed
Agency	Bob Shriber, HBM/Creamer, Boston, MA
Production Company	Petermann/Dektor
Client	Marshalls

1718

Art Director	Tom Stasinis
Writer	Bill McDonald, Chuck Blore, Don Richman
Director	Chuck Blore
Director of Photography	Jim Gillie
Agency	Vince Manze/Chuck Blore & Don Richman, Inc., Burbank, CA
Client	KNBC Channel 4, Los Angeles, CA

VACATION COUPLE/ROOMMATES/I LOVE TO SHOP
30-second
HE: I'm home.
SHE: We're away from home.
HE: We're going to buy this place.
SHE: I'm going to unpack.
HE: I'm going to quit my job!
SHE: How are we going to live?
HE: We'll live off the land.
SHE: It's sand!
HE: We'll live off the sand.
SHE: Here, then you're going to need this
HE: MMM . . . Some day.
ANNCR VO: In a world where the best things in life often come with an equally impressive price tag
There is Marshalls. Brand names for less.

DONAHUE-COMMITMENT/INVOLVED/HONEYMOON
30-second
MARI: Freddy and I broke up.
CHRISTINA: Oh, no. Why?
MARI: Well, would you make a commitment to someone who didn't watch DONAHUE every day?
CHRISTINA: No.
MARI: Well, neither would he.
VO: DONAHUE's more than a show. It's a relationship. At 3 on 4.

1719

Art Director	Mike Malatak
Writer	Don Heagy
Editor	Larry Bridges/Bob Furem
Creative Director	Bob Welke
Agency	Michael Birch—Leo Burnett Co., Inc., Chicago, IL
Client	Angelo Pagano/Hewlett-Packard

1720

Art Director	Darrell Lomas/Mark Forer
Writer	Jim Kruse/Loren Markus
Editor	Ace & Edie
Director	Dick James/Fred Petermann
Agency	Dixie Thompson, Cunningham & Walsh, Fountain Valley, CA
Producer	Bill Curran/Sally Kraus
Client	Mitsubishi Motor Sales of America

SHOWER/BUSY SIGNAL/DESERT
30-second
SFX: SHOWER.
VO: An idea can happen anytime.
And when you work for Hewlett-Packard,
you don't just sell business computing systems,
you solve problems.
So when you have an idea,
you do something
about it.
You never stop asking "what if . . ."
GUY: Dan? Mike.
Listen, y'know that electronic mail project for the bank?
What if . . . (FADE UNDER) we used HP Message in a custom
software package so they can exchange budgeting information . . .

LIFEGUARD/GERMAN/SOAK IT UP
30-second
LIFEGUARD: Lady, you can't park here.
SUZIE: No? There's plenty of room.
LIFEGUARD: Well, parking's just over there.
LIFEGUARD: Wow, what kind of car is this?
SUZIE: A Misubishi Mirage.
LIFEGUARD: Mitsubishi Mirage . . .
SUZIE: Wanna see it go?
LIFEGUARD: Yeah!
LIFEGUARD: What made you think you could park of the beach
anyway?
SUZIE: Do you know a better way . . .
SUZIE: . . . to meet a lifeguard?
SINGER: Mitsubishi . . .
ANNCR VO: '86 Mirage . . . Economy and fun . . .

1721

Art Director Chuck Mumah
Writer Robin Goodfellow
Editor Tom Schachte, Decoupage
Director Bill Hudson
Agency Earl McNulty, Tucker Wayne & Company, Atlanta, GA
Production Company Bill Hudson Films Inc.
Client Taylor Lynn/Kathy Seabolt, Southern Bell

1722

Art Director Marcus Kemp/Joe Sedelmaier
Writer Jim Copacino/Joe Sedelmaier
Editor Peggy Delay/Henry Hoda
Director Joe Sedelmaier
Director of Photography Joe Sedelmaier
Agency Cindy Henderson/Livingston & Company, Seattle, WA
Production Company Marsie Wallach, Sedelmaier Productions
Client Alaska Airlines

Southern Bell

ALREADY IN TOUCH WITH THE FUTURE.

LAKE/SURPRISE/COLLEGE
30-second
MIKE VO: Boy, I sure wish it was still summer.
MOM VO: Why dear? Don't you like school?
MIKE VO: Oh sure, but I miss the lake.
MOM VO: Oh! And Kathy too, I'll bet.
MIKE VO: Yeah!
MOM VO: Well then, why don't you call her. We're what, 60-70 miles away. It doesn't cost much.
GIRLS: Kathy! Kathy! It's Mike! Mike is on the phone!
ANNCR VO: Southern Bell Long Distance.
ANNCR VO: It costs so little and means so much.
KATHY: Hello? Mike?
MUSICAL ACCENT.

CUTTING CORNERS/CONFERENCE ROOM/WINTER
30-second
ANNCR: These days a lot of airlines are cutting corners on their meals.
MAN 1: This little beauty we'll have to call "Banquet on a Bun", right Bob?
MAN 1: Set it down, Bob. Now with this you can serve a whole planeload for just pennies.
MAN 3: I like it.
MAN 1: Plastic parsley—you can use it over and over again . . .
MAN 3: I like it.
MAN 1: Pygmie chickens, you can get an order of 105 in an ordinary shoe box.
MAN 3: I like it.
ANNCR: At Alaska Airlines, we spend a little more on our meals . . .
. . . And you can taste the difference.

1723

Art Director Mark Ashley & John Boone
Writer Ken Lewis
Director Dean Lindberg (Bajus Jones)
Agency J. Walter Thompson, Atlanta, GA
Production Company Bajus Jones
Client The Weather Channel
Creative Group Head Grant Swain

1724

Art Director Mickey Tender
Writer Hugh Wells
Director Neil Tardio
Agency Barbara Ruland/NW Ayer Inc., New York, NY
Production Company David Schermerhorn, Neil Tardio Productions
Client AT&T Consumer Products

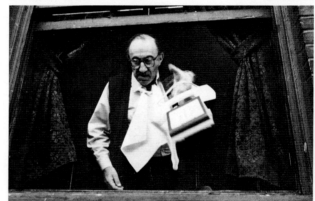

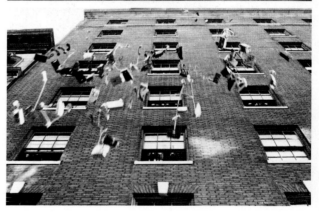

NOAH/EVOLUTION
30-second
ANNCR: In the beginning,
SFX: TRUMPET. THEN LOW RUMBLE OF DISTANT STAMPEDE, IT GETS CLOSER AND CLOSER.
ANNCR: . . . only a select few could get the weather forecast . . . when they need it.
ANNCR: But now anyone can, anytime they want. With the Weather Channel.
SFX: THUNDER AND RAIN
ANNCR: Up-to-the-minute local forecasts eight times an hour. 24 hours a day . . . *everyday.* And only on cable.
So you won't have to miss the boat ever again.
The Weather Channel. Weather of a higher order.

SECOND CLASS PHONES/COMPLAINT LINE/AMERICA DISCOVERS
30-second
(MUSIC UNDER THROUGHOUT)
SINGER: Second class Phones,
They're making . . .
WOMAN: Hello? Hey, hello?
SINGER: Second class phones.
SINGER: Phones you can't hear through
SFX: GARBLED SPEECH.
SINGER: Phones with no tone.
SFX: BICYCLE WHEEL.
ANNCR VO: Lots of people with telephone *not* made by AT&T are reporting some kind of complaint . . .
SFX: BOING, BOING
ANNCR VO: . . . When was the last time you had a complaint with an AT&T phone? . . .

1725

Art Director	Alan Chalfin, Frank Perry, Janet Greenberg
Writer	Hal Friedman, Brian Sitts
Editor	Editor's Gas
Director	Steve Horn/Elbert Budin
Creative Director	Hal Friedman
Agency	Gary Bass, David Schneiderman, Linda Murray/JWT, New York, NY
Production Company	Steve Horn, Ampersand
Client	Don Dempsey, Burger King

1726

Art Director	Don Fields and Marion Johnson, The Bloom Companies, Inc., Dallas TX
Writer	Richard Schiera and Heidi Beckerman
Director	Norm Griner
Agency	Randy Shreve/The Bloom Agency, New York, NY
Production Company	Griner/Questa
Client	Anheuser-Busch Beverage Group, Inc.

BAB ALZADO/WEITZ/THREE STOOGES
30-second
EXECUTIVE: All of us here at Burger King are happy to tell you that we have just changed the Whopper.
ALZADO: Growl.
EXECUTIVE: We're confident this meets with your approval.
ALZADO: Growl.
EXECUTIVE: The new Whopper has more beef than Big Mac or Wendy's Single and beat them both for best taste.
ALZADO: Hmmmm.
EXECUTIVE: Come on. Try it.
ANNCR VO: The new Whopper. More beef than Big Mac or Wendy's Single and winner for best taste.
ALZADO: Might I have another?

PANTY HOSE/SPRUCE GOOSE
30-second
SING: I put on my makeup
Painted my toes
I put on my pumps
And my sexy new clothes
Put on a few pounds
But nobody knows
Thanks to Control Top
Panty Hose!
You've got every reason
To celebrate
With Baybry's Champagne Cooler
Every reason to celebrate
Real champagne only cooler
Every reason to celebrate . . .

And when you buy one o' these books—
all the proceeds go to relieve the
famine in Africa. So please buy a book
and save a life. Thank you.

1727

Art Director Christie Kelley
Writer Jeanne Shorter
Editor Rich Carroll/Optimus
Director Michael McNamara/Filmfair

1728

Art Director Richard Mahan/Phil Guthrie
Writer Phil Guthrie/Richard Mahan
Agency Michael Berkman/Backer &
Spielvogel, New York, NY

1731

Art Director Gary Yoshida
Designer Gary Yoshida, Bob Coburn
Writer Bob Coburn
Editor Jerry Weldon
Director Dick James
Creative Director Larry Postaer
Agency Needham Harper Worldwide, Inc.,
Los Angeles, CA
Client A. J. Bayless Markets, Inc.

1732

Art Director Bob Fudge
Writer Monte Mathews
Editor Walter Bergman of Bergman Film
Associates
Director Leslie Dektor
Director of Photography Amir Hamed
Agency Stan Noble/SSC&B Lintas, New
York, NY
Production Company Faith Dektor, Petermann Dektor
Client Coca-Cola USA/TAB

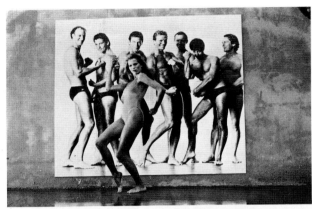

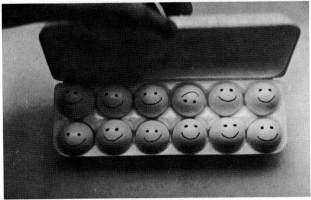

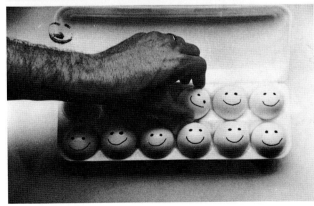

EGGS/MAYO/FAST CHECKOUT
30-second
VO: Hello.
VO: Why are these eggs smiling? Why because they're Bayless eggs,
of course. Which means they are all very good eggs.
VO: But what makes these good fellows especially happy this week is
they are on sale.
VO: That's right, our eggs are cheaper by the dozen.
VO: There are also 274 other happy items on sale at Bayless. And
that should bring a smile to your face. Have a nice day.
VO: The new Bayless. We even carry your bags.

SASS INTRO/DRUMMER/DANCER
30-second
SINGERS: Oooh you're gonna love it
Oooh you're gonna love it
TAB's got sass (sass)
Oooh you're gonna love it
A sassy crisp taste
you've been thirstin' for
TAB's got sass
Can't get enough of it
That refreshing and satisfying taste
TAB's not too sweet
TAB's got sass
Oooh you're gonna love it
A sassy crisp taste
Oooh TAB's got it

1734
Silver Award

Art Director	Harvey Hoffenberg/Olavi Hakkinen/Bruce Dundore
Writer	Ted Sann/David Johnson/Barry Udoff
Editor	Steve Schreiber/Dennis Hayes
Director	Joe Pytka/Tony Scott
Agency	Gene Lofaro/Arnie Blum/Nancy Perez—BBDO, New York, NY
Production Company	Pytka Pro./Fairbanks Films
Client	Pepsi-Cola Company

ROBOTS/SHUTTLE/ARCHAEOLOGY
60-second
SFX: CRICKETS CHIRPING, WIND BLOWING, CAR APPROACHING.
SFX: FUTURISTIC MUSIC, MOVING MACHINERY PARTS.
SFX: DOG BARKING.
SFX: CRACKLING ELECTRICITY.
SFX: RADIO MUSIC AND VOICE OF DJ, LAUGHTER.
SFX: RADIO MUSIC
VO: In the showdown between the colas,
VO: there's only one deciding factor . . . great taste.
VO: Pepsi, the choice of a new generation.
ROBOT: Ha, Ha!
SUPER: PEPSI: THE CHOICE OF A NEW GENERATION.

1735
Distinctive Merit

Art Director Joe Puhy
Writer Cary Lemkowitz
Editor Howie Weisbrot
Director Howard Guard
Director of Photography H. Johnson
Agency Joe Puhy/Young & Rubicam, New York, NY
Production Company Iris Films
Client Lincoln Mercury—Sable

GET READY/WANNA DANCE/SO BEAUTIFUL
60-second
MUSIC AND LYRICS UNDER
ANNCR VO: On December 26, the kind of car
you're ready for will be ready
for you.
Mercury is bringing a sophisticated
new shape to the American road.
Introducing . . . Sable.
MUSIC AND LYRICS
ANNCR VO: The shape you want to be in.
MUSIC AND LYRICS OUT

1736

Art Director Robert Lenz/Howard Smith
Writer Robert Meury/Ben Evans
Agency Marc Mayhew/Backer & Spielvogel, New York, NY
Client Miller Brewing Company/Lite Beer

1737

Art Director Tony DeGregorio
Writer Lee Garfinkel
Editor Bobby Smalheiser
Director Steve Horn
Producer Bob Nelson
Production Company Linda Horn, Steve Horn, Inc., New York, NY
Client Subaru of America

CAVALRY AND INDIANS/DUELING
60-second
DRAMATIC STOCK MUSIC THROUGHOUT
CAPTAIN: Whoa . . . Whoa . . .
CAPTAIN: Looks like we got company, Sergeant. Hold your fire men, hold your fire.
SERGEANT: Aln't no braver man alive.
INDIAN CHIEF: Taste great!
CAPTAIN: Less filling.
CHIEF: Taste great!
CAPTAIN: Less filling.
INDIAN CHIEF SPEAKS AN INDIAN LANGUAGE.
CAPTAIN: Mount 'em up!
ANNCR VO: No one knows how long the argument has raged, but one thing is for certain, Lite Beer from Miller will go down in history as the world's greatest lite beer.

YOU ALWAYS HURT THE ONE YOU LOVE/COUNTRY DOCTOR
60-second
MUSIC: YOU ALWAYS HURT THE ONE YOU LOVE.
ANNCR: People have a love-hate relationship with their cars. They love them, but they don't always treat them right.
Yet, with all the abuse they get, over 90% of all Subaru's registered since 1974 are still on the road.
Now imagine how much longer they would last if people didn't "love" them so much.
SUPER: SUBARU. INEXPENSIVE. AND BUILT TO STAY THAT WAY.

1742

Art Director	Ron Anderson
Writer	Bert Gardner
Editor	Post Time, Inc.—Travor LaLonde
Director	Greg Hoey
Agency	Lisa Jarrard, Bozell, Jacobs, Kenyon & Eckhardt, Minneapolis, MN
Production Company	Dalton Fenske & Friends
Client	Control Data Institute
Music Composer/Scorer	Dick Boyell

1743

Art Director	Joe DeMare
Designer	Joe DeMare
Animator	Shadow Light Productions
Writer	Mike Rogers
Editor	Bob Smalheiser/Paul Douglas—First Edition
Director	Mike Berkofsky
Director of Photography	Simon Ransley
Agency	Ellen Epstein/Doyle Dane Bernbach, New York, NY
Production Company	Jackie Barrett, Berkofsky Barrett
Client	Brown & Williamson Inc.

ZOMBIES/MUSIC/COMPUTER DRIVE
60-second
VO: A mindless job can *drain* the life right out of you.
The minute you go to work, your brain goes dead.
But one thing *could* help give you a new lease on life.
A new Career. In a field that's vital, alive and growing. The field of computer programming.
In just 6½ months, Control Data Institute could teach you the skills you need to find a rewarding future in computer programming.
So call Control Data Institute at 1-800-TRAIN ME.
It could bring you back to life.
If you call now, we'll send you a free career planning kit filled with information on financial aid, job placement, interviewing and more.
Call Control Data Institute.
Bring your future to life.

CINDERELLA
2-minute
NO SCRIPT

1744

Art Director Waldemar Kalinowski
Director Mick Haggerty
Director of Photography Peter McKay
Production Company Lyn Healy, N. Lee Lacy/Assoc.,
Los Angeles, CA
Client Jeffrey Gold—A & M Records

1745

Art Director Cindy Sowder
Editor David Hogan
Director David Hogan
Director of Photography Stephen Ramsey
Production Company Joni Sighvatsson, Greenbriar
Prod., Los Angeles, CA

STING FORTRESS AROUND YOUR HEART

VO MAN: Well . . . There it is
MAN: (BUT) He wouldn't take the money.
WOMAN: Of course not.
SMALL MAN: Mr. Sting-Wakey Wakey Mr. Sting. You have a visitor
Mr. Sting, (SOFTER), I think he remembers.
MAN: You're a hard man to find.
WOMAN: How did he look?
VO MAN: . . . Older
STING: Just for *one* song
STING: *Any* song?
WOMAN: Play it!

WHITER SHADE OF PALE PROCOL HARUM

WOMAN: Are you going back up there?
MAN (BLANKLY): I didn't think you'd care.
WOMAN: Stop. Please stop.
MUSIC FADES IN
We skip the light fandango
As the ceiling flew away
Turned a whiter shade of pale
Would not let her be

Art Director Dean Hanson
Writer Phil Hanft
Editor Lenny Michelson, Wilson-Griak,
Minneapolis, MN
Director Jim Beresford, James Gang
Agency Judy Brink, Fallon McElligott,
Minneapolis, MN
Production Company James Gang, Dallas, TX
Client Washburn Child Guidance Center

WASHBURN CHILD GUIDANCE CENTER
60-second
SFX: BEETHOVEN'S MOONLIGHT SONATA
VO: Without special help . . . kids with learning and behavioral
disorders can fall so far behind . . . they never catch up.
Support the Washburn Child Guidance Center. Here . . . no child is
left behind.

1747

Art Director Marc Surrey, Staten Island, NY
Designer Marc Surrey
Writer Marc Surrey
Editor Joe Laliker/Pelco
Director Lee Smith
Producer Mark Leo
Production Company Michael Daniel
Client New York Fire Dept.

1748

Art Director George Halvorson
Writer Al Fahden
Editor Dale Cooper
Director Jim Lund
Director of Photography Dennis Carlson
Agency George Halvorson/Halvorson
 Fahden, Minneapolis, MN
Producer Jeff Stickles
Client Minnesota Department of Public
 Safety

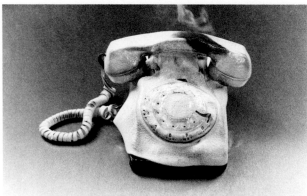

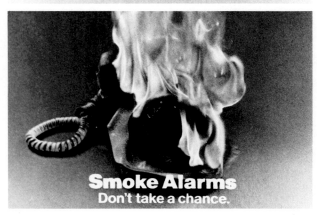

MELTED PHONE
10-second
ANNCR VO: Without a smoke alarm you may not get a chance to call for help.

RIDER SKILLS TRAINING
30-second
ANNCR: This is a BMW, made in Germany.
It can take you from zero to sixty, in 3.9 seconds.
This is a Kawasaki, made in Japan.
It can take you from zero to sixty, in 2.9 seconds.
This is a Red Oak, made in Minnesota.
It can take you from sixty to zero, in point zero seconds.
TAG: Rider Skills Training.

1749

Art Director	Jac Coverdale
Writer	Jerry Fury
Director	Bob Richards
Agency	Gail Wilcox, Clarity Coverdale Rueff Advertising, Minneapolis, MN
Production Company	The Em Com Group
Client	YMCA Metropolitan—Minneapolis/ St. Paul

1750

Art Director	Wes Hranchak
Writer	Wes Hranchak
Editor	Mark Berndt
Director	Craig Smith
Agency	Reed Allen/Hoffman York & Compton/ Milwaukee, WI
Production Company	Pam Ferderbar, Ferderbar Productions/Milwaukee, WI
Client	American Council of the Blind

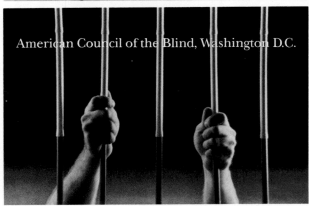

JOY OF COOKING
30-second
When you cook at the YMCA . . . you peel . . . dress . . . measure . . . tenderize . . . shake well . . . steam . . . cook . . . rinse and serve. And with a steady diet of the Y, you'll have less problems with leftovers.
Experience the Joy of Cooking. At the YMCA.

CANES
30-second
SFX: TAP, TAP, TAP.
ANNCR VO: Excuse me. You've probably seen us using canes like this on our way to work. Some of us are lawyers.
ANNCR VO: Engineers.
ANNCR VO: Psychologists.
ANNCR VO: And computer programmers.
ANNCR VO: Unfortunately, there are still employers who think blindness is . . .
ANNCR VO: . . . reason enough to lock us out of the business world.
SFX: PRISON DOOR SLAMMING.
SUPER: American Council of the Blind, Washington, D.C.
ANNCR VO: Blindness isn't a barrier unless you make it one. When hiring . . .
ANNCR VO: . . . don't close your eyes to the blind.

MIRACLES
30-second
VO: The Baltimore Burn Center works miracles.

PUT A LID ON LITTER
30-second
ANNCR VO: A lot of people in Arizona just throw their litter wherever they want. A little bit here. A little bit there. It all adds up. And pretty soon . . . Arizona won't be so pretty. That's why on October 22nd, we're asking everyone to go out of their way to pick up a piece of litter. With all of us pitching in, we can return Arizona to a natural state of beauty.
October 22nd . . .
put a lid on litter.

1753

Art Director	Richard Silverstein
Writer	Jeffrey Goodby & Andy Berlin
Editor	Positive Video & On Tape Productions
Director	Jon Francis
Agency	Debra King, Goodby, Berlin & Silverstein, San Francisco, CA
Production Company	Jocelyn Shorten, Jon Francis Films
Client	Golden Gate National Recreation Area

1754

Art Director	Brian Fandetti
Writer	Steve Bautista
Director	Mike Cassiere
Agency	Kathleen Cawley/HBM/Creamer, Inc., Providence, RI
Production Company	Business Broadcasting Systems, Inc.
Client	Salvation Army

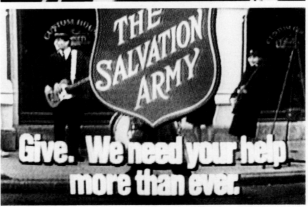

15 MINUTES
30-second
(MUSIC UNDER)
ANNCR: If you drive fifteen minutes from Los Angeles, you'll find a scene something like this.
Fifteen minutes outside Manhattan, you might find this.
And fifteen minutes from Chicago, it'll look like this.
But fifteen minutes from San Francisco,
(MUSIC SEGUES TO EERIE WIND)
you'll find a place unique in all the world.
It's no accident that it looks like this.
And it'll be no accident if it stays this way.

CHANGING OUR TUNE
30-second
(MUSIC, SALVATIONISTS PLAY "BRINGING IN THE SHEAVES")
ANNCR: For over one hundred years, this is how the Salvation Army has petitioned your support. But today, providing hot meals, clothes, and shelter for the needy is a costly proposition.
ANNCR: And our traditional fund raising efforts are falling short. So now we're forced to take on a more aggressive approach.
(BUS FILLS SCREEN)
(MUSIC, SALVATIONISTS PLAY PINK FLOYD'S "MONEY")
ANNCR: The Salvation Army. We're changing our tune.

1755

Art Director	Bob Meagher
Designer	Bob Meagher
Writer	Dave Ullman, Jay Kaskel
Editor	Bill Rentz
Director	Peter Elliott
Agency	Bob Meagher, Dave Ullman, Jay Kaskel—Cramer-Krasselt, Chicago, IL
Client	Chicago Gang Taskforce
Sound Effects	Terry Fryer

1756

Art Director	Kirk Ruhnke
Writer	Kirk Ruhnke
Editor	Mark Berndt
Director	Mark Berndt
Agency	Kirk Ruhnke/Frankenberry, Laughlin & Constable, Milwaukee, WI
Producer	Mark Berndt
Client	United Performing Arts Fund

CANDLES
30-second
ANNCR VO: Barbara Hamilton, age 16.
SFX: BELL TOLL.
ANNCR VO: Frank Carlos, age 13.
SFX: BELL TOLL.
ANNCR VO: Ben Wilson, age 17.
SFX: BELL TOLL.
ANNCR VO: Gangs.
For too long they've been snuffing out innocent lives.
But there is something we can do.
If you want to help or need help, call the Chicago Intervention Network at 744-0800.
Together we can *stop* it.
SUPER: LET'S GANG UP ON GANGS.

CURTAINS
30-second
ORCHESTRA TUNING
ANNCR: Throughout the years Milwaukee's performing arts have thrilled us and fulfilled us with music and dancing, laughter and tears.
And now, they need your help. Because although we know that there will always be performing arts,
MAN SINGS: Lady of Spain, I adore you.
ANNCR: We sometimes worry about the quality.
ANNCR: Support the troops with a gift to the United Performing Arts Fund.
If you don't act—it's curtains.
MAN SINGS: Lady of Spain, I love you . . .

1757

Art Director	Pat Burnham
Writer	Bill Miller
Editor	Marcus Stevens, Pytka Productions
Director	Marcus Stevens, Pytka Productions
Agency	Judy Brink, Fallon McElligott, Minneapolis, MN
Production Company	Meg Matthews, Pytka Productions, Los Angeles, CA
Client	Metromedia

1758

Art Director	Students of Adopt-A-School Program
Writer	Students of Adopt-A-School Program
Editor	Rich Carroll/Optimus
Agency	Bill Davenport/Ogilvy & Mather, Chicago, IL
Production Company	Jeff Jones, McDonough-Jones
Client	Adopt-A-School

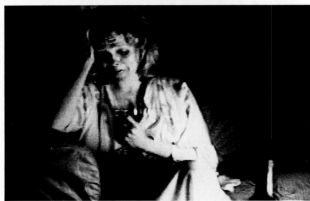

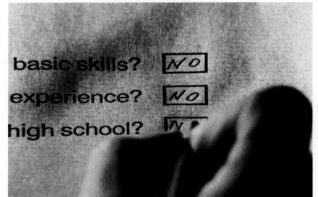

ALCOHOL AWARENESS
30-second
ANNCR: Alcohol can bring new meaning to your marriage.
MAN: (YELLING) I'm sick of you. Don't talk back to me when I'm talking to you.
ANNCR: It can make you a better parent.
MAN: (YELLING) I'm not gonna wake him up.
WOMAN: (YELLING) He's already asleep.
MAN: (YELLING) What do you think I am, some monster?
ANNCR: It can make you the life of the party.
ANNCR: Most people who have a problem with alcohol don't know it's a problem.
That's the problem.
ANNCR: A public service message from Metromedia Television.

APPLICATION
60-second
(SFX: FOOTSTEPS)
WOMAN: May I help you?
YOUNG MAN: Yeah, I'd like an application please.
WOMAN: For which position?
YOUNG MAN: Anything.
MUSIC UNDER
WOMAN: All right, fill this out, you can sit over there.
YOUNG MAN: Thank you.
MUSIC UNDER
MAN: Congratulations Bill and welcome to the firm.
2ND MAN: Thank you.
ANNCR: If you think a high school diploma isn't important . . . ask someone who doesn't have one.

1759

Art Director Geoff Hayes
Writer Evert Cilliers
Editor Craig Warnick
Director Vilmos Zsigmond
Agency Michael Pollock/TBWA
Advertising, New York, NY
Production Company Bruce Dwiggins, Ann Block, Hugh
Herbert-Burns, Cinematic
Directions
Client Unicef

1761

Art Director Kurt Fries
Writer Neal Sellman, John McKee
Editor Sol Fischler/Dennis Hayes Film
Editing
Director Steve Horn
Director of Photography Steve Horn
Creative Director John McKee
Agency Gary Kaney/Tatham-Laird &
Kudner, Chicago, IL
Production Company Linda Heuston Horn, Steve Horn
Client National Institute of Justice
Executive Art Director Jim Manera

CHOICE
60-second
ANNOUNCER VO: Sometimes all a mother has to give is love. And sometimes even that is not enough. This woman's children are sick and suffering from malnutrition. She's too weak to carry more than one of them to a place where she can get help—five days walk away. She has to choose which one to take—even though she knows the others may not survive. You have a choice, too.
UNICEF cards.
Every time you buy them, you help save a child's life—by bringing vaccines and medicines to the millions who need them.
Call now.
The choice you make can help others have a better choice than this.
To contribute or receive a catalog, call 1-800-For KIDS.

STREET
30-second
ANNCR VO: It actually happened in America. A woman was stalked by a killer & stabbed repeatedly over three blocks to her death. Perhaps more tragic than the murder is that along the way over 37 people witnessed the crime and turned away.
Some didn't want to get involved.
Some didn't even know how.
Report. Identify. Testify.

1762

Art Director	Jim Mountjoy
Writer	Don Jeffries
Director	Martin Beck
Agency	Loeffler Mountjoy & Wray Ward, Charlotte, NC
Production Company	Omni Productions
Client	Charlotte Opera

1763

Art Director	B. A. Albert
Writer	Cleve Willcoxon
Editor	Jayan Films and Crawford Post Production
Director	Glenn Kirpatrick
Creative Director	Joey Reiman
Agency	Carol Hardin/D'Arcy Masius Benton & Bowles, Atlanta, GA
Production Company	Jayan Films
Client	Alliance Theatre/Atlanta

MAN OF LA MANCHA/WILLIE STARK/MANON LESCAUT
20-second
You see, there's this old guy back in the sixteenth century who thinks he's a knight. So he puts on a suit of armor, hops on this fleabag of a horse, and goes off to save the world.
(PUNK MUSIC IN)
Boy, people back then were *weird*.
ANNCR: Man of La Mancha.
November fourteenth and sixteenth.
Ovens Auditorium.

MUSIC MAN MAYOR DOOLEY/DOUBLE DOOLEY/TO BE OR NOT TO BE
30-second
YOUNG: Seventy six trom . . . ah, Seventy six trom . . . no, Seventy six trombones lead the big parade.
DOOLEY: A horse, a horse, my kingdom for a horse.
ANDREWS: What light through yonder window breaks . . .
VO ANNCR: Atlanta needs the Alliance Theatre and Atlanta Children's Theatre to produce the best. The alternative is to depend on this kind of talent. And that would be a tragedy.
CARTER: To be or not to be. That is the question.

1764

Art Director	Tom Roberts
Writer	Walter Wanger
Editor	Tom Schatchte
Director	Ron Dexter
Director of Photography	Ron Dexter
Agency	Jackye Horn/Ogilvy & Mather, Los Angeles, CA
Production Company	DXTRS
Client	U.S. Forest Service

1765

Art Director	Richard Silverstein
Writer	Jeffrey Goodby & Andy Berlin
Editor	Positive Video & On Tape Productions
Director	Jon Francis
Agency	Debra King/Goodby, Berlin & Silverstein, San Francisco, CA
Production Company	Jocelyn Shorten, Jon Francis Films
Client	Golden Gate National Recreation Area

FAUCET/DEER/PICNIC
10-second
SFX: RUSHING WATER, BIRDS CHIRPING.
ANNCR VO: Litter in our streams and rivers.
ANNCR VO: Where will it end?
SFX: DISSOLVE TO WATER FILLING GLASS.

DAWN/15 MINUTES/MARINCELLO
30-second
(MUSIC UNDER)
ANNCR: Dawn on Wolf Ridge.
The sun burns through to the sage and the lupine.
Along Bobcat Trail, a winter's rain winds slowly down to sea. And at
Land's End, the cries of seals rise on the wind. It's happened this
way for time that can't be measured.
(MUSIC SEGUES TO EERIE WIND)
But the world is different now. And parts that once seemed certain
now depend on less certain things.
Like your support.

1766

Art Director	Jamie Mambro, Jonathan Plazonja
Writer	Jonathan Plazonja, Ray Welch
Editor	Thomas O'Hanian
Director	Peter Fasciano
Director of Photography	Mark Sarazin
Agency	Jamie Mambro, Jonathan Plazonja/ Welch/Currier, Inc., Boston, MA
Client	The Union of Concerned Scientists

1767

Art Director	George Evelyn
Animator	Kris Moser
Editor	Richard Childs
Director	George Evelyn
Director of Photography	Melissa Mullin
Production Company	Susan Tatsuno/Colossal Pictures, San Francisco, CA; Tom Pomposello/Fred/Alan, Inc.
Client	MTV Networks, Inc./Nickelodeon Channel
Music	The Jive Five

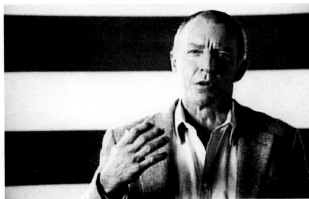

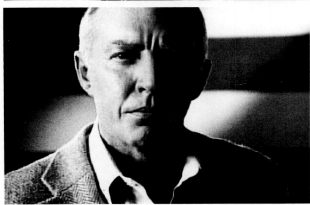

UNCLE RAY
30-second
RAY: Mr. President, respectfully, I . . . I don't know much about bombs or Star Wars. I'm a working man with a bad haircut. But I do believe in something—that maybe the best thing you could do on November 19 is drop a bomb on the Russians. A verbal bomb. A real proposal to end the arms race. This Summit is a chance to do something bold—maybe even something brave. And to waste it could be as tragic as dropping the bomb itself. So for God's sake, Sir, please don't blow it.
SUPER: The Union of Concerned Scientists

BIG BEAST QUINTET
10-second
NO SCRIPT

Art Director	Edward Bakst
Computer Animation	George Takas
Director	Edward Bakst
Production Company	Tom Pomposello & Edward Bakst for Fred/Alan Inc./Edward Bakst Prod.
Client	MTV Networks Inc./Nickelodeon, New York, NY
Senior Vice President and General Manager	Geraldine Laybourne
Executive Producer	Alan Goodman

NICK BREW
10-second
NO SCRIPT

1769

Art Director	Jerry Lieberman
Designer	Lou Brooks
Director	Debby Beece & Betty Cohen/Tony Eastman
Production Company	Tom Pomposello for Fred/Alan Inc.
Producer	Jerry Lieberman
Client	MTV Networks Inc./Nickelodeon, New York, NY
Music Composer-Lyricist	"Jive 5" & Tom Pomposello
Music Director	T. Pomposello
Voice	Joe Piasek

1770

Art Director	Bill Jarcho & Mark D'Oliveria
Animator	Bill Jarcho
Director	Bill Jarcho & Mark D'Oliveria
Production Company	Tom Pomposello for Fred/Alan; Olive Jar Animation
Client	MTV Networks Inc./Nickelodeon, New York, NY
Executive Producer	Alan Goodman
Cameraman	Brian Anthony
Lighting Director	Mark D'Oliveria
Senior Vice President and General Manager	Geraldine Laybourne
Soundtrack	Tom Pomposello, Tom Clack

NICKELODEON TOP OF THE HOUR (SCHOOL SURVIVAL DAY)
30-second
Nick, Nick, Nick, Nick, Nick, Nick, Nick, Nick—
Hour top time on Nickelodeon where we're flipping through the afternoon with you.
Have you entered Nickelodeon's School Survival Kit Contest yet? The prizes are too great to wait. Keep tuned for all the details.
There's spaghetti dancing in Mr. Wizard's kitchen right now, "Ah Momma Mia!" Then Nick Rocks right after, right here on the first kids network.
Nick, Nick, Nick, Nick, Nick, Nick, Nick, Nick—Nickelodeon.

MAIN COURSE I.D.
10-second
NO SCRIPT

Gold Award

Art Director	Richard Silverstein & Jeffrey Goodby
Writer	Andy Berlin & Jeff Goodby
Editor	Peter Verity
Director	Jon Francis
Director of Photography	Dave Myers & Keith Mason
Agency	Debra King/Goodby, Berlin & Silverstein, San Francisco, CA
Production Company	Sandra Marshall, Jon Francis Films

MILL VALLEY FILM FESTIVAL
2-minute, 55-second
ANNCR VO: Once a year, the eyes of the international film community turn to the tiny town of Mill Valley, California, and its glorious cinematic celebration.
LADY #1: Of course, we had the debut of ''Paris, Texas'' last year, and that was very nice.
LADIES (CHORUS): Very nice.
MAN #1: I guess we're all looking forward to the film noir retrospective.
MAN #2: Yeah. We like that deep focus.
MAN #1: Well, there's a surface to the genre that, if anything, improves with age.
MAN: They're bringing back that Jane Russell movie, ''Hot Blood.''
MOM: Ellen & Bob want an answer about the video-fest. Are we going or not . . . (CONTINUE UNDER)

1772

Art Director Mylene Turek
Writer Amy Goodfellow
Editor Norman Levine
Director Stuart Peltz
Director of Photography Ken Ferris
Agency Amy Goodfellow, Homer &
 Durham, New York, NY
Producer Al Ames
Client Engelhard

1773

Art Director Jim Damalas
Writer Lew Goldstein
Editor Duke Kullman
Director Rick Squire
Agency NBC Entertainment Advertising &
 Promotion, New York, NY
Production Manager John O'Connor

A DAY IN THE LIFE

MUSIC PLAYS UP THROUGHOUT, TYPE COMES UP, NO VOICE OVER

MIAMI VICE "385" NORTH
60-second
SOT: Are you ready to order now miss?
SOT: No thank you, I'm still waiting for someone.
SOT: Steven where are you?
I've been waiting for you.
(PAUSE)
What do you mean you have to stay home and watch Miami Vice?
(SOUND ONLY)
ANC: MIAMI VICE, HAVEN'T YOU WAITED LONG ENOUGH?

Art Director John Schipp
Designer Michael Bavaro
Writer John Schipp
Director William Miller
Director of Photography Glen Marlin
Agency John Schipp, NBC Sports On-Air Promotion & Advertising, New York, NY
Production Company Spotwise Productions
Client NBC Sports

Writer Bob Bibb
Editor Tony Lopez & James Howard
Director Bob Bibb
Agency NBC Entertainment Advertising & Promotion, New York, NY
Music John Williams

NBC SPORTS/THE TONIGHT SHOW PRE-EMPT
10-second
The Tonight Show Starring Johnny Carson will be delayed 15 minutes, in order to bring you this Wimbledon Update from NBC Sports.

AMAZING STORIES
60-second
Mom, Dad, it's coming!
September 29
From Executive Producer
Steven Spielberg
Amazing Stories.

1776

Art Director	John Schipp
Designer	Michael Bavaro
Writer	John Schipp
Editor	Benjamin Ortiz
Director	William Miller
Director of Photography	Larry Crowley
Agency	John Schipp, NBC Sports On-Air Promotion & Advertising, New York, NY
Production Company	Spotwise Productions
Client	NBC Sports

1777

Art Director	Paula Silver
Writer	Robert Zemeckis
Editor	Larry Plastrik
Director	Richard Greenberg
Director of Photography	Jerry Hartleben
Production Company	Robert M. Greenberg, R/Greenberg Associates, New York, NY
Client	Universal Studios/Amblin Entertainment
Line Producer	Brian Williams
Special Effects Supervisor	Kevin Pike

NBC SPORTS/THE WORLD CHAMPIONSHIP OF TRACK AND FIELD

30-second
They are preparing now.
The swift.
The strong.
The athlete.
They are competing now—
for Rome 1987.

BACK TO THE FUTURE TRAILER

MUSIC UNDER THROUGHOUT.
SYNC: FOOTSTEPS
THUD, THUD.
CLICK.
WHOOSH . . .
MUSIC BUILDS.
SFX: HUM, CLICK, BUZZ . . .
CLICK.
WHOOSH.
WOMAN VO: How far ya goin'?
YOUNG MAN: About 30 years.
THEME SONG

Art Director	Bob Nisson, John Donaghue
Writer	Lynda Pearson
Director	Randy Roberts
Creative Director	Millie Olson
Agency	Sue Rugtiv-Stewart/Ketchum Advertising, San Francisco, CA
Production Company	Bob Abel & Associates
Client	National Food Processor's Association

BRILLIANCE REV. 3
30-second
ROBOT VO: Even in the year 3000, the question will be: ''What's for dinner?'' The answer will be in a package that saves energy, nutrients and trouble. A package that can last the three-year journey to Jupiter—and back. Even in the year 3000, we see the brilliance of food in cans.

Art Director Bob Meagher
Designer Bob Meagher
Writer Dave Ullman
Director Bob Kurtz
Agency Bob Meagher, Maureen Moore,
Cramer-Krasselt, Chicago, IL
Production Company Lorraine Roberts, Kurtz & Friends
Client Lincoln Park Zoo
Music Big Daddy

MY KIND OF ZOO
30-second
MUSIC: OOO,OOO THE ZOO.
RHINO: Yeah.
RHINO: It's brand new.
LION & RHINO: The Lincoln Park Zoo.
RHINO: We're missing you.
LION, RHINO, PENGUIN, GIRAFFE: At the Lincoln Park . . . Zoo
ooo ooo.
LION: It's a world of fun.
PENGUIN: And it's brand new.
GIRAFFE: Come see us and weeee . . . lll . . .
ALL FOUR: . . . see you at the zoo . . . the Lincoln Park Zooooooo.
RHINO: What's brand new?
ALL: Lincoln Park Zoooo.
GIRAFFE (IN FALSETTO): My kind of Zoo.

1780

Art Director	Eric Hanson
Designer	Robert Peluce
Animator	Dale Case, Tom Sido, Gary Mooney
Writer	Audrey Schiff
Editor	Sim Sadler
Director	Bob Kurtz
Agency	Julia Wayne, key/donna/pearlstein, Los Angeles, CA
Production Company	Loraine Roberts, Kurtz & Friends
Client	Laura Scudder's

1781

Art Director	Bobbi John
Animator	Hilary Knight
Writer	Doris Kahn
Creative Director	Kurt Willinger
Agency	Saatchi & Saatchi Compton Inc., New York, NY
Production Company	Clearwater Films
Management Supervisor	Jean Mojo

WILD WEST
10-second
VO: There's only one problem with Laura Scudder's potato chips. Once you hear them, you gotta have them.
SUPER: Once you hear them, you gotta have them.

PEMBERWICK
30-second
SFX: RINGGGG.
PEMBERWICK: Dessert madam, it's yogurt.
MADAM: For dessert, unheard of?!
ANNCR: Introducing the yogurt that is good enough for dessert, Dannon Supreme. An extraordinarily delightful Dannon.
MADAM: Really?
NICK: Smashing!
ANNCR: Dannon's best fruit in not one, but two luscious layers.
ACTRESS: Marvelous dessert, darling!
MADAM: My idea, y'know.
PEMBERWICK: Yes, madam.
ANNCR: Yogurt good enough for dessert, Dannon Supreme.

1782

Art Director Judy Korin
Animator Judy Korin
Writer Judy Korin
Producer Korin Design, Boston, MA
Production Company Video One
Client Judy Korin
Composer Michael McNamara
Audio Engineer Jeff L'Argent

I CAN'T EVEN THINK
2-minute, 32-second
IDEA 1: I have this idea about old people and technology. It's been floating around in my head for a while now. I want do some kind of piece where there's a montage where, I don't know, what do old people think of technology, and how does it affect them, and . . . forget it.
IDEA 2: OK, next idea. Well, maybe I could do my feature. I mean, I've been wanting to do it for a few years now, and now's really the time to do something about South Africa. I mean, social significance, drama, good music, the works, I mean what more could you want from a feature? Now all I have to do is sit down and write it. Yeah, right . . .
IDEAS 3 AND 4: OK . . . ok. Well, maybe, maybe, if I just sit down and . . . forget it . . . that's so stupid.
This'll never work . . .

1783

Art Director Robert Brandel, Harry Marks
Designer Jeff Maltz
Director Mark Peterson
Director of Photography Karl Hermann
Producer Joseph Alicastro, Ralph
Famiglietta, NBC, New York, NY
Production Company NOVOCOM Inc.
Client NBC News
Technical Director James Gerkin

ANIMATION SUNRISE/TODAY/NIGHTLY NEWS

NO DIALOGUE

ear End Review

Art Directors Club

ART DIRECTORS CLUB ACTIVITIES

President Ed Brodsky Ralph Casada, Photographer

This past year has seen us move into our new facilities. It's an 8,000 square foot triplex. Located at 20th Street on Park Avenue South, it is in the heart of what is often referred to as the "New Madison Avenue." At last we have a gallery large enough to house our Annual Show, a new professional kitchen, catering facility and an expanded bar and dining area. Our collection of annuals and other reference materials are available for research in the Library, and we've set aside space for the new Kodak Videotape and Film Library.

The new space was a major renovation. Diane and her staff were there throughout most of the construction and the Club never closed. She and her staff went way beyond the call of duty. If you still haven't visited the new facility, do so soon—I think you'll be very, very impressed.

Some of the new projects for the upcoming year include the launching of an International Call for Entries and Show, the addition of an "Art Director of the Year" awards to our Hall of Fame ceremonies and the transfer of our film library of award-winning commercials to videotape to be made available to schools and advertising historians. The Visual Communicators Education Fund Committee is already planning some innovative ways of increasing the scholarship funds, and the 66th Annual Call for Entries is getting underway.

Of course we will continue with our popular Wednesday Lunch programs, Tuesday Jazz, Portfolio Reviews, "Evening with One of the Best" series, the Club newsletter and a variety of exhibitions in our new Gallery.

I'm sure you realize that all of this could not have been done by one person. I have been privileged to have had a sensational Board of Directors, an energetic and enthusiastic membership and a terrific staff at the Club. I am indebted to so many of you. I can't fit all your names on this page, but you know who you are. Don't stop now, people, we're on a roll.

Ed Brodsky
President

Progress moves slowly—March 1986

The finished product—well worth waiting for!

ART DIRECTORS CLUB ACTIVITIES

ART DIRECTORS CLUB BOARD OF DIRECTORS
1985–1986

President	Ed Brodsky
First Vice President	Kurt Haiman
Second Vice President	Klaus Schmidt
Secretary	Bob Ciano
Treasurer	Jack G. Tauss
Assistant Secretary/Treasurer	Jack Odette
Chairman Advisory Board	Andrew Kner

EXECUTIVE COMMITTEE

Laura Duggan
B. Martin Pedersen
Len Sirowitz
Karl Steinbrenner
Jessica Weber
Richard Wilde

ADVISORY BOARD

Gordon Aymar
Frank Baker
Robert H. Blattner
William P. Brockmeier
William H. Buckley
Stuart Campbell
David Davidian
Louis Dorfsman
Walter Grotz
John Jamison
Walter Kaprielian
Andrew Kner
George Lois
Garret Orr
John Peter
Eileen Hedy Schultz
Paul Smith
Robert S. Smith
William Taubin

COMMITTEES AND CHAIRPEOPLE

Agency Relations	Kurt Haiman
65th Awards Judging	Walter Kaprielian
65th Awards Presentation	Len Sirowitz
Gallery Exhibitions	Laura Duggan
Membership	Sal Lazzarotti
Newsletter	Ron Couture
Portfolio Review	Sal Lazzarotti/Richard MacFarlane
Membership & Luncheon Activities	Dorothy Wachtenheim/Dick Smith
Traveling Show	Shinichiro Tora/Minoru Morita
New Breed	Amy Goldman/Gladys Barton

ART DIRECTORS CLUB ACTIVITIES

This year's judging?

The smoothest ever . . . thanks to a brand new (but, at the time, not yet completed) location in which to do it.

The most organized ever . . . thanks to a professional, hard working staff to coordinate it.

The toughest ever . . . thanks to the largest group of entries in the Club's history.

The most emotional ever . . . thanks to strong minded, argumentative, vocal, and controversial section chairpersons all of whom I personally asked to participate.

The show itself? *You* be the judge.

Chairman
Walter Kaprielian

Judges 65th Annual Exhibition

Section Chairmen
Promotion and Graphics, Suren Ermoyan
Books, Steve Heller
Editorial, Laura Duggan
Advertising, Ted Pettus
Illustration & Photography, Melissa Tardiff
Television, Bob Reed

Advertising
Joel Azerrad
Robert O. Bach
Bill Brockmeier
Tony Cappiello
David Davis
Valerie Davis
Joe Goldberg
Roz Goldfarb
Amy Goldman
Steve Hunter
Ken Lavey
John Luke
Lyle Metzdorf
Tobias Moss
Sherry Pollack
Kathleen Quinn
Judi Radice
Herb Rosenthal
Peter Schaefer
David Wojdyla

Editorial
Mary K. Baumann
Robert Best
Connie Craven
Louis F. Cruz
Gina Davis
Jane Edlershaw
Rob George
Will Hopkins

Anna Kurz
Sal Lazzarotti
Alfred Lowry
Bobbi Rosenthal
Shinichiro Tora
Ira Yoffe
Carmile Zaino

Promotion & Graphic Design
Katsuji Asada
Robert Barthelmes
Peter Bertolami
Ralph Casado
Lee Corey
Derek Dalton
Gary DiLuca
David Freedman
Oren Frost
Chris Hill
Henry Isdith
Richard L. MacFarlane
Lawrence Miller
Victoria Peslak
Joseph Phair
William Seabrook III
Leslie Segal
Ellen Shapiro
Ken White
D. Bruce Zahor

Posters
Ed Brodsky
Bill Buckley
Edward A. Hamilton
John E. Jamison
Judy Katz
Ken Kendrick
Scott Menchin
David November
Jeff Pappalardo
John Peter

Books & Jackets
James Craig
Blanche Fiorenza
Wendell Minor
Christos Peterson
Paula Scher
David M. Seager
Anne Twomey

Illustration
Leslie Avery
Joan Brandt
Bill Charmatz
Louis N. Donato
Beverly Littlewood
Saul Mandel

Richard Mantel
Jacqui Morgan
David Rickerd
Michael Valenti

Photography
Frank Beilin
Paul Chakmakjian
Joe Diamond
Robert Grant
Kurt Haiman

Television
Gennaro Andreozzi
Larry Dobrow
Len Fink
Harvey Gabor
Frank Ginsberg
Dianne Douglas Graham
John Lucci
Lyle Metzdorf
Onofrio Paccione
Maxine Paetro
Robert Petrocelli
Jerry Philips
Mark Shap
Phil Silvestri
Robert S. Smith
Karl Steinbrenner
Jack G. Tauss

ART DIRECTORS CLUB ACTIVITIES

65th Judging—A hard job—well done.

Ruth Lubell, Photographer

Onlookers admire 65th Annual Exhibition held for the first time in the new ADC Gallery.

Ihara, Photographer

Multi-winners Kit Hinrichs and Martin Pedersen with Arno Pedersen at 65th Annual Awards Dinner.

ART DIRECTORS CLUB ACTIVITIES

Visual Communicators Education Fund

The Visual Communicators Education Fund, Inc., is a non-profit organization within the Club which has one very simple mission—to provide tuition scholarships to talented design students who attend metropolitan area art schools. Our endowment fund is modest. Yet, on May 28, 1986 at ceremonies held at the Club, the VCEF gave tuition awards totaling $6,000 to 12 wonderfully talented students. The students who received Art Directors Club Awards of Excellence were:

1986 Visual Communicators Educational Fund Scholarship Winners

School of Visual Arts The Cooper Union New York Technical College	Abbe Eckstein Gregory Roll Shandel Pitts Wayne Brown	Pratt Manhattan Pratt Institute High School of Art & Design	Gayle McMahon Banta Sheryl Lutz-Brown Joannie Tran Peter Jivkov
Fashion Institute of Technology	Meredith Kennedy Veronica Gagliardi	Parsons School of Design: Book of The Month Award Richard Taubin Memorial	Lynn Coffey Hyland Baron

Besides the scholarships, the VCEF also supports the Herb Lubalin Study Center at Cooper Union.

The endowment fund's chief guardian angel has been the High Winds Fund which, through the help of Bob Blattner, has supported the VCEF with substantial tuition gifts. In 1985 Mr. & Mrs. Bill Taubin established the Richard Taubin Award in memory of their late son. For the second consecutive year the Book-of-the-Month Club has given a tuition scholarship which I helped attain for the fund. Through the efforts of Bob Best, NEW YORK MAGAZINE has made a generous contribution this year to the fund.

The VCEF is actively seeking your support. Other than the income received from sponsoring the Hall of Fame Dinner each autumn, we depend solely on individual and corporate contributions. We encourage your tax deductible contributions to help the endowment fund.

Jessica Weber
President

1986 Scholarship winners.

ART DIRECTORS CLUB ACTIVITIES

Joel Azerrad reviews student's portfolio.

Opening Reception Antique Advertising Posters Ed Weinstein, Allan Wahler and Jack Odette

Illustrator Paul Davis speaks to S.R.O. crowd at Wednesday Luncheon.

NANCY RICE

Nancy Rice has won more awards from the New York Art Directors Club than any other art director during the past five years. As the first recipient of the Art Director of the Year Award, she represents the ideal creative person who produces a diverse portfolio of consistently high quality.

Rice is a partner with her husband Nick in Rice & Rice Advertising, a Minneapolis agency just barely a year old which promises to be a new hot shop of national repute. An uncompromising passion for creativity, excellence, challenge, teamwork, perseverance, fun and an intense mutual respect are what first drew Nancy and Nick together at The Minneapolis School of Art and which now forms the basis of their agency. Current accounts include Greensweep Liquid Lawn Care Products, Sportscoach Division of Coachman Industries, Big Brothers/Big Sisters of St. Paul, the Andersons General Store, McGladrey Hendrickson & Pullen, the Minneapolis Planetarium and Library, Ski Hut and Groves Learning Center. With a modest staff of eight, Rice is building a reputation independent of the laurels earned at her previous association with Fallon McElligott in Minneapolis and before that, at Bozell & Jacobs.

During her eleven-plus years at Bozell & Jacobs (initially Knox Reeves), Rice became a Vice President and Senior Art Director working on accounts such as General Mills, Bordens, Pillsbury, H.J. Heinz, Banquet Foods, United Way of America, The First Banks, Minnegasco, Bristol-Meyers, Parker Pens, Grain Belt Brewery, The Radisson Hotels, Northwestern Bell, American Dairy Association, Northup King, Minnesota Department of Tourism, Weight Watchers, H.B. Fuller Company and Yardley. Her work won numerous gold and silver awards in The One Show, the Andy's, the Clio's, Print Casebook, and CA as well as in the Art Directors Club Annual Exhibition.

Rice left Bozell & Jacobs in 1981 to form Fallon McElligott Rice with Pat Fallon and Tom McElligott. FMR put their creative imprint on campaigns for 3M Company, Meredith Corporation, The Minnesota Northstars, the Episcopal Ad Project, The Coleman Company, Mr. Coffee, Stearns Computer Systems, WTCN 11, Rolling Stone Magazine, Gold 'n Plump Chickens and The Wall Street Journal. In its first four years, FMR became a nationally acclaimed agency with $48 million in billings. In 1983, Advertising Age named FMR "Agency of the Year" and in 1985, Rice was named by Adweek as first runner-up for "Adwoman of the Year."

Whether consumer or business-to-business advertising, Rice's work is simple, straightforward, strong, thoughtful and smartly-targeted. Her philosophy that advertising which sells does not insult the consumer's intelligence is manifested in her witty and succint print and television ads. Her creative bent is to eliminate the unnecessary and that style was sharpened no doubt, by the necessity in her early years, of working within clients' limited budgets. Rice is absolutely meticulous and uncompromising in seeking excellence from her creative co-workers and technical suppliers and she is quick to credit them for her success. She praises in particular, the talented copywriters like Tom McElligott, Jim Newcomb and Bill Miller with whom she has worked and with whom she frequently switched roles in brainstorming ideas. Rice is in fact a talented headline writer and believes that the best copywriters also have a good visual sense.

Rice thrives in an open atmosphere with dedicated teamwork, an attitudinal requisite that also applies to her client relationships where honest dialogue is of utmost importance. Rice's success, clout and power for a young woman in advertising is impressive, but as she notes, "It takes a lot to be successful in this business as a person. Gender has nothing to do with it. It takes a lot of energy, drive, courage and support from your associates and family. But most of all, it takes talent. Neither gender has a corner on that."

ART DIRECTOR OF THE YEAR

Perception.

Reality.

If your idea of a Rolling Stone reader looks like a holdout from the 60's, welcome to the 80's.
Rolling Stone ranks number one in reaching concentrations of 18-34 readers with household incomes exceeding
$25,000. When you buy Rolling Stone, you buy an audience that sets the trends and shapes the
buying patterns for the most affluent consumers in America. That's the kind of reality you can take to the bank.

Rolling Stone

If this is all you've heard about Coleman, you're traveling in the wrong circles.

Most people know Coleman makes lanterns. What they don't know is we also make more
camping equipment than anyone in the world. For an illuminating look at the strategy
behind our surprising leadership in outdoor recreation as well as home comfort and
marine products, call 1-800-521-4900. Ext. 50. In MN, 1-800-642-2900. Ext. 50

Coleman

In the church started by a man who had six wives, forgiveness goes without saying.

The Episcopal Church believes that just as we all make mistakes, we can all be forgiven.
Come and join us in the joy of worship and fellowship soon.
The Episcopal Church

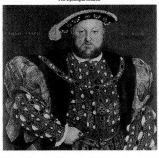

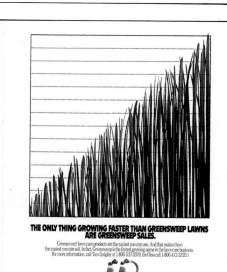

**THE ONLY THING GROWING FASTER THAN GREENSWEEP LAWNS
ARE GREENSWEEP SALES.**

Greensweep® lawn care products are the easiest you can use. And that makes them
the easiest you can sell. In fact, Greensweep is the fastest growing name in the lawn care business.
For more information, call Tom Quigley at 1-800-537-3530. (In Ohio call 1-800-472-3220.)

INDEX

ADC MEMBERSHIP LIST

Jonathan Houston
Joe Hovanec
Elizabeth Howard
Paul Howard
Janet Huet
Roy Alan Hughes
Virginia M. Hull
Jud Hurd
Gary Husk
Melanie Jennings Husk
Morton Hyatt

Ana J. Inoa
Henry Isdith

Joseph Jackson
Robert T. Jackson
Harry Jacobs
Lee Ann Jaffee
Jack Jamison
John C. Jay
Bill Jensen
Patricia Jerina
Barbara John
Shaun Johnston
Susan Johnston
Homer Lynn Jolly
Bob Jones
Kristina M. Jorgensen
Roger Joslyn
Len Jossel
Christian Julia
Barbara L. Junker

Nita J. Kalish
Kiyoshi Kanai
Cheryl Kaplan
Walter Kaprielian
Judy Katz
Rachel Katzen
M. Richard Kaufmann
Milton Kaye
Ken Kendrick
Alice Kenny
Nancy Kent
Myron W. Kenzer
Michele Kestin
Ellen Sue Kier
Elizabeth Kim
Ran Hee Kim
Leslie Kirschenbaum
Judith Klein
Mark Kleinfield
Hilda Stanger Klyde
Andrew Kner
Henry Knoepfler
Ray Komai
Robert F. Kopelman
Oscar Krauss
Helmut Krone
Thaddeus B. Kubis
Anna Kurz

James E. Laird
Howard LaMarca
Abril Lamarque
Joseph O. Landi
John Larkin
Kenneth T. Lassiter
Ann Latrobe
Pearl Lau
Kenneth H. Lavey
Marie-Christine Lawrence
Sal Lazzarotti
Jeffery Leder
Daniel Lee
Edwin Lee
John Lenaas
Robert L. Leslie

Robert C. Leung
Robert Leydenfrost
Alexander Liberman
Victor Liebert
Beverly Littlewood
Leo Lobell
Henry R. Loomis
Michael Losardo
Rocco Lotito
George Gilbert Lott
Robert Louey
Alfred Lowry
Ruth Lubell
John Lucci
Richard Luden
John H. Luke
Thomas R. Lunde
Larry Lurin
Robert W. Lyon, Jr.
Michael J. Lyons

Charles MacDonald
Richard MacFarlane
David H. MacInnes
Frank Macri
Sam Magdoff
Louis Magnani
Carol A. Maisto
Anthony Mancino
Jean Marcellino
John S. Marmaras
Andrea Marquez
Al Marshall
Daniel Marshall
William R. Martin
Caren J. Martineau
Michael Mastros
Theodore Matyas
Marce Mayhew
William McCaffery
Constance McCaffrey
Robert McCaullum
Gerald McConnell
John McCuen
Scott A. Mednick
William Meehan
Fabian Melgar
Mario G. Messina
Lyle Metzdorf
Emil T. Micha
Eugene Milbauer
Jean Miller
Lawrence Miller
John Milligan
Isaac Millman
Ryuichi Minakawa
William Minko
Michael Miranda
Leonard J. Mizerek
Cheryl Mohrman
Burton A. Morgan
Jeffrey Moriber
Minoru Morita
William R. Morrison
Thomas Morton
Roger Paul Mosconi
Roselee Moskowitz
Geoffrey Moss
Tobias Moss
Dale Moyer
Marty Muller
Virginia Murphy-Hamill
Ralph J. Mutter

Daniel Nelson
John Newcomb
Andrew M. Newman
Stuart Nezin

Deborah Nichols
Raymond Nichols
Marcus Nispel
Joseph Nissen
Evelyn C. Noether
David November
C. Alexander Nuckols

Frank O'Blak
Edward O'Connor
John O'Neil
Jack W. Odette
Noriyuki Okazaki
John Okladek
Susan Alexis Orlie
Garrett P. Orr
Larry Ottino
Nina Ovryn
Bernard S. Owett

Onofrio Paccione
Zlata W. Paces
Maxine Paetro
Robert Paganucci
Roxanne Panero
Nicholas Peter Pappas
Jacques Parker
Paul E. Parker, Jr.
Joanne Pateman
Charles W. Pates
Arthur Paul
Leonard Pearl
Barbara Pearson
Alan Peckolick
B. Martin Pedersen
Carol Peligian
Paul Pento
Vincent Pepi
Harold A. Perry
Roberta Perry
Victoria I. Peslak
John Peter
Christos Peterson
Robert L. Peterson
Robert Petrocelli
Theodore D. Pettus
Allan Philiba
Gerald M. Philips
Alma M. Phipps
George Pierson
Michael Pilla
Ernest Pioppo
Peter Pioppo
Robert Pliskin
Raymond Podeszwa
Louis Portuesi
Anthony Pozsonyi
Benjamin Pride
Bob Procida
Jay Purvis

Charles W. Queener
Elissa Querze
Anny Queyroy
Mario Quilles
Kathleen Quinn
Mike Quon

Judith G. Radice
Paul Rand
Neil Raphan
Robert C. Reed
Samuel Reed
Shelden Reed
Patrick Reeves
Wendy Talve Reingold
Herbert O. Reinke
Edwin C. Ricotta

Michelle M. Roberge
Judy Roberts
Ray Robertson
Bennett Robinson
Harry Rocker
Harlow Rockwell
Andy Romano
Barbara Rosenthal
Ed Rosenthal
Herbert M. Rosenthal
Charles Rosner
Andrew Ross
James Francis Ross
Richard Ross
Richard Ross
Warren Rossell
Arnold Roston
Leah Roth
Thomas Roth
Wayne Roth
Iska Rothovius
Mort Rubenstein
Randee Rubin
Thomas P. Ruis
Robert Miles Runyan
Henry N. Russell
Albert Russo
Don Ruther
Thomas Ruzicka

Stewart Sacklow
Martin Saint-Martin
Robert Saks
Ludvic Saleh
Robert Salpeter
Ina Saltz
William Samenko
George Samerjan
Jim Sant'Andrea
John Sargeant
Betty B. Saronson
Audrey Satterwhite
Vincent Sauchelli
Hans Sauer
Sam Scali
Peter Scannell
Ernie Scarfone
Beth Schack
Peter Schaefer
Paula Schaffer
Samuel Scherr
Klaus F. Schmidt
Joyce Schnaufer
William H. Schneider
Annette Schonhaut
Beverly Faye Schrager
Carol Schulter
Eileen Hedy Schultz
Nancy K. Schulz
Victor Scocozza
Ruth Scott
William C. Seabrook III
David M. Seager
Leslie Segal
Sheldon Seidler
John L. Sellers
Kaede Seville
Ellen Shapiro
Alexander Shear
William Sheldon
Mindee H. Shenkman
Jerry Siano
Arthur Silver
Louis Silverstein
Milt Simpson
Len Sirowitz
Richard Jay Smith
Robert S. Smith
Jack Skolnik

Edward Sobel
Martin Solomon
Harold Sosnow
Michelle R. Spellman
Victor E. Spindler
Leonard A. St. Louis
David Stahlberg
Mindy Phelps Stanton
Karsten Stapelfeldt
Alexander Stauf
Irena Steckiv
Douglas Steinbauer
Karl Eric Steinbrenner
Karl H. Steinbrenner
Vera Steiner
Charles M. Stern
Gerald Stewart
Linda Stillman
Ray Stollerman
Bernard Stone
Otto Storch
Celia Frances Stothard
William Strosahl
Ira F. Sturtevant
Len Sugarman
Brenda Suler
Amy Sussman
Ken Sweeny
Robin Sweet

Barbara Taff
Robert Talarczyk
Lita Talarico
Nina Tallarico
JoAnn Tansman
Melissa K. Tardiff
Melcon Tashian
Bill Taubin
Jack George Tauss
Ciro Tesoro
Giovanna Testani
Richard Thomas
Bradbury Thompson
Marion Thunberg
Robin Ticho
Harold Toledo
Shinichiro Tora
Edward L. Towles
Victor Trasoff
Charles Trovato
Susan B. Trowbridge
Joseph P. Tully
Karen Tureck
Anne Twomey

Clare Ultimo
Frank Urrutia

Michael Valli
Haydee N. Verdia
Elizabeth Thayer Verney
Frank A. Vitale
Thuy Vuong

Dorothy Wachtenheim
Ernest Waivada
Jurek Wajdowicz
Joseph O. Wallace
Paul Waner
Jill Wasserman
Laurence S. Waxberg
Jessica Weber
Art Weithas
Theo Welti
Ron Wetzel
Ken White
Pamela J. White
Ronald Wickham

Gail Wiggin
Richard Wilde
Rodney Craig Williams
Jack Williamson
David Wiseltier
Rupert Witalis
David Wojdyla
Henry Wolf
Sam Woo
Elizabeth G. Woodson
Robert S. Woolman
Orest Woronewych
William K. Wurtzel

Ira Yoffe
Zen Yonkovig
Michael Yurick

Susan Broman Zambelli
Bruce Zahor
Carmile S. Zaino
Paul H. Zasada
Richard Zoehrer
Alan Zwiebel

ADC INTERNATIONAL MEMBER LIST

ARGENTINA

Daniel Atilion Verdina

AUSTRALIA

Ron Kambourian

AUSTRIA

Mariusz Jan Demner
Franz Merlicek

BERMUDA

Paul Smith

BRAZIL

Leighton David Gage
Oswaldo Miranda

CANADA

John D. Brooke
Israel Fraiman
Brian C. Hannigan
Ran Hee Kim

ENGLAND

Jean Govoni
Roland Schenk

HOLLAND

Pieter Brattinga

INDIA

Brendan C. Pereira

ISRAEL

Asher Kalderon
Dan Reisinger

ITALY

Titti Fabiani

JAPAN

Masuteru Aoba
Yuji Baba
Satoru Fujii
Terunobu Fukushima
Mitsutoshi Hosaka
Michio Iwaki
Toshio Iwata
Takahisa Kamijyo
Ryohei Kojima
Yoshikatsu Kosakai
Kazuki Maeda
Seiichi Maeda
Takao Matsumoto
Shin Matsunaga
Hideo Mukai
Keisuke Nagatomo
Yasuhara Nakahara
Makoto Nakamura
Toshiyuki Ohashi
Takeshi Ohtaka
Shigeo Okamoto
Motoaki Okuizumi
Tomoyuki Ono
Susumu Sakane
Takayuki Shirasu
Kataoka Shiu
Seija Sugii
Yasuo Suzuki
Teruaki Takao
Masakazu Tanabe
Soji George Tanaka
Yusaku Tomoeda
Norio Uejo
A. Hidehito Yamamoto
Yoji Yamamoto
Takeo Yao

MEXICO

Felix Beltran
Diana Garcia de Tolone
Luis Efren Ramirez Flores

NORWAY

Kjell Wollner

SINGAORE

Chiet-Husen Eng

SRI LANKA

Kosala Rohana
 Wickramanayake

SWITZERLAND

Bilal Dallenbach
Fernand Hofer
Moritz S. Jaggi
Hans Looser

WEST GERMANY

Uwe Horstmann
Olaf Leu
Hans-Georg Pospischil

ADC AFFILIATE MEMBERS LIST

Avon Products, Inc.

Ronald Longsdorf
Timothy Musios
Perry Zompa

Cardinal Type Service, Inc.

Mark Darlow
John Froehlich
Allan R. Wahler

New York City Technical College

Benjamin Einhorn
George Halpern

Parsons School of Design

Al Greenberg
David Levy

Peter Rogers Associates

Leonard Favara
Peter Rogers

Tisdell/Caspescha

Daniel Caspescha
Clifford Tisdell

Toppan Printing Company, Ltd.

Takeo Hayano
Ryuichi Minakawa
Teruo Tanabe

Union Camp Corporation

Stewart Phelps
Robert Todd

Warner Amex Satellite Entertainment Company

Juli Davidson
Leslie Leventman
Jim Warren

INDEX

ART DIRECTORS

Seissler, Amy, 264, 279, 287, 1003, 1046, 1049
Seltzer, Carl, 391
Senzaki, Alan, 751
Senzamici, Ralph, 1194, 1203
Sessions, Steven, 449, 565, 569, 1231, 1277
Shaine, Ted, 59
Shakery, Neil, 888
Shanosky, Don, 679
Shap, Mark, 1328, 1421, 1424
Shapokas, Barbara, 480
Sheehan, Linnea Gentry, 774
Sheehan, Nora, 292, 293, 295, 298
Shelton, David, 453
Shepard, Barry, 534, 543
Shevack, Brett, 191
Shimkus, Barbara, 714
Sidjakov, Nicholas, 1266
Silverstein, Rich, 552, 639
Simms, Rebecca G., 371
Simpson, Greg, 447
Singer, Beth, 1068
Sloan, William, A., 806
Smidt, Sam, 8, 595, 646, 669
Smit, Steve, 1274
Smith, Laura, 483
Smith, Miriam, 281, 310
Smith, Randall S., 498
Smith, Rod, 56
Smith, Tyler, 609, 641
Smith, William F., Jr., 695
Smith, Yvonne, 184
Smith/Cook Designs, 1224
Smolan, Leslie, 520
Soe, Peter, Jr., 540
Soga, Jerry, 711
Sorokin, Scott, 219
Sosin, Bill, 1268
Sparkman, Don, 511
Spier, Shari, 323, 349
Sposato, John, 1010
Stables, Dan, 587
Stanger, Linda, 893
Stanton, James, 507
Steele, Mark, 586
Stefanides, Dean, 46
Steinbauer, Douglas, 263
Stern, Tom, 1079
Sullivan, Ron, 72, 558, 677, 1223
Summerford, Jack, 440
Surrey, Marc, 1287, 1747

Tanaka, Ikko, 346, 445
Tanaka, Shuichi, 502
Tausche, Kurt, 980
Taylor, Bruce, 998
Tenazas, Lucille, 580
Tench, Hal, 207, 611
Terwilliger, Jeff, 50
Tom, Linda L., 516
Tombaugh, Marianne, 761
Tooley Design, Sharon, 1188, 1223
Tooley, Sharon L., 330, 344, 473
Tora, Shinichiro, 300, 302, 1137, 1214, 1217, 1242
Torikian, Vanig, 762
Toth, Mike, 1273
Trousdell, Don, 489
Tucker, Bob, 1483
Tucker, Eddie, 918
Tyler, Carolyn, 69

Ukes, Robin, 1190

Unger, Julia, 768

Vahlow, Mary Ellen, 1002
Valenti, Michael, 1160
Van Dyke, John, 394, 395, 666
van Rooyen, Deborah, 939
Varney, Richard, 879
Vaughn, Rick, 421, 570, 636
Vincent, Kathleen, 245, 1245
Vinje, Einar, 1139, 1143
Virgilio, Pamela, 767
Viskupic, G., 990
Vitiello, Michael, 16, 25, 150, 206
von Brachel, Patricia, 282
Vrontikis, Petrula, 671, 1200

Wachtenheim, Dorothy, 820
Wages, Robert, 698, 718
Walker, Larney, 218
Wallace, Nita, 482
Warkulwiz, Robert, 695
Watson, Terry L., 472
Wedeen, Steve, 423, 566
Weilbacher, Warren, 995
Weithman, Jeff, 551, 763, 886, 951
Weitsman, Michael, 984
Weitzman, Frank, 653
Weller, Chikako, 619
Weller, Don, 619, 870
Whitaker, Beth, 306
White, Charlotte, 1176
White, Louise, 1140
Whittington, Richard, 1253
Wilcox, Dean, 765
Wilder, Susan, 1047, 1051
Williams, Clay, 430, 502
Williams, John, 776
Williams, Lowell, 515, 545, 548, 630
Willis, Len, 1027
Willis, Robert L., 512, 538
Wilson, Jan, 38
Winfield, Terry, 911
Winslow, Michael, 1295
Wiser, Robert, 785
Witzig, Fred, 929
Wolfe, Stephen, 881
Wolper, Ed, 40
Wong, Gwen, 1053
Wong, John Lee, 35
Wong, Linda, 595
Wood, Raymond, 659
Woodward, Fred, 1215, 1250
Wooley, Kathryn, 539

Yagi, Tamotsu, 736, 764
Yamada, Hedi, 726
Yee, Anthony T., 324
Yoffe, Ira, 262
Yoshida, Gary, 1578, 1731
Young & Laramore 562, 732, 734

Zaffos, Lou, 192
Zapke, Roger, 362
Ziff, Lloyd, 977, 1161
Zwiebel, Alan, 988

WRITERS

A.I.G.A., 951
Abbott, Jeff, 200, 210
Abelson, Danny, 455
Abrams, Bernard, 462

Acevedo, Luis, 883
Acker, Al, 157
Adkins, Margie, 582
Adopt-A-School Students, 1758
Agnew, Carter, McCarthy, Inc., 630
Allen, Adrienne, 469
Allenson, Charles, 1430, 1729
Altschiller, David, 131, 982, 1441
Ambrose, Julie, 747
Ancona, Bob, 138, 940, 943
Anderson, Peter, 255
Angeloff, Sam, 689
Arnold, Maxwell, 525, 547
Arnold, Stephanie, 18, 846
Atlas, Jeffrey, 95, 1388, 1640
Avery, Sam, 87, 916, 952
Axton, Hoyt, 1466, 1559
Azel, José, 329

Badami, Rich, 958
Bailey, Cheryl, 1163
Barasch, Melissa, 149
Barber, Sue, 616, 727
Barcus, Alan, 104, 1513
Barnes, Edward, 292
Barnhill, Steve, 404, 546
Barone, Maryann, 1581
Barrett, Jamie, 895
Bartholomew, Tom, 1428
Bartlett, Jennifer, 786
Bautista, Steve, 839, 1754
Baxter, Barry, 633
Baxter, David, 726
Bayer, Ann, 293
Beck, Paula, 1273
Becker, Stanley, 1418, 1541, 1550
Beckerman, Heidi, 1726
Beckwith, Harry, 556
Jack Benke & Associates, 524
Berg, Cathy, 1076
Berger, Betsy, 675
Berlin, Andy, 552, 639, 1459, 1474, 1494, 1753, 1765, 1771
Berman, Cheryl, 1634
Bernard, Ed, 593
Bertino, Fred, 56, 643
Bibb, Bob, 1775
Bible, 867
Bicker, Nick, 1374
Bijur, Arthur, 1558, 1711
Bildstein, Bruce, 166, 634, 635, 1270
Binell, Rich, 617, 724
Binnion, Tom, 189
Birnbaum, Laurie, 1336, 1481, 1603, 1624
Bishop, David, 1657
Bissonette, Paul A., 26
Black, Elizabeth & Edwin, 1030
Black, Paul, 503
Blodgett, Ronnie, 1249
Bloom, Bruce J., 26
Blore, Chuck, 1718
Bohjailan, Andrew, 1527
Bolton, Greg, 449, 569, 1231, 1277
Booms, 544
Borders, Bill, 652, 933, 1515
Bosha, Jim, 849, 862, 969
Bouchez, Brent, 1391, 1461, 1466, 1476, 1555, 1559, 1567, 1589, 1645, 1685

Bowman, Sarah, 146
Boyer, Chuck, 334
Boyer, Patrice, 396, 567
Bradford, Linda, 527
Brandalise, Laurie, 1502, 1622, 1687
Bregman, Peter, 41, 93, 1623
Bremer, Terry, 1449
Briner, Richard, 495
Broadhurst, Judith, 1226
Broder, Bruce, 1642
Brophy, Steve, 192
Broun, Bob, 799
Brousseau, Beth, 739
Brown, Alan, 541
Browne, Kathy, 474
Bryant, Thos. L., 280
Budinger, Nan, 971
Bunting, Garland, 1447, 1691
Burdiak, Barry, 168
Burton, Jerry, 727
Butler, David, 54, 231
Butler, Ron, 270

Cadman, Larry, 46, 124
Cah, Darlene, 1602
Campbell-Ewald Co., 1357, 1374
Cantor, David, 1614, 1618
Caplan, Hildy B., 1224
Carey, Katherine W., 338
Carlson, Bruce, 1580
Carlson, Janet Marie, 637
Caroline, Peter, 56, 446, 608, 642, 889, 1123
Carothers, Martha, 1177
Carrier, Lark, 792
Carter, Graydon, 289
Casey, Kerry, 61, 857
Catlin, Jim, 850, 853, 859
Chapin, Jud, 1708
Chapman, Tony, 110, 1564
Charron, Ted, 119
Chearney, Michael, 1519
Chudakov, Barry, 1626
Chwast, Seymour, 782
Cillieres, Evert, 113, 838, 1759
Cishy, Alex, 737
Clewes, Richard, 1661
Clow, Lee, 1500
Coad, Rich, 1311, 1377
Coburn, Bob, 1578, 1731
Cohen, Andrew, 1633
Cohen, James, 1623
Cohen, Scott, 284, 1146
Cohn, Sheldon, 1372, 1638
Cole, Ed, 1375, 1435, 1464, 1466, 1474, 1544, 1559, 1567, 1571, 1680
Coleman, Mark, 1040
Collins, Dana, 763
Colt, George, 303
Colvin, Leslie, 535
Conde, Clemente, 749
Conniff, Richard, 294
Connors, Bill, 162
Cook, Ken, 638
Cooke, Marty, 145, 536
Cooper, Kenneth C. Ph.D., 321
Copacino, Jim, 1566, 1570, 1573, 1722
Corey, Tom, 742
Corridan, Michea, 526
Cranberg, Nicole, 1330, 1704
Craven, Jerry, 128
Crolick, Sue, 629, 631, 738
Cromer, Jack, 733

DIRECTORS

PRODUCERS

PRODUCTION COMPANIES

ILLUSTRATORS

PHOTOGRAPHERS

AGENCIES

PUBLICATIONS

PRINTERS